The Nikon Flash Guide

The Definitive Speedlight Reference

by Thom Hogan

SILVER PIXEL PRESS

Rochester, NY

The Nikon Flash Guide
The Definitive Speedlight Reference

Published in the United States of America by
Silver Pixel Press®
A Tiffen® Company
21 Jet View Drive
Rochester, NY 14624
www.silverpixelpress.com

ISBN 1-883403-84-7

Creative photography © Thom Hogan
Product illustrations © Silver Pixel Press
Cover design by Andrea Zocchi
Printed in Belgium by die Keure n.v.

Some photos may have appeared previously in
digitalFOTO, BACKPACKER, or other magazines.

Nikkor, Nikon, and Speedlight are registered trademarks of
Nikon Corporation, Japan. Other registered trademarks are
recognized as belonging to their respective owners.

Library of Congress Cataloging-in-Publication Data
Hogan, Thom, 1952-
 The Nikon flash guide : the definitive Speedlight reference / by Thom Hogan.
 p. cm.
ISBN 1-883403-84-7 (pbk.)
 1. Electronic flash photography--Handbooks, manuals, etc. 2.
 Nikon camera--Handbooks, manuals, etc. I. Title.
 TR606 .H64 2001
 778.7'2--dc21 00-050468

BACKPACKER photo editor Deborah Burnett-Stauffer really liked, she and I held plenty of lively discussions that continue to influence my work.

Likewise, art director Chris Hercik and I argued passionately over so many photographs, especially covers, I fear some might have mistaken us as a married couple. Chris, Deborah, Galen, and Layne all made me think, and for a photographer, that's a good thing.

Thanks, too, to mom, for letting me borrow the Brownie and Nikkormat when I was just a kid and for helping scan slides in my adulthood (i.e., second childhood). Without her lifelong encouragement, I'd never have tackled any creative endeavors. Quite a few NikomF (http://groups.yahoo.com) and NikonUsers (www.nikonusers.org) discussion list participants had interactions with me that influenced this book, and several took the time to carefully pick through the manuscript for errors and omissions: Jeff Carlin, Jim MacKenzie, Victor Newman, John Owlett, and Todd Peach.

Mom shows off just one of her many art pieces.

As always, Marti Saltzman and her crew at Silver Pixel Press have been instrumental in keeping me focused on finishing the book and helping to fill in a few gaps here and there.

Acknowledgements

Much of the initial encouragement in figuring out how my Speed-light worked came from Galen Rowell in one of his extended photography seminars. I'm sure he was somewhat bemused to find that each time I returned to go shooting with him, I had to relearn many of the same things he thought he had already taught me. Indeed, without his gentle prodding and useful (sometimes repeated) suggestions, I wouldn't have created the picture that eventually became the first magazine cover I sold. I owe Galen more than I can repay.

Galen being Galen.

Along the way, Layne Kennedy's suggestions and encourage-ment have kept me working towards developing my own style and body of work. And while it seems that I could never quite produce a picture that

Layne tries to figure out why Thom isn't using fill-flash at one of his seminars.

Layne demonstrates an unorthodox technique (self-timer, slow shutter speed).

iii

Contents

The Nikon Flash Guide

Contents

Introduction

Back in the early 1990s I changed from Minolta to Nikon equipment because of Nikon's flash capabilities. At the time, several of my colleagues thought I was nuts, since Minolta had a sophisticated wireless flash capability that was both unique and flexible. But my decision was sound. I believed Nikon's flash system had two clear advantages:

1. Nikon camera bodies had the ability to synchronize the flash burst with the closing of the shutter (called "rear sync," or sometimes "second-curtain sync").

2. Pros I knew using Nikon Speedlights were getting more consistent results with flash in a wider range of conditions (partly due to the D-type lenses, which pass focus information to the camera for use in exposure calculations).

My early results, however, were poor. Nikon's flash system is sophisticated and requires the photographer to learn how to use it to its best advantage. This book is the result of my learning.

I make the assumption in this book that you know the basics about your camera and something about exposure calculations. For those of you who need to know more about a particular Nikon camera, I suggest you consult the appropriate *Magic Lantern Guide* to supplement your basic camera manual. (If all you need is a refresher reference, may I so humbly suggest my own *Nikon Field Guide?*) If you need a better understanding of exposure, I'd suggest Ralph Jacobson, et. al., *The Manual of Photography,* 9th ed. (Oxford: Focal Press, 2000) ISBN 0-240-51574-9. You don't need to be an expert on either your camera or exposure to get value from this book, but the more comfortable you are with those two topics, the easier it will be to understand how to use a Nikon flash.

This book is divided into several major sections:

The Basics—Mastering flash photography requires that you know a bit about how a flash works, how it interacts with the camera, how flash exposures are calculated, and how batteries might influence your Speedlight use. The first section of this book covers this background information.

Nikon Terminology—Nikon uses some specific, and sometimes confusing, terminology. I'll try to cut through the jargon and give you a clear view of what these terms mean.

Flash Techniques—It is possible to perform a wide variety of flash techniques with Speedlights, and I'll cover them with examples and generic instructions on how to perform them. You'll learn everything from fill-flash to using multiple flash units for one shot. Most of this section is not specific to any particular Speedlight model, so if you're using a recent Nikon camera body and flash unit, you'll be able to put these techniques to use.

Flash-Specific Instructions—You'll find step-by-step instructions on how to use virtually every Speedlight that Nikon makes in this section. Moreover, you'll find full specifications for each of the Speedlights and any special usage notes you might need to be aware of. If you bought a used Speedlight and didn't get Nikon's original documentation, this section of the book is complete enough to serve as your manual.

Wrap Up—Rounding out the book are brief descriptions of Speedlight flash accessories, troubleshooting tips, plus answers to some frequently asked questions.

My goal in writing this book is to create the definitive Speedlight document. If this book doesn't have the answer to something you wanted to know about using Nikon flash equipment, drop me an e-mail at thom_hogan@msn.com and I'll make sure it gets into subsequent editions. And, as always, I'll keep a set of corrections, clarifications, and extensions to the book on my Web site: www.bythom.com.

Thom Hogan
Emmaus, PA

In high-contrast situations, fill-flash is almost a requirement. Without fill, Adam's face and chest would have been very dark with substantial loss of detail. Watch out for flash shadows (the shadow behind the Jackson chameleon gives away the position of the flash).

The Basics

Nikon's latest Speedlight technology is extremely sophisticated and can be operated without intervention in several automatic modes. But to master flash use, it is necessary to have a basic understanding of how the elements that comprise a flash work as well as how flash exposures are calculated. This chapter tackles those basic building blocks.

How Does a Flash Unit Work?

Let's start at the beginning: the basic elements that make up a flash. All flash units have four common elements:

- *A power supply.* Typically, Nikon flashes run off four AA batteries, although many have the ability to be powered from a remote source. (A few earlier models use AAA or only two AA batteries.)

- *A capacitor.* Capacitors temporarily store energy and can be triggered to quickly release that energy.

 Note: In Nikon manuals, the capacitor is sometimes called a "condenser." This can be confusing, as Nikon uses the word condenser to mean other things, as with the SW-8 Condenser Adapter for the SB-21, which would more accurately be named a Near Focus Diffuser.

- *A flashtube.* Flash units normally use a tube filled with xenon gas to emit light. First, the xenon gas is ionized by a small charge, and then energy stored in the capacitor is subsequently discharged in the flashtube, which produces the flash as the ionized atoms react to the sudden presence of high voltage.

The basic schematic of a flash system. (This oversimplification is useful for visualizing the primary components of a flash unit.)

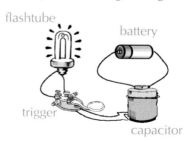

flashtube

battery

trigger

capacitor

13

• *A trigger circuit.* The trigger circuit is what does all the work of moving and controlling energy from the power supply to the capacitor to the flashtube. Recent Nikon flash units have sophisticated trigger circuits that allow a multitude of options in controlling when and how long the flash is fired. For example, current Speedlights have a "shunt circuit" that, upon receiving a command from the camera, quickly diverts the remaining charge from the flashtube, which has the effect of immediately quenching the output of the flashtube (i.e., it instantaneously stops the flash).

When you turn a flash ON, the batteries are used to "charge up" the storage capacitor. Early Nikon Speedlights emit clear, high whines while doing so, though more recent models are quieter and subtler. A typical Speedlight takes from one to eight seconds to charge the capacitor when the batteries are new (and at room temperature), longer if the batteries have been used or are cold. Once the capacitor has stored a full charge, the flash control circuitry turns on a ready light (newer Speedlights send the ready signal to the camera as well, which shows up in the viewfinder or on the camera's LCD panel).

The camera and flash communicate through the five pins on the flash unit's foot and the contacts on the camera's hot shoe. (See page 366 to learn about the function of each contact.)

Pressing the shutter release on your camera sends a signal to the flash unit, whose trigger circuit first sends a small pulse to ionize the xenon gas in the flashtube, then a larger discharge to generate the flash. "Dumb" flash units simply flash at their full capability and stop when the discharge is complete (i.e., the entire charge held in the capacitor is released through the flashtube). Only a handful of the early Speedlights could be characterized as "dumb"; most recent Speedlights do a lot more than merely run the full charge through the flashtube.

Most recent Speedlight models have these additional elements:

• *A light sensor and automatic flash circuitry.* Adding a light sensor and circuitry that shuts the flashtube OFF on demand provides

14

automatic (A mode) flash capability. The sensor, like a light meter, attempts to evaluate the amount of light reflected from a subject and use that to control how long the flashtube is left ON. Like a light meter, this sensor makes some assumptions about the subject (e.g., the subject is a neutral gray value, not lighter or darker). Also like a light meter, the flash unit needs to know about the speed of the film (ISO value) and the aperture being used. Note that as long as the sync speed is set correctly, the Speedlight doesn't need to know about the shutter speed, since the flash burst defines the duration of the exposure; essentially, all auto flash exposure calculations are done in a pseudo shutter-priority mode (see "Flash Exposure," page 17).

- *TTL circuitry.* TTL stands for "Through The Lens." TTL circuitry requires that the camera body have light sensors and circuitry to calculate exposure from those sensors. The flash unit's circuitry is really quite simple—the calculations are done by the camera, and the Speedlight has only to respond to a "shut off" command from the camera.

- *Camera/Flash communications.* Modern Speedlights use a variety of voltages on the hot shoe contacts and flash foot to communicate with the camera (see "What does each contact on the hot shoe do?" in the "Questions & Answers" chapter on page 366). The camera delivers aperture, ISO film speed, flash mode, flash compensation, and shutter release data to the flash. The flash unit conveys the over- or underexposure warning, the flash is ready to fire, and flash mode information to the camera. Nikon has steadily improved and added to the communications between camera and flash, so the most recent Speedlights (e.g., the SB-26, SB-27, and SB-28) have communication abilities that earlier ones (SB-20, SB-22, etc.) don't.

With modern Nikon camera and Speedlight combinations, the camera controls the length of time the flash is ON (see "How Does a Speedlight Flash Unit Work?" page 37).

Amazingly, the flash unit's calculation, switching, and firing happen in a fraction of a second. Indeed, the actual flash burst is typically 1/1,000 to 1/20,000 second and occurs within milliseconds after you press the shutter release.

Note: If the flash lasts only 1/1,000 second or less, why can't the camera synchronize to the flash at a shutter speed of 1/1,000 second? All Nikon camera bodies use a shutter with a moving curtain (called a focal plane mechanism, see following illustration),

so the entire picture is not being exposed simultaneously. Think of a small opening moving across the picture. The faster the shutter speed, the smaller the opening. At slow shutter speeds, the opening is wider than the frame, though the opening still moves across the frame. The flash sync speed of a Nikon body is determined by the amount of time the entire frame is open. Typically, this ranges from 1/30 to 1/250 second on most Nikon bodies. This is called the "maximum sync speed."

c.........l.........i.........c.........k!

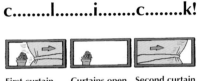

First curtain begins to open **Curtains open, flash fires** **Second curtain begins to close**

*Focal plane shutters consist of several blades, or "curtains." Only when the blades are completely out of the frame can the flash be fired.**

** Most Nikon bodies have curtains that move vertically, not horizontally. For the point of illustration it doesn't really make any difference which way the curtains move—the net result is the same.*

Assuming that full power was used, after a picture is taken with flash, the capacitor is almost completely empty of charge. At that point, the power supply again charges up the capacitor. The amount of time it takes to do this varies and is called the "recycle time." Many things influence the recycle times:

- *Battery condition.* As you use the flash, alkaline batteries gradually lose voltage. As they lose voltage, recycle times increase. Lithium batteries lose very little voltage over time and thus tend to have more consistent recycle times over their useful life. NiCds fall somewhere in between alkalines and lithiums in recycling properties. (See "Batteries" on page 24.)

- *Temperature.* Batteries work most efficiently at room temperature. Alkaline batteries rapidly lose efficiency as temperature goes down, often refusing to work at all below freezing. Lithium batteries continue to work at lower temperatures, but also lose some efficiency as temperature decreases.

- *Flash duration.* If the camera shut the flash off early or fired it at a low power (as is often the case when using fill-flash), the capacitor is not always fully discharged and thus may take less time to "refill."

- *Speedlight model.* Some Speedlights have faster recycling times than others. For example, the SB-27 recycles in 5 seconds as opposed to the 8 seconds it takes the SB-28. Of course, the SB-27 has a lower guide number than the SB-28 (i.e., it produces less light). Even so, the SB-27 is my preferred field flash when shooting wildlife, as I am rarely using the flash at full power and want the fastest possible recycling time so I can keep up with a fast-moving animal.

Flash Exposure

Generally when you're using a Speedlight, the flash unit provides the primary exposure for your shots. Moreover, the flash duration is effectively the shutter speed, regardless of what's set on the camera. Let's think about those statements for a moment.

Consider the following situation: You're in a totally dark room with your camera and flash. When you press the camera's shutter release, the flash fires and provides the only light for the photo. In that case, it's easy to see that the shutter speed doesn't have any effect on the exposure. Since there's no other light in the room, it doesn't matter how long you keep the shutter open; no more light reaches the film. (Remember, the three primary elements that determine non-flash exposures are the film's ISO, the lens aperture, and the shutter speed.)

The more usual case is that you're in a darkened room with some ambient light. Even in this situation, most flash units fired at full power provide the primary exposure for the film. In fact, they are so much brighter than the room light, anything lit by the room light (but not the flash) appears underexposed on the resulting shot. Why is this?

Well, to start with, flash units are quite bright. For example, an SB-28 fired at full power at slightly more than 8.5 feet (2.6 m) provides the equivalent of daytime sunlight! A typical indoor setting is often 5 or more stops dimmer. The best film has a usable range of perhaps 5 to 6 stops from the brightest thing it records to the darkest. So, when you fire a flash indoors, even with other light available, the flash still tends to provide the primary exposure. (We'll examine how to use the flash as a supplement to available light when we discuss fill-flash later in this book.)

Most modern Nikon bodies automatically default to shutter speeds of between 1/60 and 1/250 second when you mount a flash

and turn it ON. These mid-range shutter speeds are rarely long enough to properly expose the background, thus, for most shots taken with flash, the flash itself determines the exposure; the shutter speed isn't a factor. Try it. If you've got any automatic Nikon body and you're reading this indoors:

- Put the camera in aperture-priority (A) mode.
- Set the aperture to f/8.
- Frame a shot.
- Press the shutter release halfway and note the shutter speed the camera sets. (***Example:*** I just did that with my N90s and got a shutter speed of 1.3 seconds.)

Now mount a Speedlight on the camera and turn it ON. You'll see that the camera sets a different shutter speed (1/60 second in my example). Yet the resulting picture will probably be well exposed, as the Speedlight provides enough light on the subject. (Again, the background may be a problem, but we'll deal with that later in the book on page 51.)

Flash exposures are usually determined by only four factors:

1. The film speed, or ISO.
2. The aperture used.
3. The power of the flash unit (specified as a guide number, which we'll discuss in "Guide Numbers," on page 21).
4. The distance the subject is from the flash.

The first two items should be familiar. The first, ISO, is a measure of a film's sensitivity to light. The higher the ISO number, the less light is needed to expose the film.

Note: This book uses a standard of ISO 100 film in all examples and calculations.

For light to reach the film, a lens must collect it. The aperture used on a lens determines how much of the available light can reach the film. The smaller the aperture is, the less light reaches the film.

Thus, for non-flash exposures, you could say the following: For any given amount of light on a subject, the aperture controls how much of that light reaches the film at any given instant. Even the largest lens aperture isn't big enough to fully expose a shot instantly (film isn't that sensitive), so another factor enters into exposure calculations: the amount of time the film is exposed to light (i.e., the shutter speed). The relationship between the three variables under

the photographer's control (ISO film speed, aperture, and shutter speed) determines the exposure.

Since photographers rarely alter the film speed (indeed, they may be using only one type of film), most discussion of exposure drifts towards choosing appropriate aperture and shutter speed combinations. In fact, since depth of field is so important to many types of photography, most photographers choose the aperture, and then the only variable in setting proper exposure becomes the shutter speed. Sports photographers need a fast shutter speed to stop action, so the only variable they control for exposure tends to be the aperture.

Flash photography is different, as it introduces two additional variables, the amount of light present and flash-to-subject distance. In most instances, a flash unit provides the main exposure in the very brief time it takes to fire, thus the shutter speed the camera body sets is irrelevant.

Note: This is not always the case. When you set slow sync or rear sync, the flash provides supplemental light and the shutter speed again becomes relevant as it determines how the background will be exposed. Nevertheless, if the flash is providing the main exposure, the power of the flash and the subject distance are more relevant to exposure than shutter speed.

Unfortunately, flash units don't provide even illumination of everything in the frame. An object 10 feet (3 m) away receives more light from the flash than one that's 20 feet (6 m) away. This is due to something called the Inverse Square Law, which, unfortunately, light from your flash follows to the letter.

What Is the Inverse Square Law?

Simply put, the brighter a light is, the farther its usable light travels. Conversely, the weaker a light is, the shorter the distance its usable light travels. The Inverse Square Law defines those amounts: If a fixed light source generates X amount of light at distance Y, it will generate a quarter of that light at distance 2Y. This can be stated in a formula:

Light = 1 / Distance²

Example: For a **Distance** of 10 feet, the value for **Light** is 1/100. For a **Distance** of 20 feet, the value for **Light** is 1/400, or one-quarter the amount of light!

Note that the background in this photo is darker than the subject. That's because the light source (the flash) is farther from the background than the subject (the Inverse Square Law applies).

Really technical people would point out that I need to add another variable to the equation; that is, the flash power:

Light = Flash Power x (1 / Distance2)

Fortunately, we don't really have to apply this equation and make precise calculations using it very often—it's usually good enough to know the general principle and keep an eye out for situations where it might make an impact on our photography. Just remember that the amount of light generated by a fixed source at twice the distance is a quarter of what it was at the original distance. And at half the distance, a constant source provides four times as much light. Put another way: Each time you move your flash twice the distance from a subject, the flash puts out the equivalent of 2 stops less light.

This is more insidious than it seems at first. If your flash uses a quarter of its power to properly expose a subject at 10 feet, it fires at full power when the subject is at 20 feet. Your shot would be two stops underexposed if the subject were at 40 feet, and so on. Even though you can sometimes select a different aperture to compensate for changes in the flash unit's power over distance, you're still affecting only the exposure of your subject.

Light Falls Off Fast!							
Distance: 1x	2x	3x	4x	5x	6x	7x	8x
Light: 1	1/4	1/9	1/16	1/25	1/36	1/49	1/64

Think about that for a moment. Let's say it's night and you're taking a picture of a friend standing 10 feet away from you, and they, in turn, are standing 20 feet in front of the Lincoln Memorial. If your friend is properly exposed by your flash, the Lincoln Memorial will be only a dim relic in the background. This is one of many things that catch first-time flash users by surprise—they expect everything in the scene to be properly exposed.

Indeed, the light fall-off from flash between foreground and background requires the photographer to make some tough choices.

Moreover, light fall-off often leads to incorrect statements about whether the Nikon flash technology did its job or not. Sometimes when someone says the flash "overexposed" their shot, they are objecting to items in front of their main subject being washed out due to the Inverse Square Law; likewise, "underexposure" is often used to describe the dark backgrounds found in many flash-only shots. Look only at the subject to tell if the camera properly exposed the shot. And if the subject is not lit correctly, examine your technique to make sure that you didn't trick the camera into thinking something else was the subject.

Guide Numbers

Of all the specifications to know about your flash, the guide number is both the most important and the most useful. A guide number (GN) is simply a statement of how much output the flash produces. As we just learned, the Inverse Square Law gobbles up light with distance—the way to combat that problem is by getting a flash that generates more light. Guide numbers are what tell us how much light a flash unit produces.

Unfortunately, all guide numbers aren't created equal. You need to pay close attention to how the number is expressed, as guide numbers vary with ISO film speed, distance scale (feet or meters), and sometimes angle of coverage (for example, Speedlights produce a lower guide number when a wide-angle adapter is used). Your flash manual may even have a table of GNs (a table is also reproduced in this book on page 23). So make sure that you know which guide number you're using and why.

All guide numbers in this book are specified in the following form: X feet (X m). The first number is the guide number at ISO 100 expressed in feet, the number in parentheses is the same thing expressed in meters. The higher the GN, the more light the flash unit produces.

Note: Guide numbers also vary with the position of the flash reflector or the use of a wide-angle adapter. If the flash has to cover a wider angle, it produces less effective output. GNs in this book are calculated for 35mm lenses unless otherwise noted.

If you know the guide number and the distance to your subject, you can manually calculate the correct aperture to use. Shutter speed doesn't make any difference if the subject is primarily lit by the flash and you're using a shutter speed lower than the maximum sync speed of the camera. The basic calculation is:

GN / Distance = Aperture

Example: GN 100 / 25 feet = f/4

In other words, shooting a subject 25 feet away with ISO 100 film and with a flash on your camera that has a GN of 100, you get a "perfect" flash exposure by setting an aperture of f/4.

Note: Always match up the right GN with the measurement you're using! Don't use a GN calculated for feet with a distance measured in meters.)

You can also solve for subject distance if the **Aperture** and **GN** are known:

GN / Aperture = Distance

Example: GN 80 (in feet) / f/5.6 = 14.2 feet

In other words, if you've decided to use the full flash power and an aperture of f/5.6, you'd need to make sure that your subject is 14.2 feet away in order to be properly exposed.

Commit these two calculations to memory! In extreme situations where you might not trust a Speedlight's automated exposure mechanism to perform correctly, you can always revert to manual flash and get perfect exposures if you know these calculations and how to apply them. (Just make sure you're using the correct guide number, i.e., the one that matches the lens, distance scale, and ISO value you're using. Laminated cards with this information are available for most recent Speedlights through my Web site: www.bythom.com.)

To calculate a guide number for an ISO film speed value other than 100, use the following adjustments:

ISO Film Speed	Multiply GN By
25	0.5
40	0.63
50	0.7
64	0.8
80	0.9
100	1.0
125	1.12
160	1.25
200	1.4
250	1.6
320	1.8
400	2
500	2.25
640	2.5
800	2.8
1,000	3.15
1,250	3.55
1,600	3.95

Here's a sample calculation using a film with an ISO other than 100 (in this case, assuming that you're using ISO 400 film, which has a GN multiplier of 2):

(GN x Film Speed Multiplier) / Distance = Aperture

Example: (GN 100 x 2) / 25 feet = f/8

In other words, if you're in a dark room shooting ISO 400 film, you've got a flash on your camera that has a GN of 100, and you know your subject is 25 feet away, you'll obtain a "perfect" flash exposure by setting an aperture of f/8. This is true for any shutter speed at which the flash will sync.

It's important to note that guide numbers are based on the distance between flash and subject, not the distance from the camera to the subject. When you move the flash off camera (as you might by using an SC-17 Cord or with a slave mechanism, such as the SU-4), guide numbers drop once the flash is more than 30° off the camera-subject axis. A general rule of thumb is to open the aperture by:

- +1/2 stop at 45° off camera-subject axis
- +1 stop at 60° off camera-subject axis
- +2 stops at 70° off camera-subject axis

Finally, guide numbers are calculated with the assumption that some light bounce will occur from reflected surfaces (e.g., indoors, some light is reflected off walls, ceilings, and floors). Outdoors, however, almost no light from the flash bounces off a nearby surface and onto the subject, thus the guide number is typically about a third lower. To compensate, multiply the GN by 0.7 (70%) to get an approximate outdoor GN, or simply open the aperture 1/3 stop after calculating exposure with the regular guide number.

Batteries

Since Speedlights are almost always operated using battery power, it helps to understand how batteries work, the differences between types, and how a battery's characteristics might influence your flash usage. Most Nikon flash units use AA size batteries (typically requiring four).

Nikon selected AA batteries as their reference for professional gear because of the fact that they can be obtained nearly anywhere on earth. While this discussion is targeted at using AA batteries, much of it applies to other sizes as well.

Five primary types of batteries are available. In order of approximate cost:

- *Carbon zinc (sometimes manganese).* These low-cost batteries are the least dependable for flash use. They have the following properties:

 1. They lose charge over time and have a limited shelf life. Most of the time, carbon zinc batteries will fail to deliver the stated number of flashes and recycling times listed in Nikon specifications.

2. Carbon zinc batteries are the worst performers in cold weather and rarely work at freezing temperatures.

3. Carbon zinc batteries are highly unstable in storage and very prone to bursting and leakage, even when they haven't been used.

4. Earlier versions of the carbon zinc batteries contained mercury, an element that is very bad for the environment. However, even without mercury, these batteries are considered environmentally toxic.

- *Alkaline.* These are the typical batteries that can be found everywhere from the grocery store to national park gift shops. Alkalines are the lowest-cost batteries I'd consider using in my Speedlights. Alkaline batteries have several properties you need to know about:

Alkaline batteries

1. When used, alkalines lose a little bit of voltage over time. In other words, those 1.5 volt batteries slowly become 1.4 volt, then 1.3 volt, and so on. Nikon designed their equipment with this gradual reduction in mind. While a Speedlight typically wants to have 6 volts of total power available, it can operate on less. As voltages in the batteries drop, the Speedlight will take longer to charge. Alkalines also have a limited shelf life, as they lose a little bit of their capacity over time, even when not in use.

2. Alkalines don't perform well in cold temperatures. Generally, as the temperature nears freezing, you'll see diminished capacity, and when the temperature drops below freezing, alkalines often fail to provide power at all (note, however, that once fully returned to room temperature, they will again operate normally).

3. While most modern batteries are far better than those of a decade ago, alkalines are more prone to corrosion and leakage than any battery type other than carbon zinc. Don't expose alkaline batteries to a salty, humid environment, and definitely don't leave them in your equipment when it's in storage (a month or more).

4. Alkaline batteries are one-use, disposable technology. When you've discharged them, they cannot be recharged (at least not reliably or safely). Worse still, the chemical

makeup of all batteries is environmentally toxic, so it's not good form to throw them away, especially in developing countries, where disposal sites are already problematic. Please collect your exhausted alkaline batteries and send them to a disposal center that knows how to deal with toxic substances (most battery companies now provide addresses of such centers on their packaging).

- *Nickel cadmium (NiCd).* The external, rechargeable power packs that Nikon makes for Speedlights use NiCds (a few now use a newer lithium-enhanced variant, known as Lion), but you can find AA NiCds at photo stores and other places that sell large volumes of battery-powered equipment. NiCds have the following properties:

 1. Like alkalines, NiCds lose a little bit of voltage when used, though not nearly as much as alkalines do. This means that flash recycling times get longer as the batteries discharge, but typically not as much as with alkalines.

 2. NiCds also perform slightly better in cold temperatures than alkalines, but not enough to make much of a difference. As temperatures hover near freezing, you'll see a degradation of performance; I've never been able to use NiCds when the temperature approached 0° F (–18° C).

 3. NiCds tend to be vulnerable to leaking when they're overcharged, but it's been my experience that they rarely corrode the way alkalines do.

 4. NiCds are designed to be recharged and can often handle 100 or more recharges. Thus, NiCds are probably the most environmentally friendly battery, though you still need to dispose of them at special centers (the metals used in batteries can pollute water supplies if improperly disposed of). NiCds tend to lose their charge when stored, so you should always charge your batteries just prior to use, if possible (and conversely, leave them uncharged in storage). It's not unheard of to have a completely charged NiCd lose virtually all its charge in a couple of weeks.

 5. NiCds have a low internal resistance (compared to alkalines). Thus, they maintain a higher voltage under the heavy current draws of a flash unit. Because of this, NiCds provide faster recycle times.

6. Finally, early NiCds had a reputation for "learning" incomplete charge levels. In other words, if you drained the battery only halfway and recharged it, in subsequent use it would tend to charge only up to half its capacity, and provide only that amount. To combat this, battery manufacturers encouraged users to fully discharge a NiCd before recharging (some even built dischargers into their charging stations). Current NiCds generally are immune from this problem, though it's probably still good advice to fully discharge a NiCd before recharging it, if you can.

Note: NiCds (and other rechargeable battery types, such as NiMH) are often marked as being 1.25 or 1.25+ volts. That's normal. You can still use them in place of 1.5v AA alkalines.

- *Nickel metal hydride (NiMH).* Related to the NiCd, NiMH batteries first saw use in portable computers and other high-current-demand devices. Their properties are similar to NiCds:

NiMH battery

1. NiMH batteries lose a bit of voltage during use. Unlike NiCds, they lose their capacity slowly when not used (e.g., in storage).

2. NiMH batteries perform slightly better than NiCds in the cold, which is to say, not particularly well.

3. NiMH batteries don't seem as prone to leakage or bursting as NiCds.

4. NiMH batteries, like NiCds, can be recharged many times (often as many as 1,000 times) before their performance starts to degrade.

5. Unlike NiCds, NiMH batteries never "learn" reduced battery capacity. You can safely recharge them regardless of how much of the battery's capacity has been used.

- *Lithium.* These batteries use the most recently developed technology and have a number of attributes that make them superior to other battery types. Unfortunately, there's only one supplier of lithium AA batteries (Energizer), and they're quite expensive compared to alkalines. The properties of lithiums that are useful to know are:

Lithium battery

1. Lithiums retain most of their voltage throughout their useful life, thus flash recycling times tend to remain nearly constant until shortly before they discharge.

2. Lithiums operate at far lower temperatures (and recover faster) than other battery types.

3. I've never heard of a lithium battery leaking, though it's still quite possible. Lithium, unfortunately, is also an environmentally unfriendly chemical. Thus disposal, as with all batteries, should be to a dedicated disposal facility, not your local trash.

4. Like alkalines, lithium AA batteries are not rechargeable (though some external power packs use lithium cells that are rechargeable).

5. Lithium batteries are quite light (about half the weight of a comparable alkaline), thus in situations where weight is an issue, they are the battery of choice.

6. Lithium batteries have very long storage lives, as they will lose less than 10% of their capacity over a decade. This is significantly better than any other current prepackaged AA technology can claim.

7. One little-known fact about lithium batteries is that as a safety precaution they automatically shut down when they become too hot. In hot climates, keep your spare lithium batteries out of the sun and off of hot surfaces.

Personally, I believe that all photographers should follow these guidelines in using batteries with their Speedlights:

• *For most photography, use rechargeable NiCds or NiMHs.* It's less costly than using disposable batteries, better for the environment, and both types offer several slight performance advantages over alkalines.

• *When cold temperatures are expected, or weight needs to be minimized, use lithiums.* In both cases, lithiums are unmatched in their performance; indeed, no other technology comes close.

Note: If you're using alkaline batteries and the Speedlight's ready light takes more than 30 seconds to light, you need to replace the batteries. If you're using rechargeable NiCd or NiMH batteries and the ready light takes more than 10 seconds to light, you should recharge the batteries.

Battery Hazards

For the most part, batteries are relatively benign. However, you need to be aware of several hazards:

- *Leaving partially used batteries in equipment can result in corrosion.* The reactions that produce the electrical power in batteries have a by-product of moisture. Given that most of the metals and chemicals inside a battery corrode when exposed to moisture, batteries that have been partially depleted and then left in storage tend to leak corrosive material. You don't want that to happen inside your equipment, so always remove batteries from your Speedlight if you're not going to use it in the next month. Alkalines seem more prone to corrosion than NiCds, NiMHs, and lithiums, but all batteries can, and do, eventually corrode.

- *Combining battery types (and even some brands) is a no-no.* Battery performance is related to internal resistance, and when mismatched batteries are used, you may cause "reverse current flow" or overheating. At a minimum, you'll get lower performance. But in extreme cases, an unbalanced load can cause one or more batteries to burst and leak, damaging your equipment.

- *Batteries should never be thrown on a fire or allowed to severely overheat.* In both cases, minor explosions can occur.

Should You Refrigerate Unused Batteries?

Battery storage is best done at low temperatures (just above freezing). Because battery power is dramatically lower at cold temperatures, many people question whether cold storage is appropriate for batteries. It is, because as the temperature drops, the internal resistance of a battery rises, slowing the kinds of reactions that tend to result in burst or leaking batteries.

If you're going to be storing new (non-lithium) batteries for more than a month, it's probably a good idea to put them in your refrigerator. Just make sure to let them warm fully to room temperature before you attempt to use them. Lithium batteries are reasonably inert and have long shelf lives, so they don't need to be stored at cold temperatures.

Battery Capacity

With rechargeable batteries, often a "storage capacity" is quoted. For example, at the time of this writing, Kodak makes two different rechargeable AA batteries, with stated capacities of 1,450 and 1,650 milliampere-hours. As you might suspect, larger numbers are slightly beneficial to flash use.

Milliampere-hour specifications are almost always performed using something called the "C/10" standard. Simply put, the capacity is measured using a constant drain designed to discharge the battery over exactly 10 hours. Thus, if a battery is specified as having a 1,650 milliampere-hour capacity, that means that the battery can provide a constant 165 milliamperes of current for 10 hours.

By way of comparison, most flash units draw several amperes of current when they recycle (fortunately this is for only a few seconds, otherwise the batteries would be discharged in a matter of minutes!). All else being equal, a higher capacity battery should provide more flashes per charge.

In practice, however, the differences are minimal, and flash use varies enough to make direct comparisons difficult. The one thing I have noticed with larger capacity rechargeables is this: recycle times tend to stay lower for a few more flashes. For professionals, that's often the difference between getting the shot and missing it because they're changing batteries or waiting for their depleted ones to recycle the Speedlight.

Many rechargeables are labeled as being 1.25 volts instead of 1.5 volts. As you've learned, alkalines don't stay at 1.5 volts for long, and Nikon's equipment has been designed to take lower voltages into account, so there really isn't any meaningful difference as far as operation is concerned.

One final note about battery capacities: With most rechargeable batteries you'll see a modest improvement in capacity after the first few charges. This is normal. Likewise, after you've used the battery for some time, you may see signs of "aging," where the capacity starts to drop. Most batteries can be recharged hundreds of times before they begin to lose capacity (some, as many as 1,000 charges). At some point, however, the batteries lose significant capacity and become worthless. As with disposable batteries, take your used rechargeables to a recycling center rather than tossing them in the trash.

Nikon Terminology

Nikon uses many similar-sounding and cryptic terms, which over the years have confused countless Nikon users. Worse still, some terms were modified slightly or used interchangeably in various Nikon manuals. This chapter clarifies these terms and helps you understand what each means.

Flash Modes

Nikon Speedlights operate in one of three overall "flash modes." Flash modes determine how the Speedlight is controlled (e.g., how much light is produced, and whether the camera or the flash unit makes that determination). Some Speedlight models support all three modes; others may only operate in a single mode. There are three primary modes:

TTL Stands for "Through The Lens." When set in TTL mode, Speedlight flash units rely upon information received directly through the lens, measured and calculated by the camera's sensors to determine flash duration. In this mode, the camera controls the amount of light produced by the flash. Not all Nikon bodies or all Speedlights support TTL mode, though almost all recent Nikon equipment does (see "TTL-Capable Bodies," on page 326).

A Stands for "Automatic flash." When set in A mode, some older Speedlights calculate flash-to-subject distance by emitting an infrared or visible light pulse and taking a measurement when it sees the reflection. This produces enough information to determine the subject's distance from the flash and is used to determine the duration the flash should fire. Most recent Speedlights have light sensors that detect reflected light from the subject and use that to determine when to shut the flash off. In this mode, the Speedlight controls the amount of light produced by the flash.

Note: Some Speedlights have several automatic aperture-distance ranges, which Nikon usually labels with numbers, such as A1, A2, A3, etc.

M Stands for "Manual flash." When set in M mode, a Speedlight fires at a predetermined power (typically full power). Some Speedlight models allow you to adjust the power to other

settings (1/2 means the flash fires at half power, 1/4 means the flash fires at quarter power, etc.). In this mode, the Speedlight controls the amount of light produced by the flash.

Note: Some Speedlights have additional low-power manual modes. These are either labeled with the power (e.g., 1/2, 1/4, etc.), or are distinguished in another way, such as using MD to stand for "motor drive."

The key difference between TTL and A flash modes is the component that performs the flash duration calculations. In TTL mode, the camera determines when to shut off the flash, and this is based on what the camera sees (e.g., the lens used may make a difference). In A mode, the Speedlight does all the work without any real-time input from the camera (and the Speedlight often sees light reflecting off surfaces that are out of the frame, which may adversely influence the exposure). Indeed, a Speedlight in A mode can correctly illuminate a subject without being attached to the camera (you'll need some way to trigger it, such as a SU-4 slave unit).

In almost every circumstance, you are better off using a TTL mode if your camera and flash support it. The Speedlight A mode is primarily useful on older manual cameras, such as the FM2n, that do not have the CPU and TTL sensors necessary to calculate flash exposures.

Nikon's Confusing Array of TTL Terms

Unfortunately, the method by which the camera performs TTL varies considerably, depending upon the camera body and lens that is used. Indeed, eight variants of TTL exist in Nikon equipment. Nikon manuals are thus often full of terms that, on first glance look similar, but really do imply significant differences in how flash calculations are made. If your camera and flash support TTL, you've probably seen one or more of the following terms (Nikon has also used several other variations in marketing and promotional literature!):

- *3D multi-sensor balanced fill-flash.* This is the most advanced TTL technique available on Nikon equipment. The camera sets the appropriate flash output level using:

 1. Distance information from the lens.

 2. Information from the meter in the camera (regardless of metering method).

3. Information obtained when the Speedlight fires a series of pre-flashes immediately prior to the actual exposure.

Note: Nikon's literature typically uses the term "monitor pre-flashes," though sometimes it simplifies this to "pre-flashes." Both mean the same thing.

Once an initial exposure value has been calculated, the shutter is opened, and information from the TTL sensors is used to determine when the calculated amount of light has reached the film. At that point, the camera shuts off the flash. This mode is available only if you're using D-type lenses on a suitable body. Nikon claims this mode is particularly effective when highly reflective surfaces are in the scene (such as a mirror) and when the background is something that shouldn't be considered in the flash calculation (such as sky).

- *Multi-sensor balanced fill-flash.* Exactly the same as 3D multi-sensor balanced fill-flash except that distance information from the lens is not considered (it may not be present). If you mount a non-D autofocus lens or an AI-P lens on a camera body capable of 3D multi-sensor balanced fill-flash, the camera defaults to this mode instead.

 Note: There is no obvious indicator or visual display that tells you when you're in multi-sensor balanced fill-flash mode instead of 3D multi-sensor balanced fill-flash mode. The only way to know which mode you're in is to keep track of what type of lens is on the camera.

- *Matrix balanced fill-flash.* Ambient (background) exposure is calculated using the matrix meter. During exposure, only the TTL sensors perform flash calculations. Pre-flash is not per-formed, nor is distance information from the lens considered. Setting the camera's exposure mode to matrix metering does not necessarily put the flash unit into this mode!

 Note: Some Nikon documentation uses the term matrix balanced fill-flash interchangeably with multi-sensor balanced fill-flash, but that is incorrect, they are distinctly different modes.

- *Center-weighted fill-flash.* Similar to matrix balanced fill-flash, only center-weighted metering is used for the ambient light calculations. During exposure, only the TTL sensors perform flash calculations. Pre-flash is not performed, nor is distance information from the lens considered. Setting the camera's

exposure mode to center-weighted metering does not necessarily put the flash into this mode!

- *Spot fill-flash.* Similar to matrix balanced fill-flash, only spot metering is used for the ambient light calculations. During exposure, only the TTL sensors perform flash calculations. Preflash is not performed, nor is distance information from the lens considered. Setting the camera's exposure mode to spot metering does not necessarily put the flash into this mode!

- *Automatic balanced fill-flash.* This is a "catch-all" term that Nikon usually uses to describe the family of balanced fill-flash modes. In other words, 3D multi-sensor balanced fill-flash is a type of automatic balanced fill-flash, as is center-weighted fill-flash.

- *Programmed TTL auto flash.* Applicable to a small group of camera bodies (N2020/F-501, N4004s/F-401s, N4004/F-401, and N2000/F-301), this mode controls everything: the camera calculates the aperture, shutter speed, and flash exposure. However, no attempt is made to balance the flash unit's output with the background exposure.

LCD Indicators

TTL + ⬡	3D Multi-Sensor Balanced Fill-Flash
TTL + ⬡	Multi-Sensor Balanced Fill-Flash
TTL + ▣*	Matrix Balanced Fill-Flash
TTL + ▣*	Center-Weighted Fill-Flash
TTL + ▣*	Spot Fill-Flash
TTL only	Standard TTL Flash
A	Automatic Flash
M	Manual Flash
⟨⟨⟨	Repeating Flash

** On the N6006/F-601 and N6000/F-601m, only* **TTL** *appears.*

Indicators on the Speedlight's LCD can have different meanings. This means you must sometimes check other items to figure out which mode you're really in (e.g., the type of lens determines the difference between 3D and multi-sensor balanced fill-flash, while the metering mode is what determines the difference between matrix balanced, center-weighted, and spot fill-flash on certain cameras).

- *Standard TTL flash.* The flash output is controlled solely by the TTL sensors; no attempt is made to take the camera's exposure metering into account.

What Do You Really Need to Know?

The two most important (and confusing) words in Nikon's terminology soup are "balanced" and "fill-flash."

Whenever you see the word "balanced," it means that the camera is using both the camera's exposure meter and its TTL sensors; the camera attempts to create relatively equal exposures from both (i.e., the background and the flash-lit subject receive similar exposures).

Note that this implies that the camera may set exposure compensation (for either the ambient or flash exposures, or both). It's important to remember that the camera is in control of all exposure decisions in balanced modes, not you. While Nikon's system is good, it isn't foolproof, and you're relying on the camera to do the right thing.

Unfortunately, Nikon's own default settings sometimes get in the way of the term's promise. For example: If the camera is set in the program (P) exposure mode, the range of available shutter speeds is limited to between 1/60 and 1/250 second (varies on some cameras), regardless of the shutter speed that should be used to properly capture the ambient light. This restricted shutter speed range often leads to an underexposed background (it's a rare

The five-segment TTL sensor in recent Nikon bodies is actually in the front of the camera and is aimed back at the film plane (or shutter curtain for pre-flash). Note that four segments cover large portions of the outer areas of the frame, while the fifth sensor covers an area that approximates the central autofocus area.

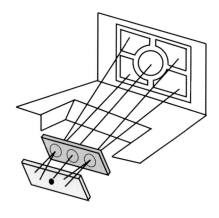

situation when overexposure occurs, but that, too, is possible). Worse still, the camera doesn't report that the scene may be underexposed (however, it does in aperture-priority [A] and shutter-priority [S] exposure modes).

Limited shutter speed range is one reason why many professionals, who tend to use aperture-priority (A) mode, also leave their camera set to slow sync; this sync mode allows shutter speeds as long as 30 seconds on most camera bodies, so it's easier to balance dim backgrounds with flash-lit foregrounds.

Note: Don't assume that slow sync and rear sync do the same thing, only at different points in the exposure. Rear sync cancels the monitor pre-flash, potentially putting the flash system into a different TTL mode.

The other important Nikon term is "fill-flash." Fill-flash implies that the Speedlight does not provide the primary exposure for the photo or subject; instead, it fills in shadows and dark regions in the picture. Again, Nikon's use of the term isn't accurate or consistent. Depending upon the situation, it's quite possible for a Speedlight set in a fill-flash mode to provide the primary lighting on a subject.

Nikon often uses the words "fill-flash" in conjunction with "balanced," which is somewhat contradictory. Technically speaking, "fill" usually means that the flash fires at a lower level than the ambient light, while "balanced" implies that the ambient light and flash are equal. Nikon is consistent, however, in using both terms to say that flash and existing light are mixed in some fashion in the resulting shot. How well they are mixed depends upon the situation and your understanding of the equipment.

Be sure to note the differences in how the flash calculations are performed in the two most commonly used flash modes with recent bodies (e.g., N90/F90, N90s/F90X, N70/F70, N80/F80, F100, F4, or F5):

- *With a D-type lens and the exposure mode set to matrix metering, the camera performs 3D multi-sensor balanced fill-flash.* This means that the information from the five flash sensors (which also detect the pre-flash) is integrated with distance information from the lens and the matrix metering segments before determining how much flash to allow. This is the most sophisticated automatic metering system Nikon equipment uses.

 Note: If you set rear sync, pre-flash is disabled; you're potentially reducing the equipment's ability to calculate a correct exposure.

- *Without a D-type lens and the exposure mode set to matrix metering, the camera performs matrix balanced fill-flash.* This means that only the information from the five flash sensors (which detect the pre-flash) is integrated with the matrix metering segment information before determining how much flash to allow. Incorrect exposures are slightly more likely.

 Note: Using manual focus (AI or AIS) lenses will default the camera body to something other than matrix metering, in which case you'll get center-weighted balanced fill-flash.

 Note: Again, if you set rear sync, pre-flash is disabled.

How Does a Speedlight Flash Unit Work?

With modern Speedlights (SB-24 or later) mounted on modern Nikon bodies (N90/F90 or later), the process of calculating flash exposure is actually quite complex. You press the shutter release, and then:

1. The camera gets the camera-to-subject distance from a chip in the lens (if the lens is a D-type).

2. The mirror flips up out of the light path.

3. The camera signals the flash, and the Speedlight fires a series of up to 16 weak pulses, called the pre-flash. (Some Nikon literature calls this the monitor pre-flash).

4. Five TTL sensors in the camera body monitor the light reflected off the shutter curtain.

5. The camera's computer analyzes the TTL sensor data, the exposure data from the camera's meter, and the focus distance (and AF sensor used on camera models with multiple sensors, such as the F5 or F100), and it makes a decision on how long to fire the flash as well as how to set the background exposure.

6. The shutter opens.

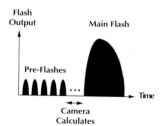

The Speedlight fires a series of up to 16 pre-flashes, then the camera assesses that data before firing the flash. (The shutter is open only while the main flash is firing.)

37

7. The camera signals to start the flash. The TTL sensors monitor the light reflecting off the film and the camera signals to turn the flash OFF when the calculated flash exposure has been reached. In most cases, the flash shuts OFF long before the shutter closes (i.e., the film continues to be exposed to existing light in the scene).

8. The shutter closes and the mirror returns to its normal position.

Nikon has only partially documented what happens in crucial Step 5, which is where the actual "exposure" is calculated. For example, Nikon claims that the following data are looked at and considered in the computations when the camera is in matrix metering mode:

- *Brightness.* The matrix meters on Nikon cameras provide overall brightness information from as few as five and as many as ten segments. (The F5's color CCD sensor array appears not to be used, though the manual implies that it is.)

- *Contrast.* Nikon's system looks at the differences between matrix metering segments, looking for patterns (bright upper segments and dark lower segments might indicate sky and subject, for example). This information is used three ways:

 1. The pattern is compared to known patterns stored in the camera's built-in database.

 2. Some segments may be combined to form a second pattern for further analysis (apparently attempting to guess where the real subject might be).

 3. Extremely bright segments are often discarded from the calculations.

- *Distance.* If a D-type lens is in use, the camera-to-subject distance may bias the camera to calculate exposure in favor of certain segments, most typically, rejecting information from outlying segments and relying upon information from the center segment if the central autofocus sensor reports "in focus." Closer objects are presumed to be the subject when there is conflicting information.

- *Focus.* The autofocus sensors are looked at to see if the subject is in the center of the frame or off-center. For example, if these AF sensors are locked onto a subject in the center of the frame, the camera presumes that the center segments are the likely best judge of exposure, and the camera biases exposure accordingly.

Only if the AF sensors show a large degree of defocusing does the camera body start to weigh the outlying segments for exposure. In theory, the newer Nikon bodies with the five-sensor autofocus system (F5, F100, and N80/F80) factor in off-center focus information better than earlier models and do a slightly better job exposing some photos. However, I haven't perceived a predictable, significant difference between what these cameras do and what my N90s does in similar situations.

Note: The interaction of the focus and exposure calculations surprises many Nikon users. For example, if you focus on your subject, lock focus, and then recompose the scene so that the subject is off-center, the camera favors the ambient exposure it saw in the center of the display when you locked focus *only* if the scene is judged to be strongly front- or back-lit.

Some other things have been revealed about how Nikon camera bodies and Speedlights interact. For example, with current models:

• *If the camera is focused at a middle to long distance (determined from the D-type lens) and the central subject is in focus (determined from the center autofocus sensor), the camera takes all the matrix fields into account but tends to give a heavier weighting to the central ones.* If the background is dark and the subject light, you'll likely end up with a completely black background (unless you're in slow sync mode), as the camera will opt to expose for the central subject.

Note: Quite a bit of e-mail traffic on various Internet Nikon discussion lists has argued about whether or not D technology is necessary on telephoto lenses (e.g., does the 300mm f/4D AF-S lens get better flash exposures than the older 300mm f/4 non-D lens?). Because the camera changes its exposure calculation strategies at longer distances, and because telephoto users tend to be used to taking shots at longer distances, D technology on telephoto lenses has less of an impact and rarely changes the overall flash exposure over what would have been calculated for a non-D lens.

• *If the camera is focused at a close distance (determined from the D-type lens) and the central subject is in focus (determined from the center autofocus sensor), the camera actually does the opposite,* reducing the weighting for the central sensors and increasing the weighting for the outlying ones, unless the camera sees very high contrast between the center and outer sensors, in

which case it again defaults back to the center. Essentially, the camera is trying not to overexpose a close subject.

If the center autofocus sensor is not focused when you expose the frame (as is the case when you focus, lock focus, then recompose before pressing the shutter release all the way), the camera often defaults to the exposure calculations it made when you locked focus. Sometimes, however, the camera will note that the original focus point was much brighter than the rest of the frame and try to compensate for that by adjusting the sensors on which it relies. This is a hit-or-miss proposition, especially if you radically reframe (by moving the subject from the center to the very edge of the frame, for example).

If you're in a hurry and the scene you're shooting is highly subject to change (as is the case in most photojournalism), Nikon's automatic flash calculations are arguably better than those of any other automatic system. But if you have time to set up your shots and exposure, you'll want to spend time learning how (and when) to override your camera and flash, as you'll make better and more consistent exposures.

Nikon TTL Results Vary with the Film Used (Fact or Fiction?)

The TTL sensors in Nikon cameras are aimed at the film plane and measure the light reflected back into them (i.e., they do not point out the lens to directly measure light entering the lens; see illustration on page 35).

One point of confusion has occurred because the latest Nikon manuals talk of these sensors measuring pre-flash pulses before the shutter curtain is opened. Thus many users assume that the sensors don't read off the film during the actual exposure.

Don't be fooled by trying to read between the lines of the Nikon manuals. With TTL flash, monitoring does occur off the film. At a minimum, this determines when the flash shuts OFF (i.e., when the flash has fired enough light to meet the camera's flash exposure calculation).

If the sensors meter off the film, it stands to reason that the reflectivity of the film might influence the flash exposure. In other words, the camera's exposure calculation may be correct, but the film reflects more or less light than expected, causing the sensors to misread the amount of light generated by the flash. So the questions

that need answering are: how different is the reflectivity of various films, and which film did Nikon use to calibrate their cameras?

Nikon has not discussed what reflectivity value they've used, though it has been speculated that it's tied to Fujichrome (Fuji slide film). Some crude measurements tell me that print films tend to have a slightly different reflectivity than slide films, and Kodak's films appear to be marginally different than Fuji's. A simple experiment I performed with two films that looked like they had widely varying reflectivity characteristics did indeed result in slightly different flash results (perhaps a third of a stop difference in exposure), though not as much as I expected.

Most professional photographers use only one or two types of film. Indeed, they often buy large quantities of film from a single production batch to insure that their results will be consistent from shoot to shoot. Prior to their first assignment, they'll take a few test pictures to exactly determine the ISO film speed value they'll use, and sometimes even the filtration and flash compensation they'll use. Once these tests are done, the unused film goes into the refrigerator to preserve its characteristics, and the photographer takes out only the film he or she needs for each shoot. The reliance on a single film and the pre-testing mean that most professionals never really have to worry about whether film reflectance might be changing flash exposures; they experimented to find the best results, then locked in those choices and didn't vary them.

Most amateurs, however, are not so faithful to a single film. Many buy whatever is least expensive or whatever's available when they shop. They're also likely to experiment and try new films just to see how they work. Thus, I suspect that some Nikon flash exposure complaints are partially related to differences in film reflectivity, though since this is only one of many variables, it's impossible to say so with confidence.

Unfortunately, short of making very controlled experiments and using a densitometer to assess the results, it is impossible for most of us to judge how film reflectivity might be affecting our results. The modest experiments I've performed haven't suggested that the difference, if any, is large, so I've tended to discount varying film reflectivity as a source of poor flash results.

My advice: Do what the pros do, and try to stick to one film (or at least one family of film, such as Fuji Provia or Kodak Ektachrome). Perform some basic flash exposure tests using standard TTL in controlled situations and look at the results. If you see a slight flash overexposure or underexposure, then dial in an

appropriate compensation value for all your TTL flash shots. When I did these tests I found that I needed to use no compensation for my three favorite film stocks (Fuji Velvia, Fuji Provia F, and Kodak Ektachrome 100 VS), but preferred a 1/3-stop increase in flash exposure for Agfa Scala.

Flash Techniques

One of the delights of using a Nikon flash unit is the variety of visually interesting techniques that can be accomplished with it.

When I'm in "serious photographer" mode (as opposed to "fooling around" mode), I almost always have a Speedlight mounted on my camera. At a minimum, I use fill-flash to help control contrast, but by having the flash always at the ready, I often try additional shots I might not have, using the flash to paint light in ways that add visual variety to my work. This chapter will help you do the same.

Fill-Flash

The difference between the brightest object in a scene and the darkest almost always spans a broader range than film can record. The basic premise of fill-flash is to add light in dark or shadow areas so that the image reveals shadow detail.

If we just use our eyes as a guide (i.e., if it can be seen, it can be recorded on film), the resulting pictures are usually not quite what we expected; the film may not have recorded something we remember seeing. That's partly because our eyes have an ability to resolve a far greater range of brightness than film, and also because we have a number of adaptive and learned responses that come into play.

For example, when we move our eyes' focus from a dark spot to a bright spot, our pupils dilate to help us resolve detail. And sometimes our brain fills in details we don't resolve. When I stare at a bright white exterior wall bathed in direct sunlight, it's so bright that I have to wait a few moments for my pupils to adjust before I can actually see the speckled texture. The wall ranges in brightness from bright to very bright (due to the angle of the wall, the angle of the sun, and a few other variables). So when I first look from the darkest to the brightest spot in the scene in front of me, my brain still tells me that the texture on the wall is there, even though I'm not able to immediately resolve it.

The same thing happens at the other end of the spectrum. Indeed, when it gets really dark, we actually use different parts of our eye to see.

If you've ever turned off a light in an otherwise dark room, you know what happens: at first you can't see a thing, but eventually

your eyes adjust to the lack of light and you can make out your surroundings reasonably well. Your pupils open fully, and your brain starts using the rods in your eyes instead of the cones to form its image.

Unfortunately, film doesn't get to change its response and adapt based upon the characteristics of what it's looking at. Film has a reasonably linear response to light (some films, like Fuji Velvia, have a steep decline in their ability to render dark areas, making the problem of limited range worse).

At a specific minimum amount of light film starts capturing detail, while at a specific maximum amount of light, it no longer holds any detail. With most slide films, the usable range from minimum to maximum is 5 or 6 stops. With print film it can range as high as 8 stops. With some digital cameras and a few very black-and-white film emulsions, it can be as much as 10 stops. Yet, our eyes still generally resolve more range.

What this all means is simple: When you look at a scene, your eyes are probably seeing more detail in the dark and shadow areas than the film you're using can resolve. This is absolutely true when a scene encompasses a very wide range of light values. For example, when shooting at sunrise or sunset, the sky immediately around the sun (and anything still lit by the sun) can be quite bright while foreground objects may be in complete shadow, with little indirect light bouncing in to light them.

No Detail <-----------------------*Detail*----------------------> *No Detail*

Slide film renders everything from black (no detail) to white (clear acetate) in 5 or 6 stops of light. Subtle use of fill-flash can take items that would otherwise appear as black (no detail) and lift them into the range where film captures some detail. The trick is to use just enough flash so that some detail is rendered in the deepest shadows.

The solution: Use flash to increase the light values in the darker areas of the scene to illuminate information that the film can record. We call this technique "fill-flash."

Nikon Speedlights, when used with any of the more recent cameras, sport a bewildering array of fill techniques (see "Nikon's Confusing Array of TTL Terms," on page 32), but these all boil down to two possibilities: (1) let the camera determine the fill amount; or (2) control the fill amount manually.

If you choose to have the camera provide fill-flash, there's very little that you have to consider or do. Once the settings are made, everything is automatically determined by the camera. Here are the steps to getting the best available automatic fill-flash (this applies to virtually all Nikon cameras, beginning with the N8008/F-801 and all Speedlights starting with the SB-24):

1. Set the camera to matrix metering.

2. Set the camera to program (P), aperture-priority (A), or shutter-priority (S) exposure mode.

3. Set the Speedlight to TTL flash mode (the ▥ and the ▨ or ▨ should both be displayed on the Speedlight's LCD). Set the Speedlight's mode switch to normal (i.e., don't set rear sync).

Note: It's dangerous to set flash exposure compensation when using any of the balanced fill-flash modes, because you don't know what compensation the camera is already automatically applying. If you really want to control the flash output, use flash exposure bracketing or set standard TTL mode and use flash exposure compensation (I'll describe how on the next page).

If you're using a D-type lens, you'll typically get 3D multi-sensor balanced fill-flash when you make the above settings. On a few of the older bodies (or if you're using a non-D-type lens), you'll get multi-sensor balanced fill-flash or matrix balanced fill-flash. In all cases, you'll get Nikon's most sophisticated attempt to balance fill light from the flash with the natural ambient light. You need to watch out for a few potential problems, however:

- *Shutter speeds work in a limited range.* In program (P) and aperture-priority (A) exposure modes, the camera typically sets shutter speeds between 1/60 and 1/250 second (or, if slower, the maximum speed the camera can sync at). This means that the exposure for the background may not be correct (i.e., it may end up being under- or overexposed). *Solution:* Use slow sync to get

longer shutter speeds and thus expose the background
more fully.

- *Apertures work in a limited range in program (P) mode.* Most
 Nikon bodies have limits to the apertures that are selected in
 program (P) exposure mode. These limits vary with the film's
 ISO. **Solution:** Switch to another exposure mode (typically
 aperture-priority [A] if you're fighting this limit).

- *The camera might not recognize the subject correctly.* As
 outlined in the last chapter, Nikon's system makes a number of
 calculations based upon the data it sees in the scene and a
 database of situations stored in the camera's CPU. Off-center
 subjects, subjects with a substantially different reflectance than
 the background, and subjects not at the focus distance (espe-
 cially behind the focus distance) may create results you didn't
 expect. **Solution:** Use standard TTL and manually set the
 fill value.

- *The scene may be too bright for normal fill.* Since you've got
 only a limited shutter speed range to work with, you may not be
 able to use fill-flash at all. This is especially true when using
 high-speed films outdoors. You may simply not have an aperture
 and shutter speed combination that works for the amount of
 light in the scene. **Solution:** Use high-speed sync if your
 Speedlight and camera body support it.

Personally, after having several bad experiences with 3D multi-
sensor balanced fill-flash, I now use standard TTL for almost all my
fill shots. With certain cameras and Speedlights, simply switching to
rear sync or manual (M) exposure mode forces the camera into
standard TTL (check your manuals to see if this is the case). Here's
how to set fill-flash manually (again, this applies to most modern
body-Speedlight combinations):

1. Set the camera to your preferred metering and exposure system.
 (Typically, I leave my cameras in matrix metering and manual
 (M) exposure mode, occasionally switching to spot metering
 when I want more control or want to compare what I'd do to
 what the camera is doing.)

2. Set your exposure on the camera as you normally would (if the
 camera is in an automatic mode, you can skip this step).

3. Turn the flash ON and set the it to standard TTL flash mode.
 Only the ▥ symbol should be displayed on the Speedlight. To
 cancel the balanced TTL mode on most newer Speedlights you

press the mode button (▣ or ◙ symbol); on older units you press the Ⓜbutton.

4. Now you have to select the amount of fill the flash provides. Most of the time, I select a value of –1.7 stops (Galen Rowell's magic fill number), though I've been known to go as high as –0.7 and as low as –2.0 depending upon the subject. Most newer Speedlights let you select this value by pressing the 🔲 button until the flash exposure compensation section on the LCD begins blinking, then using the 🔽 and 🔼 or ➕ and ➖) buttons to set the actual value. Press the 🔲 button again or wait 8 seconds for the value to lock in.

 Note: If you fired the Speedlight at full TTL, the flash would not be providing fill light, it would be attempting to light the main subject! The decision you make in Step 4 determines the amount of fill relative to the ambient lighting.

To set fill-flash on older cameras and flash units that don't allow you to use flash compensation (but still support TTL), you need to "fool" the flash by setting false ISO values. With the flash OFF:

1. Set the ISO value on the camera to an inflated value (typically 1 to 2 stops). This change should reflect the amount of fill compensation you want (e.g., if you want –1 stop of fill light, set the ISO value 1 stop higher than normal).

 Note: With most earlier camera bodies on which you'd use this technique (e.g., the F3), you can't set an ISO value of higher than 400 for TTL flash.

2. Put the camera in manual (M) exposure mode.

3. Set a shutter speed. Make sure that you don't adjust it to a value higher than the camera's sync speed.

4. Meter the scene, as usual, and set the correct aperture.

5. Here's where we compensate for the adjustment we made in Step 1: for each stop you increased the ISO film speed, open the aperture 1 stop (e.g., if you set ISO 200 instead of 100 and your metered aperture is f/4, you would set f/2.8 [1 stop larger] instead).

6. Use the calculator dial on the flash or the tables in the Speed-light instructions section of this book to verify that the flash range at the aperture you set in Step 5 includes your camera-to-subject distance.

7. Turn the flash ON and make sure that it's set for TTL operation. When the ready light glows, you can take the picture.

 Example: If you are photographing outdoors on a sunny day with Kodachrome 64, you might set the film speed on your F3 to ISO 200. Metering with a shutter speed of 1/60 second gives you an aperture of f/16, which you increase by 1.7 stops (the amount you changed the ISO film speed) to a little over f/8. You can then take pictures at distances of up to 10 feet (3 m) and the TTL metering automatically adjusts the flash.

 Note: This technique works best with films that are slower than ISO 100.

Automatic Flash Mode (A)

You can use automatic (A) flash mode with any Nikon camera and lens combination (and usually with any ISO value). You should use this mode only:

- *When the subject is in a position where it will reflect the Speedlight's light back to the flash unit's sensor* (this typically means a subject in or near the center of the frame, and the subject is the closest object to the flash). If your subject is severely off-center, small, or if another object is closer to the flash, the Speedlight may not calculate its output correctly.

- *If you are* not *bouncing the flash off a wall or ceiling.* While automatic (A) flash should expose the film correctly with bounced flash, you can no longer rely upon the distance scale on the Speedlight, which may make it difficult to select a valid aperture.

- *Nothing is blocking the Speedlight's light and sensor.* Be careful of cables; I once got incorrect exposures because the SC-17 Cord I was using accidentally wandered in front of the sensor. Branches, leaves, fences, and even glass between your flash and subject tend to result in the flash shutting off too early.

Here's how to set the automatic (A) mode (this example presumes the controls of an SB-28; if you're using a different Speedlight model, the buttons you press may be slightly different [see the instructions for your Speedlight model in later sections of this book]):

1. Make sure the flash is ON and the proper ISO value is entered on the Speedlight (most newer Nikon bodies automatically

supply this information to the flash unit, but you should still verify the setting).

2. Press the Speedlight's ▣▣▣ button until ▣ appears on the flash unit's LCD.

3. Note the flash-to-subject distance. (Assuming the flash is mounted on the camera, focus on your subject and read the distance on the lens.)

4. Press the Speedlight's ▣ button, then use the ▣ and ▣ buttons to select an aperture. The LCD displays the distance range the flash can reach as you select the various apertures. Compare that to the distance you determined in Step 3. If the range the flash indicates includes the distance you determined in Step 3, you can go to the next step; otherwise, keep trying wider apertures until the subject is within the flash unit's range.

5. Set the camera's exposure mode to either A (aperture-priority) or M (manual).

6. Set the aperture on the camera lens to match the value you selected in Step 4 (and which should still be displayed on the flash unit's LCD).

7. Set your camera's shutter speed to a syncable speed. If hand-holding the camera and the flash is supplying the main light for the scene, you should pick the fastest possible sync speed (usually 1/125 or 1/250 second on most Nikon bodies) to reduce potential camera shake.

8. Take the picture.

9. Check the ready light on the Speedlight. If it blinks for 3 seconds after shooting, the flash thinks it supplied insufficient light. In such a case, you probably selected an aperture in Step 4 that wasn't wide enough.

Manual Flash Mode (M)

You can use manual flash mode with any Nikon camera and lens combination (and usually with any ISO value film). You should use manual mode when you can't rely on the camera's calculations, don't want to use the Speedlight's light sensor, or you want to set the flash duration to a specific value.

Here's how to set the manual (M) mode (this example presumes the controls of an SB-28; if you're using a different Speedlight

model, the buttons you press may be slightly different [see the instructions for your Speedlight model in the back of this book]):

1. Make sure the flash is ON and the proper ISO value is entered on the Speedlight (most newer Nikon bodies automatically supply this information to the flash unit, but you should still verify the setting).

2. Press the Speedlight's ᴍᴏᴅᴇ button until 🅼 appears on the flash unit's LCD.

3. Set the camera's exposure mode to either A (aperture-priority) or M (manual).

4. Note the flash-to-subject distance. (Assuming the flash is mounted on the camera, focus on the subject and read the distance on the lens.)

5. Meter the scene and set your exposure. Make sure to set the camera's shutter speed to the fastest sync speed (usually 1/125 or 1/250 on most Nikon bodies) or slower.

6. Set the aperture you selected in Step 5 on the Speedlight, if necessary. Press 🆂🅴🅻 until the aperture indicator is blinking, then use the 🔼 and 🔽 buttons to adjust the value to the aperture you wish to use.

 If you're using an F4, F5, F100, N90/F90, N90s/F90X, N70/ F70, N80/F80, or N8008s/F-801S with an autofocus or AI-P lens mounted, changing the aperture on the camera also changes the aperture on the Speedlight and you cannot manually select the aperture on the SB-28.

 If you're using an older Nikon camera or a newer one with an AI or AI-S lens, changing the aperture on the camera doesn't do anything on the Speedlight, so you must manually dial in the same aperture, as noted above.

7. Adjust the flash output level until the distance indicator matches the distance you noted in Step 4. To do so, press the Speedlight's 🆂🅴🅻 button, then use the 🔼 and 🔽 buttons to select the output level (on the SB-28 this is done in 1/3-stop steps; on some older Speedlights you can only set power levels at full stop increments). The LCD displays the distance range the flash can reach as you change settings.

8. Take the picture.

9. Check the ready light on the Speedlight. If it blinks for 3 seconds after shooting, the flash thinks it may have supplied insufficient

light. In such a case, you probably selected an aperture in Step 5 that wasn't wide enough.

Slow Sync

Slow sync is used to balance the ambient light exposure of a dim background with the flash exposure of the subject. Slow sync mode doesn't change the way the flash operates in any way. It only changes the shutter speeds the camera body allows. Normally, when a flash is mounted and turned ON, only shutter speeds of between 1/60 and 1/250 second (or the top sync speed) are allowed. Slow sync mode removes the bottom limit.

Slow Sync with Newer Nikon Bodies

Most newer Nikon bodies have automated slow sync modes, which allow you to use all the features of the camera's metering system at shutter speeds as long as 30 seconds (longer on the F5 if you've set custom setting 19 to allow it).

Slow sync is usually set on the camera as follows:

1. Set the camera's metering and exposure modes as you normally would.

2. Hold down the 🔲 button on the camera and turn the control dial until 🔲 appears on the camera's LCD panel.

3. Set the exposure as you normally would, though now you should be able to choose shutter speeds up to 30 seconds long.

Note: Slow sync really only applies to dimly lit situations. In bright lighting, you'll almost always be fighting against the top shutter speed limit (and should consider high-speed sync if your flash and camera support it).

Slow Sync with Older Nikon Bodies

Cameras such as the manual FM2n and F3 do not have automated slow sync modes. Fortunately, you can still balance the background exposure with that of the flash even if your camera doesn't support slow sync. Here's how to do it:

1. Start with the Speedlight OFF.

2. If your Nikon body has automatic exposure ability, set the camera's exposure mode to manual (M) instead.

3. Pick an aperture to use. Since one of the goals of slow sync is to expose the background properly, often you'll pick a small aperture (f/11 or f/16, for example) so that depth of field will render the background in focus.

4. Meter the scene and set the appropriate shutter speed for the aperture you selected. Be sure not to set a shutter speed faster than the camera's sync speed.

5. Turn the Speedlight ON. If possible, set it to automatic (A) or TTL flash mode.

6. Focus on your subject and note the distance on the lens.

7. Check the Speedlight's range indicator to make sure it has sufficient power to reach the distance you determined in Step 6. If your Speedlight is an older model or only supports manual (M) flash mode, you'll have to use the guide number to calculate distance (see "Calculations," page 374). If the distance is outside the Speedlight's range, go back to Step 3 and try a wider aperture (e.g., f/5.6 instead of f/8).

8. If your Speedlight's ready light is ON, take the picture, otherwise wait for the Speedlight to charge.

Note: Slow sync normally produces very long shutter speeds at night, so if you want the background to be sharp, you'd best mount your camera on a tripod. However, many photographers use background blur due to camera shake to great advantage, especially if the foreground subject is moving. You see this effect in mountain biking pictures all the time, but it can also be used with any moving subject. I'll cover this in "Tricks Using Slow Sync," page 54.

Slow Sync versus Rear Sync

Rear sync is a variant of slow sync. Like slow sync, it allows shutter speeds of up to 30 seconds to be set. The primary difference is when the flash is produced during the exposure.

With slow sync, the flash occurs at the first possible moment during the exposure. With rear sync, the flash occurs at the last possible moment. With short shutter speeds, this difference is rarely noticeable or useful. With long shutter speeds, the difference sometimes becomes visible (see "Motion Trails [Subject Moves]," on page 54).

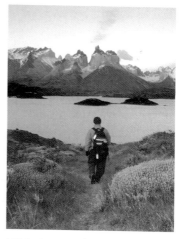

This is what can happen when one moves before the camera is finished with its exposure in slow sync.

With the visual cue from the flash in rear sync, I stayed put and got the shot.

Note: Rear sync cancels monitor pre-flashes! In other words, when you set rear sync, you force the Speedlight into a less capable TTL mode.

Tip: One interesting use I've found for rear sync is as a signaling device to tell me that a self-timed photo is complete (see photos on opposite page). When I'm off in the wilderness by myself, I often end up using the self-timer to allow me to appear as the model in a scene. More often than not, these photos are taken in dim light at dawn or dusk, and I'm often some distance from the camera. By setting the flash to fire in rear sync, I have a signalling device that tells me exactly when the picture is complete. Even when I'm facing away from the camera, I can often see the flash out of the corner of my eye. And this visual cue is much more reliable than trying to listen for the shutter to close (especially when you're standing in a 40 mile-an-hour wind and can't hear anything over the gale!).

Tricks Using Slow Sync

Since you're often using very long shutter speeds in slow sync mode, this causes interesting things to happen if the subject or camera moves during the exposure. Creative photographers have found ways to take advantage of these "artifacts," developing flash photography that has a unique and often bizarre style. You may waste some film playing the slow sync games I describe, but when something clicks, you'll forget all about the images you threw away. Just keep careful notes about what you did, so when you find something you really like, you'll be able to repeat it!

I'll describe the primary techniques, but don't be afraid to experiment.

Note: Remember, you can use these techniques in any light. Indeed, many of these tricks work great with fill-flash in daylight.

Motion Trails (Subject Moves)

If your subject is moving and you want to create "trails" of light to emphasize the motion, use slow sync. The trails are generated by the subject's motion during a long exposure. When the flash fires, it "freezes" the subject and the ambient lighting creates the trails. For this to work best the camera needs to remain stationary and the subject should move across the width of the frame.

You'll need to consider several elements to get the exact results you want:

• *Trails in front or behind? Unless you specify otherwise, Nikon flash units fire just after the shutter first opens.* And remember that a typical Speedlight has a flash duration of 1/1,000 second or shorter. What this means is that with a shutter speed on the camera set to 1/15 second, the flash fires at the beginning of the exposure, freezing the subject, but the shutter remains open for nearly 1/15 second afterwards. Thus, the trails created using basic slow sync always appear in front of the exposed subject, suggesting the direction that the subject will move. This doesn't look correct to our eyes, as we expect to see motion indicated in the space that the subject has been (thanks to Saturday morning cartoons, I suspect). To have the motion trails follow the subject, set the camera body to *rear sync.* This fires the flash at the end of the exposure, reversing the order in which the subject and trails are exposed.

- *Speed equals trail length.* The interaction of the shutter speed you use and the subject's speed determines the length of the trails created. What you need to estimate is how far the subject will move across the frame while the shutter is open. If you're using a wide-angle lens, a relatively short shutter speed of 1/30 second, and the subject is walking, the trail is likely to be short. If your subject is a biker and the shutter speed is 1/15 second, the trail will likely be longer. There are two ways to get the exact trail length you want:

 1. Resurrect your high school math skills and calculate how far your subject moves in the time the shutter is open, then have someone walk that off while you look through the viewfinder.

 2. Bracket your shutter speeds (be sure to change your aperture, too, so that your basic exposure doesn't change).

- *Ambient light defines trail strength.* The flash lights your subject in a fixed position. Assuming that subject speed is a constant, the strength of the trails is determined by the amount of ambient exposure the subject receives relative to the flash. Generally, you should start with balanced flash and ambient exposures. Remember that the subject is moving through your shot, so the exposure it gets without the flash is less at any given position in the frame than the flash exposure. Thus, the trails always appear weaker than the subject exposure. If the subject is slow-moving, though, the trails may be too strong. I've found that I like the look of trails when they're exposed at about 1 stop lower than the flash for most subjects moving less than 5 m.p.h. (8 km/hr).

Soft Edges (Subject or Camera Moves)

Soft edges are related to motion trails in that they are normally created by subject motion. Soft edges are most commonly used in portraits. Depending upon how the soft edge is created, it can sometimes look either like a "glow" or merely a blurring of the person's edge definition.

Again, you need to set your Speedlight to slow sync mode. Since you're usually looking for edges all the way around your subject (as opposed to the directional effect of trails), either the subject or the camera needs to move during exposure. I tend to use camera motion, but other photographers I've met have their subject step forward towards them during the exposure. (Stepping away makes them smaller in the frame, thus putting the soft edges inside the

normal edges defined by the figure; an interesting effect, but not usually the one you're looking for).

While the settings and decisions you need to make are similar to those of creating trails (see "Motion Trails," page 54), you'll find that soft edges tend to work best when they're relatively small and fainter than the basic flash exposure. Thus, I almost always set my ambient exposure slightly lower than the flash exposure and use shutter speeds in the 1/8 to 1/15 second range. Indeed, by hand-holding the camera at these speeds, you're almost guaranteed motion for the ambient exposure.

If you use camera shake to create the soft edges, bracket your shots by:

- *Varying the amount of shake.* Deliberate shake is remarkably hard to control, especially since there's a brief delay between when you press the shutter release and the moment the shutter opens. This is something that, ironically, takes practice to get right (and you thought you were already good at producing camera shake!). The best camera shake for creating soft edges is random motion around an epicenter, something that's very difficult to do with any consistency.

- *Imparting direction to the camera motion.* Try twisting the camera in a particular direction, or panning or tilting instead of shaking. Each variant of camera motion imparts a slightly different effect, though you should note that this would also be directional (e.g., panning to the right during exposure puts soft edges to the left). Personally, I've had the best luck by starting my camera motion prior to pressing the shutter release and continuing it through the entire exposure, but that's one fun aspect to slow sync: experimentation leads you to a personal style that's all your own.

If you use subject motion to create the soft edges, bracket your shots by:

- *Varying the shutter speed, the length of motion, or both.* If you're having the subject move towards you, have the subject try little steps and big steps. You'll also find that it's difficult for the subject to anticipate when the shutter is open, so you're best off having the subject start moving before you press the release (e.g., tell her to move, and shoot when she does).

- *Mixing up the type of motion.* The best shots I've obtained with subject motion are when I have the subject do something

unusual. Have him lunge at you, jump up in the air, stand on one foot, or any other action that might keep him from holding still or making a predictable motion.

• *Using really long shutter speeds.* Mathew Brady portraits notwithstanding, it's very difficult for a subject to remain completely still for more than a second. I've obtained decent results by using exceedingly long shutter speeds with nervous subjects and simply not instructing them to stand completely still. Sometimes I'll do the opposite and tell them to stand perfectly still, then in the middle of the exposure ask them to shiver, relax, or vibrate, all of which tend to generate enough subject movement to soften the edges.

Zooming during Slow Sync

Zooming during a long exposure with the flash in slow sync or rear sync gives you an image with streaks leading respectively to or from the subject. The most common technique is to zoom out from your subject if your flash is in slow sync or to zoom into the subject if your flash is set to rear sync. Either way, you'll end up with light trails that seem to run into your subject. (It's generally easier to control the trails by zooming out in slow sync.)

Again, don't be afraid to experiment. Instead of zooming, you can simply walk closer or farther away (the trails aren't as rigidly straight as with a zoom). Panning the camera while zooming adds an interesting twist. Fast zooms look different than slow zooms, and constant speed zooms look different than zooms that speed up or slow down (obviously, long shutter speeds of 1 second or more help you try such variations).

Panning during Slow Sync

Panning with a moving subject using a slow shutter speed (slower than 1/15 second) and the flash in slow sync or rear sync (preferred) mode does two things:

1. The subject is frozen by the flash in perfect exposure, often with a bit of blur or "glow" around them (since you can't keep the subject perfectly still during the long exposure, the ambient light creates this blur/glow on your subject).

2. The background becomes a trail of color with no detail; the longer the shutter is open, the more the background becomes a blur of color. Don't be afraid to try 1- or 2-second pans!

Tip: Veteran photographer Layne Kennedy teaches a simple additional trick in his seminars. At the very end of your long exposure in slow sync mode, twist the camera in the direction of the subject's movement (i.e., clockwise for a subject moving left to right, counterclockwise for a subject moving right to left). A little bit of twist adds an amazing amount of extra energy to the image, often turning a dull photo into a remarkable one.

Tip: Experiment by varying the primary light source. Try photos in which the exposure is set for the ambient light and the flash provides only fill (typically a –0.3- or –0.7-stop flash compensation, maybe as much as –1 stop in some situations), and try others where you set the ambient exposure slightly under- or overexposed with the flash exposure set for normal exposure. The first technique often results in soft, dreamlike photos, while the latter tends to give edgier, exaggerated effects.

Red-Eye Reduction

Many of Nikon's more recent cameras and Speedlights feature the ability to perform red-eye reduction. Before describing how (and whether) to use this feature, we need to first discuss what red-eye is and how it is caused.

Most animals have a mirrorlike layer called the tapetum lucidum. The tapetum lucidum is inside their retina, tucked behind the light-collecting rods and cones. If you shine a light into an animal's eyes, you'll see a reflection back from this layer, the color of which varies a bit from animal to animal. (This layer is thought to improve night vision, especially motion detection, as it gives light a second chance to hit a light-detecting rod.)

Humans don't have a tapetum lucidum (well, Australian aborigines do, but the rest of us don't). What we have behind our rods and cones is a dense series of blood vessels. Therefore, light that bounces off the back of the retina picks up a red color when it reflects back into the world.

We don't see this phenomenon in normal situations for two reasons: First, it takes a great deal of directed light to create a reflection off the back of our retina, and we must be nearly on the same axis as that light to see the reflection. Most of us don't go around with powerful light sources on our foreheads, so we don't perceive red-eye in normal conditions.

But flash units almost always satisfy both conditions, don't they? First, they create a large pulse of directed light. And the source of

that light is often very near where our eyes are, so we see what it reflects off of.

In general, red-eye occurs when the angle created by drawing a line from the center of the lens to the subject's eyes and back to the flash is less than 2.5°.

For you mathematically inclined readers, here's a useful formula:

X = (Y / 2) / tan (a)

where:

X is the camera-to-subject distance;

Y is the height of the flash above the lens; and

a is the angle created by the lens axis and the flash to the subject's eyes.

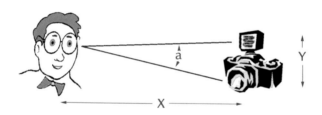

We want **a** to be greater than 2.5°. The two variables we have to work with are camera-to-subject distance (reducing this increases **a**) and distance of the flash from the lens (increasing this increases **a**).

The tangent of a 2.5° angle is 0.04, by the way, so we can plug some figures into the formula to figure out some guidelines. For example, my Speedlight SB-28 sits just a little more than 6 inches (0.5 foot) above the lens on my F5, so let's solve for **X** to see at what subject distance the 2.5° angle occurs:

X = (0.5 foot / 2) / 0.04 = 0.25 / 0.04 = 6.25 feet

Thus, at distances of 6.25 feet or more, the angle is low enough that we're likely to get red-eye with the SB-28 and F5 combination.

You may wonder where the 2.5° number comes from. Fortunately, this isn't an absolute, it's an average condition. The actual angle at which red-eye occurs varies with the size of the subject's

pupil. If the pupil is decreased, so is the angle. Likewise, if the pupil is increased, the angle at which red-eye occurs will be, too.

Nikon's red-eye reduction scheme relies upon that observation. By firing the flash before the shot, most subjects' pupils react to the light by decreasing in size. Note that this early flash is not the same as the pre-flash used in TTL calculations. Pre-flashes are very weak and occur too close to the actual flash to have any real affect on reducing red-eye.

Personally, I find these pre-flash red-eye reduction methods to be worthless, because:

- *The lag time is increased.* The time between when the shutter release is pressed and the actual picture is taken increases significantly due to the extra time needed for the red-eye reduction flashes. In candid situations, this usually means the difference between getting the shot and missing it.

- *The subject stiffens.* The natural reaction to having a bright light go off in one's face is to tighten up, perhaps even blink or squint. The delay between the red-eye flash and the actual picture is just enough that most subjects change their pose a bit, almost always for the worst.

- *Recycling time is lengthened.* You're discharging the flash either more often or more completely, both of which increase recycling times. Moreover, if you're taking a lot of pictures in quick succession, you may find that you need to let the flashtube cool, as you'll approach the maximum firing levels Nikon recommends (generally 40 flash bursts in a short period of time).

- *Red-eye isn't eliminated.* Remember, it's called red-eye *reduction,* not red-eye *elimination.* At distances of 12 feet (3.6 m) or more, the reduction effect is minimal.

That said, to use red-eye reduction is reasonably simple if you've got a body (N90/F90 or later) and Speedlight (SB-25 or later) that are capable of this mode:

1. Make sure that the camera and Speedlight are both ON (the Speedlight can be in standby mode).

2. Set the camera to single frame ([S]) advance and single servo (S) autofocus (it can also be in manual [M] focus mode).

3. On the camera body, hold the 🔳 button down and turn the command dial until the ☺ indicator is seen in the camera's LCD panel (it should also show up in the Speedlight's LCD panel).

Note: Rear sync and red-eye reduction are mutually exclusive. Both cannot be set simultaneously. Likewise, repeating flash mode cannot be set at the same time as red-eye reduction.

4. To cancel red-eye reduction, repeat Step 3, but set the flash to another mode (OFF, normal, slow, or rear sync, generally).

Better solutions for minimizing red-eye are:

- *Move the flash off-camera.* Move the flashtube a minimum of 12 inches (0.3 m) and preferably 18 inches (0.5 m) away from the lens. At 12 inches, red-eye is insignificant out to 12 feet (3.7 m); at 18 inches, this increases to almost 20 feet (6 m).

- *Turn on room lights.* Anything you can do to increase the ambient lighting will have the net result of lowering pupil size, which in turn reduces red-eye. I've known some photographers that point a flashlight at a subject's eyes prior to taking a shot, but in my opinion that just tends to annoy the subject (try it with a lion and see what happens!).

- *Have the subject look off-camera.* Red-eye most often occurs when the subject looks directly at the camera. If you have the subject look instead at a 10° angle off the camera-to-subject axis, red-eye can't occur (though you could still get an objectionable reflection off the whites of a subject's eye in some cases).

Bounce Flash

Normally one points the flash directly at one's subject, providing direct illumination. Most Speedlights support "bounce flash" operation, where the subject is lit indirectly by bouncing the light from the flash off a nearby object, such as a wall or ceiling. Most late-model Speedlights have "click stops" for angling the head at 45, 60, or 75° above horizontal. Using bounce flash influences the light primarily in two ways:

- *The light is softened.* The object the light is bounced off of diffuses the light, bouncing it in multiple directions. In fact, the more irregular the surface the light is bounced off of, the more diffuse the light becomes. Diffuse light softens shadows and tends to mask the light source (i.e., diffuse light isn't as directional).

- *The amount of light may be reduced.* If you remember your high school geometry, you'll quickly note that the distance light

has to travel when bounced is greater than if it travels directly from your flash to your subject. And since one of the properties of light is that its intensity is reduced by the square of the distance it travels, using bounce flash effectively reduces the power of your Speedlight. If the light is close to the surface it's being bounced off, this reduction can be small, but if you are bouncing light off a 14-foot (4.3 m) ceiling, the light fall-off will be dramatic.

Bounce flash causes all kinds of problems for those who expect it to work without intervention. Bounce flash has a number of potential hidden pitfalls for the novice:

- *Pre-flash functions aren't performed.* Normally in TTL mode, the Speedlight fires a series of pre-flashes, which the camera measures to determine proper exposure. When you move a Speedlight from its normal position to any bounce angle, pre-flash firing is turned off. While Nikon hasn't documented its flash technology well enough to say with certainty how this changes the exposure, I've found that the camera often calculates a slight underexposure with bounce. With my F100 and SB-28, I often have to dial in as much as a +1 stop flash compensation.

- *The bounce surface affects color rendition.* If you've ever browsed the rack of paint chips at your local hardware store, you're probably aware that there are hundreds of hues of white paint. So even if you note that the walls and ceiling are white, they may still impart a color cast to the flash unit's output. Fortunately, most near-white paints are tinted towards warm colors (think about the range from ivory to beige), and warm colors enhance skin tones. Be aware that many of the "brighter" whites have a slight magenta cast, which can seriously degrade skin tones into something ghastly. Nonwhite surfaces become very problematic for bounce flash, as strong colors do very strange things to the overall colors in your photo. You certainly wouldn't want to use bounce flash in a hospital ward painted green, as this will just make your subjects look sicker (unless that is what you want).

- *Bounce, while predictable, is difficult to control.* When light bounces off a surface, it bounces off at the same angle it hit (e.g., if you bounce light at 45° to a surface, it bounces off at 45°). This is called the angle of reflection. But uneven surfaces tend to disperse the light, making the reflection cover a wider

angle. Also, if you're more than a few degrees off in calculating your bounce angle, you may not be putting the bulk of your light on the subject. If you want "perfect" bounce light and exposure, you'll need to measure angles and distances carefully, and do a few trigonometric calculations. Fortunately, in most cases it's usually easy to obtain decent results by simply pointing the flash at a point in the ceiling that's midway between you and the subject. This technique works less well near corners or when you (or the subject) are against a wall (the wall often acts as an additional reflector and should be taken into account), but it's a good starting point.

• *Keep the bounce surface close.* Often it's better to use a piece of cardboard near the flash head than to try to bounce it off a tall ceiling. First, you're minimizing the distance the light must travel, maximizing the amount of light available. Second, it's easier to control bounce off near surfaces, especially ones that you can vary the angle of.

• *The camera reports potential flash underexposure.* If the flash fires at full power, as is often the case when using bounce, both the flash and camera may report that the shot may have been underexposed (by flashing the distance scale or the flash icon).

Tip: When a flash head has a built-in bounce card, use it to bounce flash. Doing so reflects a bit of light directly towards the subject, providing a delicate and desirable fill-light effect.

Flash Color

Flash units are designed to produce light that matches the color of midday sunlight. Although Nikon doesn't list it in the specification sections of current Speedlight manuals, most Nikon Speedlights produce light with a color temperature of about 5,600 Kelvin. Most daylight film is balanced for a similar color temperature; thus, you should always use daylight film when using your flash.

Nevertheless, many professionals find that the color balance of their Speedlights is a little "too daylight" (blue) for their tastes. Moreover, daylight's color temperature varies considerably over the course of the day, with cloud cover, and in shade. Indeed, areas in daylight shadow often tend to be a higher color temperature than film is balanced for, resulting in everything having a slightly blue cast. That's one reason why you'll see a lot of pros pull an 81a

"warming" filter out of their bag when they're shooting in shadow—
they want to take some of that blue cast out of their picture.

But most pros go farther than that. Many add a light warming gel
to at least a portion of the flash head of their Speedlights. While this
slightly cuts down the amount of light produced (the filter I use has
an 88% transmission factor, meaning about 10% of the light from
the flash is lost), it also makes it warmer in color and, in some
circumstances, makes fill-flash harder to detect in the final photo.

Two points of warning if you decide to try this yourself:

1. Be careful what kind of material you use, as the flash head can
 produce enough heat to melt a filter mounted directly on it. Go
 to a stage lighting supply store and find gels that are made to be
 placed over hot stage lights (as a side benefit, many of these
 filters, though expensive, provide information on the exact
 spectrum of light they change).

2. Don't cover the entire flash head with filter material. Not only
 will you reduce your Speedlight's output, but you're also likely
 to overdo the effect; it takes only a small amount of filter
 material to make a dramatic change in the color quality of
 the light.

Tip: Here are a few companies that make sample books you can
use for flash filtration:

Bogen Photo	www.bogenphoto.com
GamProducts	www.gamonline.com
Lee Filters	www.leefilters.com
Rosco	www.rosco.com

The GamProducts, Lee Filters, and Rosco sample books contain
information about exactly what light is being filtered, which is very
useful for experimenters.

Flash Compensation

Flash compensation is not the same as exposure compensation.
Exposure compensation varies the overall exposure (underexposing
or overexposing the entire scene), while flash compensation varies
the amount of light that comes from the flash versus what would
normally be output. Flash compensation may or may not result in
over- or underexposure, depending upon the amount of ambient
light in the scene.

The distinction between overall exposure and flash exposure is
important to understand. If the flash is your main source of lighting

and you use flash compensation, your overall exposure will vary with the amount of compensation you set. However, if flash is used as fill lighting, the overall scene may still be properly exposed; only the amount of flash may be too little or too much to generate the fill ratio you sought.

Many first-time flash users are caught unaware by the difference in flash and exposure compensation settings and think that they're interchangeable. They're not; re-read the previous paragraph and commit it to memory.

The primary function of flash compensation is to adjust the balance between the exposure of the background or overall scene (not lit by the flash) and the foreground (lit by the flash). Several likely possibilities need to be considered:

- _The flash provides the main light, the background is dimly lit, and the flash isn't in slow sync mode._ Choosing flash compensation in this case either under- or overexposes the picture (exclusive of the background), as the flash provides the main light for the scene, and the background by itself is already underexposed.

- _The flash provides the main light, the background is dimly lit, but the flash is set to slow sync._ In this instance, changing flash compensation potentially changes the balance between flash and background lighting. Since slow sync should properly expose the background, the shot remains reasonably well exposed (though if the subject being lit by flash isn't in the same light as the background, the overall exposure may be off).

- _The flash provides fill light, the camera exposure is set for the background lighting._ Flash compensation changes the level of fill, but the overall exposure should be correct (unless the flash overpowers the ambient lighting).

Performing Flash Compensation

For most Nikon bodies, flash compensation is normally set on the Speedlight (this assumes that you have a Speedlight SB-24, SB-25, SB-26, SB-27, or SB-28; see the individual Speedlight sections in this book for instructions on how to set flash compensation for your model). The exceptions are:

- _The N6006/F-601._ Flash compensation must be set on the camera body.

- *The N70/F70.* This camera body can set flash compensation directly (you can also set it on the Speedlight, instead).

- *Cameras with the optional databack.* For example, the MF-26 Databack for the N90s/F90X supports flash compensation settings, as do the optional backs for the F5, F100, and N80/F80.

Warning: *If you set flash compensation on both the camera body and the Speedlight, the effect is cumulative! In other words, if you set −2 stops of compensation on the N70/F70 and −1 stop on an SB-26 that's attached, the flash would fire at −3 stops compensation.*

Many photographers use flash compensation to set low levels of fill light in their outdoor shots. For example, both Galen Rowell and George Lepp have written in *Outdoor Photographer* about setting flash compensation to accomplish a natural, nearly undetectable level of fill in outdoor landscape photography. The level that is set on the flash is generally between −1 and −2 stops.

Flash at −1 stops or lower is virtually undetectable in the resulting picture, while anything less than −2 stops has very little effect, since film has such a narrow range it can capture (for many slide films, +/−2.5 stops). In one of his columns, Galen wrote about how he typically sets flash compensation at −1.7 stops, the magic number at which he feels the flash is undetectable in the scene, yet still provides enough light to make a difference in the shadows.

My experience has shown that Galen's −1.7 number works pretty well in a remarkable range of situations. If I'm particularly worried about strong shadows or very dark areas, I'll bump flash compensation up to −1.3 stops. If you're uncertain about what setting to use, bracket between −1.0 and −1.7 stops.

If your camera body and/or flash doesn't support flash exposure compensation but allows TTL flash, you can still set flash levels manually:

1. Set the camera body to manual (M) exposure mode.

2. Meter the scene and set your camera exposure accordingly.

3. If the camera body supports exposure compensation, use it to set the amount of flash compensation you want (e.g., −1 stop). If the camera body doesn't have a way of setting exposure compensation, change the ISO film speed value on the camera (for −1 stop set a higher film speed—for instance, ISO 200 if you are using film with an ISO of 100). Don't change the aperture and shutter speed you set in Step 2!

4. Turn your Speedlight to the ON position and make sure that it is set for TTL flash.

5. Take the picture. Note that the camera and/or flash may be warning of under- or overexposure, but if you've performed these steps correctly, you can ignore that.

The above procedure works because the background (ambient) exposure was correctly set in Step 2, while the flash is working off of altered settings you made in Step 3. Note that if the light changes in any way, you need to reset the camera to normal and repeat the procedure beginning at Step 2.

Using Flash Meters with Speedlights

Because most current Nikon Speedlights emit pre-flash pulses prior to their primary burst in many modes, most hand-held flash meters are fooled into thinking that the output of the Speedlight is less than it is (i.e., the meter measures only the pre-flash). The best way to get an accurate reading of flash output is to manually fire the Speedlight prior to your shot. Use the meter results to set the camera and flash. (I assume that you're using a meter to set flash levels manually, as using a flash meter won't help you for automatic exposures.)

If you know that the Speedlight is in a mode that doesn't emit a pre-flash, then the measurement you take with a flash meter is accurate. For example, when you mount an AI or AI-S-type lens on an F5, it reverts to center-weighted fill-flash or spot fill-flash mode (depending on the metering method), neither of which perform pre-flashes. Here's a short list of settings or situations that cause the pre-flash to be canceled:

- _The flash head is tilted for bounce or rotated from its normal position._ (Exception: when head is tilted down slightly for closeups. If flash distance indicator bars appear on the Speedlight's LCD, the flash performs pre-flash in TTL modes.)

- _The camera is set to perform rear sync._

- _The flash is set to fire in standard TTL flash mode._

- _A lens without a CPU is mounted on the camera._

Built-in Camera Flash Units

Several Nikon bodies have built-in Speedlights. Generally, these units are low power (compared to the SB-28, for example) and

have a limited angle of coverage. Two consequences derive from these facts:

- *Light fall-off with extremely wide-angle lenses.* Since the coverage of the built-in flash generally extends only to 28mm (74° horizontally), when you use the flash with a wider lens, the corners of the image are dark, as the flash can't cover the full frame. Indeed, even with a 28mm lens, you may see a bit of fall-off in the corners (perhaps 1/3 to 1/2 stop) due to some design compromises.

- *Flash can be used only at short distances.* The limited GN of the built-in Speedlights (typically about 46 in feet [14 m]) means that they can provide illumination only at short distances. (Remember, GN / Aperture = Distance, so at f/8 the built-in flash provides full power at a little under 6 feet [~2 m]).

Moreover, the flash head for these units does not rise above the camera as much as the removable flash units, which can cause two significant problems:

- *Red-eye.* Since the flash unit is barely above the imaginary line drawn from the subject to the film, there's a high probability that you'll encounter red-eye (see "Red-Eye Reduction," page 58).

- *Lens shadow.* With a long or wide lens (and especially when lens hoods are used), the lens may block light from the flash to your subject! This exhibits itself as a dark circular shadow intruding on the lower edge of the frame for horizontal photos.

These limitations notwithstanding, the built-in Speedlights can still be quite useful. Some support flash compensation and can be used very effectively for fill. Better still, the on-camera flash can be used to trigger a larger off-camera flash (see "Using Additional Slave Flash Units," page 78). Finally, in a pinch, they provide just enough capability to get you by in those instances where you might be traveling without your larger Speedlight.

Finally, using the built-in flash quickly drains the camera battery. Since most Nikon bodies with built-in flash capability use the more expensive, less readily available 3-volt lithiums, you'll probably want to limit your use of the on-camera flash.

Zoom Heads

Many of the more recent Speedlight models have what Nikon calls "zoom heads." When coupled with a modern Nikon body, the flash unit adjusts its coverage to match that of the lens. For example, if

you mount a 50mm lens on the camera, the Speedlight sets its flash head to 50mm. Likewise, if you remove the 50mm lens and put on a 28mm lens, the Speedlight sets itself to match the wider coverage of that lens.

The name "zoom" is a slight misnomer, however, as Nikon's flash units always set themselves to specific focal lengths (20mm, 24mm, 28mm, 35mm, 50mm, 70mm, and 85mm). Thus, if you mount the 60mm Micro Nikkor on your camera, your Speedlight defaults to its 50mm setting, because that's the nearest setting that guarantees that the flash fully covers what the lens sees. In other words, Speedlights always round down to insure that the flash covers the full frame captured by the lens.

This rounding results in slightly lower than expected power capability, but it is generally not enough to worry about unless you're using a very wide-angle lens. For example, if you zoomed the 20-35mm f/2.8 Nikkor to 23mm, the flash would have to set itself to cover 20mm. The GN for an SB-28 at 24mm is 98 (in feet) while the GN at 20mm is 66, so the fact that the Speedlight is throwing its output over a wider angle than your lens may result in a limited working range (e.g., at f/8 the flash could fire at full power at a little over 12 feet when set to 24mm, but only about 8 feet when set at 20mm).

The actual zooming is accomplished by moving the flashtube in relation to the plastic lens on the Speedlight's head. That lens is a "Fresnel" lens, which takes a beam of light and disperses it in a controlled fashion. By moving the tube in relation to this lens, the angle of dispersion is changed. Indeed, in order to work with a very wide-angle lens, the SB-26 and SB-28 feature an additional dispersal lens that flips down in front of the primary lens. Nikon's Fresnel lenses do a pretty good job of spreading the light evenly, but you may still notice a bit of fall-off towards the corners, especially when using wide-angle settings (20mm to 28mm).

You don't have to rely on the Speedlight to select its coverage to match the lens. Indeed, many photographers have learned to manipulate the zoom settings on the flash to their advantage. Consider the following uses of overriding the automatic zoom settings:

- *Reduce the output.* By zooming the Speedlight out to a setting much wider than the lens used (e.g., Speedlight set to 24mm with an 85mm lens on the camera), you reduce the "throw" of the flash, effectively reducing its GN. I've sometimes gone one step further and bounced this wide flash beam off a large

reflective surface, which provides a gentler, more diffused light on a near subject than I'd get by simply letting the flash match the lens setting and firing at the subject directly.

- *Channel flash to the eyes.* In wildlife photography, it's important to see the animal's eyes. This isn't as easy as it seems, as eyes are often set back and in shadow, plus most animals tend to have black or dark pupils. Without flash, your photos come back with undetailed black blobs for the animal's eye sockets. The trick is to use a tiny amount of flash to reflect off the eye, adding a bit of highlight. Sometimes I'll zoom the flash out when using a telephoto lens so that my flash is adding only a small touch of light to the scene. With wide-angle lenses, I sometimes do the opposite: zoom the flash unit so that it is providing light only around the animal's head. In both cases, I use the flash only as fill, and generally at 2 stops less light than the primary exposure.

- *Light only the subject or the background.* By positioning the flash and changing its angle of coverage, you can control what is and isn't lit by the flash. When using slow sync mode to capture the background at ambient light levels, I'll often zoom my Speedlight to cover only the subject. Other times my subject may be in the light but the background is not, so I'll reverse the practice, sometimes even putting my Speedlight just behind (and hidden by) the subject to light the background (in this instance, the flash is on a remote cable).

- *Fire the slave unit.* If the main purpose of the on-camera flash is merely to trigger other remote flash units (see "Using Additional Slave Flash Units," page 78), I'll often zoom the flash to its most telephoto setting (typically 85mm) and point it directly at the remote slave sensor. This increases the likelihood that the slave sees the firing signal, because the full output of the on-camera flash is directed narrowly towards the slave unit's sensor.

- *Fill the foreground.* Many times when taking wide-angle landscape shots I'll find that the foreground is not nearly as well lit as the background. At dawn and dusk, shadows often pose additional problems for foregrounds.

 Sometimes the foreground subject is so close to the camera (within inches), that I have to pull the flash off the camera and use an SC-17 Remote Cord. In order not to over-light the foreground, I'll zoom the Speedlight to its widest position. Generally, I'm not looking to fully illuminate this area (doing so

can look artificial, as our brain tells us that the near object can't possibly have the same lighting intensity as the background). Instead, I want to underexpose the foreground between 1 and 2 stops—so there is enough light to render some shadow detail but keeping it darker than the background.

Also, remember the Inverse Square Law when lighting foregrounds that are very close! The shot may look artificial simply because of the fall-off from the flash (yes, that flower at one foot is exposed properly, but the one at two feet is 2 stops dim!). You generally don't want your near foreground to look lit, the medium foreground to be dim, and the far foreground to be completely underexposed. That's one reason why I often take the flash off camera when filling foregrounds: I'm trying to better balance the light fall-off.

So don't be a slave to the automatic zoom settings determined by your Speedlight. Instead, learn to think of ways in which you can manipulate the flash unit's angle of coverage to your advantage.

Wide-Angle Adapters

Many older Speedlights don't have zoom heads. Instead, most of them have either built-in or optional wide-angle adapters. A few, like the SB-E and SB-10 are what-you-see-is-what-you-get units, and cover only the 35mm spectrum.

Most of Nikon's wide-angle adapters extend only to a 28mm focal length. If you're a true fan of wide-angle lenses, only the SB-26 or SB-28 will do, as they are the only ones that can cover the entire spectrum of Nikon's current autofocus, non-fisheye, wide-angle lenses.

Using a wide-angle adapter changes the guide number the flash produces, sometimes quite significantly. The individual Speedlight instructions later in this book list all the changes to guide numbers when Nikon's adapters are used.

Macro Flash

Nikon introduced a new concept in Speedlights—a flash dedicated to macro photography—with the Speedlight SB-21 (see "SB-21A and SB-21B," page 186). (Nikon had previously made ringlights, the SR-1/SM-1 and SR-2/SM-2, but these weren't as capable or as flexible as the Speedlight SB-21, and weren't stand-alone flash units).

The SB-21 contains two flashtubes mounted on an oversized ring that fits on the front of a macro lens. The lens-mounted flash unit connects via a dedicated cable to a controller that mounts in the camera's hot shoe. Nikon later updated this basic concept with the SB-29 (see "SB-29," page 318).

The macro Speedlights are unique in that they produce a relatively directionless, diffuse light on subjects that are extremely close to the camera and lens. Both manual and TTL operation are supported.

Because of the unique nature of the SB-21 and SB-29, a few things work differently than they do for the other flash units this book describes.

Guide numbers, for example, work differently. Normally a guide number (see "Guide Numbers," page 21) is a measure of flash power that is useful in determining distance or aperture. But the macro Speedlight models have guide numbers that are expressed for a fixed flash-to-subject distance of 3.3 feet (1 m). These models are really not designed to be used at anything but close distances, so when you make guide number calculations with an SB-21 or SB-29, you should really calculate only for aperture.

For manual operation, the SB-21's guide number allows you to calculate aperture as follows (assumes a reproduction ratio of 1:10 or less):

Aperture = GN / Distance

Where **Distance** is carefully measured from flash to subject. (Note that the Speedlight mounts in front of the lens, so at close distances, **Distance** is almost always significantly less than the lens's distance scale indicates.)

Plugging some figures into the equation quickly tells you part of the answer: at a working distance of only 20 feet, you'd need a lens capable of f/2 in order to use the SB-21. But the other part of the answer lies in the way the light of the Speedlight is focused. The flashtubes of the macro Speedlights are designed to provide light that is as non-directional as possible in the near field. Directionality of light at close working distances would almost certainly result in harsh, unwanted shadows; the two flashtubes of the macro Speedlights are designed to create a directionless light by producing light from all sides of the close-up subject. With the SW-8 Condenser Adapter on the Speedlight, the light is spread even more widely (and focused even nearer the lens).

In short, the macro Speedlight flashtubes are designed to produce their optimal light at distances of between about 1.6 inches

and 3 feet (4 cm and 1 m). The SB-21, for example, produces light across a 65° horizontal at 3.3 feet (1 m). You should not take this to mean that they produce an equally wide and even light at 10 or 20 feet (3 or 6 m). You should experiment first at distances of over 3 feet (1 m) to make sure that the macro Speedlight is going to do what you want it to. At distances shorter than 1.6 inches (4 cm), use the included SW-8 Condenser Adapter to better distribute the light on the close subject. Note that the SW-8 most definitely focuses light on close objects and is not suitable for shooting at flash-to-subject distances longer than a few centimeters.

Macro Photography with Regular Speedlights

If you can't afford to add an SB-21 or SB-29 to your gear closet, don't despair. TTL-capable Speedlights can be used at subject distances closer than the 2 feet (0.6 m) that Nikon lists in their manuals.

Indeed, most modern Speedlights have a section in their manual labeled "Close-Up Flash Photography in TTL Mode." Unfortunately, Nikon didn't always translate these instructions into non-metric measurements and left out a few other important pieces of information.

Here's what you need to know:

1. Mount the Speedlight on an SC-17 or SC-24 cord. Plug the cable into your camera's hot shoe (the flash should be OFF when you do this). When you position the flash, make sure that it is no more than 30° off the subject-film axis (if it is more than 30° off this axis, you'll need to take light fall-off into account).

 Tip: Kirk Enterprises and Really Right Stuff make brackets that allow Speedlights to be mounted right next to the front of the lens and are perfect for close-up flash photography.

2. Set the flash for TTL operation (see the appropriate instructions for your flash later in this book). Generally you'd also set the Speedlight to its widest zoom setting. (Alternatively, use the wide-angle diffuser for flash units that don't have zoom heads). That's because you need to make sure that the flash fully covers the subject, and you want as diffuse a light as possible ("tunneling" the flash at close distances can produce really harsh shadows and directional light). Don't worry about the reduced output at wider zoom settings—you're working at such close distances that you're still well within the capability of any Speedlight.

3. Set the camera to either aperture-priority (A) or manual (M) exposure mode.

4. Determine the aperture to use based upon the following equation:

Aperture = X / Flash-to-Subject Distance

Where **X** is a value taken from one of the following tables (Remember, both the numerator and the denominator must use the same scale, so if you calculate **X** for inches, your **Flash-to-Subject Distance** must be entered as inches as well.):

SB-20, SB-22, SB-24, SB-25, SB-26, SB-27, SB-28

ISO	X for Feet	X for Inches	X for Meters
25	6.6	79.2	2
32	7.2	86.4	2.2
40	8.2	98.4	2.5
50	9.2	110.4	2.8
64	10.5	126	3.2
80	11.5	138	3.5
100	13.1	157.2	4
125	14.4	172.8	4.4
160	16.4	196.8	5
200	18.4	220.8	5.6
250	20.7	248.4	6.3
320	23.3	279.6	7.1
400	26.2	314.4	8
500*	29.2	350.4	8.9
640*	33.1	397.2	10.1
800*	36.1	433.2	11
1,000*	42.7	512.4	13

Note: Starting with the SB-25, it appears that Nikon's documentation simplified the earlier published tables, providing values that covered a range of ISO speeds. Astute observers will see that the new values Nikon quotes are simply the value for the top of each ISO range in the table presented above. Nikon also rounds to integer values, though this isn't likely to cause incorrect settings. Using this new, simplified method results in conservative maximum aperture settings at all ISO values except 100, 400, and 800. The table shown here is more accurate and should be used to get a true maximum aperture value.

SB-22s Only

ISO	X for Feet	X for Inches	X for Meters
25	4.9	58.8	1.5
50	7.2	86.4	2.2
100	9.8	117.6	3
200	14	168	4.3
400	20	240	6
800*	27.9	334.8	8.5
1,000*	31.5	378	9.6

* Some earlier TTL cameras have an upper limit of ISO 400 for TTL flash.

5. You may set any aperture equal to or (physically) smaller than that which you calculated in Step 4 (e.g., if your calculation determined that f/5.6 was acceptable, you could also choose f/8, f/11, f/16, etc.; generally, in close-up photography, you're going to want to choose small apertures for depth of field anyway— Step 4 calculates the largest aperture you can use).

6. Make sure your camera is at an acceptable sync speed. If you're trying to balance flash and ambient light, consider using slow sync mode.

Off-Camera Flash Use

The two primary methods for using flash off camera are:

1. Use an SC-17 or other cable to connect the off-camera flash with the camera's hot shoe.

2. Use a flash on the camera to trigger "slave" flash units (see "Using Additional Slave Flash Units," page 78).

Using Multiple Speedlights

With the proper attention to cables and settings, several Speedlights can usually be connected to recent Nikon cameras. However, several caveats must be noted:

- _Some Speedlights can be used only as a "master" flash_ (i.e., the flash that is directly attached to the camera). These exceptions are noted in the "Speedlight Information and Instructions" section of this book (and also on the next page).

- _The resistance level of Speedlights varies considerably,_ with some putting very little "load" on the cabling and others putting

much heavier loads on the cabling. The total number of Speedlights that can be connected, therefore, varies with the units being used.

In connecting multiple units, the total load shouldn't exceed 1,400 muA at room temperatures (68° F, 20° C), or 910 muA in hot situations (104° F, 40° C). The following table outlines the relative load that each of the multiple-flash-capable Speedlights adds:

SB-11, SB-14, SB-140, SB-25, SB-26, SB-27, SB-28	70 muA
SB-15, SB-16, SB-17, SB-21, SB-23	280 muA
SB-20	630 muA
SB-22	540 muA

Unfortunately, cable length must also be factored in. The total cable length should not exceed 33 feet (10 m).

Finally, no more than five Speedlights should be connected in multiple flash mode, regardless of the other two factors just mentioned.

- Generally one would use either TTL or manual (M) flash mode on all the Speedlights (i.e., they should all be set the same).

- Lighting ratios must be taken into account (see "Key-to-Fill Lighting Ratios," page 80). One Speedlight should provide the primary light, and the others should be positioned in such a way that they provide less light (a 2:1 ratio of main light to fill light is nice to shoot for as a starting point, especially for portraiture). If you mix Speedlights with different guide numbers, this ratio can become quite difficult to calculate, however. With Speedlights that have the same guide number, you can simply use flash-to-subject distance to control lighting ratios (same distance means a 1:1 lighting ratio, twice the distance makes a 4:1 ratio, etc.).

- Make sure you aren't attempting to use a mode that uses the pre-flash (only **TTL** should appear on the flash unit's LCD panel). Because pre-flash calculations are done with the assumption that only one flash unit is being used, incorrect exposures may result if the camera-mounted flash is left in a mode that generates pre-flashes.

- The SB-15, SB-16, SB-17, SB-21A, SB-24, SB-25, SB-26, SB-27, and SB-28 all have connections on the flash unit for an SC-18 or SC-19, which are used to connect the secondary flash unit(s). The SB-11, SB-14, SB-140, SB-20, SB-21B, SB-22, and SB-23

require the use of an SC-17 Cord in order to provide the connection for additional flash units.

Speedlights That Can Be Used as a Master Flash Unit
SB-15, SB-16B, SB-18, SB-20, SB-21B, SB-22, SB-23, SB-24, SB-25, SB-26, SB-27, SB-28, SB-29

Speedlights That Can Be Used as a Slave Flash Unit
SB-15, SB-16A/B, SB-17, SB-18, SB-20, SB-21B, SB-22, SB-24, SB-25, SB-26, SB-27, SB-28, SB-29

Fortunately, once you've paid attention to these caveats, multiple flash use is relatively simple:

1. Make sure all flash units are set to the OFF position before connecting them!

2. Attach the Speedlight to be used as the main (master) flash to the camera's hot shoe (remember, some Speedlights may require this be done via an SC-17 Cord in order to provide additional connections).

3. Connect the secondary (slave) flash unit(s) to the main one via an SC-18 or SC-19 (it may have to plug into the SC-17).

4. Turn the Speedlights ON, starting with the main unit and working your way down the cable away from the camera. Standby functions should NOT be used (i.e., the Speedlights power switches should all be set to ON, not STBY).

5. Set the flash mode of the main Speedlight to TTL or manual (M). If you set it to manual, perform the necessary settings, as usual (see the instructions for manual use for individual Speedlights later in this book). Generally, you must set the zoom head position and the flash-to-subject distance manually.

 Note: Nikon says to use the AS-10 Multi-Flash Adapter when using three or more units for TTL operation. It is unclear whether this is a requirement or a recommendation. I have only three TTL-capable Speedlights, so have not been able to verify what Nikon meant.

6. Set the flash mode of the secondary flash units to the same mode you set the main unit to.

Using Additional Slave Flash Units

Much noise has been made about the off-camera slave function first built into the SB-26 and then later dropped with the introduction of the SB-28. To understand why Nikon changed course, one has to understand how the SB-26 worked.

Basically, the SB-26 had a "naïve" slave unit built in. When set to the proper mode, an SB-26 would fire *after* it saw another flash fire. Note the word "after." In order not to influence the camera's flash TTL calculations, when the SB-26 is in slave mode, it delays firing. First the flash on the camera fires and shuts off, and then the remote SB-26 fires. What this means is that the remote SB-26 can't shut off when the main flash does (i.e., it isn't affected by the TTL calculations). Indeed, the sensor in the flash unit controls the remote SB-26's flash output. Unless you are careful about positioning and setting the off-camera flash unit's power level, you risk overexposing the shot. Values on the remote SB-26 must be set to match the camera and one must consider what will happen when the extra exposure is added to the main exposure.

Normally the remote SB-26 is set to auto (A) flash mode, which makes it attempt to provide the proper amount of light on the subject from its position. Make sure to set the aperture and ISO film speed on the remote flash so that it matches that of your camera! Still, since the light that the remote SB-26 provides is in addition to the light provided by the camera's flash, overexposure is possible even when this is done.

Professionals use the remote SB-26's aperture settings to control how much light it produces. Here are the step-by-step details of how to use a remote SB-26 to provide automatic fill light from the side:

1. Mount one flash on the camera (it doesn't have to be another SB-26, but it should have the same GN as the SB-26). While you don't have to set the flash to TTL mode, I usually do.

 Note: Since light coming directly from the camera position tends to look a little artificial—we don't have light sources in our eyes—I tend to mount the main flash a few degrees off to the left side of my camera using an SC-17 Cord.

2. Set your camera to your preferred exposure mode, as you normally would. I tend to work in aperture-priority (A) or manual (M) exposure mode, since that way I'm controlling the aperture, which we need to note in later steps anyway.

3. Set the camera's exposure as you normally would. In the process of doing this, you'll determine which aperture you'll be using; note it, you'll need it in Step 7.

 Note: While Nikon doesn't mention it in any of their literature, it appears possible in some very specific situations (fast shutter speeds and full flash durations on both Speedlights) that the remote SB-26 might not complete firing before the shutter begins to close. To play it safe, I always use 1/125 second or slower shutter speeds when using a remote SB-26 on delay.

4. Locate your remote SB-26 to one side, about 30 to 45° off the camera-subject axis. The remote SB-26 should be approximately the same distance from your subject as the on-camera flash.

5. Set the remote SB-26 for automatic flash (A) mode (i.e., move the flash unit's selectors to normal and A).

6. Set the ISO film speed value on the remote flash to match that set on the camera (without a camera attached, the SB-26 defaults to ISO 100 or the last manual value entered, which may not match what you're using).

7. Likewise, you need to tell the remote SB-26 which aperture to calculate for. Instead of using the aperture you set on your camera in Step 3, select an aperture 1 or 1-1/2 stops larger. Thus, if you selected f/5.6 in Step 3, you'd set the remote SB-26 to f/4 or between f/2.8 and f/4. Telling the flash that a larger aperture is being used makes it produce less light, and fill light should generally be 1 to 2 stops less than the main light.

8. On the front of the remote SB-26, move the switch to the "D" (delay) position.

9. Take the picture. You won't be able to see it, but the remote SB-26 will fire after the main flash has finished. Thus, the main flash unit's exposure is correctly calculated by the TTL circuitry in the camera, while the remote flash unit's output was done entirely by the remote flash; neither flash sees the output of the other while making its exposure calculations.

 Amateurs who don't read the SB-26 manual carefully often assume that the off-camera flash is tied to the TTL flash metering in their camera and get disappointing results because of this. Nikon didn't like having users not understand how to get good multi-flash results, so they took the confusing system out of subsequent flash units and looked for another method.

Still, once you understand that the remote unit isn't connected to the TTL meter, using a remote SB-26 for fill is relatively easy, and it provides remarkably good results when set up correctly. But still a remote SB-26 isn't my preferred method of using remote fill-flash.

SU-4 Wireless Slave Flash Controller

Nikon considered all the complaints they received from photographers who didn't understand how the SB-26 remote slave function worked and set out to do better. Nikon's answer was the SU-4 Wireless Slave Flash Controller. This versatile accessory can provide automatic TTL exposure control when used with the appropriate

Key-to-Fill Lighting Ratios

Photographers using multiple light sources often talk about "key-to-fill" ratios. A "key light" is the light source that provides the primary illumination for a subject. The "fill light" is used to fill in shadows created by the primary light.

Most books tell you that the key light should provide twice the output of the fill light (known as a 2:1 lighting ratio). Lower ratios (1:1, for example) seem a bit artificial to our eyes, as the lack of clear shadow direction doesn't look right.

If the ratio is too high (8:1 or more) film may not be able to render the difference, and the presence of strong directional shadows possibly adds a "mood" to the shot that you don't want. Personally, I try to keep my ratios between 2:1 and 4:1, depending upon what I'm trying to achieve.

Sometimes you'll also hear about "rim light" (also known as

"kicker lights" or "backlights"), which are positioned behind a subject and are used to provide a lit edge to the subject that helps separate it from the background. (Some of these terms derive from uses in the motion picture industry and later television, where multiple light sources create quite complex problems due to the movement of actors within the scene. Studio photographers often use similar multiple light techniques, though they don't have to worry as much about subject movement.)

It's certainly possible to use multiple SU-4 Wireless Slave Flash Controllers (see text above) to add rim light or background light, though this really belongs in a discussion of studio lighting, a topic worthy of its own book.

Note that we tend to associate light as coming from above (the sun's influence, obviously), so the

camera and flash units. Any TTL-capable flash in the camera
(including the built-in pop-up flashes of the N50/F50, N60/F60,
N65/F65, N70/F70, and N80/F80) can be used to trigger the remote
flash on the SU-4.

1. Place a Speedlight capable of TTL (basically an SB-15 or later) in
 the SU-4's hot shoe.

2. Set the switch on the SU-4 to auto.

3. Make sure the SU-4 is no more than 23 feet (7 m) from the main
 flash unit.

4. Set your main on-camera flash to TTL mode and shoot.

most natural placement of the
primary light is usually 30 to 45°
above the camera-subject axis.
(If it were closer to 90°, you'd get
deeply shadowed areas in the eye
sockets, which look unnatural—
just look at any portrait you've
shot outdoors at high noon to see
why you'd want to avoid this.)

Usually, you'd also move the
primary light to the side, as that
helps reveal the depth of the
subject (due to shadows). Again,
30 to 45° is about right. To get
rid of the shadows, place a
somewhat weaker light on the
opposite side of the primary light
(see illustration below).

_If flash A and flash B fire at
equal amounts, you'll get a
1:1 ratio. When flash A fires
at twice the level of flash B,
you'll get a 2:1 ratio. If flash
A and flash B fire at the
same level, you achieve a
2:1 ratio by moving flash B
so that it is about 1.5 times
the distance from the
subject as flash A._

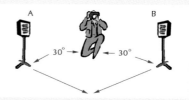

The SU-4 triggers the flash in its hot shoe when it senses that another flash has fired, and it immediately quenches its flash when it senses that the other flash has stopped firing. Since the flash on the camera is using TTL control, it is presumed that no more light is needed when the main flash stops, thus the SU-4 shuts down its flash, too.

If the SU-4's flash uses all of its output before it senses that the main flash has turned off, the SU-4 beeps to indicate possible underexposure (assuming you've set the SU-4 to audible beep). This doesn't necessarily mean the shot was underexposed, only that the flash on the SU-4 probably didn't provide enough exposure by itself (this is especially true if you have a more powerful flash on the camera or one that has a longer flash duration).

The SU-4 system still doesn't necessarily provide "perfect" exposures, though it is less prone to overexposure error than a system using multiple SB-26s. It's up to you to decide the relative placement of the two flash units, which ultimately determines how much light comes from each. In general, if you were to use identical flash units on both the camera and the SU-4, you'd place the SU-4 1-1/2 to 2 times the distance from the subject the camera is (resulting in about a 2:1 to 4:1 ratio).

Using an SU-4 to Provide Fill Lighting

Let's translate all this into precise instructions on how to set up a slave flash using an SU-4. With two SB-28s, a SC-17 Sync Cord, and an SU-4 mounted on a light stand or tripod, here's what I recommend:

1. One SB-28 goes in the left hand, connected to the camera's hot shoe via the SC-17 Cord.

2. The other SB-28 mounts on the SU-4.

3. Position the SU-4 so that its flash unit is angled down on the subject at about 30° and is off to the right (about 30° off the camera-subject axis). Position this unit slightly farther from the subject than you'll be. The second flash should be 1.4 times the distance from the subject as the main flash, if you want a 2:1 lighting ratio (and the flash units have the same GN, as in this example). If you are worried about the subject moving, manually zoom the SB-28 on the SU-4 out to the next wider coverage than the lens being used (e.g., set 35mm on the flash if you are using a 50mm lens on the camera).

4. When shooting, raise the flash in the left hand as high and to the left as your arm will reach, pointing the flash at the subject.

5. Everything is set to TTL auto, so fire away. If you are using matching flash units and change their batteries at the same time, you can assume that if the flash connected to the camera is showing that it's ready to re-fire, the slave is as well (in practice, this seems to work fine).

If everything is hooked up and working correctly, you'll get strong primary light from just off the camera's axis, with a weaker fill light coming from the other side. I don't labor over achieving a perfect 2:1 ratio between the flashes; anything close is good enough, and I'd challenge most viewers to identify when it wasn't exactly 2:1.

Using an SU-4 to Light Backgrounds

The SU-4 is capable of much more than the fill role I've just described. One handy use of the SU-4 and a slave flash is to light backgrounds. Remember, light falls off with the square of the distance it travels. Let's assume it's night and that you have a subject that's 10 feet (3 m) away from you and 20 feet (6 m) away from some interesting, unlit background. If you used just a flash on the camera for illumination, the subject would be perfectly lit and the background would be 8 stops dimmer, which is beyond the range of what film can capture. Of course, you could use the slow sync mode for the shot, but then you risk having subject movement show up in the shot (a nice, but overused effect).

Instead, set up another flash on an SU-4 positioned about 10 feet (3 m) from the background (and out of your shot, obviously). Since it's about the same distance from the background as your flash is from the subject, the background and subject should now be lit at similar levels. You can vary the SU-4's position slightly to make the background darker or brighter, as necessary.

Using an SU-4 for Primary Lighting

Nikon clearly intended for flash units mounted on an SU-4 to be used as the primary light source, too. Indeed, this is one of my favorite uses of the SU-4, especially with a camera body that has a built-in flash, such as the N70/F70 or N80/F80.

Supplied with the SU-4 is an SG-1 Diffuser. This handy unit slips into the camera's hot shoe and has a clip-in diffusion screen that hangs down in front of the camera's flash. Use another TTL-capable

Speedlight mounted on an SU-4 off to the side of your subject as your primary light, and the camera's pop-up flash generates the fill.

This setup works pretty well and is remarkably immune to user error. The relative imbalance in flash strengths, especially with the camera's flash being spread through the diffuser, pretty much guarantees that the flash on the SU-4 provides the main light as long as it isn't set up too far from the subject. The off-camera primary light provides subject depth via shadows, but the on-camera fill lightens those shadows to an acceptable level.

Additional SU-4 Notes

While using an SU-4 is relatively straightforward, you might want to consider the following:

- *Speedlights that you put on an SU-4 can be set to M (manual) flash mode to fire at a predetermined level.* When you do this, the SU-4 triggers the flash based upon seeing the on-camera flash go off, but does not stop an SU-4-mounted Speedlight; instead it fires at the level you asked for. If you're comfortable figuring flash exposure manually, this is a sure way of getting the exact amount of light from the remote flash that you want. Just remember the basic guide number calculations (see "Guide Numbers," page 21), and you should be able to get exactly the exposure you desire.

- *Multiple SU-4s can be used, though the practical limit appears to be three or four units,* otherwise the SU-4s fail to shut flash power off correctly (because it cannot tell when the main flash has stopped firing).

Warning: Don't use the SU-4 if other photographers are in the same room using flash! The SU-4 isn't "smart," i.e., it doesn't know which flash is yours, and so it fires the remote flash whenever it sees any flash fire. When you finally do want it to fire, it may still be recycling and thus not fire at all! (Not to mention that the other photographers will be annoyed by the extra light that their cameras can't control, unless, of course, they're also using Nikon equipment!)

- *In practice, Nikon's instructions on locating the SU-4's light sensor are optimistic.* Always point the SU-4's sensor directly at the trigger flash, if possible, and keep the distance between the two flash units to less than 20 feet (6 m).

Recommendations

Having shot perhaps as many as 10,000 pictures with various Speedlights, I've come to some conclusions about using them. Many of the following recommendations appear elsewhere in this book, but I've put them all together here for quick reference:

- *Use rechargeable or lithium batteries.* For general use, get several sets of NiMH or NiCd rechargeables and charge them up just before a shoot. If you know you're going to be shooting in cold weather, bring lithiums instead.

- *Warm the flashtube.* More often than not I find that I'm using fill-flash in shadows, where the light is already considerably on the blue side. Put a small piece of a warming gel permanently over a portion of the flashtube. When you're using standard flash for portraits, the warming effect is often preferred, anyway.

- *Always perform static, controlled tests to determine the standard flash look you like and dial the resulting compensation in.* Many users find the automatic balanced fill-flash results some camera-Speedlight combinations provide are somewhat underexposed for their taste. Fortunately, Nikon TTL results are reasonably consistent. Figure out how much compensation you desire by performing a controlled test. At the least, try +0.3 and +0.7 compensation for a roll and see if you like those pictures better.

- *When using a Speedlight only for fill light, set the flash to standard TTL and set exposure compensation on the flash to between –1 and –1.7.* Personally, I like the non-obvious look of –1.7 most of the time, but some photographers prefer the less subtle –1-stop value.

- *Always use a Speedlight for fill light (set at –1.7 stops flash compensation) when taking pictures of animals, both wild and domestic.* The difference between saleable, professional-looking animal photography and what most amateurs produce is all in the animal's eyes. Fill-flash virtually guarantees a "catch light" in the eyes, and often fills a bit of the shadow in deep eye sockets. No flash typically produces big black spots where the eyes should be.

- *Use TTL if possible, otherwise use manual (M) flash.* Assuming that you've performed tests to adjust the results to your satisfaction, Nikon's TTL system is darn good—it's consistent and saves a lot of mental gymnastics. But if you need perfect results with oddly placed subjects, nothing beats using the GN to do manual

calculations (and if the picture turns out badly, you have only yourself to blame).

- *When in doubt, check the camera's exposure first, with the Speedlight OFF.* Even though I've learned how Speedlights function in most situations, there are still times when I wonder about the readings I see in the viewfinder. In such cases, I turn the flash OFF and check to see what the camera's doing on its own. Just be sure to watch carefully for what happens to the settings when you turn the Speedlight ON and you'll almost certainly have all the information you need to retain full control.

- *Use slow sync mode most of the time.* When set in standard TTL mode, you have a very narrow range of background exposure to work with due to the 1/30 to 1/250 second shutter speed limitations most Nikon bodies impose (even narrower if the body has a slower top sync speed!). Assuming that you're working on a tripod, slow sync gives you a wider range of background exposure to work with.

- *Use slow sync rather than rear sync if you want the camera to perform the best possible balanced fill-flash mode.* The pre-flash doesn't work in rear sync mode.

- *Use D-type lenses for focal lengths under 100mm.* Most of the time, the differences in flash pictures shot with D and non-D Nikkors is minimal, if any. Every now and then an off-center shot or one with a bright reflective surface shows you just how different (and better) the results can be if you're using D lenses. Using lenses that are longer than 100mm, I've found very few instances where the results would be different with a non-D lens, especially since such lenses are normally used to frame a subject tightly (i.e., such shots don't include much, if any, background that would influence the flash calculations).

- *When storing Speedlights, take the batteries out, and fire the flash once a month.* The batteries should be taken out to keep them from leaking and causing an expensive repair. The once-a-month test firing helps keep the capacitor from deforming.

- *Buy and use an SC-17.* Getting the flash even a few feet off the camera-subject axis gives you lighting flexibility that adds a dimensionality to your shots you wouldn't otherwise get. Plus you'll eliminate red-eye.

- *Carefully analyze the space in front of your subject.* If the light is correct on your subject, it can be wildly blown out on anything

closer to the camera. Even a small flower stem, flying bug, or dust between you and the subject could generate a bright highlight that destroys an otherwise good shot.

- *Carry a small reflector with you.* For close work (anything under 4 feet [1.2 m], in my experience), you'll get a softer, easier-to-control light by bouncing the Speedlight off a reflector rather than pointing it directly at the subject (exceptions: the SB-21 and SB-29 macro flash units).

- *Forget over-the-head diffusers.* Yes, they work, but they also cut down the overall light considerably, reducing your working distances and limiting your options. Learn to bounce light off nearby surfaces or the reflector you bring along. Generally you can achieve the same effect and get more light on the subject. If you do decide to use an over-the-head diffuser because of its convenience, do yourself a favor and perform tests to determine the new guide number for your Speedlight. Someday you'll run into a situation where you'll be glad you did.

- *Finally, the most important recommendation of all is to experiment and take notes.* The other day I saw some flash pictures that were a bit different than any I'd ever seen. When I asked the photographer what he had done, he said "I got tired of panning the camera during slow sync—everyone's doing that these days, and so everyone's pictures look the same. Instead, I decided to see what would happen if I kept the camera on a tripod and moved the flash during exposure." Apparently it took him quite some time to perfect the technique (and I promised I wouldn't reveal his secret), but now he has unique, interesting results that no one else does.

This one-second (!) exposure was generated by setting the flash to rear sync and panning with the subject. I also twisted the camera slightly clockwise at the end of the pan. This black and white rendition doesn't do the original justice: if you have lots of color in the background, those long streaks become a wild tapestry from which the subject seems to pop.

Speedlight Information and Instructions

Nikon has produced more than 30 Speedlight variants, each of which is described in detail in this chapter. Here you'll find specifications, field operating instructions, and special notes that apply to each flash unit.

Notes about Specifications

- Guide numbers listed at the beginning of each Speedlight section are for normal coverage (35mm lens for non-macro units). Guide numbers for other coverage are included in tables in the text.

- All guide numbers specified are for ISO 100 film.

- I've used the numbers listed in original Nikon documentation (complete with rounding inconsistencies) wherever possible. In cases where the Nikon documentation was wrong, I've noted my corrections.

- Recyle and number-of-flash specifications are all given for standard AA alkaline batteries at room temperature. These numbers are really only useful for making comparisons between units, as in real use, the recycle times quoted by Nikon tend to be low and the number of flashes per battery set tend to be high.

Notes about Instructions

- In many cases, my instructions don't follow the same order as Nikon's documentation. I've tried to use a consistent approach and one that reduces confusion and information that is extraneous to the task at hand.

- Wherever possible, I've tried to note differences that are specific to certain camera bodies. However, since Nikon has continued to produce new cameras that can be used with older flash units, not all the discrepancies have been documented.

Summary of Speedlight Capabilities

Flash	Coverage	Recycle*	GN**	Major Features Supported
SB-E	35mm	9 secs	56 (17 m)	
SB-1	35	4	125 (38 m)	EP
SB-2	35	8	80 (25 m)	WA (option)
SB-3	35	8	80 (25 m)	WA (option)
SB-4	35	9	52 (16 m)	
SB-5	28	2.6	105 (32 m)	EP, HS
SB-6	35	NA	147 (45 m)	HS
SB-7E/8E	35	8	82 (25 m)	WA (option)
SB-9	35	9	46 (14 m)	
SB-10	35	8	82 (25 m)	WA (option)
SB-11	35	8	118 (36 m)	EP, WA (option)
SB-12	35	8	82 (25 m)	WA (option)
SB-14	28	8	105 (32 m)	EP, TTL, WA (option)
SB-140	28	8	32 (10 m)	SL, TTL, WA (option)
SB-15	35	8	82 (25 m)	HS, TTL, WA (option)
SB-16A/B	28–85	8	105 (32 m)	TTL, WA (option)
SB-17	35	8	82 (25 m)	TTL, WA (option)
SB-18	35	6	66 (20 m)	TTL
SB-19	35	7	66 (20 m)	
SB-20	28-85	7	98 (30 m)	AF, BO, EP, TTL
SB-21A/B	NA	8	39 (12 m)	EP, TTL
SB-22	35	4	82 (25 m)	AF, BO, EP, TTL, WA (option)
SB-22s	35	4	92 (28 m)	AF, BO, EP, TTL, WA (option)
SB-23	35	2	66 (20 m)	AF, TTL
SB-24	24–85	7	118 (36 m)	AF, BO, EP, RS, TTL
SB-25	20–85	7	118 (36 m)	AF, BO, EP, RE, RF, RS, TTL, WA
SB-26	18–85	7	118 (36 m)	AF, AZ, BO, EP, HS, RE, RF, RS, TTL, WA, WS
SB-27	24–70	5	98 (30 m)	AF, AZ, BO, EP, RE, RS, TTL, WA
SB-28	18–85	6.5	118 (36 m)	AF, AZ, BO, EP, HS, RE, RF, RS, TTL, WA
SB-29	20–24	3	35 (11 m)	AF, EP, RS, TTL

** Recycle times listed are the fastest obtainable for a full charge and with alkaline batteries.*

*** Guide numbers specified in feet for 35mm lens coverage and ISO 100 film. Number in parentheses is GN expressed in meters for a 35mm lens and ISO 100 film.*

AF = Autofocus assist illuminator for dim light
AZ = Automatically zooms the flash head to match focal length of lens in use
BO = Flash head can be swiveled to bounce light
EP = External power sources supported
HS = High-speed sync mode
NA = Not available
RE = Red-eye reduction supported (with appropriate cameras)
RF = Repeating flash
RS = Rear-curtain sync supported (with appropriate cameras)
SL = Special light (UV, infrared)
TTL = Supports TTL on appropriate camera bodies
WA = Wide-angle adapter
WS = Wireless slave flash control

Note: Most Nikon Speedlights turn the ready light ON when the flash is recycled to about 80% of capacity (i.e., if you need full power from the flash, you won't get it if you fire the flash the moment the ready light glows). When using manual (M) or automatic (A) flash mode and shooting near the maximum flash distance, always wait a few seconds after the ready light comes ON before firing the flash. As batteries become exhausted and recycle times grow longer, you need to wait even longer. In TTL flash mode at distances significantly shorter than the maximum range for your selected aperture, it's probably okay to fire the flash immediately when the ready light comes ON.

SB-1

Nikon's first Speedlight was a handle-mount unit introduced in 1969. While not very sophisticated, for its time it had a high guide number and fast recycle times.

1 Quick release for SK-2 bracket	8 On/Off switch
2 Sync socket	9 Exposure calculator dial
3 Ringlight socket	10 Distance scale
4 Flashtube	11 Aperture scale
5 AC socket	12 GN scale
6 Grip/Battery compartment	13 ISO scale
7 Battery compartment cover	14 Ready light
	15 Test fire button

Specifications

GN:	125 (ft), 38 (m)
Weight:	21.5 oz (670 g) (main unit with SN-1 Battery), 8.4 oz (260 g) (camera mounting bracket)
Size:	NA
Power:	Rechargeable, or 6 D-cells in SD-2
Recycle Time:	4 seconds minimum (full discharge, SN-1)
No. of Flashes:	80 (SN-1)
Flash Duration:	1/2,000 second
Coverage:	35mm lens (56° horizontal, 40° vertical)
Case:	NA
Key Features:	Camera bracket mount (uses tripod socket); multiple power sources (including AC via SA-1); close-up (SR-1) and macro (SM-1) attachments were also available; flash head could be tilted. Up to two additional units could be controlled via SE-2 Cord.

Setting Manual Flash Exposure

1. Set the ISO film speed value in the white cutout labeled ASA at the bottom of the dial located on the back of the SB-1. The ISO value of the film you're using should align with the small arrow marked Color.

 Note: ASA is the predecessor to ISO for rating film; ASA and ISO values are equivalent. For example, an ASA 100 film has the same sensitivity as an ISO 100 film.

2. Focus on your subject and note the distance. On the top of the exposure calculation dial on the back of the SB-1 note the aperture that corresponds to that distance (the outer values are the distances in feet, the next ring is apertures, and the numbers in the innermost ring are the distance in meters).

3. Set the aperture calculated in Step 2 on the lens, and make sure that the shutter speed is within the sync range of your camera (see "Camera Capabilities," pages 326–327).

4. Turn the flash unit ON. Wait several seconds after the ready light begins to glow, then take the picture (the ready light glows before a full charge is available).

SB-1 Notes

- Color temperature of the flashtube is a bluish 6,000 Kelvin.

- The SB-1 came standard with the SN-1 NiCd Battery Pack, a sync cord, and the SA-1 Charger.

- Guide numbers can be read directly in the cutout labeled GN for the GN Auto Nikkor 45mm f/2.8 lens.

- Use the optional SC-4 to provide a viewfinder ready light on the F2.

- The SR-1 Ringlight (predecessor to the SB-21A and SB-21B and SB-29) is a close-up flash accessory for the SB-1 (the SM-1 is similar, only designed for use with lenses with greater than 1:1 ratios). The 4-pin plug at the end of the ringlight's power cord plugs into a socket on the camera side of the SB-1's flash head. The SR-1 can be fired at full or 1/4 power (controlled by a switch on the top of the ringlight). Exposure for an SR-1 is calculated as follows (all ISO 100):

Distance	Full Power	1/4 Power
4"	—	f/45
8"	—	f/38 (f/32 minus 1/2 stop)
12"	—	f/27 (f/22 minus 1/2 stop)
16"	—	f/22
20"	f/45	f/16
24"	f/22	f/11

Distance	Full Power	1/4 Power
100mm	—	f/45
200mm	—	f/38 (f/32 minus 1/2 stop)
300mm	—	f/27 (f/22 minus 1/2 stop)
400mm	—	f/22
500mm	f/45	f/16
600mm	f/22	f/11

SB-2 and SB-3

These nearly identical units provide automatic flash control.
Introduced in 1977, the SB-2 was designed to connect to the F2 and
other cameras with the original Nikon flash connection mounted on
the rewind lever. The SB-3 was designed for cameras, such as
Nikkormats, that use the more standard prism-mounted hot shoe.

1 Light sensor
2 Aperture selector switch
3 Aperture indicator
4 Distance scale
5 ISO scale
6 Battery compartment
 release
7 Flashtube

The Nikon Flash Guide

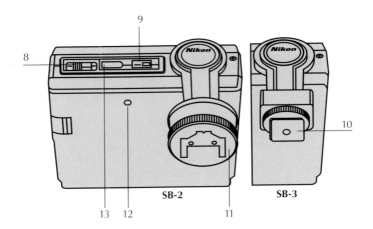

SB-2 SB-3

8 On/Off switch
9 Ready light/test fire button
10 Flash mounting foot (ISO)
11 F/F2/F3 mounting shoe
12 Sync socket
13 AC power socket

Specifications

GN:	80 (ft), 25 (m)
Weight:	15 oz (430 g) (w/o batteries)
Size:	1.6" (40 mm) tall x 4.3" (110 mm) wide x 4.1" (104 mm) deep
Power:	4 AA batteries
Recycle Time:	8 seconds minimum (full discharge)
No. of Flashes:	~140 at full manual
Flash Duration:	1/2,000 second
Coverage:	35mm lens (56° horizontal, 40° vertical)
Case:	NA
Key Features:	Flash automatically shuts off when flash-to-subject distance is 2 to 20 feet (0.6 to 6 m); choice of three working apertures. Head tilts through 180° arc.

Setting Automatic Flash Exposure

1. Set the ISO value in the white cutout labeled ASA at the bottom of the dial located on the back of the SB-2/SB-3. The ISO value of the film you're using should align with the small arrow across from the ASA label.

 Note: ASA is the predecessor to ISO for rating film; ASA and ISO values are equivalent. For example, an ASA 100 film has the same sensitivity as an ISO 100 film.

2. Focus on the subject and note the distance.

3. On the dial on the top of the SB-2/SB-3 find the distance calculated in Step 2 and read outward to find the corresponding aperture. The innermost ring of numbers lists feet, then meters are listed, and apertures are listed on the outermost ring.

4. You'll see three lines running from orange, yellow, and blue markers to the aperture selection switch. ***Important***: Select any of these apertures whose marker is to the left of the aperture you noted in Step 3. Move the aperture selection switch to that aperture setting, and set that aperture on your camera. Make sure that the camera is set to a speed at which it can sync with flash (see "Camera Capabilities," pages 326–327).

 Example: At ISO 100, if you measure a distance of 12 feet in Step 2 (which corresponds to somewhere between f/5.6 and f/8 in Step 3), you could set either f/5.6 (yellow) or f/4 (orange) in Step 4.

 Note: The minimum flash distance is always 2 feet (0.6 m) in automatic mode.

5. Turn the flash unit ON. Wait several seconds after the ready light first glows, then take the picture.

SB-2 and SB-3 Usable Apertures and Flash Range in Automatic Mode (ISO 100)

Color of Markers	Aperture	Range in Ft	Range in M
orange	f/4	2–20	0.6–6
yellow	f/5.6	2–15	0.6–4.5
blue	f/8	2–10	0.6–3

Setting Manual Flash Exposure

1. Set the ISO film speed value in the white cutout labeled ASA at the bottom of the dial located on the back of the SB-2/SB-3. The ISO value of the film you're using should align with the small arrow across from the ASA label.

 Note: ASA is the predecessor to ISO for rating film; ASA and ISO values are equivalent. For example, an ASA 100 film has the same sensitivity as an ISO 100 film.

2. Focus on the subject and note the distance.

3. On the dial on the top of the SB-2/SB-3 find the distance calculated in Step 2 and read outward to find the corresponding aperture. The innermost ring of numbers lists feet, then meters are listed, and apertures are listed on the outermost ring.

4. Set the aperture noted in Step 3 on the camera. Make sure the camera is at a shutter speed that will sync with flash (see "Camera Capabilities," pages 326–327).

5. Move the aperture selector switch on the SB-2/SB-3 to the M position.

6. Turn the flash unit ON. Wait several seconds after the ready light first glows, then take the picture.

SB-2 and SB-3 Note

• An SF-1 may be plugged into the Speedlight and mounted on the camera's eyepiece to provide a ready light that can be seen with your eye at the viewfinder.

SB-4

Introduced in 1977, the SB-4 was the first small flash unit produced by Nikon with automatic flash control. It has a foot that attaches to cameras with a standard flash shoe such as the Nikon F and F2, the Nikonos II and III, and the Nikkormat EL, FT2, FTn, FT, and FS. It was also intended for use in still-frame mode with the Nikon R8 and R10 Super 8 movie cameras.

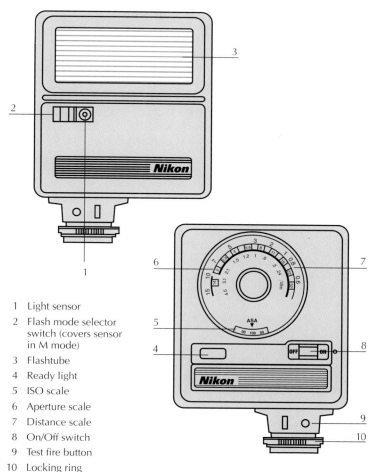

1 Light sensor
2 Flash mode selector switch (covers sensor in M mode)
3 Flashtube
4 Ready light
5 ISO scale
6 Aperture scale
7 Distance scale
8 On/Off switch
9 Test fire button
10 Locking ring

Specifications

GN:	52 (ft), 16 (m)
Weight:	6.3 oz (180 g) (w/o batteries)
Size:	3" (75 mm) tall x 2.8" (70 mm) wide x 1.6" (40 mm) deep
Power:	2 AA batteries
Recycle Time:	9 seconds minimum (full discharge)
No. of Flashes:	~140 at full manual
Flash Duration:	1/800 second
Coverage:	35mm lens (56° horizontal, 40° vertical)
Case:	SS-3
Key Features:	Flash automatically shuts off when flash-to-subject distance is 2 to 13 feet (0.6 to 4 m).

Setting Automatic Flash Exposure

1. Make sure the Auto/Manual switch on the front of the SB-4 is set to auto (the orange light sensor is uncovered when the switch is in the auto position).

2. Set the ISO film speed value in the white cutout labeled ASA at the bottom of the dial located on the back of the SB-4. The ISO value of the film you're using should align with the small arrow under the ASA label.

 Note: ASA is the predecessor to ISO for rating film; ASA and ISO values are equivalent. For example, an ASA 100 film has the same sensitivity as an ISO 100 film.

3. Set the aperture to the value indicated by the orange exposure index in the upper portion of the dial on the back of the flash, and make sure that the shutter speed is within the sync range of your camera (see "Camera Capabilities," pages 326–327).

4. Turn the flash unit ON. When the ready light glows, take the picture. Note that if you are shooting near the range limit of the flash (~19 feet [6 m]), you should wait a few seconds after the ready light glows before taking a picture, as the light comes on before the flash unit is fully charged.

Setting Manual Flash Exposure

1. Move the Auto/Manual switch on the front of the SB-4 to manual (an M should be revealed and the orange light sensor covered).

2. Set the ISO film speed value in the white cutout labeled ASA at the bottom of the dial located on the back of the SB-4. The ISO value of the film you're using should align with the small arrow under the ASA label.

 Note: ASA is the predecessor to ISO for rating film; ASA and ISO values are equivalent. For example, an ASA 100 film has the same sensitivity as an ISO 100 film.

3. Focus on the subject and note the distance. On the top of the dial on the back of the SB-4 note the aperture that corresponds to that distance (the outer values are the distance in meters, the next ring lists apertures, and the small numbers in the innermost ring are the distance in feet). For example, at ISO 100 and 10 feet (3 m), the f/stop is 5.6. If in doubt, choose the larger aperture (f/4 in this example), especially outdoors.

4. Set the aperture calculated in Step 3 on your camera, and make sure that the shutter speed is within the sync range of your camera (see "Camera Capabilities," pages 326–327).

5. Turn the flash unit ON. Wait several seconds after the ready light first glows, then take the picture (the ready light glows before a full charge is available; in manual flash mode you may get underexposure if you fire the flash the moment the ready light appears).

SB-4 Notes

- *Nikon F3:* Requires the AS-4 or AS-7 Adapter.
- *Nikon F2:* Requires the AS-1 or AS-2 Coupler.
- *Nikon F:* Requires the AS-1 or AS-2 Coupler. Set the shutter speed to 1/60 second or slower, then lift and turn the knurled sync selector ring around the shutter-speed dial of the camera until the Fx mark appears in the selector window (this can be done only with the Photomic FTn finder removed).

- *Nikkormat FTn:* Requires the Nikkormat Accessory Shoe and SC-8 Sync Cord (connects the SB-4's sync socket to the camera's X terminal; Nikon recommends that you insert the SC-8 into the camera's X terminal before attaching the flash unit to prevent accidental firing).

- *Nikkormat EL:* Set the shutter speed to 1/125 second or slower, then lift and turn the knurled sync selector ring until the ϟ symbol appears in the selector window.

- *If you choose to use the SB-4 off camera* (i.e., not mounted in the flash shoe at the top of the camera), plug the SC-8 Sync Cord into the camera's X terminal first before plugging it into the flash.

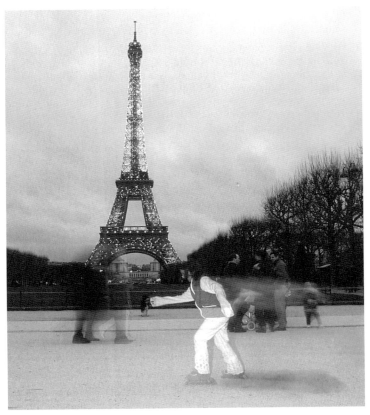

Slow sync trails are difficult beasts to control. Length of exposure and speed of action control the length of the trail. However, as can be seen here, you also have to watch colors. Light colors moving against light backgrounds don't leave much of a trail (e.g., the skates leave a distinct trail but the skater's white pants barely register on the light-colored pavement).

SB-5

The second of Nikon's handle-mounted Speedlights, the SB-5 was the first to provide automatic flash control. Intended for professionals using the Nikon F and F2, this flash unit introduced MD (motor drive) mode, allowing 1/8th-power flash bursts for as many as 40 frames at up to 3.8 fps. It was introduced in 1980.

1 SK-3 bracket
2 Flashtube
3 External power socket
4 Neckstrap belt
5 Bracket release button
6 Battery chamber cap

The Nikon Flash Guide

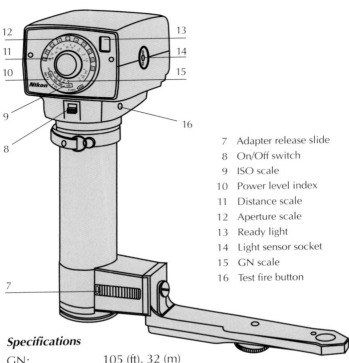

7 Adapter release slide
8 On/Off switch
9 ISO scale
10 Power level index
11 Distance scale
12 Aperture scale
13 Ready light
14 Light sensor socket
15 GN scale
16 Test fire button

Specifications

GN:	105 (ft), 32 (m)
Weight:	31.7 oz, (900 g) (w/o batteries or mounting bracket)
Size:	9.9" (252 mm) tall x 3.7" (93 mm) wide x 4.9" (125 mm) deep
Power:	SN-2 NiCd Battery Pack (included)
Recycle Time:	2.6 seconds minimum (with SN-2) (full discharge)
No. of Flashes:	~75 at full manual
Flash Duration:	NA
Coverage:	28mm lens (67° horizontal, 48° vertical)
Case:	NA
Key Features:	Automatic flash at up to 26 feet (8 m); motor drive (high-speed) flash at 1/8 power; fast recycle times (often less than 1 second when using SU-1 and automatic mode); doesn't require adapter to cover 28mm; rotates in 30° increments.

Setting Automatic Flash Exposure

Automatic flash requires use of the SU-1 Light Sensor unit that comes with the SB-5.

1. Set the ISO film speed value in the white cutout labeled ASA at the bottom of the dial located on the back of the SB-5's flash head. The ISO value of the film you're using should align with the small white arrow at the outermost edge of the ring.

 Note: ASA is the predecessor to ISO for rating film; ASA and ISO values are equivalent. For example, an ASA 100 film has the same sensitivity as an ISO 100 film.

2. Set the flash output power by turning the knurled knob at the center of the dial on the SB-5's head. Align the selected power (Full, 1/4, MD [1/8]) with same white arrow you used in Step 1. Guide numbers can now be read off the ring just inside the ASA cutout (aligned with the small white arrow next to the knurled power setting knob).

3. Set the SU-1 to an aperture setting (orange = f/4, yellow = f/5.6, blue = f/8 at ISO 100). Set the aperture on the camera to the same value. Make sure that your shutter speed is within the sync range of your camera (see "Camera Capabilities," pages 326–327).

4. Turn the flash unit ON. When the ready light glows, you can take the picture.

SB-5 Usable Apertures and Flash Range in Automatic Mode (ISO 100)

Color of Markers	Aperture	Range in Ft	Range in M
orange	f/4	2–26	0.6–8
yellow	f/5.6	2–18	0.6–5.6
blue	f/8	2–13	0.6–4

Setting Manual Flash Exposure

1. Set the ISO film speed value in the white cutout labeled ASA at the bottom of the dial located on the back of the SB-5's flash head. The ISO value of the film you're using should align with the small white arrow at the outermost edge of the ring.

Note: ASA is the predecessor to ISO for rating film; ASA and ISO values are equivalent. For example, an ASA 100 film has the same sensitivity as an ISO 100 film.

2. Set the flash output power by turning the knurled knob at the center of the dial on the SB-5's head. Align the selected power (Full, 1/4, MD [1/8]) with same white arrow you used in Step 1. Guide numbers can now be read off the ring just inside the ASA cutout (aligned with the small white arrow next to the knurled power setting knob).

3. If the SU-1 is connected, set it to manual (the SB-5 fires in manual mode only if the SU-1 is not attached). Use the indicated guide number to adjust the aperture to match the shooting distance (see "Guide Numbers," page 21). Make sure that the shutter speed is within the camera's sync range (see "Camera Capabilities," pages 326–327).

4. Turn the flash unit ON. When the ready light glows, you can take the picture.

SB-5 Notes

• To enable the flash to keep up with a motor drive, set the flash power setting to MD (motor drive). This allows up to 40 consecutive flash firings at a motor drive rate of 3.8 fps (equivalent to a flash recycling time of 0.25 second). As an alternative, you can use 1/4 power with slower motor drives (<2 fps, typically), as recycling has a maximum time of 0.5 second.

Note: At full power, the SN-2 NiCd battery can provide operation for only about two rolls of film when fired in MD mode. If you plan to do lots of rapid flash work, bring extra charged batteries or use the optional SD-4 Battery Pack!

• When mounted on the camera, the SU-1 Sensor allows automatic flash even if the SB-5 is set to bounce light. However, if the SU-1 is mounted on the SB-5, the flash must not be set to a bounce position.

• The SB-5 can be used to trigger remote slave flash units. Set the SU-1 to slave, and attach the remote flash unit to an ML-1 Flash Receiver.

Note: When the SB-5 is set to slave, it does not fire a normal flash burst. Instead, it sends a modulated flash pulse that is used only to trigger the remote flash (i.e., don't count on the SB-5 to provide any illumination on the scene!).

SB-6

An unusual Speedlight, the SB-6 was intended for high-speed continuous flash on F and F2 bodies (requires the AS-6 Converter for use with the F3). It was introduced in 1976.

1 Reflector
2 Flashtube
3 Flashtube protector

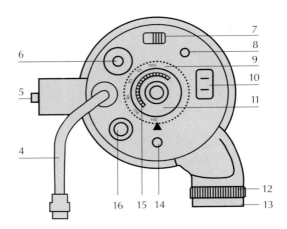

4	Power cord
5	Tripod mount
6	Sensor socket
7	Flash mode selector switch
8	Ready light
9	Power level/ISO scale

10	Sync socket (for SC-5 to SC-7)
11	Distance scale
12	Locking ring
13	F/F2/F3 mounting shoe
14	Test flash button
15	Aperture scale
16	Motor drive socket

Specifications

GN:	147 (ft), 45 (m)
Weight:	2 lbs, 7 oz (1.1 kg) (w/o power unit)
Size:	4.1" (128 mm) round by 6.1" (190 mm) deep
Power:	AS-3 AC Power Unit (can also use SD-5 Battery Pack)
Recycle Time:	Ostensibly none
No. of Flashes:	NA
Flash Duration:	NA
Coverage:	35mm lens (56° horizontal, 40° vertical)
Case:	NA
Key Features:	Up to 40 flash bursts per second! Can be synchronized with any motor drive up to 3.8 fps; strobe operation of 5, 10, 20, or 40 flashes per second. Automatic flash with the optional SU-1 Sensor.

Setting Automatic Flash Exposure

Automatic flash requires use of the optional SU-1 Light Sensor Unit.

1. Set the flash mode selector on the back of the SB-6 to single.

2. Turn the output power selector ring until Full is across from the pointer just outside the dial (at the bottom). Set the ISO film speed value across from that same marker.

 Note: ASA is the predecessor to ISO for rating film; ASA and ISO values are equivalent. For example, an ASA 100 film has the same sensitivity as an ISO 100 film.

3. Set the SU-1 to an aperture setting (orange = f/4, yellow = f/5.6, blue = f/8 at ISO 100) based upon the distance to your subject (see table, below). Set the aperture on the camera to the same value. Make sure that your shutter speed is within the sync range of your camera (see "Camera Capabilities," pages 326–327).

4. Turn the flash unit ON. When the ready light glows, you can take the picture.

SB-6 Usable Apertures and Flash Range in Automatic Mode (ISO 100)

Color of Markers	Aperture	Range in Ft	Range in M
orange	f/4	3–36	1–11
yellow	f/5.6	3–26	1–8
blue	f/8	3–18	1–5.5

Setting Manual Flash Exposure

1. Set the flash mode selector on the back of the SB-6 to single.

2. Turn the output power selector ring until the desired power level (diamonds marked Full, 1/2, 1/4, 1/8, 1/16, 1/32) is across from the pointer just outside the dial (at the bottom). Set the ISO value across from that same marker.

 Note: ASA is the predecessor to ISO for rating film; ASA and ISO values are equivalent. For example, an ASA 100 film has the same sensitivity as an ISO 100 film.

3. Focus on the subject. Note the distance.

4. Use the exposure dial to determine the aperture that corresponds to the distance noted in Step 3. Note that the dial is labeled only in meters. Set the aperture noted on your camera. Make sure that your camera is set to a shutter speed at which flash will sync (see "Camera Capabilities," pages 326–327).

5. Turn the flash unit ON. When the ready light glows, you can take the picture.

Strobe Flash

1. To fire the flash as a strobe, move the flash mode selector on the SB-6 to multi.

2. The power setting must be 1/4, 1/8, 1/16, or 1/32 (set the exposure manually, as noted in the "Setting Manual Flash Exposure" section, page 109).

3. Hold the test fire button down to start the strobe.

4. Set the camera to a shutter speed of Bulb when using this mode.

The number of flash bursts the SB-6 produces in this mode is as follows:

Power	Flashes/Second	Number of Bursts
1/4	5	25 to 45
1/8	10	19 to 37
1/16	20	16 to 31
1/32	40	11 to 18

A flickering ready light indicates that the flashtube is nearing stress levels. Discontinue using the strobe mode until the ready light returns to a steady-lit state.

SB-6 Note

• As many as three SB-6 flash units can be connected, but do not use an SB-6 with other Speedlights.

SB-7E and SB-8E

Introduced in 1978, these two small flash units differ primarily in the way they connect to the camera. The SB-7E has a foot designed to fit on the Nikon F and F2 cameras (over the rewind knob), while the SB-8E has a standard hot foot for use with cameras such as Nikkormats.

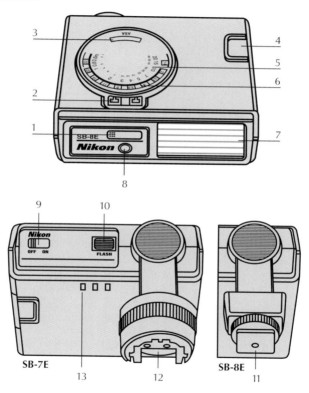

1	Flash mode selector switch	8	Light sensor
2	Flash mode selector indicator	9	On/Off switch
3	ISO scale	10	Ready light/Test fire button
4	Battery compartment release	11	Hot shoe mounting foot
5	Distance scale	12	F/F2 mounting shoe
6	Aperture scale	13	Sync socket
7	Flashtube		

Specifications

GN:	82 (ft), 25 (m)
Weight:	10.6 oz (300 g) (SB-7E) or 9.5 oz (270 g) (SB-8E) (w/o batteries)
Size:	1.5" (37 mm) tall x 4.3" (110 mm) wide x 3.1" (79 mm) deep
Power:	4 AA batteries
Recycle Time:	8 seconds minimum (full discharge)
No. of Flashes:	~160 at full manual
Flash Duration:	NA
Coverage:	35mm lens (56° horizontal, 40° vertical)
Case:	SS-7
Key Features:	Flash automatically shuts off when flash-to-subject distance is 2 to 13 feet (0.6 to 4 m) (at f/4). Head can be rotated through an arc of 180° (click stops every 90°). Accessory SW-2 Wide-Angle Adapter for 28mm lens coverage. The SB-7E can control up to two additional off-camera Nikon flash units with the SE-2 Extension Cord.

Setting Automatic Flash Exposure

1. Move the Auto/Manual switch on the front of the SB-7E/8E so that the white indicator line adjacent to the dial is opposite either the orange (f/4) or blue (f/8) marker.

2. Set the ISO film speed value in the white cutout labeled ASA at the bottom of the dial located on the top of the SB-7E/8E. The ISO value of the film you're using should align with the small arrow under the ASA label. The distance listed on the top dial adjacent to the aperture you selected (f/4 or f/8) is the maximum range the flash can provide exposure for. Subjects at any distance between the minimum (2 feet/0.6 m) and this maximum will be correctly lit by the flash.

 Note: ASA is the predecessor to ISO for rating film; ASA and ISO values are equivalent. For example, an ASA 100 film has the same sensitivity as an ISO 100 film.

3. Set the aperture on the camera to the value you set in Step 1 (either f/4 or f/8), and make sure that the shutter speed is within

the sync range of your camera (see "Camera Capabilities," pages 326–327).

4. Turn the flash unit ON. When the ready light glows, you can take the picture. Note that if you are shooting near the range limit of the flash (19 feet [6 m] for f/4, half that for an aperture of f/8), you should wait a few seconds after the ready light glows before taking a picture, as the light comes on before the flash is fully charged.

SB-7E and SB-8E Usable Apertures and Flash Range in Automatic Mode (ISO 100)

Color of Markers	Aperture	Range in Ft	Range in M
orange	f/4	2–19.7	0.6–6
blue	f/8	2–9.8	0.6–3

Setting Manual Flash Exposure

1. Move the Auto/Manual switch on the front of the SB-7E/8E so that the white indicator line adjacent to the dial is opposite the white M marker.

2. Set the ISO film speed value in the white cutout labeled ASA at the bottom of the dial located on the top of the SB-7E/8E. The ISO value of the film you're using should align with the small arrow under the ASA label.

 Note: ASA is the predecessor to ISO for rating film; ASA and ISO values are equivalent. For example, an ASA 100 film has the same sensitivity as an ISO 100 film.

3. Focus on your subject and note the distance. On the top of the dial on the back of the SB-7E/8E note the aperture that corresponds to that distance (the outer values are apertures, the next ring is the distance in meters, and the small numbers in the innermost ring are the distance in feet). For example, at ISO 100 and 10 feet (3 m), the aperture is f/8. If in doubt, choose the larger aperture (f/5.6 in this example).

4. Set the aperture calculated in Step 3 on your camera, and make sure that the shutter speed is within the sync range of your camera (see "Camera Capabilities," pages 326–327).

5. Turn the flash unit ON. Wait several seconds after the ready light first glows, then take the picture (the ready light glows

before a full charge is available; in manual flash mode you may
get underexposure if you fire the flash the moment the ready
light appears).

SB-7E and SB-8E Notes

- *Nikon F3:* Requires the AS-4 or AS-7 Adapter.

- *Nikon F2:* Prefers the SB-7E, which incorporates the necessary
 rewind mount; the SB-8E requires the AS-1 Coupler. The
 F2's flash ready light indicator works with the SB-7E or SB-8E
 but disables the ready light on the flash unit, ostensibly to
 save power.

- *Nikon F:* Requires the AS-1 Coupler.

- *Nikkormat FTn:* Requires the Nikkormat Accessory Shoe and
 SC-7 Sync Cord (connects the SB-7E/8E's sync socket to the
 camera's X terminal; Nikon recommends that you insert the
 SC-7 into the camera's X terminal before attaching the flash in
 order to prevent an accidental firing).

- *Nikkormat EL:* Set the shutter speed to 1/125 second or slower,
 then lift and turn the knurled sync selector ring until the ⚡
 symbol appears in the selector window.

- *Nikon EL2, FM, Nikkormat FT2, FT3:* SB-7E requires the AS-2
 Coupler.

- *Nikon FE:* SB-8E does not automatically set the sync speed in
 auto mode as does the similar SB-10.

- *Newer Bodies:* Many new bodies don't have a PC sync terminal.
 Use an AS-15 Sync Terminal Adapter to mount an SB-7E or
 SB-8E on them. The SB-7E requires an adapter in order to be
 mounted on the hot shoe. Also, if you choose to use the SB-7E/
 8E off camera (i.e., not in the flash socket at the top of the
 camera), plug the SC-7 Sync Cord into the camera's X terminal
 first before plugging it into the flash.

SB-9

Introduced in 1977, the SB-9 is a lightweight, low-power flash that is slim and tall, but whose controls can be confusingly simple to those without a manual.

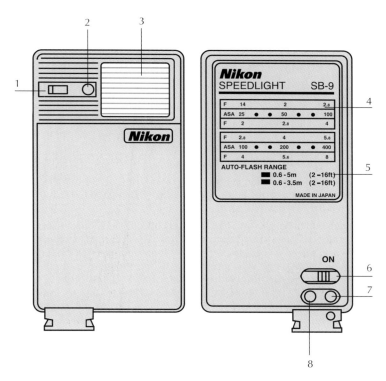

1 Flash mode selector switch
2 Light sensor
3 Flashtube
4 Aperture scale
5 Flash range chart
6 On/Off switch
7 Ready light
8 Test fire button

The Nikon Flash Guide

Specifications

GN:	46 (ft), 14 (m)
Weight:	3 oz (87 g) (w/o batteries)
Size:	3-7/8" (99 mm) tall x 2-3/16" (56 mm) wide x 15/16" (24 mm) deep
Power:	2 AA batteries
Recycle Time:	9 seconds minimum (full discharge)
No. of Flashes:	~55 at full manual
Flash Duration:	NA
Coverage:	35mm lens (56° horizontal, 40° vertical)
Case:	SS-9
Key Features:	Flash automatically shuts off when flash-to-subject distance is 2 to 11.5 feet (0.6 to 3.5 m) (at f/4).

Setting Automatic Flash Exposure

1. Move the flash mode selector switch on the front of the SB-9 to either the orange (smaller apertures) or green (larger apertures) position.

2. Determine the aperture to use based upon the ISO film speed and the flash mode selector switch setting you made in Step 1. For example, if you set the selector switch to green, look for the green f/number (in the upper row) that corresponds to the ISO film speed of the film you're using (at ISO 100 and "green," this would be f/2.8). If you set the selector switch to orange, look for the green f/number (in the bottom row) that corresponds to the ISO film speed of the film you're using (at ISO 100 and "orange," this would be f/4). The distance range over which the flash can control exposures is printed in a chart labeled "Auto-Flash Range" just underneath it. Subjects at any distance in this range will be correctly lit by the flash.

 Note: ASA is the predecessor to ISO for rating film; ASA and ISO values are equivalent. For example, an ASA 100 film has the same sensitivity as an ISO 100 film.

3. Set the aperture on the camera to the value you found in Step 2, and make sure that the shutter speed is within the sync range of your camera (see "Camera Capabilities," on pages 326–327).

4. Turn the flash unit ON. When the ready light glows, you can take the picture.

SB-9 Usable Apertures and Flash Range in Automatic Mode (ISO 100)

Color of Markers	Aperture	Range in Ft	Range in M
green	f/2.8	2–16.4	0.6–5
orange	f/4	2–11.5	0.6–3.5

SB-9 Notes

- The SB-9 is an automatic-only flash (it has no manual mode).

- *Nikon F3:* Requires the AS-4 or AS-7 Adapter.

- *Nikon F2:* Requires the AS-1 Coupler.

- *Nikon F:* Requires the AS-1 Coupler. Set the shutter speed to 1/60 second or slower, then lift and turn the knurled sync selector ring around the shutter-speed dial of the camera until the Fx mark appears in the selector window (this can be done only with Photomic finders removed).

- *Nikkormat FTn:* Requires the Nikkormat Accessory Shoe and SC-10 Sync Cord (connects the SB-9 to the camera's X terminal; insert the SC-10 into the camera's X terminal first before attaching the flash).

- *Nikkormat EL:* Set the shutter speed to 1/125 second or slower, then lift and turn the knurled sync selector ring until the ⚡ symbol appears in the selector window.

- *Nikon EL2, FM, Nikkormat FT2, FT3:* SB-9 requires the AS-2 Coupler.

SB-E

The SB-E is another lightweight, low-power flash that is slim and tall. Introduced in 1979, it was designed to be used with the Nikon EM.

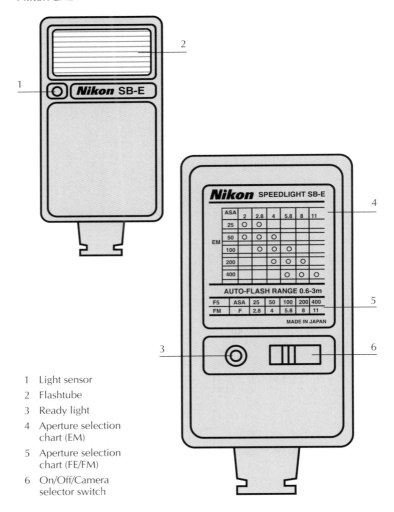

1 Light sensor
2 Flashtube
3 Ready light
4 Aperture selection chart (EM)
5 Aperture selection chart (FE/FM)
6 On/Off/Camera selector switch

Specifications

GN: 56 (ft), 17(m)
Weight: 4.6 oz (130 g) (w/o batteries)
Size: 4.3" (110 mm) tall x 2.2" (55 mm) wide x 1.3"
 (33 mm) deep
Power: 2 AA batteries
Recycle Time: 9 seconds minimum (full discharge)
No. of Flashes: ~80 at full manual
Flash Duration: NA
Coverage: 35mm lens (56° horizontal, 40° vertical)
Key Features: Flash automatically shuts off when flash-to-
 subject distance is 2 to 9.8 feet (0.6 to 3 m)
 (at f/4).

Setting Automatic Flash Exposure

1. Move the camera selector switch on the back of the SB-E to
 FE/FM (for all early cameras except the EM) or EM (for the EM
 and later bodies that have the additional flash contact on the
 shoe, such as the FG) position.

 Note: Some units are labeled A instead of EM.

2. *For the EM:* Find your film's ISO speed in the upper portion of
 the aperture selector scale and note the three apertures that can
 be used. Set the aperture on the camera to one of these. For
 example, with ISO 100 film, you can set apertures of f/2.8, f/4,
 or f/5.6 (or any intermediate stop).

 For the FE/FM: Find your film's ISO speed in the lower portion of
 the aperture selector scale and note the single aperture that can
 be used. For example, with ISO 100 film you can set f/5.6.

3. Make sure that the shutter speed is within the sync range of your
 camera (see "Camera Capabilities," pages 326–327).

SB-E Usable Apertures and Flash Range in Automatic Mode (ISO 100)

Aperture	Range in Ft	Range in M
*	2–9.8	0.6–3

* Usable aperture varies with camera model and ISO.

SB-E Notes

- The SB-E is an automatic-only flash (it has no manual mode).

- *Nikon EM:* The EM's ready light blinks if you set an aperture outside the available range. The camera should be set to auto shutter speed (not M90 or B, which can be used only if you set the flash to FE/FM mode [it is very confusing to the novices the EM was targeted for]).

SB-10

The SB-10 is basically a modest update of the SB-8E. Introduced in 1979, it was intended for the Nikon FE and FM.

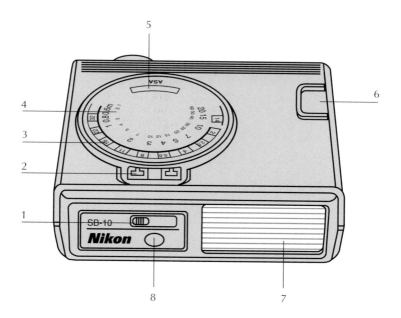

1 Flash mode selector switch
2 Flash mode indicator
3 Aperture scale
4 Distance scale
5 ISO scale
6 Battery compartment release
7 Flashtube
8 Light sensor

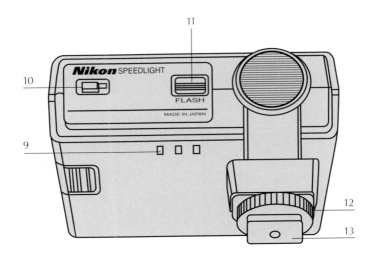

9 Sync socket
10 On/Off switch
11 Ready light/test fire button
12 Locking ring
13 Flash mounting foot (ISO)

Specifications

GN:	82 (ft), 25 (m)
Weight:	270 g (w/o batteries)
Size:	1.5″ (37 mm) tall x 4.3″ (110 mm) wide x 3.1″ (79 mm) deep
Power:	4 AA batteries
Recycle Time:	8 seconds minimum (full discharge)
No. of Flashes:	~160 at full manual
Flash Duration:	NA
Coverage:	35mm lens (56° horizontal, 40° vertical)
Case:	SS-7

Key Features: Flash shuts off automatically when the flash-to-
subject distance is 2 to 19.6 feet (0.6 to 6 m)
(at f/4). Head can be rotated through an arc of
180° (click stops every 90°). Accessory SW-2
Wide-Angle Adapter (SW-2) for 28mm lens
coverage. The SB-10 can synchronize with an
additional off-camera flash when mounted in a
hot shoe, though not from its own sync socket
(i.e., the second flash must be plugged into the
camera body).

Setting Automatic Flash Exposure

1. Move the Auto/Manual switch on the front of the SB-10 so that
the white indicator line adjacent to the dial is opposite either the
orange (f/4) or blue (f/8) marker.

2. Set the ISO film speed value in the white cutout labeled ASA at
the bottom of the dial located on the top of the SB-10. The ISO
value of the film you're using should align with the small arrow
under the ASA label. The distance listed on the top dial adjacent
to the aperture you selected (f/4 or f/8) is the maximum range for
which the flash can provide exposure. Subjects at any distance
between the minimum (2 feet/0.6 m) and this maximum will be
correctly lit by the flash.

 Note: ASA is the predecessor to ISO for rating film; ASA and
 ISO values are equivalent. For example, an ASA 100 film has the
 same sensitivity as an ISO 100 film.

3. Set the aperture on the camera to the value you set in Step 1
(either f/4 or f/8), and make sure that the shutter speed is within
the sync range of your camera (see "Camera Capabilities," pages
326–327).

4. Turn the flash unit ON. When the ready light glows, you can
take the picture. Note that if you are shooting near the range
limit of the flash (19.6 feet [6 m] for f/4, or half that for f/8), you
should wait a few seconds after the ready light glows before
taking a picture, as the light comes on before the flash is
fully charged.

SB-10 Usable Apertures and Flash Range in Automatic Mode (ISO 100)

Color of Markers	Aperture	Range in Ft	Range in M
orange	f/4	2–19.6	0.6–6
blue	f/8	2–9.8	0.6–3

Setting Manual Flash Exposure

1. Move the Auto/Manual switch on the front of the SB-10 so that the white indicator line adjacent to the dial is opposite the white M marker.

2. Set the ISO film speed value in the white cutout labeled ASA at the bottom of the dial located on the top of the SB-10. The ISO value of the film you're using should align with the small arrow under the ASA label.

 Note: ASA is the predecessor to ISO for rating film; ASA and ISO values are equivalent. For example, an ASA 100 film has the same sensitivity as an ISO 100 film.

3. Focus on the subject and note the distance. On the top of the dial on the back of the SB-10 note the aperture that corresponds to that distance (the outer values are apertures, the next ring is the distance in meters, and the small numbers in the innermost ring are the distance in feet). For example, at ISO 100 and 9.8 feet (3 m), the aperture is f/8. If in doubt, choose the larger aperture (f/5.6 in this example), especially if outdoors.

4. Set the aperture calculated in Step 3 on your camera, and make sure that the shutter speed is within the sync range of your camera (see "Camera Capabilities," pages 326–327).

5. Turn the flash unit ON. Wait several seconds after the ready light first glows, then take the picture (the ready light glows before a full charge is available; in manual flash mode you may get underexposure if you fire the flash the moment the ready light appears).

SB-11

The SB-11 is a redesigned flash-gun-style Speedlight with more power than the previous Nikon flash-gun-style model (SB-5) plus the ability to provide TTL exposure with the F3. It was introduced in 1980.

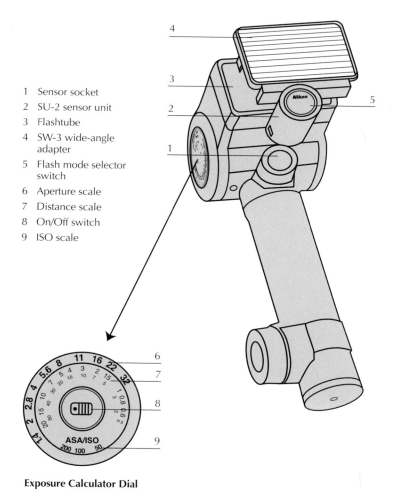

1 Sensor socket
2 SU-2 sensor unit
3 Flashtube
4 SW-3 wide-angle adapter
5 Flash mode selector switch
6 Aperture scale
7 Distance scale
8 On/Off switch
9 ISO scale

Exposure Calculator Dial

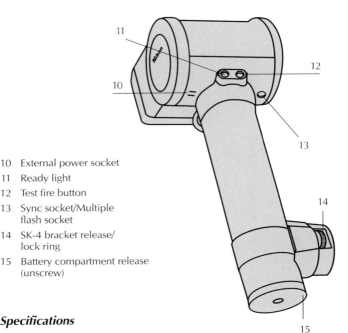

10 External power socket
11 Ready light
12 Test fire button
13 Sync socket/Multiple
 flash socket
14 SK-4 bracket release/
 lock ring
15 Battery compartment release
 (unscrew)

Specifications

GN:	119 (ft), 36 (m)
Weight:	30.3 oz (860 g) (w/o batteries)
Size:	10.9" (276 mm) tall x 4.1" (104 mm) wide x 4.6" (118 mm) deep
Power:	8 AA batteries
Recycle Time:	8 seconds minimum (full discharge)
No. of Flashes:	~150 at full manual
Flash Duration:	1/800 second
Coverage:	35mm lens (56° horizontal, 40° vertical)
Case:	NA
Key Features:	Flash automatically shuts off when flash-to-subject distance is 2 to 30 feet (0.6 to 9 m) at f/4. Head can be tilted to 30, 60, 90 or 120°. Accessory SW-3 Wide-Angle Adapter for 28mm lens coverage. The SB-11 can synchronize with an additional off-camera flash using an SC-11 Sync Cord between the two flash units. External power capability with the SD-7 Battery Pack.

Setting Automatic Flash Exposure (Non-F3)

The SU-2 Sensor that comes with the SB-11 can be mounted on the flash or remotely on a camera body that has a hot shoe (via an SC-13 Extension Cord).

1. Set the ISO film speed value in the dark cutout labeled ASA/ISO at the bottom of the dial located on the back of the SB-11. The ISO value of the film you're using should align with the small arrow under the ASA/ISO label.

2. Set an appropriate aperture on the camera (f/4, f/5.6, or f/8). Check to see that your subject is within the distance indicated by the colored arcs on the dial (orange is f/4, yellow is f/5.6, and blue is f/8 at ISO 100). Make sure that the shutter speed is within the sync range of your camera (see "Camera Capabilities," pages 326–327).

3. On the SU-2 Sensor, align the color-coded ring with the white index dot for the aperture you selected (orange for f/4, yellow for f/5.6, and blue for f/8).

4. Turn the flash unit ON. When the ready light glows, you can take the picture.

SB-11 Usable Apertures and Flash Range in Automatic Mode (ISO 100)

Color of Markers	Aperture	Range in Ft	Range in M
orange	f/4	2–30	0.6–9
yellow	f/5.6	2–21	0.6–6.4
blue	f/8	2–15	0.6–4.5

Setting Automatic TTL Flash Exposure (F3 Only)

With an SC-12 Sensor Cord installed between them, an F3 and SB-11 together provide TTL flash exposure.

1. Set the ISO film speed value in the dark cutout labeled ASA/ISO at the bottom of the dial located on the back of the SB-11. The ISO value of the film you're using should align with the small arrow under the ASA/ISO label.

2. Set your choice of aperture on the camera (f/2 to f/22), and set the F3's shutter speed dial to A (the viewfinder indicates a shutter speed of 1/80 second). You can see the range of distances the flash covers by looking at the color-coded arced lines above the

127

distance scale (in white letters). Each aperture is labeled at the far left of the arc (e.g., f/4 is the third arc, in orange).

Note: If you set a shutter speed of 1/125 second or faster on the F3, the SB-12 forces the F3 to default to 1/80 second. If you set the shutter speed dial to a shutter speed of 1/80 second or slower, the F3 uses that shutter speed.

3. Turn the flash unit ON. When the ready light glows, you can take the picture.

Setting Manual Flash Exposure

1. Set the ISO film speed value in the dark cutout labeled ASA/ISO at the bottom of the dial located on the back of the SB-11. The ISO value of the film you're using should align with the small arrow under the ASA/ISO label.

2. Focus on the subject and note the distance. Using that distance, find the corresponding aperture on the dial on the back of the SB-11 (the outermost set of numbers are apertures, the next ring is the distance in meters, the innermost set of numbers is the distance in feet).

3. Set the aperture calculated in Step 2 on the camera (e.g., at ISO 100 and a distance of 9.6 feet (3 m), the aperture should be f/11). Make sure that the shutter speed is within the sync range of your camera (see "Camera Capabilities," pages 326–327).

4. On the SU-2 Sensor, align the marking labeled M with the white index dot.

5. Turn the flash unit ON. When the ready light glows, you can take the picture.

Using the SB-11 to Trigger Off-Camera Slave Units

1. Align the marking labeled S on the SU-2 Sensor with the white index dot.

2. Attach your off-camera (slave) flash unit(s) to a remote control unit (such as the ML-1 set to channel 2).

3. Set the off-camera flash units' exposure controls, as appropriate (i.e., set the remote flash to automatic or manual and follow that flash unit's instructions for setting the aperture on your camera).

4. Turn the off-camera flash unit(s) ON. Turn on the SB-11. When the ready light glows, you can take the picture.

SB-12

Introduced in 1980 and designed to be used only on the Nikon F3, the SB-12 provides TTL flash exposure.

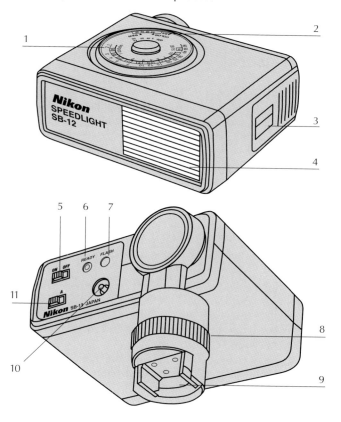

1 Auto range indicator	7 Test fire button
2 ISO scale	8 Locking ring
3 Battery compartment cover (slides open)	9 F/F2/F3 mounting shoe
4 Flashtube	10 Sync socket
5 On/Off switch	11 Flash mode selector switch
6 Ready light	

Specifications

GN:	82 (ft), 25 (m)
Weight:	12.3 oz (350 g) (w/o batteries)
Size:	1.6" (40 mm) tall x 4.1" (105 mm) wide x 3.3" (85 mm) deep
Power:	4 AA batteries
Recycle Time:	8 seconds minimum (full discharge)
No. of Flashes:	~160 at full manual
Flash Duration:	NA
Coverage:	35mm lens (56° horizontal, 40° vertical)
Key Features:	Automatic TTL flash up to 20.3 feet (6.2 m) at f/4 and ISO 100. Head can be rotated through an arc of 180° (click stops every 90°). Accessory SW-4 Wide-Angle Adapter for 28mm lens coverage. The SB-12 can be used off camera in manual mode by connecting an SC-14 Cable between the camera and the SB-12's sync connector, or an additional flash can be controlled.

Setting Automatic TTL Flash Exposure (F3 Only)

1. Move the Auto/Manual switch on the back of the SB-12 to A (auto).

2. Set the ISO film speed value in the black cutout labeled ASA/ISO at the bottom of the dial located on the top of the SB-12. The ISO value of the film you're using should align with the small arrow under the ASA/ISO label (the ISO numbers are in the white outer ring at the bottom).

 Note: ASA is the predecessor to ISO for rating film; ASA and ISO values are equivalent. For example, an ASA 100 film has the same sensitivity as an ISO 100 film. The ISO on the F3 must be set to between 25 and 400 as well (and it should match what you set on the flash).

3. Set your choice of aperture on the camera, and set the F3's shutter speed dial to A (the viewfinder indicates a shutter speed of 1/80 second). You can see the range of distances the flash will cover by looking at the color-coded, arced lines above the distance scale (in white letters). Each aperture is labeled at the far left of the arc (e.g., f/4 is the third arc, in orange). The large white numbers are meters, and the innermost, smaller numbers

are feet. Make sure your subject is in the distance range indicated by the proper arc.

Note: If you set a shutter speed of 1/125 second or faster on the F3, the SB-12 forces the F3 to default to 1/80 second. If you set the shutter speed dial to a speed of 1/80 or slower, the F3 uses that shutter speed.

4. Turn the flash unit ON. When the ready light glows, you can take the picture.

Note: The F3's viewfinder ready light also illuminates.

SB-12 Usable Apertures and Flash Range in Automatic TTL Mode (Normal, 35mm) (ISO 100)

Aperture	Range in Ft	Range in M
f/2	6.6–39.4	2–12
f/2.8	4.6–28.9	1.4–8.8
f/4	3.3–20.3	1–6.2
f/5.6	2.6–14.4	0.8–4.4
f/8	2.3–10.2	0.7–3.1
f/11	2.0–7.2	0.6–2.2
f/16	2.0–4.9	0.6–1.5
f/22	2.0–3.6	0.6–1.1

Note: For ISO film speed values greater than 100, shift the aperture up 1 stop for each doubling (e.g., f/8 works at 14.4 feet at ISO 200); for ISO values less than 100, shift the aperture down 1 stop for each doubling (e.g., f/4 works at 14.4 feet at ISO 50).

SB-12 Usable Apertures and Flash Range in Automatic TTL Mode (Wide-Angle SW-4) (ISO 100)

Aperture	Range in Ft	Range in M
f/2	5.9–28.9	1.8–8.8
f/2.8	4.3–20.3	1.3–6.2
f/4	2.6–14.4	0.8–4.4
f/5.6	2.3 –10.2	0.7–3.1
f/8	2.0–7.2	0.6–2.2
f/11	2.0–4.9	0.6–1.5
f/16	2.0–3.6	0.6–1.1
f/22	2.0–2.6	0.6–0.8

Note: For ISO film speed values greater than 100, shift the aperture up 1 stop for each doubling (e.g., f/5.6 works at 14.4 feet at ISO 200); for ISO values less than 100, shift the aperture down 1 stop for each doubling (e.g., f/2.8 works at 14.4 feet at ISO 50).

Setting Manual Flash Exposure (F3 only)

1. Move the Auto/Manual switch on the back of the SB-12 to M (manual).

2. Set the ISO film speed value in the black cutout labeled ASA/ISO at the bottom of the dial located on the top of the SB-12. The ISO value of the film you're using should align with the small arrow under the ASA/ISO label (the ISO numbers are in the white outer ring at the bottom).

 Note: ASA is the predecessor to ISO for rating film; ASA and ISO values are equivalent. For example, an ASA 100 film has the same sensitivity as an ISO 100 film. The ISO on the F3 must be set to between 25 and 400 as well (and that ISO should match what you set on the flash unit).

3. When set on manual flash exposure, the SB-12 always fires at full power. Thus it is important to match the subject's distance and aperture correctly. Focus on the subject and note the distance. On the top of the dial on the back of the SB-12 follow the distance lines out and note which aperture arc begins at that distance. Set that aperture on the camera. If the distance falls between two f/stops, set an intermediary aperture on your lens. The large white numbers are meters, and the innermost, smaller numbers are feet. Set the F3's shutter speed dial to A (the viewfinder indicates a shutter speed of 1/80 second).

 Note: If you set a shutter speed of 1/125 second or faster on the F3, the SB-12 forces the F3 to default to 1/80 second. If you set the shutter speed dial to a shutter speed of 1/80 second or slower, the F3 uses the set shutter speed.

4. Turn the flash unit ON. Wait several seconds after the ready light first glows, then take the picture.

SB-12 Manual Flash Exposure Settings (ISO 100)

Aperture	Distance in Ft (M)
f/22	3.6 (1.1)
f/16	4.9 (1.5)
f/11	7.2 (2.2)
f/8	10.2 (3.1)
f/5.6	14.4 (4.4)
f/4	20.3 (6.2)
f/2.8	28.9 (8.8)
f/2	39.4 (12)
f/1.4	49.2 (15)

Note: For ISO film speed values greater than 100, shift the aperture up 1 stop for each doubling (e.g., f/8 works at 14.4 feet at ISO 200); for ISO values less than 100, shift the aperture down 1 stop for each doubling (e.g., f/4 works at 14.4 feet at ISO 50).

SB-14

The SB-14 is a flash-gun style Speedlight with slightly less power than the SB-11, but also a smaller profile. Requires an SD-7 Battery Pack (e.g., batteries don't mount in the flash unit like they did in the SB-11). It was introduced in 1982.

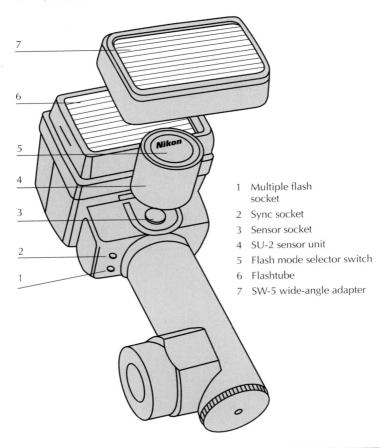

1 Multiple flash socket

2 Sync socket

3 Sensor socket

4 SU-2 sensor unit

5 Flash mode selector switch

6 Flashtube

7 SW-5 wide-angle adapter

Note: Nikon did not make an SB-13 Speedlight.

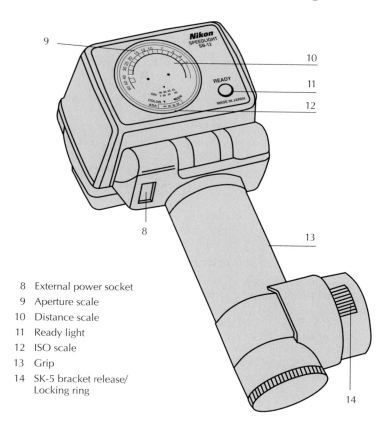

8 External power socket
9 Aperture scale
10 Distance scale
11 Ready light
12 ISO scale
13 Grip
14 SK-5 bracket release/
 Locking ring

Specifications

GN:	105 (ft), 32 (m)
Weight:	18.1 oz (515 g), plus 10.2 oz (290 g) SK-5 Bracket (w/o battery pack)
Size:	8.5″ (217 mm) tall x 3.7″ (94 mm) wide x 3.6″ (91 mm) deep
Power:	SD-7 Battery Pack (uses 6 C cells)
Recycle Time:	9.5 seconds minimum (substantially less with NiCd or SD-6) (full discharge)

135

No. of Flashes: ~270 at full manual
Flash Duration: 1/800 second
Coverage: 28mm lens (67° horizontal, 48° vertical)
Case: NA
Key Features: Flash automatically shuts off when flash-to-subject distance is 2 to 26.2 feet (0.6 to 8 m) at f/4. Head can be tilted to 30, 60, 90 or 120° and rotated 120° to either side. Accessory SW-5 Wide-Angle Adapter for 24mm lens coverage. The SB-14 can synchronize with an additional off-camera flash using an SC-11 or SC-15 Sync Cord between the two flash units. External power only.
Comes With: SU-2 Sensor Unit, SK-5 Bracket, SW-5 Wide-Angle Adapter, SC-11 Sync Cord.

Setting Automatic Flash Exposure (Non-F3)

The SU-2 Sensor that comes with the SB-14 can be mounted on the flash unit or remotely on a camera body that has a shoe mount (via an SC-13 Cord).

1. Set the ISO film speed value in the cutout labeled ASA/ISO at the bottom of the dial located on the back of the SB-14. The ISO value of the film you're using should align with the larger arrow under the ASA/ISO label. If you're using the SW-5 Wide-Angle Adapter, align the smaller arrow labeled W.

2. Set an appropriate aperture on the camera (at ISO 100: f/4, f/5.6, or f/8). Check to see that your subject is within the distance the aperture supports (i.e., the distance is to the right of the thick orange line for f/4, the thick yellow line for f/5.6, etc.; if you're using the SW-5 Wide-Angle Adapter, make sure the distance is to the right of the thin orange line for f/4, the thin yellow line for f/5.6, etc.). Make sure that the shutter speed is within the sync range of your camera (see "Camera Capabilities," pages 326–327).

3. On the SU-2 Sensor, align the color-coded ring with the white index dot for the aperture you selected (orange for f/4, yellow for f/5.6, and blue for f/8 at ISO 100).

4. Turn the flash unit ON. When the ready light glows, take the picture.

Note: For proper automatic exposure, the SB-14's flash head should be in the normal shooting position (i.e., not tilted back or rotated to either side).

Note: If the SB-14 fires at full power (indicating that the subject was either at or beyond the flash unit's maximum range), the ready light blinks for about 2 seconds after the exposure. Double check your calculations in Step 2! You can verify that the subject is within the flash unit's range (very useful when using bounce flash, by the way) by pressing the test fire button to fire the flash unit manually. If the ready light doesn't blink, you're okay, otherwise, select a wider aperture (on the SU-2, too) and try again.

SB-14 Usable Apertures and Flash Range in Automatic Mode (Normal, 35mm) (ISO 100)

Color of Markers	Aperture	Range in Ft	Range in M
orange	f/4	2.0–26.2	0.6–8
yellow	f/5.6	2.0–18.4	0.6–5.6
blue	f/8	2.0–13.1	0.6–4

SB-14 Usable Apertures and Flash Range in Automatic Mode (Wide-Angle SW-5) (ISO 100)

Color of Markers	Aperture	Range in Ft	Range in M
orange	f/4	2.0–18.4	0.6–5.6
yellow	f/5.6	2.0–13.1	0.6–4
blue	f/8	2.0–9.2	0.6–2.8

Note: For ISO film speed values greater than 100, shift the aperture up 1 stop for each doubling (e.g., f/8 works at 18 feet at ISO 200); for ISO values less than 100, shift the aperture down 1 stop for each doubling (e.g., f/4 works at 18 feet at ISO 50).

Setting Automatic TTL Flash Exposure (F3 Only)

The F3 must be connected to the SB-14 with the SC-12 Sensor Cord.
1. Set the ISO film speed value in the cutout labeled ASA/ISO at the bottom of the dial located on the back of the SB-14. The ISO value of the film you're using should align with the larger arrow under the ASA/ISO label. If you're using the SW-5 Wide-Angle Adapter, align the smaller arrow labeled W.

2. Set an appropriate aperture on the camera (f/4, f/5.6, or f/8). Check to see that the subject is within the distance the aperture supports (the distance is to the right of the thick orange line for f/4, the thick yellow line for f/5.6, etc.; if you're using the SW-5 Wide-Angle Adapter, make sure the distance is to the right of the thin orange line for f/4, the thin yellow line for f/5.6, etc.). Make sure that the shutter speed is within the sync range of your camera (see "Camera Capabilities," pages 326–327).

3. Turn the flash unit ON. When the ready light glows, you can take the picture.

Note: For proper automatic exposure, the SB-14's flash head should be in the normal shooting position (i.e., not tilted back or rotated to either side).

Note: If the SB-14 fires at full power (indicating that the subject was either at or beyond the flash unit's maximum range), the ready light blinks for about 2 seconds after the exposure. Double check your calculations in Step 2! You can verify that the subject is within the flash unit's range (very useful when using bounce flash, by the way) by pressing the test fire button to fire the flash unit manually. If the ready light doesn't blink, you're okay, otherwise, select a wider aperture (on the SU-2, too) and try again.

Setting Manual Flash Exposure

1. Set the ISO film speed value in the cutout labeled ASA/ISO at the bottom of the dial located on the back of the SB-14. The ISO value of the film you're using should align with the larger arrow under the ASA/ISO label. If you're using the SW-5 Wide-Angle Adapter, use the smaller arrow labeled W to align the ISO value.

2. Focus on the subject and note the distance. Using that distance, find the corresponding aperture on the dial on the back of the SB-14 (the outermost set [black numbers on white background] are apertures, the next ring is the distance in meters, the inner-most set of numbers is the distance in feet).

 Note: With the SW-5 Wide-Angle Adapter, the apertures are off by 1 stop (e.g., read the distance at f/5.6 instead of f/4 if the aperture you set was f/4).

3. Set the aperture calculated in Step 2 on the camera (e.g., at ISO 100 and a distance of 9.7 feet (3 m), the aperture should be f/11, or f/8 with the SW-5 Wide-Angle Adapter). Make sure that the

shutter speed is within the sync range of your camera (see "Camera Capabilities," pages 326–327).

4. On the SU-2 Sensor, align the marking labeled M with the white index dot.

5. Turn the flash unit ON. When the ready light glows, you can take the picture.

Using the SB-14 to Trigger Off-Camera Slave Units

1. Align the marking labeled **s** on the SU-2 Sensor with the white index dot.

2. Attach your off-camera flash to a remote control unit (such as the ML-1, set to channel 2).

3. Set the off-camera (slave) flash unit's exposure controls, as appropriate (i.e., set the remote flash to automatic or manual and follow that flash unit's instructions for setting the aperture on your camera).

4. Turn the SB-14 ON. When the ready light glows, you can take the picture.

SB-14 Note

• The test fire button on the SB-14 won't trigger the flash if the sync cord is connected and the camera is set to a shutter speed of Bulb (B). If you'd like to fire the flash manually during a long exposure (i.e., "paint" the scene with multiple flash units), disconnect the sync cord.

SB-140

An unusual variant of the SB-14 (see diagrams on pages 134-135), the SB-140 provides flash for visible light, UV rays, or infrared photography. Requires SD-7 Battery Pack (i.e., batteries don't mount in the flash like they do in the SB-11). It was introduced in 1982.

Specifications

GN:	105 (ft), 32 (m)
Weight:	18.1 oz (515 g) plus 10.2 oz (290 g) SK-5 Bracket (w/o battery pack)
Size:	8.5" (217 mm) tall x 3.7" (94 mm) wide x 3.6" (91 mm) deep
Power:	SD-7 Battery Pack (uses 6 C cells)
Recycle Time:	9.5 seconds minimum (substantially less with NiCd or SD-6) (full discharge)
No. of Flashes:	~270 at full manual
Flash Duration:	NA
Coverage:	28mm lens (70° horizontal, 53° vertical)
Case:	NA
Key Features:	Flash automatically shuts off when flash-to-subject distance is 2 to 26.2 feet (0.6 to 8 m) at f/4. Head can be tilted to 30, 60, 90 or 120° and rotated 120° to either side. Accessory SW-5 Wide-Angle Adapter for 24mm lens coverage. The SB-14 can synchronize with an additional off-camera flash using an SC-11 or SC-15 Sync Cord between the two flash units. External power only.
Comes With:	SU-3 Sensor Unit; SK-5 Bracket; SW-5V, SW-5UV, SW-5IR Adapters; SC-11 Sync Cord.

Setting Automatic Flash Exposure (Visible Light)

The SU-3 Sensor that comes with the SB-140 can be mounted on the flash or remotely on a camera body that has a hot shoe (via an SC-13).

1. Place the SW-5V Flash Adapter over the flashtube.

2. Set the ISO film speed value in the cutout labeled ISO at the bottom of the dial located on the back of the SB-140. The ISO

value of the film you're using should align with the arrow labeled Auto/MFull.

3. Focus on the subject and note the distance.

4. Locate the distance on the exposure calculation dial (innermost numbers are feet, next ring is in meters, outer ring is apertures). Note the aperture it corresponds to (by drawing an imaginary line out from the center of the dial, through the distance, to the apertures on the outer ring). Pick the aperture to the left of the one you just noted that aligns with the dot, triangle, or square on the outside edge of the dial. For example, at ISO 100 and a subject distance of 25 feet, the corresponding aperture is somewhere between f/4 and f/5.6, and f/4 is the aperture to the left that aligns with one of the symbols (a dot). In this example, you'd set f/4 as the aperture. Make sure that the shutter speed is within the sync range of your camera (see "Camera Capabilities," pages 326–327).

5. On the SU-3 Sensor, align the dot, triangle, or square (determined in Step 4) with the white index dot.

6. Turn the flash unit ON. When the ready light glows, you can take the picture.

Note: For proper automatic exposure, the SB-140's flash head should be in the normal shooting position (i.e., not tilted back or rotated to either side).

Note: If the SB-140 fires at full power (indicating that the subject was either at or beyond the flash unit's maximum range), the ready light blinks for about 2 seconds after the exposure. Double check your calculations in Step 2! You can verify that the subject is within the flash unit's range (very useful when using bounce flash, by the way) by pressing the test fire button to fire the flash manually. If the ready light doesn't blink, you're okay, otherwise, select a wider aperture (on the SU-3, too) and try again.

SB-140 Usable Apertures and Flash Range in Automatic Mode (Normal, 35mm) (ISO 100) (Visible Light)

Color of Markers	Shape	Aperture	Range in Ft	Range in M
orange	dot	f/4	2.0–26	0.6–8
yellow	triangle	f/5.6	2.0–18	0.6–5.6
blue	square	f/8	2.0 –13	0.6–4

Note: For ISO film speed values greater than 100, shift the aperture up 1 stop for each doubling (e.g., f/8 works at 18 feet at ISO 200); for ISO values less than 100, shift the aperture down 1 stop for each doubling (e.g., f/4 works at 18 feet at ISO 50).

Setting Manual Flash Exposure (Visible Light)

1. Place the SW-5V Flash Adapter over the flashtube.

2. Set the ISO film speed value in the cutout labeled ISO at the bottom of the dial on the back of the SB-140. The ISO value of the film you're using should align with the arrow labeled Auto/MFull if you want the flash to fire at full power, with M1/4 if you want the flash to fire at 1/4 power.

3. Focus on the subject and note the distance. Using that distance, find the corresponding aperture on the dial on the back of the SB-140 (the outermost set [black numbers on white background] are apertures, the next ring is the distance in meters, the innermost set of numbers is the distance in feet).

4. Set the aperture calculated in Step 3 on the camera (i.e., at ISO 100 and a distance of 9.7 feet (3 m), the aperture should be f/11. Make sure that the shutter speed is within the sync range of your camera (see "Camera Capabilities," pages 326–327).

5. On the SU-3 Sensor, align the marking labeled M with the white index dot for full power, across from 1/4 for 1/4 power.

6. Turn the flash unit ON. When the ready light glows, you can take the picture.

SB-140 Usable Apertures and Flash Range in Manual Mode (Normal, 35mm) (ISO 100) (Visible Light)

Color of Markers	Shape	Aperture	Range in Ft	Range in M
orange	dot	f/4	2.0–26	0.6–8
yellow	triangle	f/5.6	2.0–18	0.6–5.6
blue	square	f/8	2.0 –13	0.6–4

Note: For ISO values greater than 100, shift the aperture up 1 stop for each doubling (e.g., f/8 works at 18 feet at ISO 200); for ISO values less than 100, shift the aperture down 1 stop for each doubling (e.g., f/4 works at 18 feet at ISO 50).

Using the SB-140 with Ultraviolet Film

Use the "Setting Manual Flash Exposure (Visible Light)" instructions (page 142), but substitute the SW-5UV Flash Adapter in Step 1, and set the ISO film speed value to 25 in Step 2 (you'll see a small UV under the 25).

This ability was designed specifically for Kodak Spectroscopic Type 103-O film. If you are using a different type of UV-responsive film, you'll have to experiment to find the correct ISO value.

Nikon recommends bracketing by 1 stop in both directions.

The added wavelength range with the SW-5UV Adapter peaks at around 300 nanometers, with some light from 0 to 400 nanometers. Almost no light is produced from 400 to 650 nanometers. Above 650 nanometers, the light produced is similar to that produced using the SW-5V Adapter, though at a lower levels. If you were to use the SW-5UV Adapter with a modern color film, you'd get a distinctly blue result.

GNs vary with film type when you use the SW-5UV. For Type 103-O film, the GN is 52 (16 in meters).

The original manual makes the following claim "For UV flash photography, use the UV-Nikkor 104mm f/4.5 lens only." That lens was designed to transmit mostly 220 to 900 nanometer wavelengths and is corrected for focusing distortions that may occur across the UV and low-end visible spectrum. If your goal is true UV work (police, medical, and restoration demands, for example), the advice is well taken. For casual and experimental photography, you can probably ignore this claim.

Using the SB-140 with Infrared Film

Use the "Setting Manual Flash Exposure (Visible Light)" instructions (page 142), but substitute the SW-5IR Flash Adapter in Step 1, and set the ISO film speed value to 50 in Step 2 (you'll see a small IR under the 50).

This ability was designed specifically for Kodak High-Speed Infrared Film 2481. If you are using a different type of IR-responsive film, you'll have to experiment to find the correct ISO value to set.

Remember that some infrared films require a filter on the lens or refocusing the lens to a different marker. The former has an impact on setting the SB-140 correctly. If you use a filter on the lens, you need to perform exposure calculations based upon the effective aperture, not the marked aperture (i.e., compensate for the light reduction the filter makes).

Nikon recommends bracketing by 1 stop in both directions.

The SW-5IR limits light production under 800 nanometers. No light energy is produced below 750 nanometers, and virtually all of the light produced falls between 800 and 1000 nanometers.

GNs vary with film type when you use the SW-5IR. For Infrared 2481 film, the GN is 72 (22 in meters).

SB-140 Notes

- The test fire button on the SB-140 won't trigger the flash if the sync cord is connected and the camera is set to a shutter speed of Bulb (B). If you'd like to fire the flash manually during a long exposure (i.e., "paint" the scene with multiple flash bursts), disconnect the sync cord.

- If the ready light blinks for a few seconds after the SB-140 fires, this means that the flash fired at full power, which may indicate underexposure.

- Nikon does not recommend bouncing the flash in UV or IR modes.

- The SW-5UV Flash Adapter should be stored in a location of low humidity or with a desiccant to reduce humidity.

SB-15

Introduced in 1982, the SB-15 is an updated version of the SB-12 that provides TTL control of the flash exposure when used with the FA, FE2, FG, Nikonos V, and later Nikon models, and automatic flash exposure on other models.

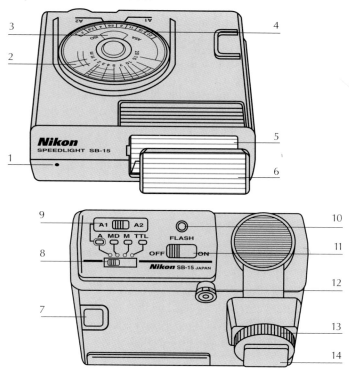

1	Light sensor	8	Flash mode selector switch
2	Shooting range indicator	9	Automatic mode switch
3	ISO scale	10	Ready light/test fire button
4	Aperture scale	11	On/Off switch
5	Flashtube	12	Sync socket
6	SW-6 wide-angle adapter	13	Locking ring
7	Battery compartment release	14	Flash mounting foot (ISO)

Specifications

GN:	82 (ft), 25 (m)
Weight:	9.5" (270 g) (w/o batteries)
Size:	1.7" (42.5 mm) tall x 4" (101 mm) wide x 3.5" (90 mm) deep
Power:	4 AA batteries
Recycle Time:	8 seconds minimum (full discharge)
No. of Flashes:	~160 at full manual
Flash Duration:	NA
Coverage:	35mm lens (60° horizontal, 45° vertical)
Case:	SS-15
Key Features:	TTL flash control with FA, FE2, FG, and Nikonos V (and later TTL-capable models as well); two-aperture automatic flash with other models. Head can be rotated through an arc of 180° (click stops every 90°), and tilted to 90° (click stops at 15, 30, 60, and 90°). Accessory SW-6 Wide-Angle Adapter for 28mm lens coverage. The SB-15 can synchronize with up to five additional off-camera flash units. Four-frame motor drive capability (up to 3.8 fps).

Setting TTL Flash Exposure (FA, FE2, FG, Nikonos V, Later TTL-Capable Bodies)

Note: The Nikonos V requires a V-type sync cord.

1. Move the flash mode selector on the back of the SB-15 to 🎞.

2. Set the ISO film speed value in the white cutout labeled ASA/ISO at the bottom of the dial located on the top of the SB-15. The ISO value of the film you're using should align with the small arrow adjacent to the N label (align it with the W label if using the SW-6 Wide-Angle Adapter). TTL operation is available only for ISO values of 25 to 400.

 Note: ASA is the predecessor to ISO for rating film; ASA and ISO values are equivalent. For example, an ASA 100 film has the same sensitivity as an ISO 100 film.

3. Set an appropriate aperture on the camera, and set a shutter speed that is within the sync range of your camera (see "Camera Capabilities," pages 326–327). Use the calculator dial to verify that the flash range at your selected aperture includes the

146

camera-to-subject distance (e.g., at ISO 100 and an aperture of f/4, the flash will cover a range of 3 to 19.6 feet [1 to 6 m]).

Note: Many Nikon bodies automatically switch to a valid shutter speed when the SB-15 is mounted in the hot shoe and turned ON.

Note: TTL operation does not work if an FG or Nikonos V is set to a shutter speed of M90 or if an FA or FE2 is set to a shutter speed of M250 or B (Bulb).

4. Turn the flash unit ON. When the ready light glows, you can take the picture.

If the body has a viewfinder ready light and a hot shoe, this feature should work. If the ready light blinks continuously in the viewfinder, the camera is not capable of using the TTL function, you've set an improper shutter speed (e.g., B, M90, M250), or you've exceeded the ISO range for TTL flash operation (i.e., you are using an ISO other than 25 to 400). Ready lights do not operate as described if the SB-15 is used off camera via a sync cord.

Note: These instructions apply to most other later Nikon models as well (e.g., the SB-15 provides TTL flash exposure with a Nikon N90s/F90x).

Note: If the SB-15 fires at full power (indicating that the subject was either at or beyond the flash unit's maximum range), the ready light will blink for about 3 seconds after the exposure has been made.

Note: Up to five appropriate flash units (generally, SB-15 or later) can be connected using the SC-17, SC-18, or SC-19 Sync Cords and the AS-10, and operated in TTL mode.

Setting Automatic Flash Exposure (All Nikon Bodies)

1. Move the flash mode selector on the back of the SB-15 to A.

2. Move the aperture switch located above the shooting mode switch to A1 for f/8 or A2 for f/4.

3. Set the aperture selected in Step 2 on the camera.

4. Set the ISO film speed value in the white cutout labeled ASA/ISO at the bottom of the dial located on the top of the SB-15. The ISO value of the film you're using should align with the small arrow adjacent to the N label (align it with the W label if using

the SW-6 Wide-Angle Adapter). On the flash unit's exposure dial, verify that your subject is within the range covered by the aperture chosen in Step 2 (e.g., at ISO 100, 2 to 20 feet (0.6 to 6.1 m) for f/4 and 2 to 10 feet (0.6 to 3.1 m) for f/8).

Note: ASA is the predecessor to ISO for rating film; ASA and ISO values are equivalent. For example, an ASA 100 film has the same sensitivity as an ISO 100 film.

5. Set the shutter speed to one within the sync range of your camera (see "Camera Capabilities," pages 326–327).

6. Turn the flash unit ON. When the ready light glows, you can take the picture.

Note: If the SB-15 fires at full power (indicating that the subject was either at or beyond the flash's maximum range), the ready light blinks for about 3 seconds after the exposure has been made.

SB-15 Usable Apertures and Flash Range in Automatic Mode (Normal, 35mm) (ISO 100)

Aperture	Range in Ft	Range in M
f/2	6.6–39	2–12
f/2.8	4.6–29	1.4–8.8
f/4	3.3–20	1–6.2
f/5.6	2.6–14	0.8–4.4
f/8	2.3–10	0.7–3.1
f/11	2.0–7.2	0.6–2.2
f/16	2.0–4.9	0.6–1.5
f/22	2.0–3.6	0.6–1.1

SB-15 Usable Apertures and Flash Range in Automatic Mode (Wide-Angle SW-6) (ISO 100)

Aperture	Range in Ft	Range in M
f/2	4–29	1.4–8.8
f/2.8	3–20	1–6.2
f/4	2.6–14	0.7–4.4
f/5.6	2.3–10	0.6–3.1
f/8	2.0–7.2	0.6–2.2
f/11	2.0–4.9	0.6–1.5
f/16	2.0–3.6	0.6–1.1
f/22	2.0–2.6	0.6–0.8

Setting Manual Flash Exposure (All Nikon Bodies)

1. Move the flash mode selector on the back of the SB-15 to M.

2. Set the ISO film speed value in the white cutout labeled ASA/ISO at the bottom of the dial located on the top of the SB-15. The ISO value of the film you're using should align with the small arrow adjacent to the N label (align it with the W label if using the SW-6 Wide-Angle Adapter).

 Note: ASA is the predecessor to ISO for rating film; ASA and ISO values are equivalent. For example, an ASA 100 film has the same sensitivity as an ISO 100 film.

3. Focus on the subject and note the distance. On the top of the dial on the back of the SB-15 note the aperture that corresponds to that distance (the outermost values are apertures, the next ring is the distance in meters, and the small numbers in the inner-most ring are the distance in feet). For example, at ISO 100 and 10 feet (3 m), the aperture is f/8. If in doubt, choose the larger aperture (f/5.6 in this example).

4. Set the aperture calculated in Step 3 on your camera, and make sure that the shutter speed is within the sync range of your camera (see "Camera Capabilities," pages 326–327).

5. Turn the flash unit ON. When the ready light glows, you can take the picture.

SB-15 Manual Flash Exposure Shooting Distances (ISO 100)

Aperture	Normal in Ft (M)	Wide-Angle (SW-6) in Ft (M)
f/2	39 (12)	29 (8.8)
f/2.8	29 (8.8)	20 (6.2)
f/4	20 (6.2)	14 (4.4)
f/5.6	14 (4.4)	10 (3.1)
f/8	10 (3.1)	7.2 (2.2)
f/11	7.2 (2.2)	4.9 (1.5)
f/16	4.9 (1.5)	3.6 (1.1)
f/22	3.6 (1.1)	2.6 (0.8)

Note: For ISO film speed values greater than 100, shift the aperture up 1 stop for each doubling (e.g., f/8 works at 14 feet at ISO 200); for ISO values less than 100, shift the aperture down 1 stop for each doubling (e.g., f/4 works at 14 feet at ISO 50).

Setting Four-Frame Motor Drive Flash

Note: When in the MD mode, the flash fires at a lower power (i.e., the effective guide number is 23 [7 m]), which is 1/13th full power. MD mode is a manual-only mode; neither TTL nor automatic exposure operation are available.

1. Move the flash mode selector on the back of the SB-15 to MD.

2. Set an ISO film speed value in the white cutout labeled ASA/ISO at the bottom of the dial located on the top of the SB-15. The ISO value of the film you're using should align with the small arrow adjacent to the MD label.

 Note: ASA is the predecessor to ISO for rating film; ASA and ISO values are equivalent. For example, an ASA 100 film has the same sensitivity as an ISO 100 film.

 Note: If you're using the SW-6 Wide-Angle Adapter, you cannot use the exposure dial to calculate an aperture. The guide number with the SW-6 drops further to 16 in feet (5 m).

3. Focus on the subject and note the distance. On the top of the dial located on the back of the SB-15, note the aperture that corresponds to that distance (the outermost values are apertures, the next ring is the distance in meters, and the small numbers in the innermost ring are the distance in feet). For example, at ISO 100 and 10 feet (3 m), the aperture is f/8. If in doubt, choose a larger aperture (f/5.6 in this example).

4. Set the aperture calculated in Step 3 on your camera, and make sure that the shutter speed is within the sync range of your camera (see "Camera Capabilities," pages 326–327).

5. Turn the flash unit ON. Wait 30 seconds after the ready light glows, and then take the pictures.

 Note: The maximum motor drive sequence that can be supported is 4 frames at no faster than 3.8 fps.

SB-15 Normal versus Motor Drive Distances (ISO 100)

Aperture	Normal Distance in Ft (M)	Motor Drive Distance in Ft (M)
f/22	1.0–3.6 (0.6–1.1)	—
f/16	2.0–4.9 (0.6–1.5)	—
f/11	2.0–7.2 (0.6–2.2)	1.0–3.6 (0.6–1.1)
f/8	2.3–10 (0.7–3.1)	2.0–4.9 (0.6–1.5)
f/5.6	2.6–14 (0.8–4.4)	2.0–7.2 (0.6–2.2)
f/4	3.0–20 (1.0–6.2)	2.3–10 (0.7–3.1)
f/2.8	4.0–29 (1.4–8.8)	2.6–14 (0.8–4.4)
f/2	7.0–39 (2.0–12)	3.0–20 (1.0–6.2)
f/1.4	10–49 (3.0–15)	4.0–29 (1.4–8.8)
f/1	13–49 (4.0–15)	7.0–39 (2.0–12)

Note: For ISO film speed values greater than 100, shift the aperture up 1 stop for each doubling (e.g., f/8 works at 14 feet at ISO 200); for ISO values less than 100, shift the aperture down 1 stop for each doubling (e.g., f/4 works at 14 feet at ISO 50).

SB-15 Note

• By flipping the flash over and then tilting the bounce head, you can make it point down at an angle up to 90°. This is useful for impromptu macro shooting.

SB-16A and SB-16B

This is a powerful, sophisticated flash produced in two models for use on Nikon bodies with ISO hot shoes (SB-16B) or the Nikon F3 series cameras (SB-16A). They both provide TTL control of flash exposure and were introduced in 1983.

1 SW-7 wide-angle adapter	10 Angle locking lever
2 Main flashtube	11 On/Off switch
3 Secondary flashtube	12 Shooting range indicator
4 Sync socket	13 ISO scale
5 Multiple flash socket	14 Zoom setting knob
6 Battery compartment (slides open)	15 Auto aperture scale
7 Zoom head switch	16 Shooting mode selector
8 Zoom scale	17 Indicator LEDs
9 Bounce angle scale	18 Ready light/test flash button

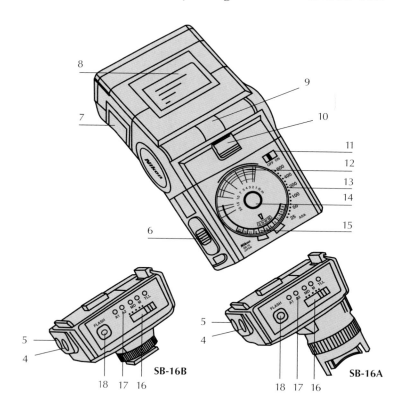

Specifications

GN:	105 (ft), 32 (m)
Weight:	15.7 oz (445 g) (SB-16B); 17.1 oz (485 g) (SB-16A) (w/o batteries)
Size:	5.7″ (144 mm) (SB-16B) or 6.5″ (165.5 mm) (SB-16A) tall x 3.9″ (100 mm) wide x 3.2″ (82 mm) deep
Power:	4 AA batteries
Recycle Time:	11 seconds minimum (alkaline batteries) (full discharge)

153

No. of Flashes:	~100 at full manual
Flash Duration:	1/1,250–1/8,000 second
Coverage:	28mm lens (60° horizontal, 45° vertical)
Case:	SS-16
Key Features:	TTL flash control with TTL-capable bodies; two-aperture automatic flash. Head can be rotated through an arc of 270° (click stops every 30°), and tilted to 90° (click stops every 15°). Secondary flash head for eye catchlight. Accessory SW-7 Wide-Angle Adapter for 24mm lens coverage. Can synchronize with up to five additional off-camera flash units. Eight-frame motor drive capability (up to 4 fps).

Note: The difference between an SB-16A and an SB-16B is the integral flash coupler (AS-8 for the F3, AS-9 for ISO hot shoes).

Setting TTL Flash Exposure (TTL-Capable Nikon Bodies)

1. Move the flash mode selector on the back of the SB-16's flash coupler to **TTL**.

2. Set the ISO film speed value by aligning the index mark on the outer exposure dial edge with the correct ASA/ISO value printed outside the dial.

 Note: ASA is the predecessor to ISO for rating film; ASA and ISO values are equivalent. For example, an ASA 100 film has the same sensitivity as an ISO 100 film.

 Note: TTL operation is available only for ISO values of 25 to 400.

3. Push or pull the flash unit's head to the appropriate mark (indicated on the top of the head when in normal shooting position) corresponding to the focal length of the lens you are using. Set the flash head to T if using a lens of 85mm or longer (telephoto), S for a lens of 50mm (standard), N for a lens of 35mm (normal), and W1 for a lens of 28mm (wide).

 Note: If using the SW-7 Wide-Angle Adapter and a 24mm lens, set the flash head to W1 (wide).

4. On the SB-16's exposure dial, set the zoom setting knob (lower black cutout) to the same setting you picked in Step 3 (if using a 24mm lens use W2 despite the fact that you set the flash head to W1 in Step 3).

5. Set an appropriate aperture and an appropriate shutter speed on the camera (see "Camera Capabilities," pages 326–327). Use the calculator dial to verify that the flash range at your selected aperture includes your camera-to-subject distance (e.g., at ISO 100, normal flash head setting, and an aperture of f/4, the flash will cover a range of 4 to 22 feet [1.4 to 8 m]).

6. Turn the flash unit ON. When the ready light glows, you can take the picture.

Note: If the SB-16 fires at full power (indicating that the subject was either at or beyond the flash unit's maximum range), the ready light will blink for about 3 seconds after the exposure.

Note: If the ready light continuously flashes (even prior to a flash burst), either the SB-16 isn't securely fastened to the camera, you've set a shutter speed (such as T or one of the mechanical speeds on the FA, FE2, FG, or Nikonos V) that can't be used in TTL mode, or you've selected an ISO value on the camera that isn't within the usable range of the flash unit (remember, in TTL mode, only ISO 25 to 400 is available).

Note: Up to five appropriate flash units (generally, SB-15 or later) can be connected and operated in TTL mode using the SC-18 or SC-19 Sync Cords.

Note: When used off camera via a sync cord, the SB-16 will not operate the ready light inside the camera's viewfinder.

SB-16 Usable Apertures and Flash Range in TTL Mode (T Zoom) (ISO 100)

Aperture	Range in Ft	Range in M
f/2	12–69	3.8–21
f/2.8	8.9–46	2.7–14
f/4	6.2–33	1.9–10
f/5.6	4.6–24	1.4–7.4
f/8	3.3–17	1.0–5.2
f/11	2.6–12	0.8–3.7
f/16	2.6–8.5	0.8–2.6
f/22	2.6–5.9	0.8–1.8

SB-16 Usable Apertures and Flash Range in TTL Mode (S Zoom) (ISO 100)

Aperture	Range in Ft	Range in M
f/2	11–62	3.4–19
f/2.8	7.9–43	2.4–13
f/4	5.6–31	1.7–9.5
f/5.6	3.9–22	1.2–6.7
f/8	3.0–15	0.9–4.7
f/11	2.0–11	0.6–3.3
f/16	2.0–7.5	0.6–2.3
f/22	2.0–5.2	0.6–1.6

SB-16 Usable Apertures and Flash Range in TTL Mode (N Zoom) (ISO 100)

Aperture	Range in Ft	Range in M
f/2	9.8–52	3.0–16
f/2.8	6.6–36	2.0–11
f/4	4.6–26	1.4–8.0
f/5.6	3.3–18	1.0–5.6
f/8	2.3–13	0.7–4.0
f/11	2.0–9.2	0.6–3.3
f/16	2.0–6.6	0.6–2.0
f/22	2.0–4.6	0.6–1.4

SB-16 Usable Apertures and Flash Range in TTL Mode (W1 Zoom) (ISO 100)

Aperture	Range in Ft	Range in M
f/2	7.9–43	2.4–13
f/2.8	5.2–31	1.6–9.5
f/4	3.9–22	1.2–6.7
f/5.6	3.0–15	0.9–4.7
f/8	2.0–11	0.6–3.3
f/11	2.0–7.5	0.6–2.3
f/16	2.0–5.2	0.6–1.6
f/22	2.0–3.6	0.6–1.1

SB-16 Usable Apertures and Flash Range in TTL Mode (W2 Zoom) (ISO 100)

Aperture	Range in Ft	Range in M
f/2	5.6–31	1.7–9.5
f/2.8	3.9–22	1.2–6.7
f/4	3.0–15	0.9–4.7
f/5.6	2.0–11	0.6–3.3
f/8	2.0–7.5	0.6–5.2
f/11	2.0–5.2	0.6–1.6
f/16	2.0–3.6	0.6–1.1
f/22	2.0–2.6	0.6–0.8

Note: For ISO film speed values greater than 100, shift the aperture up 1 stop for each doubling (e.g., use f/8 instead of f/5.6 for ISO 200); for ISO values less than 100, shift the aperture down 1 stop for each doubling (e.g., use f/4 instead of f/5.6 at ISO 50).

Setting Automatic Flash Exposure (All Nikon Bodies)

1. Move the flash mode selector on the back of the SB-16's coupler to A1 (blue dot) for an aperture of f/8 or A2 (orange dot) for f/4.

2. Set the aperture you selected in Step 1 on the camera.

3. Set the ISO film speed value by aligning the index mark on the outer exposure dial edge with the correct ASA/ISO value printed outside the dial.

 Note: ASA is the predecessor to ISO for rating film; ASA and ISO values are equivalent. For example, an ASA 100 film has the same sensitivity as an ISO 100 film.

4. Push or pull the flash unit's head to the appropriate mark (indicated on the top of the head when in normal shooting position) corresponding to the focal length of the lens you are using. Set the flash head to T if using a lens of 85mm or longer (telephoto), S for a lens of 50mm (standard), N for a lens of 35mm (normal), and W1 for a lens of 28mm (wide).

 Note: If using the SW-7 Wide-Angle Adapter and a 24mm lens, set the flash head to W1 (wide).

5. On the SB-16's exposure dial, set the zoom setting knob (lower black cutout) to the same setting you picked in Step 4 (if using a 24mm lens use W2 despite the fact that you set the flash head to W1 in Step 4).

6. On the flash unit's exposure dial, verify that the subject is within the range covered by the aperture chosen in Step 1 (see "SB-16 Shooting Range in Automatic Mode," below).

 Note: With the flash head set to T, the closest flash distance changes from 2 feet (0.6 m) to 2.6 feet (0.8 m).

7. Turn the flash unit ON. When the ready light glows, you can take the picture.

 Note: If the SB-16 fires at full power (indicating that the subject was either at or beyond the flash unit's maximum range), the ready light will blink for about 3 seconds after the exposure.

 Note: If the ready light continuously flashes (even prior to a flash burst), either the SB-16 isn't securely fastened to the camera, you've set a shutter speed (such as T) that can't be used in TTL mode, or you've selected an ISO film speed value on the camera that isn't within the usable range of the flash unit (remember, in TTL mode, only ISO 25 to 400 is available).

 Note: Up to five appropriate flash units (generally, SB-15 or later) can be connected using the SC-18 or SC-19 Sync Cords and operated in TTL mode.

 Note: When used off camera via a sync cord, the SB-16 will not operate the ready light inside the camera's viewfinder.

SB-16 Shooting Range in Automatic Mode

Setting	f/8 (A1, Blue)	f/4 (A2, Orange)
T	2.6–17 ft (0.8–5.2 m)	2.6–33 ft (0.8–10 m)
S	2.0 – 15 ft (0.6–4.7 m)	2.0–31 ft (0.6–9.5 m)
N	2.0–13 ft (0.6–4.0 m)	2.0–26 ft (0.6–8 m)
W1	2.0–11 ft (0.6–3.3 m)	2.0–22 ft (0.6–6.7 m)
W1 (SW-7)	2.0–7.5 ft (0.6–2.3 m)	2.0–15 ft (0.6–4.7 m)

Setting Manual Flash Exposure (All Nikon Bodies)

1. Move the flash mode selector on the back of the SB-16's coupler to M.

2. Set the ISO film speed value by aligning the index mark on the outer exposure dial edge with the correct ASA/ISO value printed outside the dial.

Note: ASA is the predecessor to ISO for rating film; ASA and ISO values are equivalent. For example, an ASA 100 film has the same sensitivity as an ISO 100 film.

3. Push or pull the flash unit's zoom head to the appropriate mark (indicated on the top of the head when in normal shooting position) corresponding to the focal length of the lens you are using. Set the flash head to T if using a lens of 85mm or longer (telephoto), S for a lens of 50mm (standard), N for a lens of 35mm (normal), and W1 for a lens of 28mm (wide).

 Note: If using the SW-7 Wide-Angle Adapter and a 24mm lens, set the flash head to W1 (wide).

4. On the SB-16's exposure dial, set the zoom setting knob (lower, black cutout) to the same setting you picked in Step 3 (if using a 24mm lens use W2 despite the fact that you set the flash head to W1 in Step 3).

5. Focus on the subject and note the distance. On the top of the dial on the back of the SB-16 note the aperture that corresponds to that distance (the outermost values are apertures, the next ring is the distance in meters, and the small numbers in the innermost ring are the distance in feet). For example, at ISO 100, normal flash head setting, and 10 feet (3 m), the aperture is f/16. If in doubt, choose the larger aperture (f/11 in this example).

6. Set the aperture calculated in Step 5 on your camera, and make sure that the shutter speed is within the sync range of your camera (see "Camera Capabilities," pages 326–327).

7. Turn the flash unit ON. When the ready light glows, you can take the picture.

Setting Eight-Frame Motor Drive Flash

When in the MD mode, the flash fires at a lower power (the effective guide number is 26 [8 m]). The Nikon manual refers to this as a 1/16th full power (a reduction of GN from 105 feet [32 m] to 26 feet [8 m]), or about a 4-stop difference from normal manual (M) flash mode.

 MD mode is a manual-only mode; neither TTL nor automatic exposure operation are available.

1. Move the shooting mode selector on the back of the SB-16's flash coupler to MD.

2. Set the ISO film speed value by aligning the index mark on the outer exposure dial edge with the correct ASA/ISO value printed outside the dial.

 Note: ASA is the predecessor to ISO for rating film; ASA and ISO values are equivalent. For example, an ASA 100 film has the same sensitivity as an ISO 100 film.

3. Push or pull the flash unit's zoom head to the appropriate mark (indicated on the top of the head when in normal shooting position) corresponding to the focal length of the lens you are using. Set the flash head to T if using a lens of 85mm or longer (telephoto), S for a lens of 50mm (standard), N for a lens of 35mm (normal), and W1 for a lens of 28mm (wide).

 Note: If using the SW-7 Wide-Angle Adapter and a 24mm lens, set the flash head to W1 (wide).

4. On the SB-16's exposure dial, set the zoom setting knob (lower black cutout) to the same setting you picked in Step 3 (if using a 24mm lens use W2 despite the fact that you set the flash head to W1 in Step 3).

5. Focus on the subject and note the distance. On the top of the dial on the back of the SB-16 note the aperture that corresponds to that distance (the outermost arcs are the aperture ranges, and you'll see a notch in each arc; the notch is the point you want to note). For example, at ISO 100, normal flash head setting, and 10 feet (3 m), the aperture is f/2.8. If in doubt, choose the larger aperture (f/2 in this example).

6. Set the aperture calculated in Step 5 on your camera, and make sure that the shutter speed is within the sync range of your camera (see "Camera Capabilities," pages 326–327).

7. Turn the flash unit ON. When the ready light glows, you can take the picture.

 Note: The maximum supported motor drive sequence is 4 frames at no faster than 4 fps.

 Note: Only the main flash head fires; the auxiliary catchlight tube does not fire.

SB-16 Normal versus Motor Drive Distances (At ISO 100)

Aperture	Normal Distance in Ft (M)	Motor Drive Distance in Ft (M)
f/22	1.0–3.6 (0.6–1.1)	—
f/16	2.0–4.9 (0.6–1.5)	—
f/11	2.0–7.2 (0.6–2.2)	1.0–3.6 (0.6–1.1)
f/8	2.3–10 (0.7–3.1)	2.0–4.9 (0.6–1.5)
f/5.6	2.6–14 (0.8–4.4)	2.0–7.2 (0.6–2.2)
f/4	3.0–20 (1.0–6.2)	2.3–10 (0.7–3.1)
f/2.8	4.0–29 (1.4–8.8)	2.6–14 (0.8–4.4)
f/2	7–39 (2.0–12)	3.0–20 (1.0–6.2)
f/1.4	10–49 (3.0–15)	4.0–29 (1.4–8.8)
f/1	13–49 (4.0–15)	7–39 (2.0–12)

Note: For ISO film speed values greater than 100, shift the aperture up 1 stop for each doubling (e.g., use f/8 instead of f/5.6 at ISO 200); for ISO values less than 100, shift the aperture down 1 stop for each doubling (e.g., use f/4 instead of f/5.6 at ISO 50).

SB-16 Angle of Coverage at Zoom Head Settings

Setting	Angle of Coverage	Equivalent Lens	GN
T	23° vert, 31° horz	85mm or longer	138 (42 m)
S	34° vert, 46° horz	50mm or longer	125 (38 m)
N	45° vert, 60° horz	35mm or longer	105 (32 m)
W1	53° vert, 70° horz	28mm or longer	89 (27 m)
W1 (SW-7)	60° vert, 78° horz	24mm or longer	62 (19 m)

Note: The guide number varies with flash head setting in all flash modes. The guide number for the secondary catchlight tube is 26 (8 m).

SB-16 Note

• When an SB-16 is mounted on an all-metal accessory shoe via the AS-6 Coupler (e.g., the Nikkormat FTn), the SB-16 will not fire, even if connected via a sync cord. Either use the SC-10 Sync Cord or isolate the flash contact on the shoe (Nikon suggests using vinyl tape).

SB-17

A variant of the SB-15 designed specifically for the F3 and TTL flash metering, the SB-17 replaces the SB-12. It provides TTL control of flash exposure and was introduced in 1983.

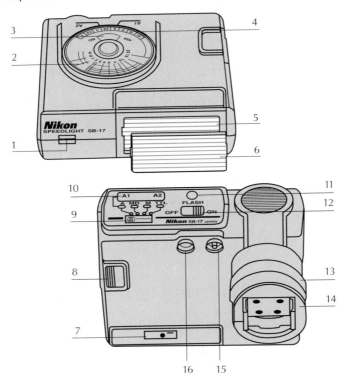

1 Light sensor	9 Flash mode selector switch
2 Shooting range indicator	10 Auto mode switch (A1/A2)
3 ISO scale	11 Ready light/Test fire button
4 Aperture scale	12 On/Off switch
5 Flashtube	13 Locking ring
6 SW-6 wide-angle adapter	14 F/F2/F3 mounting shoe
7 Flashtube tilt/lock switch	15 Sync socket
8 Battery compartment release (slides open)	16 Multiple flash socket

Specifications

GN: 82 (ft), 25 (m)
Weight: 10.6 oz (300 g) (w/o batteries)
Size: 1.7" (43 mm) tall x 4" (101 mm) wide x 3.5"
 (90 mm) deep (excluding mounting foot)
Power: 4 AA batteries
Recycle Time: 8 seconds minimum (full discharge)
No. of Flashes: ~160 at full manual
Flash Duration: 1/1,400–1/10,000 second
Coverage: 35mm lens (60° horizontal, 45° vertical)
Case: SS-17 (supplied with flash)
Key Features: TTL flash control with the F3 (can also be used
with most other Nikon bodies with appropriate
coupler); two-aperture automatic flash. Head can
be rotated through an arc of 180° (click stops
every 90°), and tilted to 90° (click stops at 15, 30,
60, and 90°). Supplied accessory SW-6 Wide-
Angle Adapter for 28mm lens coverage. The
SB-17 can synchronize with up to five additional
off-camera flash units. Four-frame motor drive
capability (up to 3.8 fps).

Setting TTL Flash Exposure (F3 Only)

1. Move the flash mode selector on the back of the SB-17 to ▉.

2. Set the ISO film speed value in the white cutout labeled ASA/ISO
at the bottom of the dial located on the top of the SB-17. The
ISO value of the film you're using should align with the small
black arrow at the bottom of the cutout. Align the white arrow
with the N label (align it with the W label if using the SW-6
Wide-Angle Adapter).

 Note: ASA is the predecessor to ISO for rating film; ASA and
 ISO values are equivalent. For example, an ASA 100 film has the
 same sensitivity as an ISO 100 film.

 Note: TTL operation is available only for ISO values of 25
 to 400.

3. Set an appropriate aperture on the camera, and set the shutter speed dial to A (you can also set shutter speeds of 1/60 second or slower, if desired). Use the calculator dial to verify that the flash range at the selected aperture includes your camera-to-subject distance (e.g., at ISO 100 and an aperture of f/4, the flash covers a range of 3 to 20 feet [1 to 6 m]).

 Note: You cannot use the remote release with the shutter speed set to T (time).

4. Turn the flash unit ON. When the ready light glows, you can take the picture.

 Note: If the SB-17 fires at full power (indicating that the subject was either at or beyond the flash's maximum range), the ready light blinks for about 3 seconds after the exposure.

 Note: If the ready light flashes continuously (even prior to a flash burst), either the SB-17 isn't securely fastened to the F3 or you've selected an ISO film speed value on the camera that isn't in the unit's usable range (remember, in TTL mode, only ISO 25 to 400 is available).

 Note: Up to five appropriate flash units (generally, SB-15 or later) can be connected using the SC-18 or SC-19 sync cords and operated in TTL mode.

 Note: When used off camera via a sync cord, the SB-17 will not operate the ready light inside the camera's viewfinder, nor will it automatically set the camera's shutter speed to 1/80 second when the flash unit is turned ON.

SB-17 Usable Apertures and Flash Range in TTL Mode (Normal, 35mm) (ISO 100)

Aperture	Range in Ft	Range in M
f/2	7–39	2–12
f/2.8	4–29	1.4–8.8
f/4	3–20	1.0–6.2
f/5.6	2.6–14	0.8–4.4
f/8	2.3–10	0.7–3.1
f/11	2–7.2	0.6–2.2
f/16	2–4.9	0.6–1.5
f/22	2–3.6*	0.6–1.1

* *Nikon manual is incorrect.*

SB-17 Usable Apertures and Flash Range in TTL Mode (Wide Angle) (ISO 100)

Aperture	Range in Ft	Range in M
f/2	4–29	1.4–8.8
f/2.8	3–20	1.0–6.2
f/4	2.6–14	0.8–4.4
f/5.6	2.3–10	0.7–3.1
f/8	2–7.2	0.6–2.2
f/11	2–4.9	0.6–1.5
f/16	2–3.6	0.6–1.1
f/22	2–2.6	0.6–0.8

Note: For ISO film speed values greater than 100, shift the aperture up 1 stop for each doubling (e.g., use f/8 instead of f/5.6 at ISO 200); for ISO values less than 100, shift the aperture down 1 stop for each doubling (e.g., use f/4 instead of f/5.6 at ISO 50).

Setting Automatic Flash Exposure (All Nikon Bodies)

To use the SB-17 on bodies with an ISO hot shoe, you must use the AS-6 Coupler (except for the F2 series cameras, which require the AS-5 Coupler).

1. Move the flash mode selector on the back of the SB-17 to A.

2. Set the ISO film speed value in the white cutout labeled ASA/ISO at the bottom of the dial located on the top of the SB-17. The ISO value of the film you're using should align with the small black arrow at the bottom of the cutout. Align the white arrow with the N label. (Align it with the W label if using the SW-6 Wide-Angle Adapter). Move the aperture switch above the shooting mode switch to **A2** for a small aperture or **A1** for an aperture 2 stops wider (f/8 and f/4, respectively, at ISO 100).

3. You can use either the aperture marked by the blue A1 band or the aperture marked by the red A2 band (for ISO 100, these apertures are f/8 and f/4, respectively). Check to make sure the distance range covered by the aperture you set covers the distance to your subject (e.g., at ISO 100, f/4 covers 3 to 20 feet [1 to 6 m] and f/8 covers 2 to 10 feet [0.7 to 3 m]). Set the aperture on the camera to the one you have chosen.

Note: The distances on the SB-17 calculator dial do not match those in the Nikon manual. Trust the calculator dial!

4. Above the shooting mode switch on the back of the SB-17, move the aperture switch to **A1** if you have chosen the smaller aperture (e.g., f/8 at ISO 100), or to **A2** if you have chosen the larger (e.g., f/4 at ISO 100).

5. Set the shutter speed to one within the sync range of your camera (see "Camera Capabilities," pages 326–327).

 Note: The SB-17 automatically sets the shutter speed of some cameras if you are using an AS-6.

 Note: If you use the SB-17 and the AS-6 Flash Coupler on a Nikon EM, FG, FE, or FE2, then the shutter speed is automatically set to the fastest sync speed for that camera when the flash unit is turned ON.

6. Turn the flash unit ON. When the ready light glows, you can take the picture.

 Note: If the SB-17 fires at full power (indicating that the subject was either at or beyond the flash unit's maximum range), the ready light will blink for about 3 seconds after the exposure (but not on an F2 series camera).

 Note: If the camera's ready light blinks continuously, even before a flash, check to make sure you haven't accidentally set the SB-17 to TTL mode.

 Note: When used off camera via a sync cord, the SB-17 will not operate the ready light inside the camera's viewfinder, nor will it automatically set synchronization speed on the camera body.

SB-17 Shooting Range in Automatic Mode

Setting	Normal in Ft (M)	Wide-Angle (SW-6) in Ft (M)
A1 (blue)	2.0–10 (0.6–3.1)	2.0–7 (0.6–2.2)
A2 (red)	2.0–20 (0.6–6.2)	2.0–14 (0.6–4.4)

Setting Manual Flash Exposure (All Nikon Bodies)

1. Move the flash mode selector on the back of the SB-17 to M.

2. Set the ISO film speed value in the white cutout labeled ASA/ISO at the bottom of the dial located on the top of the SB-17. The ISO value of the film you're using should align with the small black arrow at the bottom of the cutout. Align the white arrow with the N label (align it with the W label if using the SW-6 Wide-Angle Adapter).

Note: ASA is the predecessor to ISO for rating film; ASA and ISO values are equivalent. For example, an ASA 100 film has the same sensitivity as an ISO 100 film.

3. Focus on the subject and note the distance. On the top of the dial on the back of the SB-17 note the aperture that corresponds to that distance (the outermost values are apertures, the next ring is the distance in meters, and the small numbers in the innermost ring are the distance in feet). For example, at ISO 100 and 10 feet (3 m), the aperture is f/8. If in doubt, choose the larger aperture (f/5.6 in this example).

4. Set the aperture calculated in Step 3 on your camera, and make sure that the shutter speed is within the sync range of your camera (see "Camera Capabilities," pages 326–327).

5. Turn the flash unit ON. When the ready light glows, you can take the picture.

Setting Four-Frame Motor Drive Flash

When in the MD mode, the flash fires at a lower power: the effective guide number is 23 in feet (7 m). This lower power is 1/13th full power, a reduction of just over 3-1/2 stops. For example, a subject 5'9" (1.75 m) away requires an aperture f/4 at a GN of 23 (7 m) in MD mode, compared to f/14 at the full GN of 92 (25 m) in regular manual (M) flash mode.

MD mode is a manual-only mode; neither TTL nor automatic exposure operation are available.

1. Move the flash mode selector on the back of the SB-17 to MD.

2. Set the ISO film speed value in the white cutout labeled ASA/ISO at the bottom of the dial located on the top of the SB-17. The ISO value of the film you're using should align with the small black arrow at the bottom of the cutout. Align the white arrow with the MD label.

Note: ASA is the predecessor to ISO for rating film; ASA and ISO values are equivalent. For example, an ASA 100 film has the same sensitivity as an ISO 100 film.

The Nikon Flash Guide

Note: If you're using the SW-6 Wide-Angle Adapter, you cannot use the exposure dial to calculate aperture. The guide number with the SW-6 drops further to 16 (5 m). One way to work around this: Since the SW-6 Adapter consumes about 1 stop of light, you can align the black arrow at the bottom of the cutout with a film speed 1 stop less than you're actually using (e.g., ISO 50 if you're actually using ISO 100) and align the white arrow with the MD label.

3. Focus on the subject and note the distance. On the top of the dial on the back of the SB-17 the radial lines going out from the distances cross the arcs of several apertures. Note the smallest aperture that corresponds to that distance (the outer values are apertures, the next ring is the distance in meters, and the small numbers in the innermost ring are the distance in feet). For example, at ISO 100 and 10 feet (3 m), the aperture is f/8. If in doubt, choose the larger aperture (f/5.6 in this example).

4. Set the aperture calculated in Step 3 on your camera, and make sure that the shutter speed is within the sync range of your camera (see "Camera Capabilities," pages 326–327).

5. Turn the flash unit ON. Wait 30 seconds after the ready light glows, and then take the pictures.

Note: The maximum motor drive sequence supported is 4 frames at no faster than 3.8 fps.

SB-17 Normal versus Motor Drive Distances (ISO 100)

Aperture	Normal Distance in Ft (M)	Motor Drive Distance in Ft (M)
f/22	1.0–3.6 (0.6–1.1)	—
f/16	2.0–4.9 (0.6–1.5)	—
f/11	2.0–7.2 (0.6–2.2)	1.0–3.6 (0.6–1.1)
f/8	2.3–10 (0.7–3.1)	2.0–4.9 (0.6–1.5)
f/5.6	2.6–14 (0.8–4.4)	2.0–7.2 (0.6–2.2)
f/4	3.0–20 (1.0–6.2)	2.3–10 (0.7–3.1)
f/2.8	4.0–29 (1.4–8.8)	2.6–14 (0.8–4.4)
f/2	7.0–39 (2.0–12)	3.0–20 (1.0–6.2)
f/1.4	10–49 (3.0–15)	4.0–29 (1.4–8.8)

SB-17 Notes

- When an SB-17 is mounted on an all-metal accessory shoe via the AS-6 Coupler (e.g., the Nikkormat FTn), the SB-17 will not fire, even if connected via a sync cord. Either use the SC-10 Sync Cord or isolate the flash contact on the shoe (Nikon suggests using vinyl tape).

- By flipping the flash over and then tilting the bounce head, you can make it point down at an angle of up to 90°. This is useful for impromptu macro shooting.

SB-18

Introduced in 1983, the SB-18 is a compact flash sold only as part of a promotional package with the Nikon FG. It provides TTL control of flash exposure.

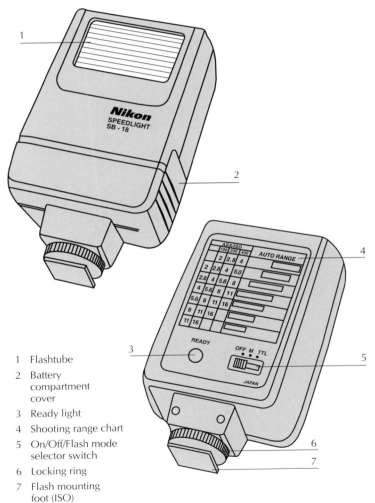

1 Flashtube
2 Battery compartment cover
3 Ready light
4 Shooting range chart
5 On/Off/Flash mode selector switch
6 Locking ring
7 Flash mounting foot (ISO)

Specifications

GN:	66 (ft), 20 (m)
Weight:	5.3 oz (150 g) (w/o batteries)
Size:	4.4" (113 mm) tall x 2.6" (66 mm) wide x 1.6" (42 mm) deep
Power:	4 AA batteries
Recycle Time:	6 seconds average (full discharge)
No. of Flashes:	~250 at full manual
Flash Duration:	NA
Coverage:	35mm lens (60° horizontal, 45° vertical)
Case:	SS-18
Key Features:	TTL flash control

Setting TTL Flash Exposure (TTL-Capable Nikon Bodies)

1. Turn the flash unit ON. Move the flash mode selector on the back of the SB-18 to **TTL**.

2. Focus on the subject. Note the distance.

3. On the shooting range table on the back of the flash unit, locate the column for the film speed you're using (labeled ASA/ISO). Locate an aperture you'd like to use and see if the distance you calculated in Step 2 is within the allowable range. If not, select another aperture.

4. Set the aperture on the camera to the one you found in Step 3.

5. Set the shutter speed dial to **P** or **A** or to an allowable sync speed (see "Camera Capabilities," pages 326–327).

6. When the ready light glows, you can take the picture.

SB-18 Usable Apertures and Flash Range in TTL Mode (ISO 100)

Aperture	Range in Ft	Range in M
f/2	6–32	1.8–10
f/2.8	4.2–23	1.3–7
f/4	3–16	0.9–5
f/5.6	2.1–11	0.7–3.5
f/8	2–8.2	0.6–2.5
f/11	2–5.8	0.6–1.7
f/16	2–4.1	0.6–1.2

Note: For ISO film speed values greater than 100, shift the aperture up one row for each doubling (e.g., use f/8 instead of f/5.6 at 11 feet and ISO 200); for ISO values less than 100, shift the aperture down one row for each doubling (e.g., use f/4 instead of f/5.6 at 11 feet and ISO 50).

Setting Manual Flash Exposure (All Nikon Bodies)

1. Turn the flash unit ON. Move the flash mode selector on the back of the SB-18 to M.

2. Focus on the subject. Note the distance.

3. Since the SB-18 always fires at full power when in manual (M) flash mode, you'll need to use the guide number to set the appropriate aperture (see "Guide Numbers," page 21). Alternatively, if the distance you found in Step 2 corresponds to one at the far right of the shooting range table (e.g., 4.1, 5.8, 8.2, 11, 16, 23, or 32 feet [1.2, 1.7, 2.5, 3.5, 5, 7, or 10 m]), set the aperture found in the appropriate ASA/ISO column at the left side of the same row. For example, if your distance is 16 feet (5 m) and your film is ISO 200, set an aperture of f/5.6 on the camera.

4. Set the shutter speed dial to **P** or **A** or to an allowable sync speed (see "Camera Capabilities," pages 326–327).

5. When the ready light glows, you can take the picture.

SB-19

Similar to the SB-E, the SB-19 has better power efficiency and two automatic settings. Introduced for use with the EM and FG-20 in 1984.

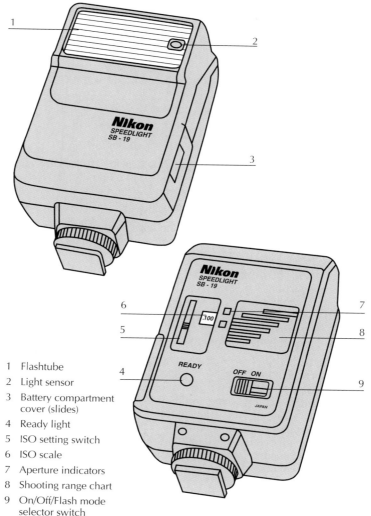

1 Flashtube
2 Light sensor
3 Battery compartment cover (slides)
4 Ready light
5 ISO setting switch
6 ISO scale
7 Aperture indicators
8 Shooting range chart
9 On/Off/Flash mode selector switch

Specifications

GN:	66 (ft), 20 (m)
Weight:	6 oz (170 g) (w/o batteries)
Size:	4.6" (116 mm) tall x 2.6" (66 mm) wide x 1.8" (46 mm) deep
Power:	4 AA batteries
Recycle Time:	7 seconds minimum (full discharge)
No. of Flashes:	~250 at full manual
Flash Duration:	NA
Coverage:	35mm lens (60° horizontal, 45° vertical)
Case:	SS-18
Key Features:	Two automatic flash modes

Setting Automatic Flash Exposure (All Nikon Bodies)

1. Turn the flash unit ON. Set the ISO film speed value on the back of the SB-19 by sliding the lever up or down until the ISO value of the film aligns with the white arrow.

2. Focus on the subject. Note the distance.

3. On the back of the SB-19, move the flash mode selector to A or B. (The Nikon manual and its nomenclature tend to confuse users.)

 In A mode you must always set the aperture on the camera to the one indicated by the boxed value in the aperture indicator scale on the back of the flash. Flash range will always be 2.0 to 11.5 feet (0.6 m to 3.5 m) in A mode. Make sure the distance you noted in Step 2 is within the A mode's fixed range! If not, you'll probably have to use the B mode.

 If you set the SB-19 to B mode, you can select which aperture to use, but the flash range varies depending upon the aperture you select. Locate the distance you found in Step 2 at the bottom of the aperture selector scale and imagine a line straight up the scale at that point. Any yellow bar the imaginary line intersects with indicates a usable aperture, which can be found by looking to the far left of the bar. Example: At 11.5 feet (3.5 m), the imaginary line intersects the top four bars, meaning you could select any of those four apertures (f/2, f/2.8, f/4, f/5.6).

4. Set the aperture on the camera to the one you found in Step 3. Set the shutter speed to one within the sync range of your camera (see "Camera Capabilities," pages 326–327).

5. When the ready light glows, you can take the picture.

SB-19 Shooting Range in A Mode (ISO 100)

Setting	Normal
Designated aperture	2.0–11.5 ft (0.6–3.5 m)

SB-19 Usable Apertures and Flash Range in B Mode (ISO 100)

Aperture	Range in Ft	Range in M
f/2	7–30	2.1–10
f/2.8	3–20	0.8–7
f/4	2–15	0.6–5
f/5.6	2–11.5	0.6–3.5
f/8	2–8	0.6–2.5
f/11	2–6	0.6–1.7

Note: For ISO film speed values greater than 100, shift the aperture up one row for each doubling (e.g., use f/8 instead of f/5.6 at 11.5 feet and ISO 200); for ISO values less than 100, shift the aperture down one row for each doubling (e.g., use f/4 instead of f/5.6 at 11.5 feet and ISO 50).

SB-20

With a visually different flash head than any other Speedlight, the SB-20 was the first Nikon flash unit to include the now ubiquitous red autofocus assist illuminator. Intended originally for the N2020/F-501, this is a versatile and underrated flash unit. It was introduced in 1986.

1 Battery compartment
 cover (slides)
2 Zoom indicator
3 Bounce angle knob
4 Bounce angle scale
5 Flashtube
6 Zoom setting ring
7 AF assist illuminator
8 Light sensor

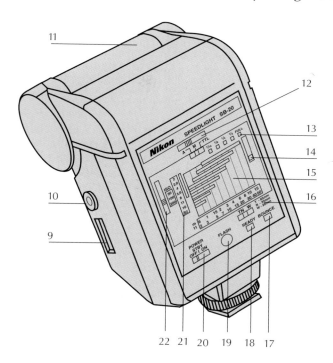

9	External power socket
10	Sync socket
11	Slot for reflector
12	Flash mode selector switch
13	Light output indicator (M mode)
14	Aperture setting switch (A and M modes)

15	Shooting range indicator
16	Distance scale selector
17	Bounce indicator light
18	Ready light
19	Test fire button
20	On/Off/standby switch
21	Aperture scale
22	ISO setting switch

Specifications

GN:	98 (ft), 30 (m)
Weight:	9.2 oz (260 g) (w/o batteries)
Size:	4.3" (110 mm) tall x 2.8" (71 mm) wide x 2.7" (70 mm) deep

Power:	4 AA batteries
Recycle Time:	7 seconds minimum (full discharge)
No. of Flashes:	~150 at full manual
Flash Duration:	1/1,200 to 1/15,000 second
Coverage:	35mm lens (60° horizontal, 45° vertical); also 28mm and 85mm settings.
Case:	SS-20
Key Features:	TTL flash control with most TTL-capable Nikon bodies; automatic and manual flash modes. Head can be titled from –7° below to 90° above horizontal. Zoom head covers 28mm, 35mm, and 85mm settings. The SB-20 can synchronize with additional off-camera flash units. Autofocus assist illuminator.

Setting Automatic TTL Flash Exposure (TTL-Capable Nikon Bodies)

1. Set the flash mode selector on the back of the SB-20 to ▥.

2. Rotate the ring around the flashtube to set the zoom setting to match the focal length of your lens (W=28mm, N=35mm, T=85mm). Then make sure that the distance scale selector on the back of the SB-20 matches this setting (W, N, or T). If not, move the selector so that it does.

3. Set the ISO film speed index on the back of the SB-20 to the speed of the film you're using.

 Note: The SB-20 doesn't allow intermediate values (i.e., you can't set ISO 64 or 80, only 50 and 100). Nikon suggests using the nearest ISO value. While this doesn't have any real implications for TTL use, it does mean that the indicated shooting distances will be off by 1/3 stop.

4. Set the camera to aperture-priority (A) or manual (M) exposure mode. The N2000/F-301, N4004/F-401, N2020/F-501 and later bodies can also be set to program (P) mode, in which case you can skip to Step 7, since the lens must be set to the minimum aperture in this mode and the aperture is automatically selected by the camera.

Note: If you're concerned with whether the subject is in the shooting range of the flash in P mode, you can use Steps 5 and 6 to verify adequate flash illumination. In program (P) mode at ISO 100 with an SB-20, the aperture the camera will select is f/5.6 (on most Nikon bodies; if in doubt, check your camera's manual). So, in Step 6, simply look at the f/5.6 shooting range to verify distance. At higher ISO values, the camera uses smaller apertures (larger f/numbers, e.g., f/8 instead of f/5.6). At lower ISO values, it does the opposite.

5. Focus on the subject. Note the distance.

6. Select an appropriate aperture on the camera (the SB-20's shooting range table should be showing you the distance ranges for the usable apertures at the settings you've made. Set one of those apertures on the camera.

7. Make sure the camera is set to a shutter speed equal to or slower than its maximum sync speed (see "Camera Capabilities," pages 326–327).

8. Turn the flash unit ON. When the ready light glows, you can take the picture.

SB-20 Usable Apertures and Flash Range in TTL Mode (N, Normal Zoom)

ISO 800	400	200	100	50	25	Range in Ft	Range in M
f/2.8	f/2	—	—	—	—	12–66	3.8–20
f/4	f/2.8	f/2	—	—	—	8.9–66	2.7–20
f/5.6	f/4	f/2.8	f/2	—	—	6.2–49	1.9–15
f/8	f/5.6	f/4	f/2.8	f/2	—	4.3–33	1.3–10
f/11	f/8	f/5.6	f/4	f/2.8	f/2	3.3–25	1.0–7.5
f/16*	f/11*	f/8*	f/5.6*	f/4*	f/2.8*	2.3–17	0.7–5.3
f/22	f/16	f/11	f/8	f/5.6	f/4	2.0–12	0.6–3.7
—	f/22	f/16	f/11	f/8	f/5.6	2.0–8.5	0.6–2.6
—	—	f/22	f/16	f/11	f/8	2.0–6.2	0.6–1.9
—	—	—	f/22	f/16	f/11	2.0–4.3	0.6–1.3

** This is what the camera uses in program (P) mode.*

The Nikon Flash Guide

SB-20 Usable Apertures and Flash Range in TTL Mode (W, Wide Zoom)

ISO 800	400	200	100	50	25	Range in Ft	Range in M
f/2.8	f/2	—	—	—	—	9.2–66	2.8–20
f/4	f/2.8	f/2	—	—	—	6.6–49	2.0–15
f/5.6	f/4	f/2.8	f/2	—	—	4.6–36	1.4–11
f/8	f/5.6	f/4	f/2.8	f/2	—	3.3–25	1.0–7.8
f/11	f/8	f/5.6	f/4	f/2.8	f/2	2.3–19	0.7–5.5
f/16*	f/11*	f/8*	f/5.6*	f/4*	f/2.8*	2.0–13	0.6–3.9
f/22	f/16	f/11	f/8	f/5.6	f/4	2.0–8.9	0.6–2.7
—	f/22	f/16	f/11	f/8	f/5.6	2.0–6.2	0.6–1.9
—	—	f/22	f/16	f/11	f/8	2.0–4.6	0.6–1.4
—	—	—	f/22	f/16	f/11	2.0–3.3	0.6–10

This is what the camera uses in program (P) mode.

SB-20 Usable Apertures and Flash Range in TTL Mode (T, Telephoto Zoom)

ISO 800	400	200	100	50	25	Range in Ft	Range in M
f/2.8	f/2	—	—	—	—	15–66	4.5–20
f/4	f/2.8	f/2	—	—	—	10–66	3.2–20
f/5.6	f/4	f/2.8	f/2	—	—	7.5–59	2.3–18
f/8	f/5.6	f/4	f/2.8	f/2	—	5.2–39	1.6–12
f/11	f/8	f/5.6	f/4	f/2.8	f/2	3.9–30	1.2–9
f/16*	f/11*	f/8*	f/5.6*	f/4*	f/2.8*	2.6–21	0.8–6.3
f/22	f/16	f/11	f/8	f/5.6	f/4	2.0–15	0.6–4.5
—	f/22	f/16	f/11	f/8	f/5.6	2.0–10	0.6–3.2
—	—	f/22	f/16	f/11	f/8	2.0–7.2	0.6–2.2
—	—	—	f/22	f/16	f/11	2.0–5	0.6–1.5

This is what the camera uses in program (P) mode.

Setting Automatic Flash Exposure (All Nikon Bodies)

1. Set the flash mode selector on the back of the SB-20 to A.

2. Rotate the ring around the flashtube to set the zoom setting to match the focal length of your lens (W=28mm, N=35mm, T=85mm). Then make sure that the distance scale selector on the back of the SB-20 matches this setting (W, N, or T). If not, move the selector so that it does.

3. Set the ISO film speed index on the back of the SB-20 to the speed of the film you're using.

Note: The SB-20 doesn't allow intermediate values (e.g., you can't set ISO 64 or 80, only 50 and 100). Nikon suggests using the nearest ISO value. While this doesn't have any real implications for automatic (A) use, it does mean that the indicated shooting distances will be off by 1/3 stop.

4. Set the camera to aperture-priority (A) or manual (M) exposure mode.

5. Focus on the subject. Note the distance.

6. Select an appropriate aperture on the camera (the SB-20's shooting range table should be showing you the distance ranges for the usable apertures at the settings you've made). Set one of those apertures on the camera. _Very important:_ Also move the aperture index knob at the right of the shooting range table so that the index at the left of the table is set to that same aperture.

7. Make sure the camera is set to a shutter speed equal to or slower than its maximum sync speed (see "Camera Capabilities" pages 326–327).

8. Turn the flash unit ON. When the ready light glows, you can take the picture.

SB-20 Usable Apertures and Flash Range in Automatic (A) Mode (Normal Zoom)

ISO 800	400	200	100	50	25	Range in Ft	Range in M
f/5.6	f/4	f/2.8	f/2	f/1.4	—	6.2–49	1.9–15
f/8	f/5.6	f/4	f/2.8	f/2	f/1.4	4.3–33	1.3–10
f/11	f/8	f/5.6	f/4	f/2.8	f/2	3.3–25	1–7.5
f/16	f/11	f/8	f/5.6	f/4	f/2.8	2.3–17	0.7–5.3
f/22	f/16	f/11	f/8	f/5.6	f/4	2.0–12	0.6–3.7

SB-20 Usable Apertures and Flash Range in Automatic (A) Mode (Wide Zoom)

ISO 800	400	200	100	50	25	Range in Ft	Range in M
f/5.6	f/4	f/2.8	f/2	f/1.4	—	4.6–36	1.4–11
f/8	f/5.6	f/4	f/2.8	f/2	f/1.4	3.3–26	1.0–7.8
f/11	f/8	f/5.6	f/4	f/2.8	f/2	2.3–18	0.7–5.5
f/16	f/11	f/8	f/5.6	f/4	f/2.8	2.0–13	0.6–3.9
f/22	f/16	f/11	f/8	f/5.6	f/4	2.0–8.9	0.6–2.7

SB-20 Usable Apertures and Flash Range in Automatic (A) Mode (Telephoto Zoom)

ISO 800	400	200	100	50	25	Range in Ft	Range in M
f/5.6	f/4	f/2.8	f/2	f/1.4	—	7.5–59	2.3–18
f/8	f/5.6	f/4	f/2.8	f/2	f/1.4	5.2–39	1.6–12
f/11	f/8	f/5.6	f/4	f/2.8	f/2	3.9–30	1.2–9
f/16	f/11	f/8	f/5.6	f/4	f/2.8	2.6–21	0.8–6.3
f/22	f/16	f/11	f/8	f/5.6	f/4	2.0–15	0.6–4.5

Setting Manual Flash Exposure (All Nikon Bodies)

1. Set the flash mode selector on the back of the SB-20 to M.

2. Rotate the ring around the flashtube to set the zoom setting to match the focal length of your lens (W = 28mm, N = 35mm, T = 85mm). Then, on the back of the SB-20, make sure that the distance scale selector matches this setting (W, N, or T). If not, move the selector so that it does.

3. Set the ISO film speed index on the back of the SB-20 to the speed of the film you're using.

 Note: The SB-20 doesn't allow intermediate values (i.e., you can't set ISO 64 or 80, only 50 and 100). Nikon suggests using the nearest ISO value. This is problematic in manual (M) flash mode, as the flash fires at the power setting you choose (i.e., it does not cut off when enough light has been achieved as it does in TTL and automatic (A) modes. Thus, you generally have to compensate with the aperture setting to get correct flash shots in manual (M) mode. Set the ISO film speed on the SB-20 to the nearest value, as Nikon suggests. See the note after Step 6.

4. Set the camera to aperture-priority (A) or manual (M) exposure mode.

5. Focus on the subject. Note the distance.

 Note: Distance should really be measured from flash to subject. Here I've assumed that the SB-20 is mounted on the camera body, and the flash head and focal plane are close enough for the distance to be used interchangeably most of the time.

6. This step is where it gets a little complicated for SB-20 users. At the bottom of the shooting range table locate the distance you calculated in Step 5. Draw an imaginary line upwards.

Notice the diagonal lines running from the upper right portion of the table to the lower left. These lines connect to the Power Setting Indicator in the upper right corner of the table. Anywhere your imaginary (distance) vertical line intersects one of these diagonal lines, you can set an aperture (found by starting at the intersection you just determined and following the horizontal bar to the left, where the aperture indicators are).

For example, at a distance of about 20 feet (6 m), the intersection with the diagonal line from full power occurs in the horizontal bar for f/4. You could also set 1/2 power and an aperture of f/2.8, or 1/4 power and f/2, as those are additional intersections with your imaginary distance line.

Whatever choice you make, set that aperture on the camera and (very important!) move the knob at the far right of the table so that the correct power indicator is set at the top right portion of the table.

Note: If the ISO film speed set in Step 3 isn't 25, 50, 100, 200, 400, 800, or 1,600, the aperture you just set isn't quite correct. Fortunately, Nikon lenses support intermediate apertures, so you can compensate (although not exactly) by adjusting the aperture.

For example, if you rounded up the ISO value (e.g., set 100 instead of 80), turn the aperture ring on the camera so that it is between the one you set in Step 6 and the next larger one (e.g., somewhere between f/2.8 and f/4 if the aperture you set was f/4).

If you rounded down the ISO value (e.g., set 50 instead of 64), turn the aperture ring on the lens so that it is between the one you set in Step 6 and the next smaller one (e.g., somewhere between f/4 and f/5.6 if the aperture you set was f/4).

7. Make sure the camera is set to a shutter speed equal to or slower than its maximum sync speed (see "Camera Capabilities," pages 326–327).

8. Turn the flash unit ON. When the ready light glows, you can take the picture.

SB-20 Specifications (Guide Numbers in Feet)

Output Level/ Coverage	WA 28mm	N 35mm	T 85mm	Duration (sec)
Full Power	GN 72	GN 98	GN 118	1/1,200
1/2 Power	GN 49	GN 69	GN 82	1/1,500
1/4 Power	GN 36	GN 49	GN 59	1/3,700
1/8 Power	GN 25	GN 36	GN 43	1/7,400
1/16 Power	GN 18	GN 25	GN 30	1/15,000
Horizontal	70°*	60°*	31°*	—
Vertical	53°*	45°*	23°*	—

** Nikon manual is incorrect (horizontal and vertical are reversed).*

SB-20 Specifications (Guide Numbers in Meters)

Output Level	WA 28mm	N 35mm	T 85mm
Full Power	GN 22	GN 30	GN 36
1/2 Power	GN 15	GN 21	GN 25
1/4 Power	GN 11	GN 15	GN 18
1/8 Power	GN 7.8	GN 11	GN 13
1/16 Power	GN 5.5	GN 7.5	GN 9

Note: GNs listed are for flash head settings, not lenses! In other words, if you use an 85mm lens but the flash head is set for Normal (35mm), using the meters chart, you get a GN of 30, not 36.

Note: Nikon has not been consistent in the way they round numbers when calculating GNs for meters. I've used the numbers in the original manuals, complete with Nikon's rounding error.

SB-20 Notes

- For TTL operation in program (P) exposure mode, Nikon specifies that you must have an AI-S, AI-P, or AF lens mounted on the camera.

- TTL operation on some cameras (e.g., FA, FE2, FG) has a more limited ISO range (25–400) than later bodies (ISO 25–1,000).

- For autofocus bodies the camera's focus mode selector should be set to single servo (S) autofocus. The camera won't shoot, and

the flash won't fire unless the subject is in focus. The autofocus assist illuminator is used automatically if the ambient light is low.

- With the power switch in standby (STBY) position and most Nikon bodies, the SB-20 automatically turns OFF about a minute after the camera's meter turns OFF. A light press on the shutter release generally turns the light meter in most Nikon bodies back ON, and the SB-20 turns ON at the same time. A few older bodies do not control the flash in this manner. On those cameras, when the SB-20 is in STBY, it automatically turns itself OFF after a minute, regardless of whether the camera meter is active or not. To restore power to the SB-20, press the test fire button (or turn the SB-20 OFF and back ON).

- If you are using the SB-20 on a body that is using mechanical shutters speeds (M250, M90, B), set the SB-20's power switch to the ON position only. Standby (STBY) is not operative.

- Ready light warnings (blinking light) occur under the following conditions:

 When you attempt to use the SB-20 in TTL mode on cameras that are not TTL-capable (see "Non-TTL-Capable Bodies," page 326).

 When you attempt to use the SB-20 in A mode on cameras set to a mechanical shutter speed (M250, M90, B).

 When you attempt to use the SB-20 in TTL mode with an unavailable film speed (e.g., ISO 800 on an FA, FE2, or FG).

 When the shutter speed is set faster than the allowable flash sync speed of the camera.

 When you've taken a flash picture with the SB-20 in TTL or A mode and the flash fired at full power (indicating it might have produced insufficient light for a flash exposure).

 When the batteries are too weak to provide sufficient exposure.

- Nikon claims the SB-20 can be used with a motor drive that delivers up to 4.2 fps:

1/4 Power	**2 consecutive frames**
1/8 Power	**4 consecutive frames**
1/16 Power	**8 consecutive frames**

These numbers can be doubled (or better) by using an accessory SD-7 Power Unit.

SB-21A and SB-21B

The SB-21A and SB-21B are Nikon's first macro Speedlights and were introduced in 1986. The difference between them is the controller unit: the SB-21A has an AS-12 for use with the F3; the SB-21B has an AS-14 for use with cameras with ISO hot shoes.

1 Focus assist illuminator	5 Flash mode selector switch
2 Flashtube	6 Flashtube selector switch
3 Flashtube	7 Adapter ring mounting levers
4 Focus illuminator button	

8 Battery compartment
 release

9 On/Off/Mode selector switch

10 Ready light/Underexposure
 light/Test fire button

11 Overexposure light

12 Locking ring

13 Connector (to main unit)

14 Aperture scale

15 Distance scale

16 ISO scale

17 Lens scale

18 Lens selector knob

19 External power connector
 (under cover)

20 Power source switch

Specifications

GN: 39 (ft), 12 (m) (at 3.3 feet [1 m] with both tubes
 firing)

Weight: 5.1 oz (145 g) (main unit), 8.8–9.8 oz
 (250–280 g) (controller w/o batteries)

Size: 5.1" (130 mm) tall x 4.7" (120 mm) wide x .8"
 (21 mm) deep (main unit); 4" (100 mm) wide x
 3.5" (90 mm) deep x 1.6" (41.5 mm) tall
 (controller)

Power: 4 AA batteries
Recycle Time: 8 seconds minimum (full discharge)
No. of Flashes: ~200 at full manual
Flash Duration: 1/2,000 second
Coverage: (65° horizontal, 85° vertical)
Case: SS-21 (or SS-17 for controller only)
Key Features: TTL flash control on most TTL-capable Nikon
 bodies; full, 1/4, or 1/16 power settings. Left,
 right, or both flashtubes can be fired. The SB-21
 can synchronize with additional off-camera flash
 units, but the SB-21 must be the master flash.
 Comes with SW-8 Condenser Adapter for
 extremely close work, 52mm and 62mm
 mounting rings.

Setting TTL Flash Exposure (TTL-Capable Nikon Bodies)

1. On the SB-21 main unit, set the mode selector switch to **TTL**.

2. On the SB-21 main unit, set the flash module selector to **[** , **]** , or **[]** to indicate which flashtubes you want to fire.

3. On the camera-mounted AS-12 or AS-14 Controller, set the power switch/flash mode selector to **TTL**.

4. On the camera-mounted AS-12 or AS-14 Controller, set the ISO film speed value in the white cutout labeled ISO at the bottom of the dial located on the top of the controller. The ISO value of the film you're using should align with the small dot adjacent to the ISO label.

 Note: TTL operation is available only for ISO values of 25 to 400 on the F3, FA, FE2, and FG; with later camera bodies, the range is 25 to 1,000.

5. On the camera-mounted AS-12 or AS-14 Controller, set the lens focal length using the knob at the very inside of the dial on the top of the controller. The focal length should align with the small triangle (look above the ISO label). If you are using a reversed lens, line up the small red indicator line (instead of the focal length) with the triangle (works with 55mm Micro Nikkor and 20-35mm lenses only).

6. Set an appropriate aperture on the camera. If you've followed these steps in order, the dial on the top of the controller can

be used to select an aperture, assuming you know the reproduc-
tion ratio.

For a lens in the normal position, the numbers on the inner ring
(black numbers on white background—1:10, 7, 5, 3, 1) indicate
these ratios (e.g., the number 3 indicates a 1:3 reproduction
ratio). The concentric rings in the dial indicate ranges through
which an aperture can be used (the thicker bars are for AA
battery use, the thin extension to the bars is for external battery
packs). To verify apertures, start with the reproduction ratio in
the inner ring and read in a straight line outwards—any bar the
line intersects indicates a usable aperture.

If you're using the lens in a reversed position, use the reproduc-
tion scale in red on the outside of the ring instead, and draw a
line in towards the middle—any bar the line intersects indicates
a usable aperture.

Note: If the SW-8 Condenser Adapter is mounted on the SB-21,
the usable aperture is actually 1/2-stop smaller than indicated
(e.g., f/6.7 instead of f/5.6).

Setting Manual Flash Exposure (All Nikon Bodies)

1. On the SB-21 main unit, set the light output selector to MFULL,
 M1/4, or M1/16 (indicates full, 1/4, or 1/16 power respectively).

2. On the SB-21 main unit, set the flash module selector to [,] ,
 or ▣ to indicate which flashtubes you want to fire.

3. On the camera-mounted AS-12 or AS-14 Controller, set the
 power switch/flash mode selector to M.

4. On the camera-mounted AS-12 or AS-14 Controller, set the ISO
 film speed value in the white cutout labeled ISO at the bottom
 of the dial located on the top of the controller. The ISO value of
 the film you're using should align with the small dot adjacent to
 the ISO label.

5. On the camera-mounted AS-12 or AS-14 Controller, set the lens
 focal length using the knob at the very inside of the dial on the
 top of the controller. The focal length should align with the small
 triangle (look above the ISO label). If you are using a reversed
 lens, line up the small red indicator line (instead of the focal
 length) with the triangle (works with 55mm Micro Nikkor and
 20–35mm lenses only).

6. If you've followed these steps in order, the dial on the top of the controller is ready to be used to select an aperture. Note that the concentric rings that indicate the range for an aperture in TTL mode also have small rectangular tick marks in them. These marks represent 1/4 and 1/16 power (the full power position is assumed to be the leftmost extension of the bar, near where the f/numbers are printed).

For a lens in the normal position, the numbers on the inner ring (black numbers on white background—1:10, 7, 5, 3, 1) indicate these ratios (e.g., the number 3 indicates a 1:3 reproduction ratio). To set an aperture, start with the reproduction ratio in the inner ring and read in a straight line outwards— where that line intersects a tick mark or the left edge of one of the rings indicates a usable aperture. Set the aperture you calculate here on the camera.

If you're using the lens in a reversed position, use the reproduction scale in red on the outside of the ring instead, and draw a line in towards the middle—again, any tick mark or left ring edge the line intersects with indicates a usable aperture. Set the aperture you calculate on the camera.

Note: If the SW-8 Condenser Adapter is mounted on the SB-21, the usable aperture is actually 1/2-stop smaller than indicated (e.g., f/6.7 instead of f/5.6).

Note: If you're using an external battery pack with the SB-21 in manual mode at full power, select an aperture 1/2-stop smaller than you calculated in Step 6 (e.g., f/3.5 instead of f/2.8). With external battery packs, the SB-21 produces slightly more light at full power than with internal AA batteries.

Using the Focus Illuminator

1. On the SB-21 main unit, press the button labeled ILLUMINATOR. The small focus assist lamp will stay on for one minute after you press the button or when you press the shutter release, whichever occurs first.

Note: The focus illuminator has two lamps, but only one of them lights if you are using internal AA batteries as your power source.

Using Multiple Flash Units

1. Set the SB-21 to TTL mode.
2. Connect the remote flash unit to the controller via an SC-18/19 (for the SB-21A) or SC-17 and SC-18/SC-19 cables (for the SB-21B). In theory, up to four additional units can be connected to an SB-21 (requires SC-18 or SC-19 cables). In practice, however, only one or two additional units are practical due to the 33 feet (10 m) limit on total cable length and the fact that you're using the SB-21 on objects that are close to the camera.

SB-21 Apertures at Minimum Working Distances

When firing the SB-21 at close subjects, some limitations are apparent. In particular, you'll either run out of aperture variations (i.e., you can't close the lens down any further) or risk overexposure.

Feet

Lens	Full Power	1/4 Power	1/16 Power
Micro Nikkors			
55mm f/2.8, f/3.5 MF	16″ at f/32	~8″ at f/27	~8″ at f/13
105mm f/2.8, f/4 MF	22″ at f/32	~16″ at f/19	~16″ at f/9.5
200mm f/4 MF	28″ at f/22	28″ at f/11	28″ at f/5.6
60mm f/2.8 AF	24″ at f/32	8″ at f/22	8″ at f/11
105mm f/2.8 AF	20″ at f/32	12″ at f/19	12″ at f/9
Regular Nikkors			
20-85mm	16″ at f/32	10″ at f/32	8″ at f/22
100-200mm	16″ at f/25	16″ at f/13	16″ at f/7

Meters

Lens	Full Power	1/4 Power	1/16 Power
Micro Nikkors			
55mm f/2.8, f/3.5 MF	0.4 m at f/32	~0.2 m at f/27	~0.2 m at f/13
105mm f/2.8, f/4 MF	0.55 m at f/32	~0.4 m at f/19	~0.4 m at f/9.5
200mm f/4 MF	0.7 m at f/22	0.7 m at f/11	0.7 m at f/5.6
60mm f/2.8 AF	0.6 m at f/32	0.2 m at f/22	0.2 m at f/11
105mm f/2.8 AF	0.5 m at f/32	0.3 m at f/19	0.3 m at f/9
Regular Nikkors			
20-85mm	0.4 m at f/32	0.25 m at f/32	0.2 m at f/22
100-200mm	0.4 m at f/25	0.4 m at f/13	0.4 m at f/7

SB-21 Apertures at Minimum and Maximum Working Distances (Lens Reversed)

When firing the SB-21 at close subjects with the lens reversed, the usable working range of the SB-21 can be quite small.

Feet

Lens	Full Power	1/4 Power	1/16 Power
Micro Nikkors			
55mm f/2.8, f/3.5 MF	10″ at f/32	~8″ at f/27	~8″ at f/13
105mm f/2.8 MF	18″ at f/32	18″ at f/18	18″ at f/9
105mm f/4 MF	20″ at f/32	17″ at f/22	17″ at f/11
60mm f/2.8 AF	12″ at f/32	10″ at f/25	10″ at f/11
105mm f/2.8 AF	16″ at f/32	16″ at f/16	16″ at f/8
Regular Nikkors			
20-24mm	6″ at f/19	6″ at f/9.5	6″ at f/5.6
28-35mm	6″ at f/32	6″ at f/16	6″ at f/8
50-58mm	10″ at f/32	8″ at f/27	8″ at f/16
80-105mm	14″ at f/32	12″ at f/25	12″ at f/11

Meters

Lens	Full Power	1/4 Power	1/16 Power
Micro Nikkors			
55mm f/2.8, f/3.5 MF	0.25 m at f/32	~0.2 m at f/27	~0.2 m at f/13
105mm f/2.8 MF	0.45 m at f/32	0.45 m at f/18	0.45 m at f/9
105mm f/4 MF	0.5 m at f/32	0.425 m at f/22	0.425 m at f/11
60mm f/2.8 AF	0.3 m at f/32	0.25 m at f/25	0.25 m at f/11
105mm f/2.8 AF	0.4 m at f/32	0.4 m at f/16	0.4 m at f/8
Regular Nikkors			
20-24mm	0.15 m at f/19	0.15 m at f/9.5	0.15 m at f/5.6
28-35mm	0.15 m at f/32	0.15 m at f/16	0.15 m at f/8
50-58mm	0.25 m at f/32	0.2 m at f/27	0.2 m at f/16
80-105mm	0.35 m at f/32	0.3 m at f/25	0.3 m at f/11

SB-21A and SB-21B Notes

• If used with any alternate power source other than the LD-2 Battery Pack, the SB-21 will fire only one of the two flashtubes.

• Note that the SB-21 will rotate on lenses whose filter ring rotates during focusing. This may cause the flashtubes to be aligned at an angle you don't want. To cope with this, screw the adapter ring into the lens but don't mount the SB-21 until you've focused. Be careful not to change your focus point as you mount the SB-21 onto the adapter ring.

• The 60mm f/2.8 Micro Nikkor AF requires a UR-3 Adapter Ring to attach the SB-21 main body to the lens, otherwise the weight of the Speedlight impairs the lens's autofocus abilities and could damage it. Attach the UR-3 to the lens first, set the lens to focus at infinity, then attach the SB-21 main body to the UR-3. Nikon's manual warns of damage to the (autofocus) camera when using autofocus Micro Nikkors with the SB-21 attached via the 52mm or 62mm adapter ring supplied and recommends manual focus.

Note: The 62mm filter ring supplied with the SB-21 can be used like the UR-3 on the 105mm f/2.8 Micro Nikkor AF lens (i.e., it can be used to slip over the lens body to provide better support, instead of screwing into the filter ring).

• Nikon does not recommend that the SB-21 be mounted on autofocus lenses other than the Micro Nikkors.

• Only lenses with a focal length of 35mm or longer should be used with the SB-21, as vignetting will occur with shorter lenses (it may also occur with some zooms set at 35mm).

• Nikon's manual says to always use TTL flash mode when shooting with "a zoom lens." They actually mean zoom lenses with variable apertures. Even then, if you've got a camera that tells you the effective aperture being used (most current bodies do), you should be able to ignore Nikon's warning. Just make sure your manual flash calculations use the effective aperture being used, not the one indicated by the aperture ring.

- The SB-21 cannot be used for TTL flash photography on the N4004s/F-401s!

- In TTL mode, the AS-12/14 unit may display either an underexposure or overexposure lamp. Most photographers are used to seeing the ready lamp (and camera viewfinder flash indicator) blink when a Speedlight fires at full power (indicating potential underexposure), but few are used to looking for overexposure warnings. Make sure to always check the AS-12/14 for any warnings immediately after taking a shot with the SB-21.

- Blinking ready light indicators work slightly differently on the AS-12 and AS-14. Fortunately, they are consistent in the camera's viewfinder. You may see a blinking ready light under the following conditions:

 When you attempt to use the SB-21 in TTL mode on cameras that are not TTL-capable (see "Non-TTL-Capable Bodies," page 326).

 When you attempt to use the SB-21 in TTL mode with an unavailable film speed (e.g., ISO 800 on an F3, FA, FE2, or FG).

 When the shutter speed is set faster than the allowable flash sync speed of the camera.

 When you've taken a flash picture with the SB-21 in TTL mode and the flash fired at full power (indicating it might have produced insufficient light for a flash exposure).

 When certain cameras are set to a mechanical shutter speed (e.g., M250, M90, or B on FA, FE2, or FG bodies).

SB-21A and SB-21B Flash Durations

Output	Both Flashtubes		One Flashtube	
Type of Power	Batteries	External	Batteries	External
Full	1/2,000	1/1,100	1/1,600	1/870
1/4	1/6,500	1/4,700	1/5,300	1/4,500
1/16	1/25,000	1/15,000	1/22,000	1/15,000

SB-22

The SB-22 is a workhorse flash that has a basic set of features, a reasonable guide number, and a very fast recycling time. It was introduced in 1987. (See also the "SB-22s" section, page 204).

1 Battery compartment cover
 (slides)
2 Bounce angle indicator
3 Flashtube
4 AF assist illuminator
5 Light sensor
6 External power socket

The Nikon Flash Guide

7 Bounce indicator light

8 Sync socket

9 ISO setting switch

10 ISO scale

11 Wide-angle adapter lock button

12 Wide-angle adapter (slides out)

13 Flash mode selector switch

14 Aperture scale

15 Shooting range chart

16 Ready light

17 Test fire button

18 On/Off/Standby switch

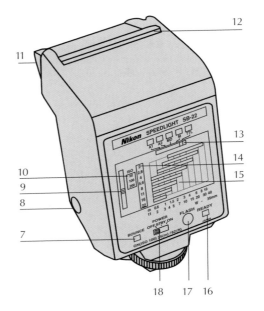

Specifications

GN:	82 (ft), 25 (m)
Weight:	8.8 oz (250 g) (w/o batteries)
Size:	4.1″ (105 mm) tall x 2.7″ (68 mm) wide x 3.1″ (80 mm) deep
Power:	4 AA batteries
Recycle Time:	4 seconds minimum (full discharge)
No. of Flashes:	~200 at full manual
Flash Duration:	1/1,700 to 1/8,000 second
Coverage:	(70° horizontal, 53° vertical) 28mm lens with diffuser in place, 35mm without diffuser
Case:	SS-22
Key Features:	TTL flash control on most TTL-capable Nikon bodies; full power TTL, manual, MD (motor drive), and two automatic settings (for choice of apertures). The SB-22 can synchronize with up to three additional flash units. Head tilts from –7° below horizontal up to 90° above horizontal. Autofocus assist illuminator.

196

Setting Automatic TTL Flash Exposure (TTL-Capable Nikon Bodies)

1. Set the flash mode selector on the back of the SB-22 to **TTL**.

2. Slide the wide-angle adapter out over the flashtube, if desired. The distance scale selector on the back of the SB-22 should automatically change to match the setting.

 Note: The flash head should be set to a bounce angle of 0°. While TTL is possible with the flash set to bounce, the flash may not have enough power to provide sufficient flash (see "Bounce Flash," page 61).

3. Set the ISO film speed index on the back of the SB-22 to the speed of the film you're using.

4. The type of TTL performed varies with different bodies and exposure mode settings:

 Matrix Balanced TTL: Available on modern bodies (starting with the N8008/F-801) if the camera is set in program (P, PD, or PH), aperture-priority (A), or shutter-priority (S) exposure mode and the camera is set to matrix metering.

 Center-Weighted Fill-Flash: Available on modern bodies if the camera is set in program (P, PD, or PH), aperture-priority (A), or shutter-priority (S) exposure mode and the camera is set to center-weighted metering.

 Standard TTL Flash: Always set if camera is in manual (M) exposure mode. Always set on an F4 in the spot metering mode. Also set on older TTL-capable cameras by default, regardless of camera metering mode or exposure mode.

 Note: While matrix balanced TTL is the most sophisticated flash mode, it is also the least predictable mode, as many different factors are considered by the camera before deciding how much flash is needed (i.e., the camera calculates a flash exposure compensation to balance the flash output with the ambient lighting exposure). If you want full control over the amount of flash, you should choose camera modes that allow standard TTL, which assumes that the flash will be the primary light in the scene (you can still achieve fill-flash by setting either camera or flash exposure compensation).

5. Make sure the camera is set to a shutter speed equal to or slower than the maximum sync speed (see "Camera Capabilities," pages 326–327).

6. Turn the flash unit ON. When the ready light glows, you can take the picture.

SB-22 Usable Apertures and Flash Range in TTL Mode (N, Normal Zoom)

ISO 800	400	200	100	50	25	Range in Ft	Range in M
f/2.8	f/2	—	—	—	—	10 –66	3.2–20
f/4	f/2.8	f/2	—	—	—	7.2–56	2.2–17
f/5.6	f/4	f/2.8	f/2	—	—	5.2–39	1.6–12
f/8	f/5.6	f/4	f/2.8	f/2	—	3.6–29	1.1–8.8
f/11	f/8	f/5.6	f/4	f/2.8	f/2	2.6–20	0.8–6.2
f/16*	f/11*	f/8*	f/5.6*	f/4*	f/2.8*	2.0–14	0.6–4.4
f/22	f/16	f/11	f/8	f/5.6	f/4	2.0–10	0.6–3.1
—	f/22	f/16	f/11	f/8	f/5.6	2.0–7.2	0.6–2.2
—	—	f/22	f/16	f/11	f/8	2.0–5	0.6–1.5
—	—	—	f/22	f/16	f/11	2.0–3.6	0.6–1.1

** This is what the camera uses in program (P) mode.*

SB-22 Usable Apertures and Flash Range in TTL Mode (W, Wide-Angle Adapter)

ISO 800	400	200	100	50	25	Range in Ft	Range in M
f/2.8	f/2	—	—	—	—	7.2–66	2.2–17
f/4	f/2.8	f/2	—	—	—	5.2–39	1.6–12
f/5.6	f/4	f/2.8	f/2	—	—	3.6–29	1.1–8.8
f/8	f/5.6	f/4	f/2.8	f/2	—	2.6–20	0.8–6.2
f/11	f/8	f/5.6	f/4	f/2.8	f/2	2.0–14	0.6–4.4
f/16*	f/11*	f/8*	f/5.6*	f/4*	f/2.8*	2.0–10	0.6–3.1
f/22	f/16	f/11	f/8	f/5.6	f/4	2.0–7.2	0.6–2.2
—	f/22	f/16	f/11	f/8	f/5.6	2.0–5	0.6–1.5
—	—	f/22	f/16	f/11	f/8	2.0–3.6	0.6–1.1
—	—	—	f/22	f/16	f/11	2.0–2.3	0.6–0.7

** This is what the camera uses in program (P) mode.*

Setting Programmed TTL Flash Exposure (N2020/F-501, N4004s/ F-401s, N2000/F-301)

1. Set the flash mode selector on the back of the SB-22 to **TTL**.

2. Slide the wide-angle adapter out over the flashtube, if desired. Then, on the back of the SB-22, make sure that the distance scale selector matches this setting (W if you're using the wide-

angle adapter, 35mm if not). If not, move the selector so that it does.

Note: The flash head should be set to a bounce angle of 0°.

3. Set the ISO film speed index on the back of the SB-22 to the speed of the film you're using.
4. Set the camera to program (P) mode.
5. Set the lens to the minimum aperture (in this mode the aperture is set automatically by the camera).
6. Turn the flash unit ON. When the ready light glows, you can take the picture.

Setting Automatic Flash Exposure (All Nikon Bodies)

1. Slide the wide-angle adapter out over the flashtube, if desired. The distance scale selector on the back of the SB-22 should automatically change to match the setting.

 Note: The flash head should be set to a bounce angle of 0°. While automatic flash is possible with the flash set to bounce, the flash unit may not have enough power to provide sufficient light (see "Bounce Flash," page 61).

2. Set the ISO film speed index on the back of the SB-22 to the speed of the film you're using.
3. Focus on the subject. Note the distance.
4. Set the flash mode selector on the back of the SB-22 to one of the automatic modes (A1 or A2). The distance you noted in Step 3 should be within the SS-22's range (see the following tables).

Flash Head Set to 35mm

Mode	Range in Ft	Range in M
A1	2.0–10	0.6–3.1
A2	2.6–20	0.8–6.2

Flash Head Set to W (28mm)

Mode	Range in Ft	Range in M
A1	2.0–7.2	0.6–2.2
A2	2.0–14	0.6–4.4

For example, if you noted a distance of 8 feet in Step 3 and the flash head was set to W, you'd need to set A2 (8 feet is outside the range of A1).

5. Make sure the camera is set to a shutter speed equal to or slower than its maximum sync speed (see "Camera Capabilities," pages 326–327).

6. Turn the flash unit ON. When the ready light glows, you can take the picture.

Setting Manual Flash Exposure (All Nikon Bodies)

1. Set the flash mode selector on the back of the SB-22 to M.

 Note: In this mode the flash always fires at maximum output, regardless of flash-to-subject distance.

2. Slide the wide-angle adapter out over the flashtube, if desired. The distance scale selector on the back of the SB-22 should automatically change to match the setting.

 Note: The flash head should be set to a bounce angle of 0°.

3. Set the ISO film speed index on the back of the SB-22 to the speed of the film you're using.

4. Set the camera to aperture-priority (A) or manual (M) exposure mode.

 Note: Most cameras will not allow program (P, PD, PH) or shutter-priority (S) exposure modes. Most newer cameras will blink ᶠᴱᴱ in the viewfinder (and/or LCD panel).

5. Focus on the subject. Note the distance.

 Note: Distance should really be measured from flash to subject, but I have assumed that the SB-22 is mounted on the camera body, and the flash head and focal plane are close enough to be used interchangeably most of the time.

6. At the bottom of the shooting range table locate the distance you calculated in Step 5. Draw an imaginary line upwards. Look for where this line intersects the end of one of the horizontal bars. Follow the horizontal bar to the left to read the appropriate aperture. For example, for a distance of 10 feet (3 m), this imaginary line hits the end of the bar for f/8, so you'd set f/8.

 Note: If the distance doesn't correspond exactly to the end of one of the aperture bars, remember that you can always set intermediate apertures on most Nikon bodies and lenses.

For example, if the distance was 8 feet (2.5 m), you would set an aperture between f/8 and f/11.

7. Make sure the camera is set to a shutter speed equal to or slower than its maximum sync speed (see "Camera Capabilities," pages 326–327).

8. Turn the flash unit ON. When the ready light glows, you can take the picture.

Setting Motor Drive Mode

1. Set the flash mode selector on the back of the SB-22 to MD.

 Note: In this mode the flash will always fire at 1/10 output, regardless of the flash-to-subject distance.

2. Slide the wide-angle adapter out over the flashtube, if desired. The distance scale selector on the back of the SB-22 should automatically change to match the setting.

 Note: The flash head should be set to a bounce angle of 0°.

3. Set the ISO film speed index on the back of the SB-22 to the speed of the film you're using.

4. Set the camera to aperture-priority (A) or manual (M) exposure mode.

 Note: Most cameras will not allow program (P, PD, PH) or shutter-priority (S) exposure modes. Most newer cameras blink FEE in the viewfinder (and/or LCD panel).

5. Focus on the subject. Note the distance.

 Note: Distance should really be measured from flash to subject, but I have assumed that the SB-22 is mounted on the camera body, and the flash head and focal plane are close enough to be used interchangeably most of the time.

6. At the bottom of the shooting range table locate the distance you calculated in Step 5. Draw an imaginary line upwards. Look for where this line intersects the small markers in the middle of the horizontal bars. Follow the horizontal bar to the left to read the appropriate aperture. For example, for a distance of 10 feet (3 m), this imaginary line hits the small marker in the bar for f/2.8, so you'd set f/2.8.

 Note: If the distance doesn't correspond exactly to a marker, remember that you can always set intermediate apertures on

most Nikon bodies and lenses. For example, if the distance was 8 feet (2.5 m), you would set an aperture between f/2.8 and f/4.

7. Make sure the camera is set to a shutter speed equal to or slower than its maximum sync speed (see "Camera Capabilities," pages 326–327).

8. Turn the flash unit ON. When the ready light glows, you can take the picture.

SB-22 Specifications (Guide Numbers in Feet)

Output Level	W 28mm	N 35mm	Duration (sec)
Full Power (M)	GN 59	GN 82	1/1,700
MD	GN 18	GN 26	1/8,000

SB-22 Specifications (Guide Numbers in Meters)

Output Level	WA 28mm	N 35mm	
Full Power (M)	GN 18	GN 25	
MD	GN 5.6	GN 8	

Note: GNs listed are for flash head settings, not lenses! In other words, if you use a 85mm lens but the flash head is set for normal (35mm), you get a GN of 25 (in meters), not 18.

Note: Nikon has not been consistent in the way they round numbers when calculating GNs for meters. I've used the numbers in the original manuals, complete with Nikon's rounding error.

SB-22 Notes

- For TTL operation in program (P) exposure mode, Nikon specifies that you must have an AI-S, AI-P, or AF lens mounted on the camera.

- TTL operation on some cameras (e.g., FA, FE2, FG) has a more limited ISO range (25–400) than later bodies (ISO 25–1,000).

- For autofocus bodies, the camera's focus mode selector should be set to single servo (S) autofocus. The flash will not fire unless the subject is in focus. The autofocus assist illuminator is used automatically if the ambient light is low.

- With the power switch in standby position (STBY) and most Nikon bodies, the SB-22 automatically turns OFF about a minute after the camera's meter turns OFF. A light press on the shutter release turns most Nikon bodies' light meters back ON, and the SB-22 will turn ON at the same time. A few older bodies do not control the flash in this manner. On those cameras, when the SB-22 is in STBY, it automatically turns itself OFF after a minute, regardless of whether the camera's meter is active or not. To restore power to the SB-22, press the test fire button (or turn the SB-22 OFF and back ON again).

- If you are using the SB-22 on a body that is set to a mechanical shutter speed (M250, M90, B), set the SB-22's power switch to the ON position only. Standby (STBY) is not operative.

- Ready light warnings (blinking light) occur in the following conditions:

 When you attempt to use the SB-22 in TTL mode on cameras that are not TTL-capable (see "Non-TTL-Capable Bodies," page 326).

 When you attempt to use the SB-22 in A mode on cameras set to a mechanical shutter speed (M250, M90, B).

 When you attempt to use the SB-22 in TTL mode with an unavailable film speed (e.g., ISO 800 on an FA, FE2, or FG).

 When the shutter speed is set faster than the allowable flash sync speed of the camera.

 When you've taken a flash picture with the SB-22 in TTL or A mode and the flash fired at full power (indicating it might have produced insufficient light for a flash exposure). However, in extremely bright scenes, the N4004s/F-401s may not blink its flash indicator, even when insufficient light was produced by the flash.

 When the batteries are too weak to provide sufficient exposure.

- Nikon claims the SB-22 can be used with a motor drive of up to 6 fps and will fire for a maximum of 4 consecutive frames (10 or more with the optional SD-7 Power Unit.

SB-22s

An update of the highly regarded workhorse, the SB-22, the SB-22s has a number of differences from its predecessor. The most important differences are the change to flash duration (from 1/1,700 to 1/1,100 second) and the inclusion of two additional automatic modes (A3 and A4) at the expense of the MD (1/10 power) mode. Though the size is the same, it dropped 1.4 oz in weight (40 g). It was introduced in 1998.

Specifications

GN:	92 (ft), 28 (m)
Weight:	7.4 oz (210 g)
Size:	4.1" (105 mm) tall x 2.7" (68 mm) wide x 3.1" (80 mm) deep
Power:	4 AA batteries
Recycle Time:	5 seconds minimum (full discharge)
No. of Flashes:	~230 at full manual
Flash Duration:	1/1,100 second
Coverage:	(70° horizontal, 53° vertical) 28mm lens
Case:	SS-22s for main unit
Key Features:	TTL flash control on most TTL-capable Nikon bodies; full power TTL, manual, and four automatic settings (for choice of apertures). The SB-22s can synchronize with up to three additional flash units. Head tilts from –7° below horizontal up to 90° above horizontal.

Setting Automatic TTL Flash Exposure (TTL-Capable Nikon Bodies)

1. Set the flash mode selector on the back of the SB-22s to 🔲.

2. Slide the wide-angle adapter out over the flashtube, if desired. Then, make sure that the distance scale selector on the back of the SB-22s matches this setting (W if you're using the wide-angle adapter, 35mm if not). If not, move the selector so that it does.

 Note: The flash head should be set to a bounce angle of 0°. While TTL is possible with the flash set to bounce, the flash unit may not have enough power to provide sufficient light (see "Bounce Flash," page 61).

3. Set the ISO film speed index on the back of the SB-22s to the speed of the film you're using.

4. The type of TTL performed varies with different bodies and exposure mode settings:

Multi-Sensor Balanced TTL: Available on bodies that incorporate the appropriate TTL sensor (starting with the N90/F90) if the camera is set in program (P, PD, or PH), aperture-priority (A), or shutter-priority (S) exposure modes and the camera is set to matrix metering.

Note: 3D multi-sensor balanced TTL is not available using the SB-22s even with camera and lens combinations that support it, as the SB-22s does not provide the necessary monitor pre-flash.

Matrix Balanced TTL: Available on modern bodies (starting with the N8008/F-801) if the camera is set in program (P, PD, or PH), aperture-priority (A), or shutter-priority (S) exposure mode and the camera is set to matrix metering.

Center-Weighted Fill-Flash: Available on modern bodies if the camera is set in program (P, PD, or PH), aperture-priority (A), or shutter-priority (S) exposure mode and the camera is set to matrix metering.

Standard TTL Flash: Always set if camera is in manual (M) exposure mode. Always set on an F4 in spot metering mode. Also set on older TTL-capable cameras by default, regardless of camera metering mode or exposure mode.

Note: While multi-sensor and matrix balanced TTL are the most sophisticated modes, they are also the least predictable modes, as many different factors are considered by the camera before deciding how much flash is needed (i.e., the camera calculates a flash exposure compensation to balance the flash output with the ambient lighting exposure). If you want full control over the amount of flash, you should choose camera modes that allow standard TTL, which assumes that the flash will be the primary light in the scene (you can still achieve fill-flash by setting flash exposure compensation).

5. Make sure the camera is set to a shutter speed equal to or slower than its maximum sync speed (see "Camera Capabilities," pages 326–327).

6. Turn the flash unit ON. When the ready light glows, you can take the picture.

SB-22s Usable Apertures and Flash Range in TTL Mode (N, Normal Zoom)

ISO 800	400	200	100	50	25	Range in Ft	Range in M
f/2.8	f/2	f/1.4	—	—	—	10.5–65.6	3.2–20
f/4	f/2.8	f/2	f/1.4	—	—	7.2–55.8	2.2–17
f/5.6	f/4	f/2.8	f/2	f/1.4	—	5.9–45.9	1.8–14
f/8	f/5.6	f/4	f/2.8	f/2	f/1.4	4.3–32.8	1.3–10
f/11	f/8	f/5.6	f/4	f/2.8	f/2	3.0–23	0.9–7
f/16	f/11	f/8	f/5.6	f/4	f/2.8	2.0–16.4	0.6–5
f/22	f/16	f/11	f/8	f/5.6	f/4	2.0–11.5	0.6–3.5
f/32	f/22	f/16	f/11	f/8	f/5.6	2.0–8.2	0.6–2.5
f/45	f/32	f/22	f/16	f/11	f/8	2.0–5.6	0.6–1.7
f/64	f/45	f/32	f/22	f/16	f/11	2.0–3.9	0.6–1.2

SB-22s Usable Apertures and Flash Range in TTL Mode (W, Wide-Angle Adapter)

ISO 800	400	200	100	50	25	Range in Ft	Range in M
f/2.8	f/2	f/1.4	—	—	—	7.2–55.8	2.2–17
f/4	f/2.8	f/2	f/1.4	—	—	5.2–39.3	1.6–12
f/5.6	f/4	f/2.8	f/2	f/1.4		4.3–32.8	1.3–10
f/8	f/5.6	f/4	f/2.8	f/2	f/1.4	3.0–23	0.9–7
f/11	f/8	f/5.6	f/4	f/2.8	f/2	2.0–16.4	0.6–5
f/16	f/11	f/8	f/5.6	f/4	f/2.8	2.0–11.5	0.6–3.5
f/22	f/16	f/11	f/8	f/5.6	f/4	2.0–8.2	0.6–2.5
f/32	f/22	f/16	f/11	f/8	f/5.6	2.0–5.6	0.6–1.7
f/45	f/32	f/22	f/16	f/11	f/8	2.0–3.9	0.6–1.2
f/64	f/45	f/32	f/22	f/16	f/11	2.0–3.0	0.6–0.9

Setting Programmed TTL Flash Exposure (N2020/F-501, N4004s/F-401s, N2000/F-301)

1. Set the flash mode selector on the back of the SB-22s to **TTL**.
2. Slide the wide-angle adapter out over the flashtube, if desired. Then, on the back of the SB-22s, make sure that the distance scale selector matches this setting (W if you're using the wide-angle adapter, 35mm if not). If not, move the selector so that it does.

 Note: The flash head should be set to a bounce angle of 0°.

3. Set the ISO film speed index on the back of the SB-22s to the speed of the film you're using.

4. Set the camera to program (P) mode.

5. Set the lens to the minimum aperture (in this mode the aperture is set automatically by the camera).

6. Turn the flash unit ON. When the ready light glows, you can take the picture.

Setting Automatic Flash Exposure (All Nikon Bodies)

1. Slide the wide-angle adapter out over the flashtube, if desired. Then, on the back of the SB-22s, make sure that the distance scale selector matches this setting (W if you're using the wide-angle adapter, 35mm if not). If not, move the selector so that it does.

 Note: The flash head should be set to a bounce angle of 0°. While automatic flash is possible with the flash set to bounce, the flash unit may not have enough power to provide sufficient light (see "Bounce Flash," page 61).

2. Set the ISO film speed index on the back of the SB-22s to the speed of the film you're using.

3. Focus on the subject. Note the distance.

4. Set the flash to an A mode (i.e., A1, A2, A3, or A4). You'll note thin horizontal lines running from labels for the modes at the far right of the table all the way to the aperture indicator on the left. You'll use those lines in Steps 5 and 7, so note the one that corresponds to the A mode you set.

5. To verify that you've set an automatic mode that will cover the distance you noted in Step 3, draw an imaginary line up from the distance on the shooting range table on the back of the flash. The imaginary line should intersect the line for the A mode you set in Step 4. If it doesn't, note which mode line your imaginary line does intersect, and set the flash to that mode. If the imaginary line does not intersect any of the A-mode lines (which is the case for any distance over 32.8 feet [10 m]), you can't use the A mode.

6. Set the camera to aperture-priority (A) or manual (M) exposure mode.

7. Set the aperture on the camera to the one that is shown at the far left of the line for the mode you selected (i.e., find the label for the mode you selected at the far right of the shooting range table and follow the thin line that emanates from it all the way to the left of the table, where the apertures are listed). For example, with a distance of 14 feet with the flash head set to W and using ISO 100 film, you'd set f/4 if you set the flash to A3 mode, or f/2.8 if you set the flash to A4 mode.

8. Make sure the camera is set to a shutter speed equal to or slower than its maximum sync speed (see "Camera Capabilities," pages 326–327).

9. Turn the flash unit ON. When the ready light glows, you can take the picture.

Setting Manual Flash Exposure (All Nikon Bodies)

1. Set the flash mode selector on the back of the SB-22s to M.

 Note: In this mode the flash will always fire at maximum output, regardless of the flash-to-subject distance.

2. Slide the wide-angle adapter out over the flashtube, if desired. Then, on the back of the SB-22s, make sure that the distance scale selector matches this setting (W if you're using the wide-angle adapter, 35mm if not). If not, move the selector so that it does.

 Note: The flash head should be set to a bounce angle of 0°.

3. Set the ISO film speed index on the back of the SB-22s to the speed of the film you're using.

4. Set the camera to aperture-priority (A) or manual (M) exposure mode.

 Note: Most Nikon cameras will not allow program (P, PD, PH) or shutter-priority (S) exposure modes. Most newer Nikon bodies blink ⊢ΞΞ in the viewfinder (and/or LCD panel).

5. Focus on the subject. Note the distance.

 Note: Distance should really be measured from flash to subject, but I have assumed that the SB-22s is mounted on the camera body, and the flash head and focal plane are close enough to be used interchangeably most of the time.

6. At the bottom of the shooting range table locate the distance you calculated in Step 5. Draw an imaginary line upwards. Look for where this line intersects the very end of one of the horizontal bars. Follow the horizontal bar to the left to read the appropriate aperture. For example, For a distance of about 12 feet (~4 m), this imaginary line hits the end of the bar for f/8, so you'd set f/8.

 Note: If the distance doesn't correspond exactly to the end of one of the aperture bars, remember that you can always set intermediate apertures on most Nikon bodies and lenses. For example, if the distance was 10 feet (3 m), you would set an aperture between f/8 and f/11.

7. Make sure the camera is set to a shutter speed equal to or slower than its maximum sync speed (see "Camera Capabilities," pages 326–327).

8. Turn the flash unit ON. When the ready light glows, you can take the picture.

SB-22s Specifications (Guide Numbers in Feet)

Output Level	W 28mm	N 35mm	Duration (sec)
Full Power (M)	GN 56	GN 92	1/1,100

SB-22s Specifications (Guide Numbers in Meters)

Output Level	WA 28mm	N 35mm
Full Power (M)	GN 20	GN 28

Note: GNs listed are for flash head settings, not lenses! In other words, if you use a 35mm lens but the flash head is set for wide (28mm), you get a GN of 20 (in meters), not 28.

Note: Nikon has not been consistent in the way they round numbers when calculating GNs for meters. I've used the numbers in the original manuals, complete with Nikon's rounding error.

SB-22s Notes

• For TTL operation in program (P) exposure mode, Nikon specifies that you must have an AI-S, AI-P, or AF lens mounted on the camera.

- TTL operation on some cameras (e.g., FA, FE2, FG) has a more limited ISO range (25–400) than later bodies (ISO 25–1,000).

- For autofocus bodies, the camera's focus mode selector should be set to single servo (S) autofocus (N50/F50 should be set to AF, N5005/F-401x, N4004s/F-401s, and N4004/F-401 should be set to A). The camera won't take a picture and the flash won't fire unless the subject is in focus. The autofocus assist illuminator will be used automatically if the ambient light is low. Autofocus assist works only at distances up to 16.4 feet (5 m).

- With the power switch in standby position (STBY) and most Nikon bodies, the SB-22s automatically turns off 80 seconds after the camera's meter turns OFF. A light press on the shutter release generally turns most Nikon bodies' light meters back ON, and the SB-22s will turn ON at the same time. A few older bodies do not control the flash in this manner. On those cameras, when the SB-22s is in STBY, it automatically turns itself OFF after 80 seconds, regardless of whether the camera's meter is active or not. To restore power to the SB-22s, press the test fire button (or turn the SB-22s OFF and back ON again).

- If you are using the SB-22s on a body that is set to a mechanical shutter speed (M250, M90, B), set the SB-22s's power switch to the ON position only. Standby (STBY) is not operative. Likewise, standby doesn't operate if you're using an F3, FM2, FM10, FE10, or an FA or FE2 that incorporates the MD-12 Motor Drive.

- Ready light warnings (blinking light) occur under the following conditions:

 When you attempt to use the SB-22s in TTL mode on cameras that are not TTL-capable (see "Non-TTL-Capable Bodies," page 326).

 When you attempt to use the SB-22s in A mode on cameras set to a mechanical shutter speed (M250, M90, B).

 When you attempt to use the SB-22s in TTL mode with an unavailable film speed (e.g., ISO 800 on an FA, FE2, or FG).

 When the shutter speed is set faster than the allowable flash sync speed of the camera.

 When you've taken a flash picture with the SB-22s in TTL or A mode and the flash fired at full power (indicating it might have produced insufficient light for a flash exposure). However, in extremely bright scenes, the N4004s/F-401s may not blink its

flash indicator, even when insufficient light was produced by the flash.

When the batteries are too weak to provide sufficient exposure.

- Changing the ISO film speed setting on the SB-22s does not change the way the flash fires in TTL or M modes. It changes only the apertures displayed in the shooting range table. Accidentally moving the ISO setting after correctly making all flash and camera adjustments won't affect the resulting exposure.

SB-23

Introduced in 1988, the SB-23 is a compact, light, simple-to-use TTL flash designed primarily for the N2020/F-501, N4004/F-401, N2000/F-301, FA, FE2, and FG. While it has a limited range, no zoom head, and a severely limited aperture selection in program (P) mode, it also features a fast recycle time and an operational simplicity that's easy to master. The SB-23 is a good choice for N2000/F-301, N4004/F-401, and N2020/F-501 users, plus a usable basic or backup flash for later bodies.

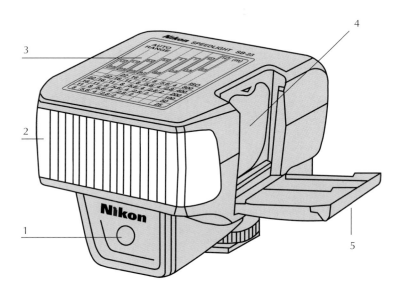

1 AF assist illuminator
2 Flashtube
3 User-mounted shooting range chart
4 Battery compartment
5 Battery compartment cover

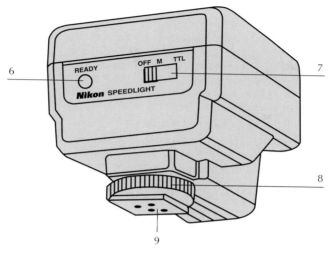

6 Ready light
7 On/Off/Flash mode
 selector switch
8 Locking ring
9 Flash mounting
 foot (ISO)

Specifications

GN:	66 (ft), 20 (m)
Weight:	4.9 oz (140 g) (w/o batteries)
Size:	2.6″ (67 mm) tall x 2.5″ (64 mm) wide x 3.3″ (84 mm) deep
Power:	4 AA batteries
Recycle Time:	2 seconds minimum (full discharge)
No. of Flashes:	~400 at full manual
Flash Duration:	1/2,000 second
Coverage:	35mm lens (60° horizontal, 45° vertical)
Case:	SS-23
Key Features:	TTL flash control with most TTL-capable bodies; autofocus assist LED.

Setting Automatic TTL Flash Exposure (TTL-Capable Nikon Bodies)

1. Set the power switch/flash mode selector on the SB-23 to **TTL**.

2. Set the camera to aperture-priority (A) or manual (M) exposure mode. The N2000/F-301, N4004/F-401, N2020/F-501 and later bodies can also be set to program (P) mode, in which case you can skip the remaining steps, since the lens must be set to the minimum aperture in this mode, and aperture is set automatically by the camera.

3. Focus on the subject. Note the distance.

4. Select an appropriate aperture on the camera (the SB-23 comes with a stick-on chart that shows usable apertures at various distance ranges; or you can use the following table).

SB-23 Usable Apertures and Flash Range

ISO 800	400	200	100	50	25	*Range in Ft*	*Range in M*
f/2.8	f/2	—	—	—	—	12–65	3.6–20
f/4	f/2.8	f/2	—	—	—	8.3–46	2.5–14
f/5.6	f/4	f/2.8	f/2	—	—	5.8–32	1.8–10
f/8	f/5.6	f/4	f/2.8	f/2	—	4.2–23	1.3–7
f/11	f/8	f/5.6	f/4	f/2.8	f/2	2.9–16	0.9–5
f/16*	f/11*	f/8*	f/5.6*	f/4*	f/2.8*	2.1–11	0.7–3.5
f/22	f/16	f/11	f/8	f/5.6	f/4	2.0–8.2	0.6–2.5
—	f/22	f/16	f/11	f/8	f/5.6	2.0–5.7	0.6–1.7
—	—	f/22	f/16	f/11	f/8	2.0–4.1	0.6–1.2
—	—	—	f/22	f/16	f/11	2.0–2.8	0.6–0.9

** This is what the camera uses automatically in program (P) mode.*

Setting Manual Flash Exposure (All Nikon Bodies)

1. Set the power switch/flash mode selector on the SB-23 to M.

2. Set the camera to aperture-priority (A) or manual (M) exposure mode.

3. Focus on the subject. Note the distance.

4. The SB-23 will always fire at full power in M mode, so you must exactly match the aperture to the distance to get correctly exposed photos. Use the formula: **GN / Distance = Aperture** to calculate the correct aperture. For example, if you noted a distance of 5 feet Step 3, then you should use f/13 (66/5 = 13), which is about 1/3 stop past f/11.

Note: Distance should really be measured from flash to subject, but I have assumed that the SB-23 is mounted on the camera body, and the flash head and focal plane are close enough to be used interchangeably most of the time.

SB-23 Specifications (Guide Number in Feet)

Output Level/Coverage	35mm	Duration (sec)
Full Power (M mode)	GN 66	1/2,000
Horizontal	60°	
Vertical	45°	

SB-23 Specifications (Guide Number in Meters)

Output Level	35mm
Full Power (M mode)	GN 20

Note: Nikon has not been consistent in the way they round numbers when calculating GNs for meters. I've used the numbers in the original manuals, complete with Nikon's rounding error.

SB-23 Notes

• The SB-23 can be used only as a master flash; it cannot be used as a slave flash unit.

• The SB-23 automatically shuts OFF about 80 seconds after the camera's power turns OFF. The flash unit will turn back ON when you partially depress the shutter release or otherwise turn the camera back ON.

• For TTL flash operation, use only AI-S or AF lenses. On the N4004/F-401, use only AF Nikkors (except 80mm f/2.8, 200mm f/3.5 ED-IF, and TC-16 or TC-16A).

• The flash doesn't fire until autofocus is achieved (the Nikon manual specifically notes this for the N2020/F-501 and N4004/F-401, but it applies to other autofocus bodies with only a few exceptions).

• Note that the camera controls the usable ISO range of the SB-23. For the FA, FE2, FG, and N4004/F-401 the range is ISO 25 to ISO 400. For later bodies, it is ISO 25 to ISO 1,000.

- With the N4004/F-401, N60/F60, N70/F70, N80/F80, F100, N90/F90, F90X/N90s, F4, and F5, the SB-23 is capable of automatic balanced fill-flash when the SB-23 is in TTL mode.

- For autofocus operation with a lens having an aperture of f/2.8 or larger (f/2, f/1.8, etc.), you must choose an aperture of f/2.8 or smaller (f/4, f/5.6, etc.). For autofocus operation with a lens with an aperture of f/3.5 or smaller (f/4, f/5.6, etc.), you must choose an aperture of f/5.6 or smaller (f/8, f/11, etc.).

SB-24

The first of the totally revamped, modern line of Speedlights, the SB-24 is a high-power unit that has a remarkable range of features, even when compared to previous top-end Speedlight models. It was introduced in 1988.

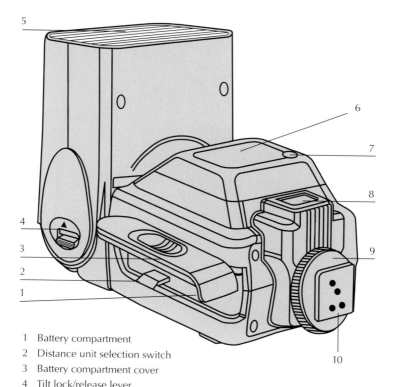

1 Battery compartment
2 Distance unit selection switch
3 Battery compartment cover
4 Tilt lock/release lever
5 Flashtube
6 AF assist illuminator
7 Light sensor
8 External power socket
9 Locking ring
10 Flash mounting foot (ISO)

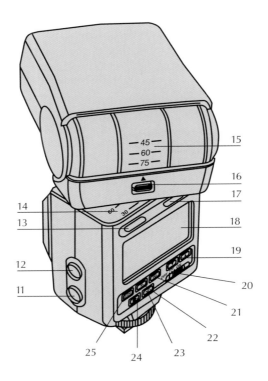

11	Sync socket	19	Adjustment toggle buttons
12	TTL multiple flash socket	20	On/Off/standby switch
13	Sync mode selector switch	21	Select (SEL) button
14	Rotation angle scale	22	M (manual adjustment) button
15	Tilt angle scale	23	Ready light/test fire button
16	Rotating lock/release lever	24	LCD illuminator button
17	Flash mode selector switch	25	Zoom button
18	LCD information display		

Note: Before using your SB-24, you should set the distance scale to feet or meters. This is done by opening the battery chamber and sliding the small switch on the left side of the chamber (as you face it) to m (for meters) or ft (for feet).

Specifications

GN:	118 (ft), 36 (m)
Weight:	13.7 oz (390 g) (w/o batteries)
Size:	5.6″ (131 mm) tall x 3.1″ (80 mm) wide x 3.9″ (100 mm) deep
Power:	4 AA batteries
Recycle Time:	7 seconds minimum (full discharge)
No. of Flashes:	~100 at full manual
Flash Duration:	1/1,000 second
Coverage:	(78° horizontal, 60° vertical) 24mm lens; also supports 28mm, 35mm, 50mm, 70mm, and 85mm coverage
Case:	SS-24 for main unit
Key Features:	TTL flash control on most TTL-capable Nikon bodies; full power TTL, five power level manual and automatic (six apertures) settings. LCD panel shows settings. Rear-curtain sync. Repeating flash. The SB-24 can synchronize with up to four additional flash units. Head tilts from –7° below horizontal up to 90° above horizontal, and rotates –270° to +180° clockwise. Autofocus assist illuminator.

The SB-24's user controls are a classic example of what is called "user interface overload." This means that some controls and display information have multiple uses or relate to multiple items depending upon the context. This reduces the number of buttons and indicators needed, but places a burden on the user to keep track of what mode they're in. A few things to remember:

• Blinking on the LCD indicates either a warning or that you're in the midst of setting an item. Blinking should not be ignored. Either the Speedlight is not set correctly, or you haven't finished setting something.

• Most buttons are designed to be pressed more than once. Each press gives you the next logical setting (next higher zoom head setting, next lower manual power amount, etc.). When buttons use multiple presses to select an item, they loop through the choices (i.e., after the last choice you'll be taken back to the first).

• Display indicators on the LCD don't appear unless they're active (i.e., you won't see the exposure compensation indicator unless you're in the midst of setting, or have already set, flash compensation).

• The camera and flash interact, but some controls override this! For example, with an autofocus zoom lens on the camera, zooming the lens will automatically change the flash zoom head setting to match. But if you manually set the zoom position, continuing to zoom the lens will not change the flash zoom head setting.

Setting Automatic TTL Flash Exposure (Newer TTL-Capable Nikon Bodies)

1. Set the flash mode selector on the back of the SB-24 to ▥.

2. Turn the power switch on the SB-24 to the standby (STBY) or ON position.

3. Set the ISO film speed on the SB-24, if necessary.

 On the N8008/F-801, F4, F5, F100, N80/F80, N70/F70, N90/ F90, N90s/F90X, N50/F50, and N60/F60, ISO film speed settings are automatically communicated to the SB-24. Press the shutter release on the camera halfway, and you should see the correct ISO value appear on the SB-24's LCD panel.

 For older camera bodies, press the ▥ button on the SB-24 until the term ISO begins blinking in the LCD panel. When it is blinking, use the ▼ and ▲ buttons to adjust the value (which appears just to the right of the blinking ISO). When the value you want is set, either wait 8 seconds or press the ▥ button again to lock it in.

 Note: You do not have to set the ISO value on the SB-24 as in TTL flash mode all exposure calculations are done by the camera. However, the shooting range scale may not show the proper results if you don't.

4. Select the type of TTL to be performed. Basically, with most modern Nikon bodies there is only one choice to make: whether or not to cancel the balanced fill-flash mode. Remember, the type of lens used (D or non-D) and the metering method used

(matrix and center-weighted) dictate the actual balanced flash mode used (see "Nikon Terminology," page 31). If you see a 🔲 and (non-blinking) 🔳 or 🔳 on the SB-24's LCD panel, the camera and flash are set to one of the balanced modes.

To cancel the balanced mode and use standard TTL flash instead, press the 🔲 button and the 🔳 should disappear.

Note: When the camera body is set for spot metering, standard TTL is set automatically.

Note: The N4004s/F-401s allows only programmed TTL flash and the 🔳 indicator does not appear, even though the camera and flash will perform TTL. See "Setting Programmed TTL Flash Exposure," page 225.

5. Set autofocus cameras to single servo (S) autofocus mode.

6. Set the camera's exposure mode if you haven't already. In aperture-priority (A), shutter-priority (S), and manual (M) exposure modes, make any necessary aperture or shutter speed selections.

With AI, AI-S, and AF teleconverters, some cameras will switch automatically to aperture-priority (A) exposure mode (program and shutter-priority modes are not available). Other cameras need to be manually switched to aperture-priority (A) mode with these lenses.

In program modes you can usually override the camera's selection of aperture and shutter speed combinations by turning the camera's control dial (when the shutter release is partially pressed).

The aperture the camera (or you) selected appears on the SB-24's LCD panel when you partially press the shutter release.

The camera and SB-24 may warn you of several possible errors when you partially press the shutter release to verify settings:

• In program modes (P, PD, PH), and on the more recent bodies (F5, F100, N80/F80), the lens must be set on its minimum aperture, or else the error message FEE appears in the viewfinder.

- Any time that ⋈ is visible in the viewfinder indicates that overexposure is likely. For many of the later bodies, starting with the N8008/F-801, the placement of the ⋈ varies with exposure mode: ⋈ and the smallest aperture appear in the camera's viewfinder if overexposure is likely in any of the program (P) modes. ⋈ appears in place of the aperture for overexposure warnings in shutter-priority (S) mode. ⋈ appears in place of the shutter speed in aperture-priority (A) mode.

- The shutter speed is automatically reset to 1/250 second if you selected a faster shutter speed in shutter-priority (S) or manual (M) exposure mode.

- In manual (M) exposure mode, under- and overexposure are indicated solely by the analog exposure display. If the exposure bar goes to either side of the ⅰ point, the ambient-only lighting exposure will not be correct.

7. Focus on the subject by pressing lightly on the shutter release. Confirm that the subject is within flash range by looking at the shooting range scale on the SB-24's LCD. After you've confirmed the distance, you're ready to shoot.

SB-24 Usable Apertures and Flash Range in TTL Mode (24mm)

ISO 800	400	200	100	50	25	Range in Ft	Range in M
f/2	f/1.4	—	—	—	—	17–66	5.2–20
f/2.8	f/2	f/1.4	—	—	—	12–66	3.7–20
f/4	f/2.8	f/2	f/1.4	—	—	8.6–66	2.6–20
f/5.6	f/4	f/2.8	f/2	f/1.4	—	6.1–49	1.8–15
f/8	f/5.6	f/4	f/2.8	f/2	f/1.4	4.4–34	1.3–10
f/11	f/8	f/5.6	f/4	f/2.8	f/2	3.1–24	1.0–7.5
f/16	f/11	f/8	f/5.6	f/4	f/2.8	2.2–17	0.7–5.3
f/22	f/16	f/11	f/8	f/5.6	f/4	2.0–12	0.6–3.7
f/32	f/22	f/16	f/11	f/8	f/5.6	2.0–8.7	0.6–2.6
—	f/32	f/22	f/16	f/11	f/8	2.0–6.1	0.6–1.8
—	—	f/32	f/22	f/16	f/11	2.0–4.3	0.6–1.3
—	—	—	f/32	f/22	f/16	2.0–3.0	0.6–0.9

SB-24 Usable Apertures and Flash Range in TTL Mode (28mm)

ISO 800	400	200	100	50	25	Range in Ft	Range in M
f/2	f/1.4	—	—	—	—	19–66	5.7–20
f/2.8	f/2	f/1.4	—	—	—	14–66	4.0–20
f/4	f/2.8	f/2	f/1.4	—	—	9.3–66	2.9–20
f/5.6	f/4	f/2.8	f/2	f/1.4	—	6.6–52	2.0–16
f/8	f/5.6	f/4	f/2.8	f/2	f/1.4	4.7–37	1.5–11
f/11	f/8	f/5.6	f/4	f/2.8	f/2	3.3–26	1.0–8
f/16	f/11	f/8	f/5.6	f/4	f/2.8	2.4–18	0.7–5.6
f/22	f/16	f/11	f/8	f/5.6	f/4	2.0–13	0.6–4
f/32	f/22	f/16	f/11	f/8	f/5.6	2.0–9.2	0.6–2.8
—	f/32	f/22	f/16	f/11	f/8	2.0–6.5	0.6–2.0
—	—	f/32	f/22	f/16	f/11	2.0–4.6	0.6–1.4
—	—	—	f/32	f/22	f/16	2.0–3.3	0.6–1.0

SB-24 Usable Apertures and Flash Range in TTL Mode (35mm)

ISO 800	400	200	100	50	25	Range in Ft	Range in M
f/2	f/1.4	—	—	—	—	21–66	6.4–20
f/2.8	f/2	f/1.4	—	—	—	15–66	4.5–20
f/4	f/2.8	f/2	f/1.4	—	—	11–66	3.2–20
f/5.6	f/4	f/2.8	f/2	f/1.4	—	7.4–59	2.3–18
f/8	f/5.6	f/4	f/2.8	f/2	f/1.4	5.3–41	1.6–12
f/11	f/8	f/5.6	f/4	f/2.8	f/2	3.7–29	1.2–9
f/16	f/11	f/8	f/5.6	f/4	f/2.8	2.7–20	0.8–6.3
f/22	f/16	f/11	f/8	f/5.6	f/4	2.0–14	0.6–4.5
f/32	f/22	f/16	f/11	f/8	f/5.6	2.0–10	0.6–3.1
—	f/32	f/22	f/16	f/11	f/8	2.0–7.3	0.6–2.2
—	—	f/32	f/22	f/16	f/11	2.0–5.2	0.6–1.5
—	—	—	f/32	f/22	f/16	2.0–3.6	0.6–1.1

SB-24 Usable Apertures and Flash Range in TTL Mode (50mm)

ISO 800	400	200	100	50	25	Range in Ft	Range in M
f/2	f/1.4	—	—	—	—	25–66	7.5–20
f/2.8	f/2	f/1.4	—	—	—	17–66	5.2–20
f/4	f/2.8	f/2	f/1.4	—	—	12–66	3.7–20
f/5.6	f/4	f/2.8	f/2	f/1.4	—	8.6–66	2.6–20
f/8	f/5.6	f/4	f/2.8	f/2	f/1.4	6.0–48	1.8–14
f/11	f/8	f/5.6	f/4	f/2.8	f/2	4.3–34	1.3–10
f/16	f/11	f/8	f/5.6	f/4	f/2.8	3.1–24	1.0–7.4
f/22	f/16	f/11	f/8	f/5.6	f/4	2.2–17	0.7–5.2
f/32	f/22	f/16	f/11	f/8	f/5.6	2.0–12	0.6–3.7
—	f/32	f/22	f/16	f/11	f/8	2.0–8.6	0.6–2.6
—	—	f/32	f/22	f/16	f/11	2.0–6.0	0.6–1.8
—	—	—	f/32	f/22	f/16	2.0–4.3	0.6–1.3

SB-24 Usable Apertures and Flash Range in TTL Mode (70mm)

ISO 800	400	200	100	50	25	Range in Ft	Range in M
f/2	f/1.4	—	—	—	—	28–66	8.4–20
f/2.8	f/2	f/1.4	—	—	—	20–66	5.9–20
f/4	f/2.8	f/2	f/1.4	—	—	14–66	4.2–20
f/5.6	f/4	f/2.8	f/2	f/1.4	—	9.7–66	3.0–20
f/8	f/5.6	f/4	f/2.8	f/2	f/1.4	6.9–54	2.1–16
f/11	f/8	f/5.6	f/4	f/2.8	f/2	4.9–38	1.5–11
f/16	f/11	f/8	f/5.6	f/4	f/2.8	3.5–27	1.1–8.3
f/22	f/16	f/11	f/8	f/5.6	f/4	2.5–19	0.8–5.8
f/32	f/22	f/16	f/11	f/8	f/5.6	2.0–13	0.6–4.1
—	f/32	f/22	f/16	f/11	f/8	2.0–9.6	0.6–2.9
—	—	f/32	f/22	f/16	f/11	2.0–6.8	0.6–2.0
—	—	—	f/32	f/22	f/16	2.0–4.8	0.6–1.4

SB-24 Usable Apertures and Flash Range in TTL Mode (85mm)

ISO 800	400	200	100	50	25	Range in Ft	Range in M
f/2	f/1.4	—	—	—	—	29–66	8.9–20
f/2.8	f/2	f/1.4	—	—	—	21–66	6.3–20
f/4	f/2.8	f/2	f/1.4	—	—	15–66	4.4–20
f/5.6	f/4	f/2.8	f/2	f/1.4	—	11–66	3.2–20
f/8	f/5.6	f/4	f/2.8	f/2	f/1.4	7.3–58	3.2–20
f/11	f/8	f/5.6	f/4	f/2.8	f/2	5.2–41	1.6–12
f/16	f/11	f/8	f/5.6	f/4	f/2.8	3.7–29	0.8–6.2
f/22	f/16	f/11	f/8	f/5.6	f/4	2.6–20	0.8–6.2
f/32	f/22	f/16	f/11	f/8	f/5.6	2.0–14	0.6–4.4
—	f/32	f/22	f/16	f/11	f/8	2.0–10	0.6–3.1
—	—	f/32	f/22	f/16	f/11	2.0–7.2	0.6–2.2
—	—	—	f/32	f/22	f/16	2.0–5.1	0.6–1.5

Setting Programmed TTL Flash Exposure (N2020/F-501, N4004s/ F-401s, N2000/F-301)

1. Set the flash mode selector on the back of the SB-24 to **TTL**.

2. Turn the power switch on the SB-24 to the standby (STBY) or ON position.

3. Confirm the ISO film speed on the SB-24.

 On these cameras, ISO film speed settings are automatically communicated to the SB-24. Press the shutter release on the camera halfway and you should see the ISO value appear on the SB-24's LCD panel.

 Note: You do not have to set the ISO value on the SB-24 as in TTL flash mode all exposure calculations are done by the camera. However, the shooting range scale may not show the proper results if you don't.

4. Set the camera to program auto (on the N4004s/F-401s: shutter speed dial at **A**, aperture dial at **S**; on the other cameras: shutter speed dial at PDUAL, P, or PHIGH and the lens set at its smallest aperture).

 Note: The N4004s/F-401s performs only programmed TTL flash. But the indicator does not appear on the SB-24's LCD.

5. Set autofocus cameras to single servo (S) autofocus mode.

6. Focus on the subject by pressing lightly on the shutter release. Confirm that the subject is within flash range by looking at the shooting range scale on the SB-24's LCD. Once the distanced is confirmed, you're ready to shoot.

 You can set apertures on the flash by using the ▼ and ▲ buttons on the SB-24. N4004s/F-401s users should set the aperture according to the ISO value being used (see following table).

SB-24 Usable Apertures and Flash Range in Programmed TTL Mode (N4004s/F-401s only)

Zoom	ISO 400	200	100	50	25	Range in Ft	Range in M
24mm	f/11	f/8	f/5.6	f/4	f/2.8	2.2–17	0.7–5.3
28mm	f/11	f/8	f/5.6	f/4	f/2.8	2.4–18	0.7–5.6
35mm	f/11	f/8	f/5.6	f/4	f/2.8	2.7–20	0.8–6.3
50mm	f/11	f/8	f/5.6	f/4	f/2.8	3.1–24	1.0–7.4
70mm	f/11	f/8	f/5.6	f/4	f/2.8	2.5–27	1.1–8.3
85mm	f/11	f/8	f/5.6	f/4	f/2.8	3.7–29	1.1–8.8

N2020/F-501 users should set an aperture that covers the desired shooting range (see the TTL tables that begin on page 222).

Setting Aperture-Priority or Shutter-Priority Programmed TTL Flash Exposure (N2020/F-501, N4004s/F-401s, N2000/F-301)

1. Set the flash mode selector on the back of the SB-24 to TTL.

2. Turn the power switch on the SB-24 to the standby (STBY) or ON position.

3. Set the ISO film speed on the SB-24, if necessary.

 On most cameras, ISO film speed settings are automatically communicated to the SB-24. Press the shutter release on the camera halfway and you should see the ISO value appear on the SB-24's LCD panel.

 Note: You do not have to set the ISO value on the SB-24 as in TTL flash mode all exposure calculations are done by the camera. However, the shooting range scale may not show the proper results if you don't.

4. Set the camera to aperture-priority (A) or shutter-priority (S) exposure mode.

5. Set autofocus cameras to single servo (S) autofocus mode (A on the N4004s/F-401s).

6. Focus on the subject by pressing lightly on the shutter release. Confirm that the subject is within flash range by looking at the shooting range scale on the SB-24's LCD. After you've confirmed the distance, you're ready to shoot.

 Adjust the camera to the desired aperture and/or shutter speed, as usual. If the camera doesn't automatically communicate apertures to the flash, apertures are set on the flash by using the ▼ and ▲ buttons on the SB-24. The aperture set on the camera and flash should match.

 Use the TTL tables that begin on page 222 to determine the shooting range (or look at the shooting range scale on the SB-24).

Setting Automatic Flash Exposure (All Nikon Bodies)

1. Set the flash mode selector on the back of the SB-24 to A.

2. Turn the power switch on the SB-24 to the standby (STBY) or ON position. The SB-24 should display ▣ in the top left of its LCD.

3. Set the ISO film speed on the SB-24, if necessary.

 In automatic (A) flash mode, all exposure calculations are done by the SB-24. If the camera doesn't automatically communicate the ISO value to the flash, you must enter the ISO value manually, or incorrect exposure may result.

4. Set the camera to aperture-priority (A) or manual (M) exposure mode.

5. Set autofocus cameras to single servo (S) autofocus mode (A on the N4004s/F-401s).

6. Focus on the subject by pressing lightly on the shutter release. Confirm that the subject is within flash range by looking at the shooting range scale on the SB-24's LCD. After you've confirmed the distance, you're ready to shoot.

 Adjust your camera to your desired aperture and/or shutter speed, as usual. If the camera doesn't automatically communicate apertures to the flash, you set apertures on the flash by using the ▼ and ▲ buttons on the SB-24. Apertures set on the camera and flash should match.

Shooting ranges for automatic (A) flash mode are shown in the tables below (or look at the shooting range scale on the SB-24).

SB-24 Usable Apertures and Flash Range in A Mode (24mm)

ISO 800	400	200	100	50	25	Range in Ft	Range in M
f/5.6	f/4	f/2.8	f/2	f/1.4	—	6.1–49	1.8–15
f/8	f/5.6	f/4	f/2.8	f/2	f/1.4	4.4–34	1.3–10
f/11	f/8	f/5.6	f/4	f/2.8	f/2	3.1–24	1.0–7.5
f/16	f/11	f/8	f/5.6	f/4	f/2.8	2.2–17	0.7–5.3
f/22	f/16	f/11	f/8	f/5.6	f/4	2.0–12	0.6–3.7
f/32	f/22	f/16	f/11	f/8	f/5.6	2.0–8.7	0.6–2.6
—	f/32	f/22	f/16	f/11	f/8	2.0–6.1	0.6–1.8

SB-24 Usable Apertures and Flash Range in A Mode (28mm)

ISO 800	400	200	100	50	25	Range in Ft	Range in M
f/5.6	f/4	f/2.8	f/2	f/1.4	—	6.6–52	2.0–16
f/8	f/5.6	f/4	f/2.8	f/2	f/1.4	4.7–37	1.5–11
f/11	f/8	f/5.6	f/4	f/2.8	f/2	3.3–26	1.0–8
f/16	f/11	f/8	f/5.6	f/4	f/2.8	2.4–18	0.7–5.6
f/22	f/16	f/11	f/8	f/5.6	f/4	2.0–13	0.6–4
f/32	f/22	f/16	f/11	f/8	f/5.6	2.0–9.2	0.6–2.8
—	f/32	f/22	f/16	f/11	f/8	2.0–6.5	0.6–2.0

SB-24 Usable Apertures and Flash Range in A Mode (35mm)

ISO 800	400	200	100	50	25	Range in Ft	Range in M
f/5.6	f/4	f/2.8	f/2	f/1.4	—	7.4–59	2.3–18
f/8	f/5.6	f/4	f/2.8	f/2	f/1.4	5.3–41	1.6–12
f/11	f/8	f/5.6	f/4	f/2.8	f/2	3.7–29	1.2–9
f/16	f/11	f/8	f/5.6	f/4	f/2.8	2.7–20	0.8–6.3
f/22	f/16	f/11	f/8	f/5.6	f/4	2.0–14	0.6–4.5
f/32	f/22	f/16	f/11	f/8	f/5.6	2.0–10	0.6–3.1
—	f/32	f/22	f/16	f/11	f/8	2.0–7.3	0.6–2.2

SB-24 Usable Apertures and Flash Range in A Mode (50mm)

ISO 800	400	200	100	50	25	Range in Ft	Range in M
f/5.6	f/4	f/2.8	f/2	f/1.4	—	8.6–66	2.6–20
f/8	f/5.6	f/4	f/2.8	f/2	f/1.4	6.0–48	1.8–14
f/11	f/8	f/5.6	f/4	f/2.8	f/2	4.3–34	1.3–10
f/16	f/11	f/8	f/5.6	f/4	f/2.8	3.1–24	1.0–7.4
f/22	f/16	f/11	f/8	f/5.6	f/4	2.2–17	0.7–5.2
f/32	f/22	f/16	f/11	f/8	f/5.6	2.0–12	0.6–3.7
—	f/32	f/22	f/16	f/11	f/8	2.0–8.6	0.6–2.6

SB-24 Usable Apertures and Flash Range in A Mode (70mm)

ISO 800	400	200	100	50	25	Range in Ft	Range in M
f/5.6	f/4	f/2.8	f/2	f/1.4	—	9.7–66	3.0–20
f/8	f/5.6	f/4	f/2.8	f/2	f/1.4	6.9–54	2.1–16
f/11	f/8	f/5.6	f/4	f/2.8	f/2	4.9–38	1.5–11
f/16	f/11	f/8	f/5.6	f/4	f/2.8	3.5–27	1.1–8.3
f/22	f/16	f/11	f/8	f/5.6	f/4	2.5–19	0.8–5.8
f/32	f/22	f/16	f/11	f/8	f/5.6	2.0–13	0.6–4.1
—	f/32	f/22	f/16	f/11	f/8	2.0–9.6	0.6–2.9

SB-24 Usable Apertures and Flash Range in A Mode (85mm)

ISO 800	400	200	100	50	25	Range in Ft	Range in M
f/5.6	f/4	f/2.8	f/2	f/1.4	—	11–66	3.2–20
f/8	f/5.6	f/4	f/2.8	f/2	f/1.4	7.3–58	3.2–20
f/11	f/8	f/5.6	f/4	f/2.8	f/2	5.2–41	1.6–12
f/16	f/11	f/8	f/5.6	f/4	f/2.8	3.7–29	0.8–6.2
f/22	f/16	f/11	f/8	f/5.6	f/4	2.6–20	0.8–6.2
f/32	f/22	f/16	f/11	f/8	f/5.6	2.0–14	0.6–4.4
—	f/32	f/22	f/16	f/11	f/8	2.0–10	0.6–3.1

Setting Manual Flash Exposure (All Nikon Bodies)

1. Set the flash mode selector on the back of the SB-24 to M.

2. Turn the power switch on the SB-24 to the standby (STBY) or ON position. The SB-24 should display **M** in the top left of its LCD.

3. Set the ISO film speed on the SB-24, if necessary.

On most cameras, ISO film speed settings are automatically communicated to the SB-24. Press the shutter release on the camera halfway and you should see the ISO value appear on the SB-24's LCD panel.

Note: You do not have to set the ISO value on the SB-24 as flash always fires at the indicated power in manual (M) flash mode. However, the shooting range scale may not show the proper results if you don't.

4. Set the camera to the desired exposure mode and set the aperture and shutter speed as usual. Make sure that the shutter speed selected is not above the camera's flash sync speed (most Nikon bodies force this).

5. Set autofocus cameras to single servo (S) autofocus mode (A on the N4004s/F-401s).

6. Focus on the subject by pressing lightly on the shutter release. Note the distance.

7. On newer cameras (F4 and N8008s/F-801s or later) equipped with lenses that have CPUs (all autofocus and AI-P lenses), simply changing the aperture on the camera will cause the SB-24 to match it. You should see the aperture on the SB-24 and the distance in the shooting range scale change as well. You have two choices (you can also use a combination of both):

1. Change the aperture on the camera until the distance noted in Step 6 is shown in the SB-24's shooting range scale.

2. Press the **M** button on the SB-24 to change the flash unit's power level until the distance noted in Step 6 is shown in the SB-24's shooting range scale.

On older cameras, or with lenses that don't have CPUs (AI and AI-S), the aperture on the camera isn't linked with the SB-24, so you should adjust the aperture and flash power settings on the SB-24 until the shooting range scale indicates the distance you noted in Step 6, and then set the aperture on the camera to match that shown on the SB-24.

Note: Nikon's manual is somewhat confusing about manual (M) flash mode, suggesting that you set the power before the aperture, and suggesting both that the SB-24 automatically sets the correct aperture to match an F4 (or later camera) and that you have to set the aperture on the camera to match. It's either/or, not both.

SB-24 Specifications (Guide Numbers in Feet)

Output Level/ Coverage	24mm	28mm	35mm	50mm	70mm	85mm	Duration (sec)
Full Power	98	105	118	138	154	164	1/1,000
1/2 Power	69	72	82	98	108	118	1/1,100
1/4 Power	49	52	59	69	75	82	1/2,700
1/8 Power	34	36	41	49	54	59	1/5,500
1/16 Power	25	26	29	34	38	41	1/11,000
Horizontal	78°	70°	60°	46°	36°	31°	
Vertical	60°	53°	45°	34°	26°	23°	

SB-24 Specifications (Guide Numbers in Meters)

Output Level	24mm	28mm	35mm	50mm	70mm	85mm
Full Power	30	32	36	42	47	50
1/2 Power	21	22	25	30	33	36
1/4 Power	15	16	18	21	23	25
1/8 Power	10.5	11	12.5	15	16.5	18
1/16 Power	7.5	8	9	10.5	11.5	12.5

Note: GNs listed are for flash head settings, not lenses! In other words, if you use a 50mm lens but the flash head is set for 35mm, using the feet table you get a GN of 118 in feet (36 m), not 138 (42).

Note: Nikon has not been consistent in the way they round numbers when calculating GNs for meters. I've used the numbers in the original manuals, complete with Nikon's rounding error.

Setting Repeating Flash (All Nikon Bodies)

1. Set the flash mode selector on the back of the SB-24 to ▦ .
2. Turn the power switch on the SB-24 to the standby (STBY) or ON position (the camera should be ON, also). The SB-24 should display ₘ▦ in the top left of its LCD. The SB-24 immediately flashes "Set" and continues to flash this until you complete Step 5.

3. Unlike other flash modes, the SB-24's repeating flash mode has very limited range (the guide number is substantially reduced, see values for 1/8 and 1/16 power in the specifications tables on page 231). Thus, it is usually best to determine the flash-to-subject distance using the SB-24 first, then adjust your camera position to match it.

Press the **M** button on the SB-24 to choose the flash power setting (only 1/8 or 1/16 are allowed). Note the distance displayed on the shooting range scale. (Changing the zoom head setting also changes the shooting distance.) This will be the flash-to-subject distance you must set up (if the subject is farther away than this distance, you're going to have to move closer).

Note: Don't proceed with the remaining steps until you've completed this one! In repeating flash (RF) mode, like manual (M) flash mode, the SB-24 fires at a fixed output level.

4. You must set both the number of flash bursts and the frequency at which they occur. Based upon the power level you set in Step 3, the SB-24 will display the maximum number of flash bursts that can be produced. You must set two items:

- The number of flash bursts is set by pressing the **▲** button until the number of flash bursts you want is shown just under the 🔢 indicator. Remember, the maximum number of flash bursts you can set is determined by the power level you set in Step 3.

- The frequency of the flash bursts is set by pressing the **▲** button until the frequency you want is shown on the LCD.

Note: For older cameras and for cameras using lenses without CPUs (AI or AI-S lenses), you must press the **SEL** button before using the **▼** and **▲** buttons to change the settings.

Note: To determine your settings, divide the number of flash bursts by the frequency (Hertz is "cycles per second"); the result should be less than the shutter speed. For example:

Number of flash bursts = 4
Frequency of flash bursts = 8 Hertz
Shutter speed = 4/8, or 1/2 second

In general, round to the next longer shutter speed, if the value falls between speeds.

5. Press the **SEL** button on the SB-24 one last time to complete your settings (the blinking should stop).

6. Set the camera to manual (M) exposure mode and set the aperture and shutter speed for ambient light levels, as usual.

 Note: If you're using repeating flash to put multiple images on a single shot, make sure that you've set a slow enough shutter speed, set Bulb (B), or have the camera set to create multiple exposures on a frame.

 Note: Nikon's manual suggests that you either place the subject against a dark background or underexpose the background. Failure to do so may result in one of two problems: (1) the background receives light from the multiple flash bursts and becomes overexposed; or (2) the subject appears to fade into the background (especially true if the distance you've calculated is off by a bit). If in doubt, bracket your exposures for the background! Another potential pitfall is that the subject doesn't move enough between flash bursts, which will tend to overexpose the overlapped area. Again, if you're in doubt, bracket (though in this case, you'd bracket the number of exposures or frequency).

Setting the Zoom Head Manually

1. Press the zoom button to change the zoom setting. Each button press selects the next higher logical setting (and you'll eventually loop back to the lowest setting). The LCD should display $_{zoom}M$ when the setting doesn't correspond to the lens being used.

2. To cancel a manual zoom setting, press the zoom button repeatedly until the $_{zoom}M$ no longer appears on the LCD (i.e., until the setting matches the focal length of the lens being used).

 Note: Remember that the guide number of the flash changes with the zoom setting (see tables on page 231).

Setting Flash Exposure Compensation

1. With the SB-24 set to TTL, press the sel button until the ⊠ indicator in the upper right portion of the LCD begins to blink.

2. Use the ▼ and ▲ buttons to adjust the amount of compensation. The SB-24 allows a maximum of +1 stop and –3 stops of flash compensation, which is indicated in 1/3-stop increments on the flash compensation indicator (i.e., each bar to the left of 0 indicates a +0.3-stop compensation, each bar to the right of 0 indicates a –0.3-stop compensation).

3. Press the ▣ button again (or wait 8 seconds) to lock in the compensation. The compensation indicator should stop blinking. The compensation amount should still appear in the LCD (unless you've set 0.0, in which case the compensation section of the LCD is blank).

4. To cancel exposure compensation, repeat Steps 1 through 3 and set a value of 0.0.

Note: Flash compensation does not change the background (ambient) exposure calculated by the camera.

Warning: *It's probably best to avoid flash compensation in any of the balanced fill-flash TTL modes. You don't know what level of compensation the camera is already making, so any changes you make are in addition to this unknown, camera-calculated compensation. For full control, switch to automatic or manual flash mode, where any compensation you dial in will be from a known flash level.*

SB-24 Notes

• TTL operation on some cameras (e.g., FA, FE2, FG) has a more limited ISO range (25–400) than later bodies (ISO 25–1,000).

• For autofocus bodies, the camera's focus mode selector should be set to single servo (S) autofocus (N50/F50 should be set to AF, and the N5005/F-401x, N4004s/F-401s, and N4004/F-401 should be set to A). The camera won't take a picture and the flash won't fire unless the subject is in focus. The autofocus assist illuminator is used automatically if the ambient light is low. Autofocus assist works only at distances from 3.2 feet (1 m) up to 26.2 feet (8 m), and with lenses up to 105mm.

• If the F indicator on the SB-24's LCD panel is blinking, that means that the flash needs you to set the aperture. This happens in several situations: (1) in automatic (A) flash mode; (2) when using lenses without a CPU (AI or AI-S lenses); and (3) when using earlier Nikon bodies (generally those prior to the F4 and N8008/F-801). If the F is blinking, use the ▼ and ▲ buttons to set the correct aperture on the flash (i.e., the aperture that matches what is set on the camera).

- With the power switch in standby (STBY) position and most Nikon bodies, the SB-24 automatically turns OFF 80 seconds after the camera's meter turns OFF. A light press on the shutter release generally turns most Nikon bodies' light meters back ON, and the SB-24 will turn ON at the same time. A few older bodies do not control the flash in this manner. On those cameras, when the SB-24 is in STBY, it automatically turns itself OFF after 80 seconds, regardless of whether the camera meter is active or not. To restore power to the SB-24, turn the SB-24 OFF and back ON.

 Note: The SB-24 has a "special" standby mode, which leaves the unit ready, regardless of the camera's meter state. To activate this special mode, start with the SB-24 in the OFF position. Hold down the LCD illumination button and turn the SB-24's power switch to STBY. Release the LCD illumination button. To cancel this mode, simply move the power switch back to the OFF position. A fresh set of alkaline batteries will last approximately 20 days in this setting; NiCds, about 10 days.

- If you are using the SB-24 on a body set to a mechanical shutter speed (M250, M90, B), set the SB-24's power switch to the ON position only. Standby (STBY) is not operative. Likewise, standby doesn't operate if you're using an F3, FM2, FM10, FE10, or an FA or FE2 that incorporates the MD-12 Motor Drive.

- The SB-24 can recycle fast enough to provide flash at the following motor drive rates:

Output	Motor Drive Speed	Maximum Flash Bursts
M1/16	3.4 to 6 fps	8
M1/16	< 3.3 fps	10
M1/8	3.4 to 6 fps	4
M1/8	< 3.3 fps	5

With the optional SD-7 External Power Accessory, the maximum number of flash bursts increases by about 25% at fast speeds, more at slower motor drive speeds. However, you should never fire the flash more than 40 times in a row. Indeed, it's best to let the flash rest for 10 minutes every time you fire off 10 or more quick flash bursts.

- The shooting range scale does not appear on the LCD panel if the flash head is tilted or rotated (exception: the scale blinks if the flash is set at −7° below horizontal).

- While the SB-24 has "click stops" for commonly used flash head positions (45, 60, 75, and 90° for tilt, every 30° for rotation), you aren't restricted to those positions. Setting an intermediate position is allowed (though it can easily be dislodged).

- Ready light warnings (blinking light) occur in the following conditions:

 When you attempt to use the SB-24 in TTL mode on cameras that are not TTL-capable (see "Non-TTL-Capable Bodies," page 326).

 When you attempt to use the SB-24 in A mode on cameras set to a mechanical shutter speed (M250, M90, B).

 When you attempt to use the SB-24 in TTL mode with an unavailable film speed (e.g., ISO 800 on an FA, FE2, FG, or N4004s/F-401s).

 When the shutter speed is set faster than the allowable flash sync speed of the camera (on FE and FM2, for example).

 When you've taken a flash picture with the SB-24 in TTL or A mode and the flash fired at full power (indicating it might have produced insufficient light for a flash exposure). However, in extremely bright scenes, the N4004s/F-401s may not blink its flash indicator, even when insufficient light was produced by the flash.

 On an N4004s/F-401s: When the SB-24 and the camera's built-in flash are both OFF, but the camera's meter recommends flash use.

- Changing the ISO film speed setting on the SB-24 does not change the way the flash fires, except in automatic (A) flash mode. In other modes, changing the ISO value changes only the apertures displayed in the shooting range table. Accidentally moving the ISO setting after correctly making all flash and camera adjustments won't affect the resulting exposure.

SB-25

In appearances and power ratings, the SB-25 looks a lot like the SB-24. However, it also has a number of additional useful features, including the pull-out diffuser for 20mm lenses, a locking pin on the hot shoe, red-eye reduction, and the FP high-speed sync flash mode. It was introduced in 1992.

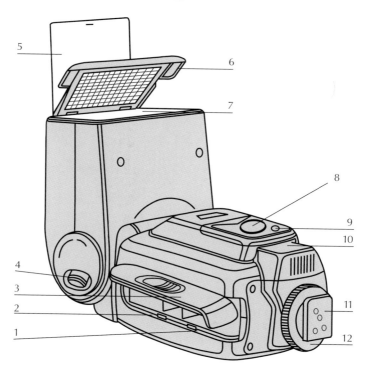

1	Battery compartment	7	Flashtube
2	Distance units selection switch	8	AF assist illuminator
		9	Light sensor
3	Battery compartment cover	10	External power socket (under logo)
4	Tilt lock/release lever		
5	Diffuser card	11	Flash mounting foot (ISO)
6	Wide-angle adapter	12	Locking ring

12 Sync socket
13 TTL multiple flash socket
14 Rubber terminal cover
15 Sync mode selector
16 Rotation angle scale
17 Tilt angle scale
18 Rotation lock/release lever
19 Flash mode selector switch
20 LCD information display
21 LCD illuminator button
22 M (manual adjustment) button
23 On/Off/standby switch
24 Selection (SEL) button
25 Adjustment toggle buttons
26 Ready light/test fire button
27 Zoom setting button

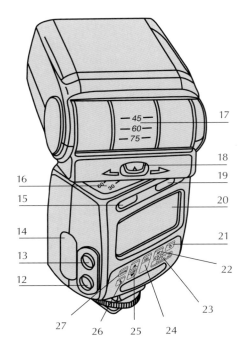

Specifications

GN:	118 (ft), 36 (m)
Weight:	13.4 oz (380 g) (w/o batteries)
Size:	5.3" (135 mm) tall x 3.1" (79 mm) wide x 4.0" (101 mm) deep
Power:	4 AA batteries
Recycle Time:	7 seconds minimum (full discharge)
No. of Flashes:	~100 at full manual
Flash Duration:	1/1,000 second
Coverage:	(102° horizontal, 90° vertical) 20mm lens; also supports 24mm, 28mm, 35mm, 50mm, 70mm, and 85mm coverage
Case:	SS-24 for main unit

Key Features: TTL flash control on most TTL-capable Nikon
bodies, monitor pre-flash on N90/F90 or later
bodies; full power TTL, seven power level
manual, and automatic (six apertures) settings.
LCD panel shows settings. Rear-curtain sync.
High-speed sync, repeating flash, red-eye
reduction. The SB-25 can synchronize with up to
four additional flash units. Head tilts from –7°
below horizontal up to 90° above horizontal, and
rotates –270° to +180° clockwise. Built-in diffuser
card. Autofocus assist illuminator.

Note: The SB-25 features a locking pin, which is controlled by the
knurled knob on the hot shoe mechanism. The knob should be
turned fully counterclockwise (to the right when facing the back of
the SB-25) to retract the pin before putting the flash onto the
camera. Once the SB-25 is on the camera, turn the knob clockwise
(to the left when facing the back of the SB-25) to lock the flash to
the camera (all bodies starting with the N90/F90 have the proper
slot for the pin. Likewise, be sure to retract the locking pin by
turning the knob fully counterclockwise (to the right when facing
the back of the SB-25) before attempting to remove the flash from
the camera. Failure to do so could damage the flash or camera.

Note: Before using your SB-25, you should set the distance scale
to feet or meters. This is done by opening the battery chamber and
sliding the small switch on the left side of the chamber (as you face
it) to m (for meters) or ft (for feet).

The SB-25's user controls are a classic example of what is called
"user interface overload." This means that some controls and
display information have multiple uses or relate to multiple items
depending upon the context. This reduces the number of buttons
and indicators needed, but places a burden on the user to keep
track of what mode they're in. A few things to remember:

• Blinking on the LCD indicates either a warning or that you're
in the midst of setting an item. Blinking should not be ignored.
Either the Speedlight is not set correctly, or you haven't finished
setting something.

- Most buttons are designed to be pressed more than once. Each press gives you the next logical setting (next higher zoom head setting, next lower manual power amount, etc.). When buttons use multiple presses to select an item, they loop through the choices (i.e., after the last choice you'll be taken back to the first).

- Display indicators on the LCD don't appear unless they're active (e.g., you won't see the exposure compensation indicator unless you're in the midst of setting, or have already set, flash compensation).

- The camera and flash interact, but some controls override this! For example, with an autofocus zoom lens on the camera, zooming the lens will automatically change the flash zoom head setting to match. But if you manually set the zoom position, continuing to zoom the lens will not change the flash unit's zoom head setting.

Setting Automatic TTL Flash Exposure (Newer TTL-Capable Nikon Bodies)

1. Set the flash mode selector on the back of the SB-25 to ▥.

2. Turn the power switch on the SB-25 to the standby (STBY) or ON position.

3. Set the ISO film speed on the SB-25, if necessary.

 On the N8008/F-801, F4, F5, F100, N80/F80, N70/F70, N90/F90, F90X/N90s, N50/F50, and N60/F60, ISO film speed settings are automatically communicated to the SB-25. Press the shutter release on the camera halfway and you should see the correct ISO value appear on the SB-25's LCD panel.

 For older camera bodies, press the ▥ button on the SB-25 until the term ISO begins blinking in the LCD panel. When it is blinking, use the ▼ and ▲ buttons to adjust the value (which appears just to the right of the blinking ISO). When the value you want is set, either wait 8 seconds or press the ▥ button again to lock it in.

 Note: You do not have to set the ISO value on the SB-25 as in TTL flash mode all exposure calculations are done by the camera. However, the shooting range scale may not show the proper results if you don't.

4. Select the type of TTL to be performed. Basically, with most modern Nikon bodies you have only one choice: whether or not to cancel the "balanced fill-flash" mode. Otherwise, the SB-25 sets the TTL mode based upon the camera body, lens type, and metering system as follows:

N90/F90 and later bodies (any body that supports the 3D flash capability, see "Camera Capabilities," pages 326–327): 3D balanced fill-flash (TTL) is performed in all metering modes if a D-type lens is mounted on the camera. Multi-sensor balanced fill-flash (TTL) is performed for all other autofocus and AI-P lenses. For all other lenses, center-weighted fill-flash (TTL) or spot fill-flash (TTL) is performed based upon metering selection.

With other TTL-capable bodies, matrix balanced fill-flash (TTL), center-weighted fill-flash (TTL), or spot fill-flash (TTL) is usually performed (matrix is available only with an autofocus or AI-P lens) depending upon metering mode. In some cases (F4 with AI or AI-S lens, for example), standard TTL is performed instead.

Note: When the camera body is set for spot metering, standard TTL is set automatically.

Note: The N4004s/F-401s allows only programmed TTL flash and the 🔲 indicator does not appear, even though the camera and flash will perform TTL. See "Setting Programmed TTL Flash Exposure," page 245.

5. Set autofocus cameras to single servo (S) autofocus mode.
6. Set the camera's exposure mode, if you haven't already. In aperture-priority (A), shutter-priority (S), and manual (M) exposure modes, make any necessary aperture or shutter speed selections.

With AI, AI-S, and AF teleconverters, some cameras will switch automatically to aperture-priority (A) exposure mode (program and shutter-priority modes are not available). Other cameras need to be manually switched to aperture-priority (A) mode with these lenses.

In program modes you can usually override the camera's selection of aperture and shutter speed combinations by turning the camera's control dial (when the shutter release is partially pressed).

The aperture the camera (or you) selected also appears on the SB-25's LCD panel when you partially press the shutter release.

Note: The camera and SB-25 may warn you of several possible errors when you partially press the shutter release to verify settings:

In program modes (P, PD, PH), and on the most recent bodies (F5, F100, F80), the lens must be set on its minimum aperture, or else the error message ғЄЄ appears in the viewfinder.

Any time that ⊷ is visible in the viewfinder indicates that overexposure is likely. For many of the later bodies, starting with the N8008/F-801, the placement of the ⊷ varies with exposure mode: ⊷ and the smallest aperture appear in the camera's viewfinder if overexposure is likely in any of the program (P) modes. ⊷ appears in place of the aperture for overexposure warnings in shutter-priority (S) mode. ⊷ appears in place of the shutter speed in aperture-priority (A) mode.

The shutter speed automatically resets to 1/250 second if you selected a faster shutter speed in shutter-priority (S) or manual (M) exposure mode.

In manual (M) exposure mode, under- and overexposure are indicated solely by the analog exposure display. If the exposure bar goes to either side of the 0 point, the ambient-only lighting exposure will not be correct.

7. Focus on the subject by pressing lightly on the shutter release. Confirm that the subject is within flash range by looking at the shooting range scale on the SB-25's LCD. After you've confirmed the distance, you're ready to shoot.

SB-25 Usable Apertures and Flash Range in TTL Mode (20mm)

ISO 800	400	200	100	50	25	Range in Ft*	Range in M
f/2	f/1.4	—	—	—	—	8.2–60	2.5–20
f/2.8	f/2	f/1.4	—	—	—	5.7–60	1.8–20
f/4	f/2.8	f/2	f/1.4	—	—	4.1–46	1.3–14
f/5.6	f/4	f/2.8	f/2	f/1.4	—	2.8–32	0.8–10
f/8	f/5.6	f/4	f/2.8	f/2	f/1.4	2.1–23	0.7–7
f/11	f/8	f/5.6	f/4	f/2.8	f/2	2.0–16	0.6–5
f/16	f/11	f/8	f/5.6	f/4	f/2.8	2.0–11	0.6–3.5
f/22	f/16	f/11	f/8	f/5.6	f/4	2.0–8.2	0.6–2.5
f/32	f/22	f/16	f/11	f/8	f/5.6	2.0–5.7	0.6–1.7
—	f/32	f/22	f/16	f/11	f/8	2.0–4.1	0.6–1.2

SB-25 Usable Apertures and Flash Range in TTL Mode (24mm)

ISO 800	400	200	100	50	25	Range in Ft*	Range in M
f/2	f/1.4	—	—	—	—	12–60	3.8–20
f/2.8	f/2	f/1.4	—	—	—	8.7–60	2.7–20
f/4	f/2.8	f/2	f/1.4	—	—	6.2–60	1.9–20
f/5.6	f/4	f/2.8	f/2	f/1.4	—	4.4–49	1.4–15
f/8	f/5.6	f/4	f/2.8	f/2	f/1.4	3.1–34	1.0–10
f/11	f/8	f/5.6	f/4	f/2.8	f/2	2.2–24	0.7–7.5
f/16	f/11	f/8	f/5.6	f/4	f/2.8	2.0–17	0.6–5.3
f/22	f/16	f/11	f/8	f/5.6	f/4	2.0–12	0.6–3.7
f/32	f/22	f/16	f/11	f/8	f/5.6	2.0–8.6	0.6–2.6
—	f/32	f/22	f/16	f/11	f/8	2.0–6.1	0.6–1.8

SB-25 Usable Apertures and Flash Range in TTL Mode (28mm)

ISO 800	400	200	100	50	25	Range in Ft*	Range in M
f/2	f/1.4	—	—	—	—	13–60	4.0–20
f/2.8	f/2	f/1.4	—	—	—	9.3–60	2.9–20
f/4	f/2.8	f/2	f/1.4	—	—	6.6–60	2.0–20
f/5.6	f/4	f/2.8	f/2	f/1.4	—	4.7–52	1.5–16
f/8	f/5.6	f/4	f/2.8	f/2	f/1.4	3.3–37	1.0–11
f/11	f/8	f/5.6	f/4	f/2.8	f/2	2.4–26	0.7–8
f/16	f/11	f/8	f/5.6	f/4	f/2.8	2.0–18	0.6–56.
f/22	f/16	f/11	f/8	f/5.6	f/4	2.0–13	0.6–4
f/32	f/22	f/16	f/11	f/8	f/5.6	2.0–9.2	0.6–2.8
—	f/32	f/22	f/16	f/11	f/8	2.0–6.5	0.6–2.0

SB-25 Usable Apertures and Flash Range in TTL Mode (35mm)

ISO 800	400	200	100	50	25	Range in Ft*	Range in M
f/2	f/1.4	—	—	—	—	15–60	4.5 -20
f/2.8	f/2	f/1.4	—	—	—	11–60	3.2–20
f/4	f/2.8	f/2	f/1.4	—	—	7.4–60	2.3–20
f/5.6	f/4	f/2.8	f/2	f/1.4	—	5.2–60	1.6–18
f/8	f/5.6	f/4	f/2.8	f/2	f/1.4	3.7–41	1.1–13
f/11	f/8	f/5.6	f/4	f/2.8	f/2	2.6–29	0.8–9
f/16	f/11	f/8	f/5.6	f/4	f/2.8	2.0–20	0.6–6.3
f/22	f/16	f/11	f/8	f/5.6	f/4	2.0–14	0.6–4.5
f/32	f/22	f/16	f/11	f/8	f/5.6	2.0–10	0.6–3.2
—	f/32	f/22	f/16	f/11	f/8	2.0–7.3	0.6–2.3

SB-25 Usable Apertures and Flash Range in TTL Mode (50mm)

ISO 800	400	200	100	50	25	Range in Ft*	Range in M
f/2	f/1.4	—	—	—	—	17–60	5.2–20
f/2.8	f/2	f/1.4	—	—	—	12–60	3.7–20
f/4	f/2.8	f/2	f/1.4	—	—	8.6–60	2.6–20
f/5.6	f/4	f/2.8	f/2	f/1.4	—	6.1–60	1.9–20
f/8	f/5.6	f/4	f/2.8	f/2	f/1.4	4.3–48	1.4–14
f/11	f/8	f/5.6	f/4	f/2.8	f/2	3.0–34	1.0–10
f/16	f/11	f/8	f/5.6	f/4	f/2.8	2.2–24	0.7–7.4
f/22	f/16	f/11	f/8	f/5.6	f/4	2.0–17	0.6–5.2
f/32	f/22	f/16	f/11	f/8	f/5.6	2.0–12	0.6–3.7
—	f/32	f/22	f/16	f/11	f/8	2.0–8.6	0.6–2.6

SB-25 Usable Apertures and Flash Range in TTL Mode (70mm)

ISO 800	400	200	100	50	25	Range in Ft*	Range in M
f/2	f/1.4	—	—	—	—	20–60	6.0–20
f/2.8	f/2	f/1.4	—	—	—	14–60	4.3–20
f/4	f/2.8	f/2	f/1.4	—	—	9.8–60	3.0–20
f/5.6	f/4	f/2.8	f/2	f/1.4	—	7.0–60	2.2–20
f/8	f/5.6	f/4	f/2.8	f/2	f/1.4	4.9–55	1.5–16
f/11	f/8	f/5.6	f/4	f/2.8	f/2	3.5–39	1.1–12
f/16	f/11	f/8	f/5.6	f/4	f/2.8	2.5–27	0.8–8.4
f/22	f/16	f/11	f/8	f/5.6	f/4	2.0–19	0.6–6.0
f/32	f/22	f/16	f/11	f/8	f/5.6	2.0–13	0.6–4.2
—	f/32	f/22	f/16	f/11	f/8	2.0–9.8	0.6–3.0

SB-25 Usable Apertures and Flash Range in TTL Mode (85mm)

ISO 800	400	200	100	50	25	Range in Ft*	Range in M
f/2	f/1.4	—	—	—	—	21–60	6.3–20
f/2.8	f/2	f/1.4	—	—	—	15–60	4.5–20
f/4	f/2.8	f/2	f/1.4	—	—	10–60	3.2–20
f/5.6	f/4	f/2.8	f/2	f/1.4	—	7.2–60	2.2–20
f/8	f/5.6	f/4	f/2.8	f/2	f/1.4	5.1–58	1.6–17
f/11	f/8	f/5.6	f/4	f/2.8	f/2	3.6–41	1.1–12
f/16	f/11	f/8	f/5.6	f/4	f/2.8	2.6–29	0.8–8.8
f/22	f/16	f/11	f/8	f/5.6	f/4	2.0–20	0.6–6.2
f/32	f/22	f/16	f/11	f/8	f/5.6	2.0–14	0.6–4.4
—	f/32	f/22	f/16	f/11	f/8	2.0–10	0.6–3.1

* Nikon's published numbers—which I've duplicated in the tables on pages 242 to 244—appear to have some inconsistencies. First, the 60-foot maximum range is different from the 66-foot range of the SB-24. Indeed, if you use standard conversion rates (3.28 m to the foot) and apply it to Nikon's listed ranges in meters, the maximum distance should be 66 (assuming that the 20 m maximum range was accurate).

Likewise, the ranges for smaller apertures (the last three lines of each table) must also have rounding or calculation errors in them. Many are the same as Nikon listed for the SB-24, but some are different.

Finally, note that while the SB-24 and SB-25 have identical guide numbers, unexplained, significant non-rounding differences appear in the usable aperture tables for each, especially at the larger apertures.

Setting Programmed TTL Flash Exposure (N2020/F-501, N4004s/ F-401s, N2000/F-301)

1. Set the flash mode selector on the back of the SB-25 to **TTL**.

2. Turn the power switch on the SB-25 to the standby (STBY) or ON position.

3. Confirm the ISO film speed on the SB-25.

 On these cameras, ISO film speed settings are automatically communicated to the SB-25. Press the shutter release on the camera halfway and you should see the ISO value appear on the SB-25's LCD panel.

 Note: You do not have to set the ISO value on the SB-25 as in TTL flash mode all exposure calculations are done by the camera. However, the shooting range scale may not show the proper results if you don't.

4. Set the camera to program auto (on the N4004s/F-401s: shutter speed dial at A, aperture dial at S; on the other cameras: shutter speed dial at PDUAL, P, or PHIGH and the lens set at its smallest aperture).

 Note: The N4004s/F-401s performs only programmed TTL flash, but the 🔄 indicator does not appear on the SB-25's LCD.

 Note: Setting exposure modes other than program (P) results in standard TTL flash being used (exception: N4004/F-401 will also perform programmed TTL flash when set to shutter-priority [S] exposure mode).

5. Set autofocus cameras to single servo (S) autofocus mode.

6. Focus on the subject by pressing lightly on the shutter release. Confirm that the subject is within flash range by looking at the

shooting range scale on the SB-25's LCD. After you've con-
firmed the distance, you're ready to shoot.

You can set apertures on the flash unit by using the ⬇ and ⬆
buttons on the SB-25. N4004s/F-401s users should set the
aperture according to the ISO value of the film they're using (see
table below).

SB-25 Usable Apertures and Flash Range in Programmed TTL Mode

Zoom	ISO 400	200	100	50	25	Range in Ft	Range in M
20mm	f/11	f/8	f/5.6	f/4	f/2.8	2.0–11	0.6–3.5
24mm	f/11	f/8	f/5.6	f/4	f/2.8	2.0–17	0.6–5.3
28mm	f/11	f/8	f/5.6	f/4	f/2.8	2.0–18	0.6–5.6
35mm	f/11	f/8	f/5.6	f/4	f/2.8	2.0–20	0.6–6.3
50mm	f/11	f/8	f/5.6	f/4	f/2.8	2.2–24	0.7–7.4
70mm	f/11	f/8	f/5.6	f/4	f/2.8	2.5–27	0.8–8.4
85mm	f/11	f/8	f/5.6	f/4	f/2.8	2.6–29	0.8–8.8

Setting Aperture-Priority or Shutter-Priority Programmed TTL Flash Exposure (N2020/F-501, N4004s/F-401s, N2000/F-301)

1. Set the flash mode selector on the back of the SB-25 to **TTL**.

2. Turn the power switch on the SB-25 to the standby (STBY) or ON
 position.

3. Set the ISO film speed on the SB-25, if necessary.

 On most cameras, ISO film speed settings are automatically
 communicated to the SB-25. Press the shutter release on the
 camera halfway and you should see the ISO value appear on the
 SB-25's LCD panel.

 Note: You do not have to set the ISO value on the SB-25 as in
 TTL flash mode all exposure calculations are done by the
 camera. However, the shooting range scale may not show the
 proper results if you don't.

4. Set the camera to aperture-priority (A) or shutter-priority (S)
 exposure mode.

5. Set autofocus cameras to single servo (S) autofocus mode (A on
 the N4004s/F-401s).

6. Focus on the subject by pressing lightly on the shutter release. Confirm that the subject is within flash range by looking at the shooting range scale on the SB-25's LCD. After you've confirmed the distance, you're ready to shoot.

 Adjust your camera to the desired aperture and/or shutter speed as usual. If the camera doesn't automatically communicate apertures to the flash, set the aperture on the flash by using the ▼ and ▲ buttons. Aperture settings on both the camera and flash should match.

 Use the TTL tables that begin on page 242 to determine the shooting range (or look at the shooting range scale on the SB-25).

Setting Automatic Flash Exposure (All Nikon Bodies)

1. Set the flash mode selector on the back of the SB-25 to A.

2. Turn the power switch on the SB-25 to the standby (STBY) or ON position. The SB-25 should display A in the top left of its LCD.

3. Set the ISO film speed on the SB-25, if necessary.

 In automatic (A) flash mode, all exposure calculations are performed by the SB-25. If the camera doesn't automatically communicate the ISO value to the flash, you must set the ISO manually, or incorrect exposure may result.

4. Set the camera to aperture-priority (A) or manual (M) exposure mode.

5. Set autofocus cameras to single servo (S) autofocus mode (A on the N4004s/F-401s).

6. Focus on the subject by pressing lightly on the shutter release. Note the distance.

7. Adjust the camera to the desired aperture and/or shutter speed, as usual. Set the aperture on the flash by using the ▼ and ▲ buttons on the SB-25. The aperture on both the camera and flash should match.

 Confirm that the subject is within flash range by looking at the shooting range scale on the SB-25's LCD and comparing it to the distance you noted in Step 6. Or, shooting ranges for automatic (A) flash mode are shown in the tables below (or look at the shooting range scale on the SB-25).

SB-25 Usable Apertures and Flash Range in A Mode (20mm)

ISO 800	400	200	100	50	25	Range in Ft	Range in M
f/5.6	f/4	f/2.8	f/2	f/1.4	—	2.8–32	0.8–10
f/8	f/5.6	f/4	f/2.8	f/2	f/1.4	2.1–23	0.7–7
f/11	f/8	f/5.6	f/4	f/2.8	f/2	2.0–16	0.6–5
f/16	f/11	f/8	f/5.6	f/4	f/2.8	2.0–11	0.6–3.5
f/22	f/16	f/11	f/8	f/5.6	f/4	2.0–8.2	0.6–2.5
f/32	f/22	f/16	f/11	f/8	f/5.6	2.0–5.7	0.6–1.7

SB-25 Usable Apertures and Flash Range in A Mode (24mm)

ISO 800	400	200	100	50	25	Range in Ft	Range in M
f/5.6	f/4	f/2.8	f/2	f/1.4	—	4.4–49	1.4–15
f/8	f/5.6	f/4	f/2.8	f/2	f/1.4	3.1–34	1.0–10
f/11	f/8	f/5.6	f/4	f/2.8	f/2	2.2–24	0.7–7.5
f/16	f/11	f/8	f/5.6	f/4	f/2.8	2.0–17	0.6–5.3
f/22	f/16	f/11	f/8	f/5.6	f/4	2.0–12	0.6–3.7
f/32	f/22	f/16	f/11	f/8	f/5.6	2.0–8.6	0.6–2.6

SB-25 Usable Apertures and Flash Range in A Mode (28mm)

ISO 800	400	200	100	50	25	Range in Ft	Range in M
f/5.6	f/4	f/2.8	f/2	f/1.4	—	4.7–52	1.5–16
f/8	f/5.6	f/4	f/2.8	f/2	f/1.4	3.3–37	1.0–11
f/11	f/8	f/5.6	f/4	f/2.8	f/2	2.4–26	0.7–8
f/16	f/11	f/8	f/5.6	f/4	f/2.8	2.0–18	0.6–5.6
f/22	f/16	f/11	f/8	f/5.6	f/4	2.0–13	0.6–4
f/32	f/22	f/16	f/11	f/8	f/5.6	2.0–9.2	0.6–2.8

SB-25 Usable Apertures and Flash Range in A Mode (35mm)

ISO 800	400	200	100	50	25	Range in Ft	Range in M
f/5.6	f/4	f/2.8	f/2	f/1.4	—	5.2–60	1.6–18
f/8	f/5.6	f/4	f/2.8	f/2	f/1.4	3.7–41	1.1–13
f/11	f/8	f/5.6	f/4	f/2.8	f/2	2.6–29	0.8–9
f/16	f/11	f/8	f/5.6	f/4	f/2.8	2.0–20	0.6–6.3
f/22	f/16	f/11	f/8	f/5.6	f/4	2.0–14	0.6–4.5
f/32	f/22	f/16	f/11	f/8	f/5.6	2.0–10	0.6–3.2

SB-25 Usable Apertures and Flash Range in A Mode (50mm)

ISO 800	400	200	100	50	25	Range in Ft	Range in M
f/5.6	f/4	f/2.8	f/2	f/1.4	—	6.1–60	1.9–20
f/8	f/5.6	f/4	f/2.8	f/2	f/1.4	4.3–48	1.4–14
f/11	f/8	f/5.6	f/4	f/2.8	f/2	3.0–34	1.0–10
f/16	f/11	f/8	f/5.6	f/4	f/2.8	2.2–24	0.7–7.4
f/22	f/16	f/11	f/8	f/5.6	f/4	2.0–17	0.6–5.2
f/32	f/22	f/16	f/11	f/8	f/5.6	2.0–12	0.6–3.7

SB-25 Usable Apertures and Flash Range in A Mode (70mm)

ISO 800	400	200	100	50	25	Range in Ft	Range in M
f/5.6	f/4	f/2.8	f/2	f/1.4	—	7.0–60	2.2–20
f/8	f/5.6	f/4	f/2.8	f/2	f/1.4	4.9–55	1.5–16
f/11	f/8	f/5.6	f/4	f/2.8	f/2	3.5–39	1.1–12
f/16	f/11	f/8	f/5.6	f/4	f/2.8	2.5–27	0.8–8.4
f/22	f/16	f/11	f/8	f/5.6	f/4	2.0–19	0.6–6.0
f/32	f/22	f/16	f/11	f/8	f/5.6	2.0–13	0.6–4.2

SB-25 Usable Apertures and Flash Range in A Mode (85mm)

ISO 800	400	200	100	50	25	Range in Ft	Range in M
f/5.6	f/4	f/2.8	f/2	f/1.4	—	7.2–60	2.2–20
f/8	f/5.6	f/4	f/2.8	f/2	f/1.4	5.1–58	1.6–17
f/11	f/8	f/5.6	f/4	f/2.8	f/2	3.6–41	1.1–12
f/16	f/11	f/8	f/5.6	f/4	f/2.8	2.6–29	0.8–8.8
f/22	f/16	f/11	f/8	f/5.6	f/4	2.0–20	0.6–6.2
f/32	f/22	f/16	f/11	f/8	f/5.6	2.0–14	0.6–4.4

Setting Manual Flash Exposure (All Nikon Bodies)

1. Set the flash mode selector on the back of the SB-25 to M.
2. Turn the power switch on the SB-25 to the standby (STBY) or ON position. The SB-25 should display **M** in the top left of its LCD.
3. Set the ISO film speed on the SB-25, if necessary.

On most cameras, ISO film speed settings are automatically communicated to the SB-25. Press the shutter release on the camera halfway and you should see the ISO value appear on the SB-25's LCD panel.

Note: You do not have to set the ISO value on the SB-25 as in the manual (M) flash mode flash always fires at the indicated power. However, the shooting range scale may not show the proper results if you don't.

4. Set the camera to the desired exposure mode and set the aperture and shutter speed, as usual. Make sure that the shutter speed selected is not above the camera's flash sync speed (most Nikon bodies force this).

5. Set autofocus cameras to single servo (S) autofocus mode (A on the N4004s/F-401s).

6. Focus on the subject by pressing lightly on the shutter release. Note the distance.

7. On newer cameras (F4 and N8008s/F-801s or later) equipped with lenses that have CPUs (all autofocus and AI-P lenses), simply changing the aperture on the camera will cause the SB-25 to match it. You should see the aperture change on the SB-25 and the distance in the shooting range scale change as well. You have two choices (you can also use a combination of both):

1. Change aperture on the camera until the distance noted in Step 6 is shown in the SB-25's shooting range scale.

2. Press the **M** button on the SB-25 to change the flash unit's power level until the distance noted in Step 6 is shown in the SB-25's shooting range scale.

Note: You can also simply press the **▼** and **▲** buttons to change the power ratings at this point in the process.

On older cameras, or with lenses that don't have CPUs (AI and AI-S), the aperture on the camera isn't linked with the SB-25, so you should adjust aperture and flash power settings on the SB-25 until the shooting range scale indicates the distance you noted in Step 6, and then set the aperture on the camera to match that shown on the SB-25.

Note: On N90/F90 and newer bodies, the power setting of the SB-25 can be controlled in 1/3-stop increments between M1/2 and M1/64 power. You control these additional settings by pressing the **SEL** button until the **⚡︎** indicator begins flashing, then using the **▼** and **▲** buttons to choose a value (0.3 is 1/3 stop, 0.7 is 2/3 stop). Press **SEL** a second time to lock in the chosen value.

Note: M1/64 1 and M1/64 2 refer to the FP high-speed flash mode (see "Setting FP High-Speed Flash," on page 254). Don't set the power rating to these for normal flash use.

Note: The SB-25 is capable of keeping up with a motor-driven camera (up to 6 fps) at powers of M1/8, M1/16, M1/32, or M1/64 as follows:

M1/8	**4 consecutive frames**
M1/16	**8 consecutive frames**
M1/32	**16 consecutive frames**
M1/64	**30 consecutive frames**

However, let the flash cool at least 10 minutes after firing the number of frames listed above.

SB-25 Specifications (Guide Numbers in Feet)

Output Level/ Coverage	20mm	24mm	28mm	35mm	50mm	70mm	85mm	Duration (sec)
Full Power	66	98	105	118	138	157	164	1/1,000
1/2 Power	46	69	72	82	98	112	118	1/1,100
1/4 Power	33	49	52	59	69	79	82	1/2,500
1/8 Power	23	33	36	43	49	56	59	1/5,000
1/16 Power	16	25	26	30	33	39	43	1/8,700*
1/32 Power	11	17	19	21	25	28	30	1/12,000
1/64 Power	8.2	12**	13	15	17	20	21	1/23,000
Horizontal	102°	78°	70°	60°	46°	36°	31°	
Vertical	90°	60°	53°	45°	34°	26°	23°	

** Nikon manual is incorrect (it states 1/87,000!).*

*** Nikon manual is incorrect (it states 17).*

SB-25 Specifications (Guide Numbers in Meters)

Output Level	20mm	24mm	28mm	35mm	50mm	70mm	85mm
Full Power	20	30	33	36	42	48	50
1/2 Power	14	21	23	26	30	34	36
1/4 Power	10	15	16	18	21	24	25
1/8 Power	7	10	11	13	15	17	18
1/16 Power	5	7.5	8	9	10	12	13
1/32 Power	3.5	5.3	5.7	6.4	7.5	8.5	9
1/64 Power	2.5	3.8	4	4.5	5.3	6	6.3

Note: GNs listed are for flash head settings, not lenses! In other words, if you use a 50mm lens but the flash head is set for 35mm, using the feet chart, you get a GN of 118, not 138.

Note: Nikon has not been consistent in the way they round numbers when calculating GNs for meters. I've used the numbers in the original manuals, complete with Nikon's rounding error.

Setting Repeating Flash (All Nikon Bodies)

1. Set the flash mode selector on the back of the SB-25 to ⚏.

2. Turn the power switch on the SB-25 to the standby (STBY) or ON position (the camera should be ON, also). The SB-25 should display Ⓜ⚏ in the top left of its LCD.

3. Press the Ⓜ button on the SB-25 to choose the flash power setting (only settings between 1/8 or 1/64 are allowed). Note the distance displayed on the shooting range scale. (*Note:* Changing the zoom head setting also changes the shooting distance.) This will be the flash-to-subject distance you must have (i.e., if the subject is farther away than this distance, you'll need to move closer). You'll get another chance to modify the distance slightly in Step 8.

 Note: Don't proceed with the remaining steps until you've completed this one! In repeating flash (RF) mode, like manual (M) flash mode, the SB-25 fires at a fixed output level.

4. You must set both the number of flash bursts and the frequency at which they occur. Based upon the power level you set in Step 3, the SB-25 will display the maximum number of flash bursts that can be produced. You must set two items:

 • The frequency of the flash bursts is set by pressing the 🔲 button until the number next to the **Hz** label begins blinking, then pressing the 🔻 and 🔺 buttons until the frequency you want is shown on the LCD.

 • The number of flash bursts is set by again pressing the 🔲 button (the number of flash bursts begins blinking), then pressing the 🔻 and 🔺 buttons until the number of flash bursts you want is shown just under the Ⓜ indicator. The maximum number of flash bursts you can set is determined by the power level you set in Step 3. Note the following chart:

Frequency	M1/8	M1/16	M1/32	M1/64
1–7 Hz	20	40	80	160
8–10 Hz	10	20	40	80
20–60 Hz	8	16	20	40

Note: To determine your settings, divide the number of flash bursts by the frequency (Hertz is "cycles per second"); the result should be less than the shutter speed. For example:

Number of flash bursts = 4
Frequency of flash bursts = 8 Hertz
Shutter speed = 4/8, or 1/2

In general, round to the next longer shutter speed if the value falls between speeds.

5. Press the ▣ button on the SB-25 one last time to complete your settings (the blinking should stop).

6. Set the camera to manual (M) exposure mode and set your aperture and shutter speed for ambient light levels, as usual.

 Note: Since you're using repeating flash to put multiple images on a single frame, make sure that you've set a slow enough shutter speed, set Bulb, or have the camera set to create multiple exposures on a frame.

 Note: Nikon's literature suggests that you either place the subject against a dark background or underexpose the background (the manual suggests 1 to 2 stops underexposure). Failure to do so may result in one of two problems: (1) the background receives light from the multiple flash bursts and becomes overexposed; or (2) the subject appears to fade into the background (especially true if you're off by a bit in your distance). If in doubt, bracket your exposures for the background!

 Another potential pitfall is that the subject doesn't move enough between flash bursts, which will tend to overexpose the overlapped area. Again, if you're in doubt, bracket (though in this case, you'd bracket the number of exposures or frequency).

7. On older camera bodies and newer ones that have an AI or AI-S lens mounted, you need to set the aperture on the SB-25 to match the one you set on the camera in Step 6 (newer bodies with autofocus or AI-P lenses do this automatically).

8. If the distance being shown on the SB-25's shooting range table doesn't match your flash-to-subject distance, press

the ▼ and ▲ buttons on the SB-25 until they do. Note that this changes the power at which the flash fires, which interacts with your other settings. Moreover, you may find that your settings won't get you the flash-to-subject distance you desire. You may find that you have to go back to Step 3 and iterate until all the settings match up well.

Setting FP High-Speed Flash (N90/F90 or Later Nikon Bodies)

1. Set the flash mode selector on the back of the SB-25 to M. Set the sync mode to normal.

 Note: The 20mm wide-angle adapter cannot be used in FP high-speed flash mode.

2. Turn the power switch on the SB-25 to the standby (STBY) or ON position. The SB-25 should display **Ⓜ** in the top left of its LCD.

3. Confirm the ISO film speed on the SB-25. (All cameras that support FP high-speed flash should automatically update the film speed on the SB-25).

4. Press the **Ⓜ** button on the SB-25 until **FP** appears next to the **Ⓜ** in the LCD panel. A 1 should appear in the lower right corner of the LCD panel. (Pressing M again should put a 2 in the lower right corner.)

5. Set the camera to the following modes:

 Exposure: Manual (M)

 Autofocus: Single servo (S) or manual (M)

 Advance: Single frame (S)

6. Set the shutter speed to a value between 1/250 and 1/4,000 second and the aperture as you normally would.

7. Focus on the subject by pressing lightly on the shutter release. Note the distance.

8. If you're using a lens that has a CPU (all autofocus and AI-P lenses), simply changing the aperture on the camera causes the SB-25 to match it. You should see the aperture change on the SB-25 and the distance in the shooting range scale change as well.

 If the distance on the shooting range scale matches the flash-to-subject distance, you're ready to shoot. Otherwise, you'll have to change the aperture (Step 6), the FP mode

(Step 4), the zoom position of the flash, or your actual distance from the subject.

Note: Nikon suggests underexposing slightly in very bright scenes (the flash will be added to the scene's lighting, possibly resulting in overexposure).

SB-25 Guide Numbers for FP High-Speed Flash (Feet)

Shutter Speed	24mm	28mm	35mm	50mm	70mm	85mm
1/250 FP1	46	50	56	65	74	77
1/250 FP2	33	36	39	46	52	56
1/500 FP1	33	36	39	46	52	56
1/500 FP2	23	25	28	33	36	39
1/1,000 FP1	23	25	28	33	36	39
1/1,000 FP2	16	17	20	23	26	28
1/2,000 FP1	16	17	20	23	26	28
1/2,000 FP2	11	13	14	16	18	20
1/4,000 FP1	11	13	14	16	18	20
1/4,000 FP2	8.2	8.5	10	11	13	14

SB-25 Guide Numbers for FP High-Speed Flash (Meters)

Shutter Speed	24mm	28mm	35mm	50mm	70mm	85mm
1/250 FP1	14	15	17	20	23	24
1/250 FP2	10	11	12	14	16	17
1/500 FP1	10	11	12	14	16	17
1/500 FP2	7	7.5	8.5	10	11	12
1/1,000 FP1	7	7.5	8.5	10	11	12
1/1,000 FP2	5	5.3	6	7	8	8.5
1/2,000 FP1	5	5.3	6	7	8	8.5
1/2,000 FP2	3.5	3.7	4.2	5	5.6	6
1/4,000 FP1	3.5	3.7	4.2	5	5.6	6
1/4,000 FP2	2.5	2.6	3	3.5	4	4.2

Setting the Zoom Head Manually

1. Press the ⬛ZOOM button to change the zoom setting. Each button press selects the next higher logical setting (and you'll eventually loop back to the lowest setting). The LCD should display ᴹ when the setting doesn't correspond to the lens being used.

Note: If you wish to lock a manual setting, press the 🔲 and 🅜 buttons simultaneously in Step 1 until the M above ᴢᴏᴏᴹ on the LCD panel begins blinking. Then use the 🔲 button, as usual, to set a focal length. As long as the M is blinking, the focal length is locked on the SB-25 (i.e., it doesn't respond to changes in lens focal length). To cancel the lock, again press the 🔲 and 🅜 buttons simultaneously until the blinking stops.

2. To cancel a manual zoom setting, press the zoom button repeatedly until the 🅜 no longer appears on the LCD (i.e., until the setting matches the focal length of the lens being used).

Note: Remember that the guide number of the flash unit changes with the zoom setting (see tables on page 251).

Note: If you pull out the built-in wide-angle adapter and move it into position in front of the flashtube, the SB-25 is set to the 20mm focal length and the automatic zoom head function no longer operates.

Setting Flash Exposure Compensation

Note: If using an N6006/F-601 or N6000/F-601m, you must set flash exposure compensation on the camera, not on the SB-25.

1. With the flash set to TTL, press the 🔲 button until the 🔽 indicator in the upper right portion of the LCD begins to blink.

2. Use the 🔽 and 🔼 buttons to adjust the amount of compensation. The SB-25 allows a maximum of +1 stop and –3 stops of flash compensation, which is indicated in 1/3-stop increments on the flash compensation indicator (e.g., each bar to the left of 0 indicates a +0.3-stop compensation, each bar to the right of 0 indicates a –0.3-stop compensation).

3. Press the 🔲 button again (or wait 8 seconds) to lock in the compensation value. The compensation indicator should stop blinking. The compensation amount should still appear in the LCD (unless you've set 0.0, in which case the compensation section of the LCD is blank).

4. To cancel exposure compensation, repeat Steps 1 through 3 and set a value of 0.0.

Note: Flash compensation does not change the background exposure calculated by the camera.

Warning: *It's probably best to avoid flash compensation in any of the balanced fill-flash TTL modes. You don't know what level of compensation the camera is already making, so any changes you make are in addition to this unknown, camera-calculated compensation. For full control, switch to automatic or manual flash modes, where any compensation you dial in will be from a known flash level.*

Setting Red-Eye Reduction (N90/F90 and Later Nikon Bodies)

1. Set red-eye reduction on the camera body (see the camera's instructions). On Nikon's more recent bodies, this is done by holding the 🔘 button on the camera and turning the command dial until ◉ appears (◉⚡ appears on the SB-25's LCD).

Note: The F5 doesn't support the red-eye reduction function.

Note: Red-eye reduction works in most flash modes, but not in the rear-curtain sync or repeating flash modes.

SB-25 Notes

- TTL operation on some cameras (e.g., FA, FE2, FG) has a more limited ISO range (25–400) than later bodies (ISO 25–1,000).

- For autofocus bodies, the camera's focus mode selector should be set to single servo (S) autofocus (N50/F50 should be set to AF, N5005/F-401x, N4004s/F-401s, and N4004/F-401 should be set to A). The flash will not fire unless the subject is in focus. The autofocus assist illuminator will be used automatically if the ambient light is low. Autofocus assist works only at distances from 3.3 feet (1 m) up to 26 feet (8 m), and with lenses up to 105mm. (The manual says 16.4 feet, but this is probably a misprint.)

- If the **F** indicator on the SB-25's LCD panel is blinking, that means that the flash needs you to set the aperture. This happens in several situations: (1) in automatic (A) flash mode; (2) when using lenses without a CPU (AI or AI-S lenses); and (3) when using earlier Nikon bodies (generally those prior to the F4 and N8008/F-801). If the **F** is blinking, use the 🔽 and 🔼 buttons to set the correct aperture on the flash (i.e., the aperture that matches what is set on the camera).

- With the power switch in standby position (STBY) and most Nikon bodies, the SB-25 automatically turns off 80 seconds

after the camera's meter turns OFF. A light press on the shutter release generally turns most Nikon bodies' light meters back ON, and the SB-25 will turn ON at the same time. A few older bodies do not control the flash in this manner. On those cameras, when the SB-25 is in STBY, it automatically turns itself OFF after 80 seconds, regardless of whether the camera meter is active or not. To restore power to the SB-25, turn the SB-25 OFF and back ON.

Note: The SB-25 has a special standby mode that leaves the unit ready, regardless of the camera's metering status. To activate this special mode, start with the SB-25 in the OFF position. Hold down the LCD illumination button (☼) and turn the SB-25's power switch to STBY. Release the LCD illumination button. To cancel this mode, simply move the power switch back to the OFF position. A fresh set of alkaline batteries lasts approximately 20 days in this setting; NiCads, about 10 days.

• If you are using the SB-25 on a body set to a mechanical shutter speed (M250, M90, B), set the SB-25's power switch to the ON position only. Standby (STBY) is not operative. Likewise, standby doesn't operate if you're using an F3, FM2, FM10, FE10, or an FA or FE2 attached to an MD-12 Motor Drive.

• After the flash fires, a ◢ symbol may appear in the SB-25's LCD along with a value. This indicates potential underexposure. This indicator appears only for 3 seconds after the shot. Use the LCD illumination button to recall the last indication.

• The maximum aperture in automatic (A) flash mode may be limited on some cameras (e.g., on the N6006/F-601 at ISO 100 the maximum aperture that will be set is f/5.6).

• Rear sync mode must be selected on the camera if you're using an N6006/F-601 or N6000/F-601m. Rear sync is not performed if using one of the vari-program modes (N90/F90, F90X/N90s, N70/F70) or when red-eye reduction is being used.

Note: Front-curtain sync is performed at all times on the following cameras, regardless of the setting on the SB-25: N5005/F-401x, N2020/F-501, N2000/F-301, N4004/F-401, N4004s/F-401s, FA, FE2, FG, Nikonos V, F3, F2, FM2, and FG-20.

• The shooting range scale does not appear on the LCD panel if the flash head is tilted or rotated (exception: the scale blinks if the flash is set at –7° below horizontal).

- While the SB-25 has "click stops" for commonly used flash head positions (45, 60, 75, and 90° for tilt, every 30° for rotation), you aren't restricted to those positions. Setting an intermediate position is allowed (though it can easily be dislodged).

- Ready light warnings (blinking light) occur in the following conditions:

When you attempt to use the SB-25 in TTL mode on cameras that are not TTL-capable (see "Non-TTL-Capable Bodies," page 326).

When you attempt to use the SB-25 in A mode on cameras set to a mechanical shutter speed (M250, M90, B).

When you attempt to use the SB-25 in TTL mode with an unavailable film speed (e.g., ISO 800 on an FA, FE2, FG, or N4004s/F-401s).

When the shutter speed is set faster than the allowable flash sync speed of the camera.

When you've taken a flash picture with the SB-25 in TTL or A mode and the flash fired at full power (indicating it might have produced insufficient light for a flash exposure). However, in extremely bright scenes, the N4004s/F-401s may not blink its flash indicator, even when insufficient light was produced by the flash.

On an N4004s/F-401s: When the SB-25 and the camera's built-in flash are both OFF, but the camera's meter recommends flash use.

- Changing the ISO film speed setting on the SB-25 does not change the way the flash fires, except in automatic (A) flash mode. In other modes, changing the ISO value changes only the apertures displayed in the shooting range table. Accidentally moving the ISO setting after correctly making all flash and camera adjustments won't affect the resulting exposure.

SB-26

A modest upgrade of the SB-25, the SB-26 adds two functions: an 18mm diffuser and the ability to function as a wireless slave flash. It was introduced in 1994.

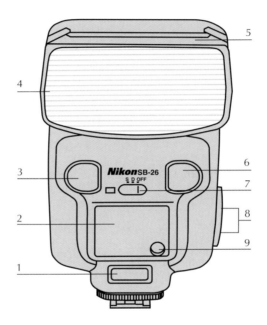

1 External power terminal (under logo)	6 Slave flash sensor
	7 Slave flash selector switch
2 AF assist illuminator	8 TTL multiple flash socket/ sync socket
3 Redeye reduction lamp	
4 Flashtube	9 Light sensor
5 Wide-angle adapter/diffuser card (pull out)	

10 Ready light/test fire
 button

11 Zoom button

12 LCD information
 display

13 Sync mode selector

14 Tilt angle scale

15 Rotation lock/release
 lever

16 Flash mode
 selector switch

17 LCD illuminator
 button

18 On/Off/standby
 switch

19 Locking ring

20 M (manual adjustment)
 button

21 Selection (SEL) button

22 Adjustment toggles

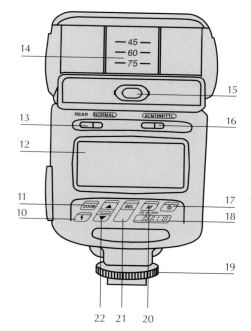

Specifications

GN:	118 (ft), 36 (m)
Weight:	13.8 oz (390 g) (w/o batteries)
Size:	5.3″ (135 mm) tall x 3.1″ (79 mm) wide x 4″ (101 mm) deep
Power:	4 AA batteries
Recycle Time:	7 seconds minimum (full discharge)
No. of Flashes:	~150 at full manual
Flash Duration:	1/1,000 second
Coverage:	(102° horizontal, 90° vertical) 18mm lens; also supports 20mm, 24mm, 28mm, 35mm, 50mm, 70mm, and 85mm coverage
Case:	SS-26 included
Key Features:	TTL flash control on most TTL-capable Nikon bodies, monitor pre-flash on N90/F90 or later bodies; full power TTL, seven power level

manual and automatic (six apertures) settings. LCD panel shows settings. Rear-curtain sync. High-speed sync, repeating flash, red-eye reduction, wireless remote. The SB-26 can synchronize with up to four additional flash units via cables. Unlimited numbers of SB-26s can be fired in the wireless remote mode. Head tilts from –7° below horizontal up to 90° above horizontal, and rotates –180° to +90 ° clockwise. Built-in diffuser card. Autofocus assist illuminator. External power source terminal, TTL multiple flash terminal, sync/multiple flash terminal.

Note: Before using your SB-26, you should set the distance scale you will use to feet or meters. This is done by opening the battery chamber and sliding the small switch on the left side of the chamber (as you face it) to m (for meters) or ft (for feet).

Note: The SB-26 features a locking pin, which is controlled by the knurled knob on the hot shoe mechanism. The knob should be turned fully counterclockwise (to the right as you face the back of the SB-26) to retract the pin before putting the flash onto the camera. Once the SB-26 is on the camera, turn the knob clockwise (to the left as you face the back of the SB-26) to lock the flash to the camera (all bodies starting with the N90/F90 have the proper slot for the pin). Likewise, be sure to retract the locking pin by turning the knob fully counterclockwise (to the right as you face the back of the SB-26) before attempting to remove the flash from the camera. Failure to do so could damage the flash or camera.

The SB-26's user controls are a classic example of what is called "user interface overload." This means that some controls and display information have multiple uses or relate to multiple items depending upon the context. This reduces the number of buttons and indicators needed, but places a burden on the user to keep track of what mode they're in. A few things to remember:

- Blinking on the LCD indicates either a warning or that you're in the midst of setting an item. Blinking should not be ignored. Either the Speedlight is not set correctly, or you haven't finished setting something.

- Most buttons are designed to be pressed more than once. Each press gives you the next logical setting (next higher zoom head setting, next lower manual power amount, etc.). When buttons use multiple presses to select an item, they loop through the choices (i.e., after the last choice you'll be taken back to the first).

Setting Automatic TTL Flash Exposure (Newer TTL-Capable Nikon Bodies)

1. Set the flash mode selector on the back of the SB-26 to ▥.
2. Turn the power switch on the SB-26 to the standby (STBY) or ON position.
3. Set the ISO film speed on the SB-26, if necessary.

 On the N8008/F-801, F4, F5, F100, N70/F70, N80/F80, N90/F90, N90s/F90X, N50/F50, and N60/F60, ISO film speed settings are automatically communicated to the SB-26. Press the shutter release on the camera halfway and you should see the correct ISO value appear on the SB-26's LCD panel.

 For older camera bodies, press the ▨ button on the SB-26 until the number next to ISO begins blinking in the LCD panel. When it is blinking, use the ▼ and ▲ buttons to adjust the value (which appears just to the right of the blinking ISO). When the value you want is set, either wait 8 seconds or press the ▨ button again to lock it in.

 Note: You do not have to set the ISO value on the SB-26 as in TTL flash mode all exposure calculations are done by the camera. However, the shooting range scale may not show the proper results if you don't.

4. Select the type of TTL to be performed. Basically, with most modern Nikon bodies you have only one choice: whether or not to cancel the balanced fill-flash mode. Otherwise, the SB-26 sets the TTL mode based upon the camera body, lens type, and metering system as follows:

 N90/F90 and later bodies (any body that supports the 3D flash capability, see "Camera Capabilities," pages 326–327): 3D

balanced fill-flash (TTL) is performed in all metering modes if a D-type lens is mounted on the camera. Multi-sensor balanced fill-flash (TTL) is performed for all other autofocus and AI-P lenses. For all other lenses, center-weighted fill-flash (TTL) or spot fill-flash (TTL) is performed based upon metering selection.

With other TTL-capable bodies, matrix balanced fill-flash (TTL), center-weighted fill-flash (TTL), or spot fill-flash (TTL) is usually performed (matrix is available only with an autofocus or AI-P lens) depending upon metering mode. In some cases (F4 with AI or AI-S lens and spot metering, for example), standard TTL is performed instead.

Note: When the camera body is set for spot metering, standard TTL is set automatically.

Note: The N4004s/F-401s allows only programmed TTL flash or standard TTL and the 🖭 indicator does not appear, even though the camera and flash performs TTL. See "Setting Programmed TTL Flash Exposure," page 268.

5. Set autofocus cameras to single servo (S) autofocus mode.

Note: Bodies with multiple AF sensors should be set to the central sensor (otherwise the AF assist light will not function).

6. Set the camera's exposure mode, if you haven't already. In aperture-priority (A), shutter-priority (S), and manual (M) exposure modes, make any necessary aperture or shutter speed selections.

With AI, AI-S, and AF teleconverters, some cameras will switch automatically to aperture-priority (A) exposure mode (program and shutter-priority modes are not available). Other cameras need to be manually switched to aperture-priority (A) mode with these lenses.

In program modes you can usually override the camera's selection of aperture and shutter speed combinations by turning the camera's control dial (when the shutter release is partially pressed).

The aperture the camera (or you) selected also appears on the SB-26's LCD panel when you partially press the shutter release.

Note: The camera and SB-26 may warn you of several possible errors when you partially press the shutter release to verify settings:

- In program modes (P, PD, PH), and on the most recent bodies (F5, F100, F80), the lens must be set on its minimum aperture, or else the error message ƎƐƐ appears in the viewfinder.

- Any time that ⊢⁖ is visible in the viewfinder indicates that overexposure is likely. For many of the later bodies, starting with the N8008/F-801, the placement of the ⊢⁖ varies with exposure mode: ⊢⁖ and the smallest aperture appear in the camera's viewfinder if overexposure is likely in program (P) modes. ⊢⁖ appears in place of the aperture for overexposure warnings in shutter-priority (S) mode. ⊢⁖ appears in place of the shutter speed in aperture-priority (A) mode.

- The shutter speed is automatically reset to 1/250 second if you selected a faster shutter speed in shutter-priority (S) or manual (M) exposure mode.

- In manual (M) exposure mode, under- and overexposure is indicated solely by the analog exposure display. If the exposure bar goes to either side of the ⁰⁚ point, the ambient-only lighting exposure will not be correct.

7. Focus on the subject by pressing lightly on the shutter release. Confirm that the subject is within flash range by looking at the shooting range scale on the SB-26's LCD. After you've confirmed the distance, you're ready to shoot.

SB-26 Usable Apertures and Flash Range in TTL Mode (18mm)

ISO 800	400	200	100	50	25	Range in Ft	Range in M
f/2	f/1.4	—	—	—	—	8.2–66	2.5–20
f/2.8	f/2	f/1.4	—	—	—	5.9–66	1.8–20
f/4	f/2.8	f/2	f/1.4	—	—	4.3–46	1.3–14
f/5.6	f/4	f/2.8	f/2	f/1.4	—	3.0–33	0.9–10
f/8	f/5.6	f/4	f/2.8	f/2	f/1.4	2.0–25	0.6–7.5
f/11	f/8	f/5.6	f/4	f/2.8	f/2	2.0–16	0.6–5
f/16	f/11	f/8	f/5.6	f/4	f/2.8	2.0–12	0.6–3.5
f/22	f/16	f/11	f/8	f/5.6	f/4	2.0–8.2	0.6–2.5
f/32	f/22	f/16	f/11	f/8	f/5.6	2.0–5.6	0.6–1.7
—	f/32	f/22	f/16	f/11	f/8	2.0–3.9	0.6–1.2

SB-26 Usable Apertures and Flash Range in TTL Mode (20mm)

ISO 800	400	200	100	50	25	Range in Ft	Range in M
f/2	f/1.4	—	—	—	—	9.2–66	2.8–20
f/2.8	f/2	f/1.4	—	—	—	6.6–66	2.0–20
f/4	f/2.8	f/2	f/1.4	—	—	4.6–49	1.4–15
f/5.6	f/4	f/2.8	f/2	f/1.4	—	3.0–36	0.9–11
f/8	f/5.6	f/4	f/2.8	f/2	f/1.4	2.3–23	0.7–7
f/11	f/8	f/5.6	f/4	f/2.8	f/2	2.0–18	0.6–5.5
f/16	f/11	f/8	f/5.6	f/4	f/2.8	2.0–13	0.6–3.8
f/22	f/16	f/11	f/8	f/5.6	f/4	2.0–8.9	0.6–2.7
f/32	f/22	f/16	f/11	f/8	f/5.6	2.0–6.2	0.6–1.9
—	f/32	f/22	f/16	f/11	f/8	2.0–4.3	0.6–1.3

SB-26 Usable Apertures and Flash Range in TTL Mode (24mm)

ISO 800	400	200	100	50	25	Range in Ft	Range in M
f/2	f/1.4	—	—	—	—	12–66	3.8–20
f/2.8	f/2	f/1.4	—	—	—	8.7–66	2.7–20
f/4	f/2.8	f/2	f/1.4	—	—	6.2–66	1.9–20
f/5.6	f/4	f/2.8	f/2	f/1.4	—	4.4–49	1.4–15
f/8	f/5.6	f/4	f/2.8	f/2	f/1.4	3.1–34	1.0–10
f/11	f/8	f/5.6	f/4	f/2.8	f/2	2.2–24	0.7–7.5
f/16	f/11	f/8	f/5.6	f/4	f/2.8	2.0–17	0.6–5.3
f/22	f/16	f/11	f/8	f/5.6	f/4	2.0–12	0.6–3.7
f/32	f/22	f/16	f/11	f/8	f/5.6	2.0–8.6	0.6–2.6
—	f/32	f/22	f/16	f/11	f/8	2.0–6.1	0.6–1.8

SB-26 Usable Apertures and Flash Range in TTL Mode (28mm)

ISO 800	400	200	100	50	25	Range in Ft	Range in M
f/2	f/1.4	—	—	—	—	13–66	4.0–20
f/2.8	f/2	f/1.4	—	—	—	9.3–66	2.9–20
f/4	f/2.8	f/2	f/1.4	—	—	6.6–66	2.0–20
f/5.6	f/4	f/2.8	f/2	f/1.4	—	4.7–52	1.5–16
f/8	f/5.6	f/4	f/2.8	f/2	f/1.4	3.3–37	1.0–11
f/11	f/8	f/5.6	f/4	f/2.8	f/2	2.4–26	0.7–8
f/16	f/11	f/8	f/5.6	f/4	f/2.8	2.0–18	0.6–5.6
f/22	f/16	f/11	f/8	f/5.6	f/4	2.0–13	0.6–4
f/32	f/22	f/16	f/11	f/8	f/5.6	2.0–9.2	0.6–2.8
—	f/32	f/22	f/16	f/11	f/8	2.0–6.5	0.6–2.0

SB-26 Usable Apertures and Flash Range in TTL Mode (35mm)

ISO 800	400	200	100	50	25	Range in Ft	Range in M
f/2	f/1.4	—	—	—	—	15–66	4.5 -20
f/2.8	f/2	f/1.4	—	—	—	11–66	3.2–20
f/4	f/2.8	f/2	f/1.4	—	—	7.4–66	2.3–20
f/5.6	f/4	f/2.8	f/2	f/1.4	—	5.2–66	1.6–18
f/8	f/5.6	f/4	f/2.8	f/2	f/1.4	3.7–41	1.2–12
f/11	f/8	f/5.6	f/4	f/2.8	f/2	2.6–29	0.8–9
f/16	f/11	f/8	f/5.6	f/4	f/2.8	2.0–20	0.7–6.3
f/22	f/16	f/11	f/8	f/5.6	f/4	2.0–14	0.6–4.5
f/32	f/22	f/16	f/11	f/8	f/5.6	2.0–10	0.6–3.1
—	f/32	f/22	f/16	f/11	f/8	2.0–7.3	0.6–2.3

SB-26 Usable Apertures and Flash Range in TTL Mode (50mm)

ISO 800	400	200	100	50	25	Range in Ft	Range in M
f/2	f/1.4	—	—	—	—	17–66	5.3–20
f/2.8	f/2	f/1.4	—	—	—	12–66	3.8–20
f/4	f/2.8	f/2	f/1.4	—	—	8.6–66	2.7–20
f/5.6	f/4	f/2.8	f/2	f/1.4	—	6.1–66	1.9–20
f/8	f/5.6	f/4	f/2.8	f/2	f/1.4	4.3–48	1.4–14
f/11	f/8	f/5.6	f/4	f/2.8	f/2	3.0–34	1.0–10
f/16	f/11	f/8	f/5.6	f/4	f/2.8	2.2–24	0.7–7.4
f/22	f/16	f/11	f/8	f/5.6	f/4	2.0–17	0.6–5.2
f/32	f/22	f/16	f/11	f/8	f/5.6	2.0–12	0.6–3.7
—	f/32	f/22	f/16	f/11	f/8	2.0–8.6	0.6–2.6

SB-26 Usable Apertures and Flash Range in TTL Mode (70mm)

ISO 800	400	200	100	50	25	Range in Ft	Range in M
f/2	f/1.4	—	—	—	—	20–66	6.0–20
f/2.8	f/2	f/1.4	—	—	—	14–66	4.3–20
f/4	f/2.8	f/2	f/1.4	—	—	9.8–66	3.0–20
f/5.6	f/4	f/2.8	f/2	f/1.4	—	7.0–66	2.2–20
f/8	f/5.6	f/4	f/2.8	f/2	f/1.4	4.9–53	1.5–16
f/11	f/8	f/5.6	f/4	f/2.8	f/2	3.5–39	1.1–12
f/16	f/11	f/8	f/5.6	f/4	f/2.8	2.6–27	0.8–8.4
f/22	f/16	f/11	f/8	f/5.6	f/4	2.0–19	0.6–6.0
f/32	f/22	f/16	f/11	f/8	f/5.6	2.0–13	0.6–4.2
—	f/32	f/22	f/16	f/11	f/8	2.0–9.8	0.6–3.0

SB-26 Usable Apertures and Flash Range in TTL Mode (85mm)

ISO 800	400	200	100	50	25	Range in Ft	Range in M
f/2	f/1.4	—	—	—	—	21–66	6.3–20
f/2.8	f/2	f/1.4	—	—	—	15–66	4.5–20
f/4	f/2.8	f/2	f/1.4	—	—	10–66	3.2–20
f/5.6	f/4	f/2.8	f/2	f/1.4	—	7.2–66	2.2–20
f/8	f/5.6	f/4	f/2.8	f/2	f/1.4	5.1–56	1.6–17
f/11	f/8	f/5.6	f/4	f/2.8	f/2	3.6–39	1.1–12
f/16	f/11	f/8	f/5.6	f/4	f/2.8	2.6–29	0.8–8.8
f/22	f/16	f/11	f/8	f/5.6	f/4	2.0–20	0.6–6.2
f/32	f/22	f/16	f/11	f/8	f/5.6	2.0–14	0.6–4.4
—	f/32	f/22	f/16	f/11	f/8	2.0–10	0.6–3.1

Note: Nikon's published numbers—which I've duplicated in the above tables—appear to have a number of inconsistencies in them. The ranges for smaller apertures (the last four lines of each table) must also have rounding or calculation errors in them. Many are the same as Nikon listed for the SB-24, SB-25, or SB-28, but some are different. In at least one case, a range of 0.7 m has been rounded to 2 feet instead of 2.2 feet, for example.

Finally, note that while the SB-26 has identical guide numbers to some other Speedlights, unexplained, significant non-rounding differences appear in the usable aperture tables for each.

Setting Programmed TTL Flash Exposure (N2020/F-501, N4004s/F-401s, N2000/F-301)

1. Set the flash mode selector on the back of the SB-26 to **TTL**.
2. Turn the power switch on the SB-26 to the standby (STBY) or ON position.
3. Confirm the ISO film speed on the SB-26.

 On these cameras, ISO film speed settings are automatically communicated to the SB-26. Press the shutter release on the camera halfway and you should see the ISO value appear on the SB-26's LCD panel.

 Note: You do not have to set the ISO value on the SB-26 as in TTL flash mode all exposure calculations are done by the camera. However, the shooting range scale may not show the proper results if you don't.

4. Set the camera to program auto (on the N4004s/F-401s: shutter speed dial at A, aperture dial at P; on the other cameras: shutter speed dial at PDUAL, P, or PHIGH and the lens set at its smallest aperture).

 Note: The N4004s/F-401s performs only programmed TTL flash. But the 🔳 indicator does not appear on the SB-26's LCD.

 Note: Setting exposure modes other than program (P) results in standard TTL flash being used (exception: N4004/F-401 will also perform programmed TTL flash when set to shutter-priority [S] exposure mode).

5. Set autofocus cameras to single servo (S) autofocus mode.

6. Focus on the subject by pressing lightly on the shutter release. Confirm that the subject is within flash range by looking at the shooting range scale on the SB-26's LCD. After you've confirmed the distance, you're ready to shoot.

 You can set apertures on the flash by using the 🔽 and 🔼 buttons on the SB-26. N4004s/F-401s users should set the aperture according to the ISO value they're using (see table below).

SB-26 Usable Apertures and Flash Range in Programmed TTL Mode

Zoom	ISO 400	200	100	50	25	Range in Ft	Range in M
18mm	f/11	f/8	f/5.6	f/4	f/2.8	2.0–12	0.6–3.5
20mm	f/11	f/8	f/5.6	f/4	f/2.8	2.0–13	0.6–3.8
24mm	f/11	f/8	f/5.6	f/4	f/2.8	2.0–17	0.6–5.3
28mm	f/11	f/8	f/5.6	f/4	f/2.8	2.0–18	0.6–5.6
35mm	f/11	f/8	f/5.6	f/4	f/2.8	2.0–20	0.6–6.3
50mm	f/11	f/8	f/5.6	f/4	f/2.8	2.2–24	0.7–7.4
70mm	f/11	f/8	f/5.6	f/4	f/2.8	2.5–27	0.8–8.4
85mm	f/11	f/8	f/5.6	f/4	f/2.8	2.6–29	0.8–8.8

Setting Aperture-Priority or Shutter-Priority Programmed TTL Flash Exposure (N2020/F-501, N4004s/F-401s, N2000/F-301)

1. Set the flash mode selector on the back of the SB-26 to 🔳.

2. Turn the power switch on the SB-26 to the standby (STBY) or ON position.

3. Set the ISO film speed on the SB-26, if necessary.

On most cameras, ISO film speed settings are automatically communicated to the SB-26. Press the shutter release on the camera halfway and the ISO value should appear on the SB-26's LCD panel.

Note: You do not have to set the ISO value on the SB-26 as in TTL flash mode all exposure calculations are done by the camera. However, the shooting range scale may not show the proper results if you don't.

4. Set the camera to aperture-priority (A) or shutter-priority (S) exposure mode.

5. Set autofocus cameras to single servo (S) autofocus mode (A on the N4004s/F-401s).

6. Focus on the subject by pressing lightly on the shutter release. Confirm that the subject is within flash range by looking at the shooting range scale on the SB-26's LCD. After you've confirmed the distance, you're ready to shoot.

 Adjust the camera to the desired aperture and/or shutter speed, as usual. If the camera doesn't automatically communicate the aperture to the flash, you set the aperture on the flash by using the ▼ and ▲ buttons on the SB-26. The aperture on both camera and flash should match.

 Use the TTL tables that begin on page 265 to determine the shooting range (or look at the shooting range scale on the SB-26).

Setting Automatic Flash Exposure (All Nikon Bodies)

1. Set the flash mode selector on the back of the SB-26 to A.

2. Turn the power switch on the SB-26 to the standby (STBY) or ON position. The SB-26 should display ▲ in the top left of its LCD.

3. Set the ISO film speed on the SB-26, if necessary.

 In automatic (A) flash mode, all exposure calculations are performed by the SB-26. If the camera doesn't automatically communicate the ISO value to the flash, you must manually set the ISO on the flash or incorrect exposure may result.

4. Set the camera to aperture-priority (A) or manual (M) exposure mode.

5. Set autofocus cameras to single servo (S) autofocus mode (A on the N4004s/F-401s).

6. Focus on the subject by pressing lightly on the shutter release. Note the distance.

7. Adjust your camera to the desired aperture and/or shutter speed, as usual. Set the aperture on the flash by using the ▼ and ▲ buttons on the SB-26. The aperture on both camera and flash should match.

 Confirm that the subject is within flash range by looking at the shooting range scale on the SB-26's LCD and comparing it to the distance you noted in Step 6. Shooting ranges for automatic (A) flash mode are shown in the tables below (or you can look at the shooting range scale on the SB-26).

SB-26 Usable Apertures and Flash Range in A Mode (18mm)

ISO 800	400	200	100	50	25	Range in Ft	Range in M
f/5.6	f/4	f/2.8	f/2	f/1.4	—	3.0–33	0.9–10
f/8	f/5.6	f/4	f/2.8	f/2	f/1.4	2.0–25	0.6–7.5
f/11	f/8	f/5.6	f/4	f/2.8	f/2	2.0–16	0.6–5
f/16	f/11	f/8	f/5.6	f/4	f/2.8	2.0–12	0.6–3.5
f/22	f/16	f/11	f/8	f/5.6	f/4	2.0–8.2	0.6–2.5
f/32	f/22	f/16	f/11	f/8	f/5.6	2.0–5.6	0.6–1.7

SB-26 Usable Apertures and Flash Range in A Mode (20mm)

ISO 800	400	200	100	50	25	Range in Ft	Range in M
f/5.6	f/4	f/2.8	f/2	f/1.4	—	3.0–36	0.9–11
f/8	f/5.6	f/4	f/2.8	f/2	f/1.4	2.3–23	0.7–7
f/11	f/8	f/5.6	f/4	f/2.8	f/2	2.0–18	0.6–5.5
f/16	f/11	f/8	f/5.6	f/4	f/2.8	2.0–13	0.6–3.8
f/22	f/16	f/11	f/8	f/5.6	f/4	2.0–8.9	0.6–2.7
f/32	f/22	f/16	f/11	f/8	f/5.6	2.0–6.2	0.6–1.9

SB-26 Usable Apertures and Flash Range in A Mode (24mm)

ISO 800	400	200	100	50	25	Range in Ft	Range in M
f/5.6	f/4	f/2.8	f/2	f/1.4	—	4.4–49	1.4–15
f/8	f/5.6	f/4	f/2.8	f/2	f/1.4	3.1–34	1.0–10
f/11	f/8	f/5.6	f/4	f/2.8	f/2	2.2–24	0.7–7.5
f/16	f/11	f/8	f/5.6	f/4	f/2.8	2.0–17	0.6–5.3
f/22	f/16	f/11	f/8	f/5.6	f/4	2.0–12	0.6–3.7
f/32	f/22	f/16	f/11	f/8	f/5.6	2.0–8.6	0.6–2.6

SB-26 Usable Apertures and Flash Range in A Mode (28mm)

ISO 800	400	200	100	50	25	Range in Ft	Range in M
f/5.6	f/4	f/2.8	f/2	f/1.4	—	4.7–52	1.5–16
f/8	f/5.6	f/4	f/2.8	f/2	f/1.4	3.3–37	1.0–11
f/11	f/8	f/5.6	f/4	f/2.8	f/2	2.4–26	0.7–8
f/16	f/11	f/8	f/5.6	f/4	f/2.8	2.0–18	0.6–5.6
f/22	f/16	f/11	f/8	f/5.6	f/4	2.0–13	0.6–4
f/32	f/22	f/16	f/11	f/8	f/5.6	2.0–9.2	0.6–2.8

SB-26 Usable Apertures and Flash Range in A Mode (35mm)

ISO 800	400	200	100	50	25	Range in Ft	Range in M
f/5.6	f/4	f/2.8	f/2	f/1.4	—	5.2–60	1.6–18
f/8	f/5.6	f/4	f/2.8	f/2	f/1.4	3.7–41	1.2–12
f/11	f/8	f/5.6	f/4	f/2.8	f/2	2.6–29	0.8–9
f/16	f/11	f/8	f/5.6	f/4	f/2.8	2.0–20	0.7–6.3
f/22	f/16	f/11	f/8	f/5.6	f/4	2.0–14	0.6–4.5
f/32	f/22	f/16	f/11	f/8	f/5.6	2.0–10	0.6–3.1

SB-26 Usable Apertures and Flash Range in A Mode (50mm)

ISO 800	400	200	100	50	25	Range in Ft	Range in M
f/5.6	f/4	f/2.8	f/2	f/1.4	—	6.1–66	1.9–20
f/8	f/5.6	f/4	f/2.8	f/2	f/1.4	4.3–48	1.4–14
f/11	f/8	f/5.6	f/4	f/2.8	f/2	3.0–34	1.0–10
f/16	f/11	f/8	f/5.6	f/4	f/2.8	2.2–24	0.7–7.4
f/22	f/16	f/11	f/8	f/5.6	f/4	2.0–17	0.6–5.2
f/32	f/22	f/16	f/11	f/8	f/5.6	2.0–12	0.6–3.7

SB-26 Usable Apertures and Flash Range in A Mode (70mm)

ISO 800	400	200	100	50	25	Range in Ft	Range in M
f/5.6	f/4	f/2.8	f/2	f/1.4	—	7.0–66	2.2–20
f/8	f/5.6	f/4	f/2.8	f/2	f/1.4	4.9–53	1.5–16
f/11	f/8	f/5.6	f/4	f/2.8	f/2	3.5–39	1.1–12
f/16	f/11	f/8	f/5.6	f/4	f/2.8	2.5–27	0.8–8.4
f/22	f/16	f/11	f/8	f/5.6	f/4	2.0–19	0.6–6.0
f/32	f/22	f/16	f/11	f/8	f/5.6	2.0–13	0.6–4.2

SB-26 Usable Apertures and Flash Range in A Mode (85mm)

ISO 800	400	200	100	50	25	Range in Ft	Range in M
f/5.6	f/4	f/2.8	f/2	f/1.4	—	7.2–60	2.2–20
f/8	f/5.6	f/4	f/2.8	f/2	f/1.4	5.1–56	1.6–17
f/11	f/8	f/5.6	f/4	f/2.8	f/2	3.6–39	1.1–12
f/16	f/11	f/8	f/5.6	f/4	f/2.8	2.6–29	0.8–8.8
f/22	f/16	f/11	f/8	f/5.6	f/4	2.0–20	0.6–6.2
f/32	f/22	f/16	f/11	f/8	f/5.6	2.0–14	0.6–4.4

Setting Manual Flash Exposure (All Nikon Bodies)

1. Set the flash mode selector on the back of the SB-26 to M.

2. Turn the power switch on the SB-26 to the standby (STBY) or ON position. The SB-26 should display **M** in the top left of its LCD.

3. Set the ISO film speed on the SB-26, if necessary.

 Most cameras automatically communicate ISO film speed settings to the SB-26. Press the shutter release on the camera halfway and the ISO value should appear on the SB-26's LCD panel.

 Note: You do not have to set the ISO value on the SB-26 as flash always fires at the indicated power in the manual (M) flash mode. However, the shooting range scale may not show the proper results if you don't.

4. Set the camera to the desired exposure mode and set the aperture and shutter speed, as usual. Make sure that the shutter speed selected is not above the camera's flash sync speed (most Nikon bodies force this).

5. Set autofocus cameras to single servo (S) autofocus mode (A on the N4004s/F-401s).

6. Focus on the subject by pressing lightly on the shutter release. Note the distance.

7. On newer cameras (F4 and N8008s/F-801s or later) equipped with lenses that have CPUs (all autofocus and AI-P lenses), simply changing the aperture on the camera will cause the SB-26 to match it. You should see the aperture change on the SB-26 and the distance in the shooting range scale change, as well. You have two choices (you can also use a combination of both):

1. Change the aperture on the camera until the distance noted in Step 6 is shown in the SB-26's shooting range scale.

2. Press the **M** button on the SB-26 to change the flash unit's power level until the distance noted in Step 6 is shown in the SB-26's shooting range scale.

Note: You can also simply press the **▼** and **▲** buttons to change the power ratings at this point in the process.

On older cameras, or with lenses that don't have CPUs (AI and AI-S), the aperture on the camera isn't linked with the SB-26, so you should adjust aperture and flash power settings on the SB-26 until the shooting range scale indicates the distance you noted in Step 6, and then set the aperture on the camera to match that shown on the SB-26.

Note: On the N90/F90 and newer bodies, the power setting of the SB-26 can be controlled in 1/3-stop increments between M1/2 and M1/64 power. You control these additional settings by pressing the **SEL** button until the **⚡⊠** indicator appears and the compensation value begins flashing, then using the **▼** and **▲** buttons to choose a value (0.3 is 1/3 stop, 0.7 is 2/3 stop). Press **SEL** a second time to lock in the chosen value.

Note: The SB-26 is capable of keeping up with a motor-driven camera (up to 6 fps) at powers of 1/8, 1/16, 1/32, or 1/64 as follows:

1/8	**4 consecutive frames**
1/16	**8 consecutive frames**
1/32	**16 consecutive frames**
1/64	**30 consecutive frames**

However, let the flash cool at least 10 minutes after firing the number of frames listed above.

SB-26 Specifications (Guide Numbers in Feet)

Output Level/18mm 20mm 24mm 28mm 35mm 50mm 70mm 85mm Coverage

Output Level	18mm	20mm	24mm	28mm	35mm	50mm	70mm	85mm
Full Power	66	72	98	105	118	138	157	164
1/2 Power	46	51	69	74	84	98	112	118
1/4 Power	33	36	49	53	59	69	79	82
1/8 Power	23	25	35	37	42	49	56	59
1/16 Power	16	18	25	26	30	35	39	42
1/32 Power	12	13	17	19	21	25	28	30
1/64 Power	8	9	13	13	15	17	20	21
Horizontal	102°	98°	78°	70°	60°	46°	36°	31°
Vertical	90°	85°	60°	53°	45°	34°	26°	23°

SB-26 Specifications (Guide Numbers in Meters)

Output Level 18mm 20mm 24mm 28mm 35mm 50mm 70mm 85mm

Output Level	18mm	20mm	24mm	28mm	35mm	50mm	70mm	85mm
Full Power	20	22	30	32	36	42	48	50
1/2 Power	14	15.5	21	22.5	25.5	30	34	36
1/4 Power	10	11	15	16	18	21	24	25
1/8 Power	7	7.7	10.5	11.3	12.7	15	17	18
1/16 Power	5	5.5	7.5	8	9	10.5	12	12.7
1/32 Power	3.5	3.8	5.3	5.7	6.4	7.5	8.5	9
1/64 Power	2.5	2.7	3.8	4	4.5	5.3	6	6.3

Note: GNs listed are for flash head settings, not lenses! In other words, if you use a 50mm lens but the flash head is set for 35mm, you get a GN of 118 in feet (36 m), not 138 (42).

Note: Nikon has not been consistent in the way they round numbers when calculating GNs for meters. I've used the numbers in the original manuals, complete with Nikon's rounding error.

SB-26 Flash Durations

Output Level	Duration (sec)
Full Power	1/1,000
1/2 Power	1/1,100
1/4 Power	1/2,500
1/8 Power	1/5,000
1/16 Power	1/8,700
1/32 Power	1/12,000
1/64 Power	1/23,000

Setting Repeating Flash (All Nikon Bodies)

1. Set the flash mode selector to 🔲 on the back of the SB-26.

2. Turn the power switch on the SB-26 to the standby (STBY) or ON position (the camera should be ON, also). The SB-26 should display 🔲🔲 in the top left of its LCD.

3. Press the 🔲 button on the SB-26 to choose the flash power setting (only settings between 1/8 or 1/64 are allowed). Note the distance displayed on the shooting range scale. (*Note:* Changing the zoom head setting also changes the shooting distance.) This will be the flash-to-subject distance you must set up (i.e., if the subject is farther away than this distance, you're going to have to move closer). You'll get another chance to modify the distance slightly in Step 8.

 Note: Don't proceed with the remaining steps until you've completed this one! In repeating flash (RF) mode, like manual (M) flash mode, the SB-26 fires at a fixed output level.

4. You must set both the number of flash bursts and the frequency at which they occur. Based upon the power level you set in Step 3, the SB-26 will display the maximum number of flash bursts that can be produced. You must set two items:

 - The frequency of the flash bursts is set by pressing the 🔲 button until the number next to the label **Hz** begins blinking, then pressing the 🔽 and 🔼 buttons until the frequency you want is shown on the LCD.

 - The number of flash bursts is set by again pressing the 🔲 button (the number of flash bursts begins blinking), then pressing the 🔽 and 🔼 buttons until the number of flash bursts you want is shown just under the M indicator. The maximum number of flash bursts you can set is determined by the power level you set in Step 3, as follows (*Note:* The Nikon manual is incorrect; the SB-26 limits the numbers you can set to those in the following table):

Frequency	1/8	1/16	1/32	1/64
1 Hz	14	30	60	90
10 Hz	4	8	20	28
20 Hz	4	8	12	24

 Note: To determine your settings, divide the number of flash bursts by the frequency (Hertz is "cycles per second"); the result should be less than the shutter speed. For example:

Number of flash bursts = 4
Frequency of flash bursts = 8 Hertz
Shutter speed = 4/8, or 1/2

In general, round to the next longer shutter speed, if the value falls between speeds.

5. Press the ▣ button on the SB-26 one last time to complete your settings (the blinking should stop).

6. Set the camera to manual (M) exposure mode and set your aperture and shutter speed for ambient light levels, as usual.

Note: Since you're using repeating flash to put multiple images on a single shot, make sure that you've set a slow enough shutter speed, set Bulb, or have the camera set to create multiple exposures on a frame.

Note: Nikon's literature suggests that you either place the subject against a dark background or underexpose the background (the manual suggests 1 to 2 stops underexposure). Failure to do so may result in one of two problems: (1) the background receives light from the multiple flash bursts and becomes overexposed; or (2) the subject appears to fade into the background (especially true if you're off by a bit in calculating your distance). If in doubt, bracket the exposures for the background!

Another potential pitfall is that the subject doesn't move enough between flash bursts, which will tend to overexpose the overlapped area. Again, if you're in doubt, bracket (though in this case, you'd bracket the number of exposures or frequency).

7. On older camera bodies and newer ones that have an AI or AI-S lens mounted, you need to set the aperture on the SB-26 to match the one you set on the camera in Step 6 (newer bodies with autofocus or AI-P lenses do this automatically).

8. If the distance being shown on the SB-26's shooting range table doesn't match the flash-to-subject distance, press the ▼ and ▲ buttons on the SB-26 until they do. Note that this changes the power at which the flash fires, which interacts with your other settings. Moreover, you may find that your settings won't get you the flash-to-subject distance you desire. You may find that you have to go back to Step 3 and iterate until all the settings match up well.

Setting FP High-Speed Flash (N90/F90 or Later Nikon Bodies)

1. Set the flash mode selector on the back of the SB-26 to M. Set the sync mode to normal.

 Note: The 18mm and 20mm zoom settings should not be used in FP high-speed flash mode. The zoom setting and mode indicators blink on the LCD to warn you if you accidentally set these wide angles.

2. Turn the power switch on the SB-26 to the standby (STBY) or ON position. The SB-26 should display **M** in the top left of its LCD.

3. Confirm the ISO film speed on the SB-26. (All cameras that support FP high-speed flash should automatically update the film speed on the SB-26.

4. Press the M button on the SB-26 until **FP** appears next to the **M** in the LCD panel. A ⁝ should appear in the lower right corner of the LCD panel. (Pressing **M** again should put a ʕ in the lower right corner.)

 Note: The SB-26 will not allow you to set FP mode unless it is mounted on a FP-capable camera (see "Camera Capabilities," pages 326–327).

5. Set the camera to the following modes:

 Exposure: Manual (M)

 Autofocus: Single servo (S) or manual (M)

 Advance: Single frame (S)

6. Set the shutter speed to a value between 1/250 and 1/4,000 second and the aperture as you normally would.

7. Focus on the subject by pressing lightly on the shutter release. Note the distance.

8. If you're using a lens that has a CPU (all autofocus and AI-P lenses), simply changing the aperture on the camera causes the SB-26 to match it. You should see the aperture change on the SB-26 and the distance in the shooting range scale change as well.

 If the distance on the shooting range scale matches the flash-to-subject distance, you're ready to shoot. Otherwise, you'll have to change the aperture (Step 6), the FP mode (Step 4), the zoom position of the flash, or your actual distance from the subject.

Note: Nikon suggests underexposing slightly in very bright scenes (the flash will be added to the scene's lighting, possibly resulting in overexposure).

SB-26 Guide Numbers for FP High-Speed Flash (Feet)

Shutter Speed	24mm	28mm	35mm	50mm	70mm	85mm
1/250 FP1	46	50	56	65	74	77
1/250 FP2	33	36	39	46	52	56
1/500 FP1	33	36	39	46	52	56
1/500 FP2	23	25	28	33	36	39
1/1,000 FP1	23	25	28	33	36	39
1/1,000 FP2	16	17	20	23	26	28
1/2,000 FP1	16	17	20	23	26	28
1/2,000 FP2	11	13	14	16	18	20
1/4,000 FP1	11	12	14	16	18	20
1/4,000 FP2	8.2	8.5	10	11	13	14

SB-26 Guide Numbers for FP High-Speed Flash (Meters)

Shutter Speed	24mm	28mm	35mm	50mm	70mm	85mm
1/250 FP1	14	15	17	20	23	24
1/250 FP2	10	11	12	14	16	17
1/500 FP1	10	11	12	14	16	17
1/500 FP2	7	7.5	8.5	10	11	12
1/1,000 FP1	7	7.5	8.5	10	11	12
1/1,000 FP2	5	5.3	6	7	8	8.5
1/2,000 FP1	5	5.3	6	7	8	8.5
1/2,000 FP2	3.5	3.7	4.2	5	5.6	6
1/4,000 FP1	3.5	3.7	4.2	5	5.6	6
1/4,000 FP2	2.5	2.6	3	3.5	4	4.2

Setting the Zoom Head Manually

1. Press the **ZOOM** button to change the zoom setting. Each button press selects the next higher logical setting (and you'll eventually loop back to the lowest setting). The LCD should display an **M** when the setting doesn't correspond to the lens being used.

 Note: If you wish to lock a manual setting, press the **ZOOM** and **M** buttons simultaneously in Step 1 until the M above ᴢᴏᴏᴍ on the LCD panel begins blinking. Then use the zoom button, as usual, to set a focal length. As long as the M is blinking, the focal

length is locked on the SB-26 (i.e., it doesn't respond to changes in lens focal length). To cancel the lock, again press the 𝗭𝗢𝗢𝗠 and 𝗠 buttons simultaneously (until the blinking stops).

2. To cancel a manual zoom setting, press the zoom button repeatedly until the LCD displays only ᴢᴏᴏᴍ (i.e., until the setting matches the lens being used).

 Note: Remember that the guide number of the flash changes with the zoom setting (see tables on page 275).

 Note: If you pull out the built-in wide-angle adapter and move it into position in front of the flashtube, the SB-26 is set to the 20mm focal length; pressing the 𝗠 button sets the 18mm focal length.

Setting Flash Exposure Compensation

Note: If using an N6006/F-601 or N6000/F-601m, you must set flash exposure compensation on the camera, not on the SB-26.

1. With the flash set to a TTL mode, press the 𝗦𝗘𝗟 button until the 𝟰⊠ indicator appears and 0.0 in the upper right portion of the LCD begins to blink.

2. Use the ▼ and ▲ buttons to adjust the amount of compensation. The SB-26 allows a maximum of +1 stop and –3 stops of flash compensation, which is indicated in 1/3-stop increments on the flash compensation indicator (e.g., each bar to the left of 0 indicates a +0.3-stop compensation, each bar to the right of 0 indicates a –0.3-stop compensation).

3. Press the 𝗦𝗘𝗟 button again (or wait 8 seconds) to lock in the compensation. The compensation indicator should stop blinking. The compensation amount should still appear in the LCD (unless you've set 0, in which case the compensation section of the LCD is blank).

4. To cancel exposure compensation, repeat Steps 1 through 3 and set a value of 0.

 Note: Flash compensation does not change the background exposure calculated by the camera.

Warning: It's probably best to avoid flash compensation in any of the balanced fill-flash TTL modes. You don't know what level of compensation the camera is already making, so any changes you make are in addition to this unknown, camera-calculated

compensation. If you want full control, switch to automatic or manual flash mode, where any compensation you dial in will be from a known flash level.

Setting Red-Eye Reduction (N90/F90 and Later Nikon Bodies)

1. Set red-eye reduction on the camera body (see camera instructions). On Nikon's most recent bodies, this is done by holding the ⚡ button on the camera and turning the command dial until ◉ appears (◉⚡ appears on the SB-26's LCD).

 Note: The F5 doesn't support the red-eye reduction function.

 Note: Red-eye reduction works in most flash modes, but not in the rear-curtain sync or repeating flash modes.

SB-26 Notes

- TTL operation on some cameras (e.g., FA, FE2, FG) has a more limited ISO range (25–400) than later bodies (ISO 25–1,000).

- For autofocus bodies, the camera's focus mode selector should be set to single servo (S) autofocus (N50/F50 should be set to AF, N5005/F-401x, N4004s/F-401s, and N4004/F-401 should be set to A). The flash will not fire unless the subject is in focus. The autofocus assist illuminator will be used automatically if the ambient light is low. Autofocus assist works only at distances from 3.3 feet (1 m) up to ~25 feet (8 m), and with lenses up to 105mm (the manual incorrectly lists 16.4 feet as the top distance).

 Note: Bodies with multiple AF sensors should be set to the central sensor otherwise the AF assist light will not function.

- If the **F** indicator on the SB-26's LCD panel is blinking, that means that the flash needs to have the aperture set. This happens in several situations: (1) in automatic (A) flash mode; (2) when using lenses without a CPU (AI or AI-S lenses); and (3) when using earlier Nikon bodies (generally those prior to the F4 and N8008/F-801). If the **F** is blinking, use the ▼ and ▲ buttons to set the correct aperture on the flash (i.e., the aperture that matches what is set on the camera).

- With the power switch in standby position (STBY) and most Nikon bodies, the SB-26 automatically turns off 80 seconds after the camera's meter turns OFF. A light press on the shutter release generally turns most Nikon bodies' light meters back

ON, and the SB-26 will turn ON at the same time. A few older bodies do not control the flash in this manner. On those cameras, when the SB-26 is in STBY, it automatically turns itself OFF after 80 seconds, regardless of whether the camera meter is active or not. To restore power to the SB-26, turn the SB-26 OFF and back ON.

Note: The SB-26 has a "special" standby mode that leaves the unit ready, regardless of the camera's meter state. To activate this special mode, start with the SB-26 in the OFF position. Hold down the LCD illumination button and turn the SB-26's power switch to STBY. Release the LCD illumination button. To cancel this mode, simply move the power switch back to the OFF position. A fresh set of alkaline batteries will last approximately 20 days in this setting; NiCads, about 10 days.

- If you are using the SB-26 on a body set to a mechanical shutter speed (M250, M90, B), set the SB-26's power switch to the ON position only. Standby (STBY) is not operative. On an F3, FM2, FM10, FE10, standby doesn't operate. On an FA or FE2 that incorporates the MD-12 Motor Drive, standby doesn't operate.

- After the flash fires, a ◢ symbol may appear in the SB-26's LCD along with a value. This indicates potential underexposure. This indicator appears only for 3 seconds after the shot. Use the LCD illumination button to recall the last indication.

- The maximum aperture in automatic (A) flash mode may be limited on some cameras (example: on N6006/F-601 at ISO 100 the maximum aperture that will be set is f/5.6).

- Rear-sync mode must be selected on the camera if you're using an N6006/F-601 or N6000/F-601m. Rear sync is not performed if using one of the vari-program modes (N90/F90, N90s/F90X, N70/F70) or when red-eye reduction is being used.

Note: Front-curtain sync is performed at all times on the following cameras, regardless of the setting on the SB-26: N5005/F-401x, N2020/F-501, N2000/F-301, N4004/F-401, N4004s/F-401s, FA, FE2, FG, Nikonos V, F3, F2, FM2, and FG-20.

- The shooting range scale does not appear on the LCD panel if the flash head is tilted or rotated (exception: the scale blinks if the flash is set at –7° below horizontal).

- While the SB-26 has "click stops" for commonly used flash head positions (45, 60, 75, and 90° for tilt, every 30° for rotation), you

aren't restricted to those positions. Setting an intermediate position is allowed (though it can be easily dislodged).

- Ready light warnings (blinking light) occur in the following conditions:

When you attempt to use the SB-26 in TTL mode on cameras that are not TTL-capable (see "Non-TTL-Capable Bodies," page 326).

When you attempt to use the SB-26 in A mode on cameras set to a mechanical shutter speed (M250, M90, B).

When you attempt to use the SB-26 in TTL mode with an unavailable film speed (e.g., ISO 800 on an FA, FE2, FG, or N4004s/F-401s).

When the shutter speed is set faster than the allowable flash sync speed of the camera.

When you've taken a flash picture with the SB-26 in TTL or A mode and the flash fired at full power (indicating it might have produced insufficient light for a flash exposure). However, in extremely bright scenes, the N4004s/F-401s may not blink its flash indicator, even when insufficient light was produced by the flash.

On an N4004s/F-401s: when the SB-26 and the camera's built-in flash are both OFF, but the camera's meter recommends flash use.

- Changing the ISO film speed setting on the SB-26 does not change the way the flash fires, except in automatic (A) flash mode. In other modes, changing the ISO value changes only the apertures displayed in the shooting range table. Accidentally moving the ISO setting after correctly making all flash and camera adjustments won't affect the resulting exposure.

- The SB-26 supports a special "wireless" remote feature. The easiest way to use it is with a TTL-capable flash on the camera:

1. Set the selector switch on the front of the remote SB-26 to D (delay).

2. Set the remote SB-26 to automatic flash mode. (You can also use manual flash mode; but this requires you make careful calculations of flash-to-subject distance and set a manually calculated aperture on the camera.)

3. Set the camera's shutter speed to 1 stop lower than its maximum sync speed (e.g., 1/125 instead of 1/250 second for most cameras).

4. Make sure that rear sync is not set on the camera or flash.

Note: If you must use rear sync, set the selector switch in Step 1 to S (simultaneous). However, note that this may not achieve the effect you're looking for, as the camera's TTL sensors see the output for both the on-camera and remote flash and shut off the on-camera flash early (i.e., the on-camera flash exposure will likely be underexposed).

5. **Important:** Set the on-camera flash to a mode that does not generate pre-flashes (e.g., standard TTL).

The wireless remote symbol (▣) appears on the Speedlight's LCD. The SB-26 fires shortly after it sees another flash fire, but you must locate the SB-26 in a position where the front sensor can see the camera-mounted unit's flashtube.

SB-27

Introduced in 1995, the SB-27 is an updated version of the SB-15.

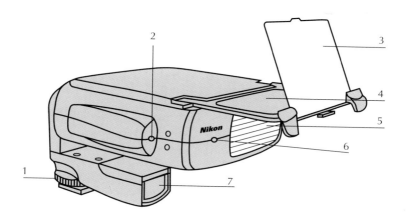

1 Locking ring
2 Light sensor
3 Diffusion card (swings down)
4 Bounce adapter (pulls out)
5 Flashtube
6 Red-eye reduction lamp
7 AF assist illuminator

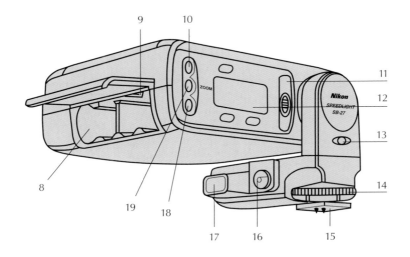

8 Battery compartment

9 Camera TTL/standby switch

10 Aperture (f) button
 (also up toggle)

11 Flash mode selector switch
 (also On/Off switch)

12 LCD information display

13 Test fire button

14 Locking ring

15 Flash mounting foot (ISO)

16 Sync socket

17 External power socket

18 M (manual adjustment) button
 (also down toggle)

19 Zoom button

Specifications

GN:	98 (ft), 30 (m)
Weight:	12 oz. (340 g) (w/o batteries)
Size:	2.8" (70 mm) tall x 4.2" (107 mm) wide x 3.8" (97 mm) deep
Power:	4 AA batteries
Recycle Time:	5 seconds minimum
# of Flashes:	~140 at full manual

Flash Duration: 1/1,000 second
Coverage: (78° horizontal, 60° vertical) 24mm lens; also supports 28mm, 35mm, 50mm, and 70mm coverage (unit may need to be rotated)
Case: SS-27 (included)
Key Features: TTL flash control on most TTL-capable Nikon bodies, monitor pre-flash on N90/F90 or later bodies; full power TTL, five power level manual and automatic (four apertures) settings. Red-eye reduction. LCD panel shows settings. Rear-curtain sync. The SB-27 can synchronize with up to four additional flash units. Head rotates 180°. Built-in bounce card. Autofocus assist illuminator.

Note: For cameras that support standby (Groups I through VI, see "Camera Groups," page 328), the switch in the battery compartment should be set to TTL S. For all other cameras—basically, most manual bodies—or if you use both manual and automatic bodies, set the switch to S. Failure to do so may result in the SB-27 not correctly switching into TTL mode.

Note: The SB-27 features a locking pin, which is controlled by the knurled knob on the hot shoe mechanism. The knob should be turned fully counterclockwise (to the right as you face the back of the SB-27) to retract the pin before putting the flash onto the camera. Once the SB-27 is on the camera, turn the knob clockwise (to the left as you face the back of the SB-27) to lock the flash to the camera (all bodies beginning with the N90/F90 have the proper slot for the pin. Likewise, be sure to retract the locking pin by turning the knob fully counterclockwise (to the right as you face the back of the SB-27) before attempting to remove the flash from the camera. Failure to do so could damage the flash or camera.

SB-27 takes that to the extreme. Virtually every control has dual functions, and some settings require you to hold a button down while turning the power switch/flash mode selector switch to a position. A few things to note:

• Blinking on the LCD indicates either a warning, or that you're in the midst of setting an item. On the SB-27, a blinking ▥ or an A symbol means that the unit is in "forced" mode (see notes at the end of this section, page 298). Blinking shouldn't be ignored. Either the Speedlight is not set correctly, it is telling you something about the mode it's in, or you haven't finished setting something.

• All three buttons on the left side of the SB-27's back have at least two labels, from top to bottom, they are:

•	▲	F	(up, aperture)
○		ZOOM	(zoom)
▢	▼	Ⓜ ISO	(down, manual, ISO)

Labels scattered above and below the LCD panel are designed to remind you of which multiple buttons must be pressed for certain modes. For example, to set flash exposure compensation, you simultaneously press the buttons labeled • and ▢ .

Setting Automatic TTL Flash Exposure (Newer TTL-Capable Nikon Bodies)

1. Set the power switch/flash mode selector on the back of the SB-27 to AUTO.

 Note: Despite the flash mode selector being set to AUTO, the LCD should display ▥, ▥◗, or ▥▣ .

2. Set the ISO film speed on the SB-27, if necessary.

 On the N8008/F-801, F4, F5, F100, N80/F80, N70/F70, N90/F90, N90s/F90X, N50/F50, and N60/F60, ISO film speed settings are automatically communicated to the SB-27.

 For older camera bodies, press the Ⓜ ISO button on the SB-27 to display the currently set ISO value. Press the Ⓜ ISO button again until the desired ISO value is displayed (each tap on the button moves the ISO number up 1/3 stop).

Note: You do not have to set the ISO value on the SB-27 as in TTL flash mode all exposure calculations are done by the camera. However, the shooting range scale may not show the proper results if you don't.

3. Select the type of TTL to be performed. Basically, with most modern Nikon bodies you have only one choice: whether or not to cancel the balanced fill-flash mode. Otherwise, the SB-27 sets the TTL mode based upon the camera body, lens type, and metering system as follows:

N90/F90 and later bodies (any body that supports the 3D flash capability, see "Camera Capabilities," pages 326–327): 3D balanced fill-flash (TTL) is performed in all metering modes if a D-type lens is mounted on the camera. Multi-sensor balanced fill-flash (TTL) is performed for all other autofocus and AI-P lenses. Center-weighted fill-flash (TTL) or spot fill-flash (TTL) is performed based upon metering selection for all other lenses.

With other TTL-capable bodies, matrix balanced fill-flash (TTL), center-weighted fill-flash (TTL), or spot fill-flash (TTL) is usually performed (matrix is available only with an autofocus or AI-P lens), depending upon metering mode. In some cases (F4 with AI or AI-S lens, for example), standard TTL is performed instead.

Note: When the camera body is set for spot metering, standard TTL is set automatically.

Note: The N4004s/F-401s allows only programmed TTL flash, and the ▣ indicator does not appear, even though the camera and flash will perform TTL. See "Setting Programmed TTL Flash Exposure," page 292.

Change from a balanced fill-flash mode to standard TTL (and vice versa, if supported) by pressing the M button on the SB-27. Balanced fill-flash is indicated by ▥▣ or ▥▣ in the LCD, while in standard TTL mode only ▥ appears.

4. Set autofocus cameras to single servo (S) autofocus mode.
5. Set the camera's exposure mode if you haven't already. In aperture-priority (A), shutter-priority (S), and manual (M) exposure modes, make any necessary aperture or shutter speed selections.

With AI, AI-S, and AF teleconverters, some cameras will switch automatically to aperture-priority (A) exposure mode (program and shutter-priority modes are not available). Other cameras need to be manually switched to aperture-priority (A) mode with these lenses.

In program modes you can usually override the camera's selection of aperture and shutter speed combinations by turning the camera's control dial (when the shutter release is partially pressed).

The aperture the camera (or you) selected also appears on the SB-27's LCD panel when you partially press the shutter release.

Note: The camera and SB-27 may warn you of several possible errors when you partially press the shutter release to verify settings:

• In program modes (P, PD, PH), and on the more recent bodies (e.g., F5, F100, F65/N65, N80/F80), the lens must be set to its minimum aperture, or else the error message FEE appears in the viewfinder.

• Any time that ⋈ is visible in the viewfinder indicates that overexposure is likely. For many of the later bodies, starting with the N8008/F-801, the placement of the ⋈ varies with exposure mode: ⋈ and the smallest aperture appear in the camera's viewfinder if overexposure is likely in the program (P) modes. ⋈ appears in place of the aperture for overexposure warnings in shutter-priority (S) mode. ⋈ appears in place of the shutter speed in aperture-priority (A) mode.

• The shutter speed is reset to 1/250 second if you selected a faster shutter speed in shutter-priority (S) or manual (M) exposure mode.

• In manual (M) exposure mode, under- and overexposure are indicated solely by the analog exposure display. If the exposure bar goes to either side of the ⁰ point, the ambient lighting exposure will not be correct.

6. Focus on the subject by pressing lightly on the shutter release. Confirm that the subject is within flash range by looking at the shooting range scale on the SB-27's LCD. After you've confirmed the distance, you're ready to shoot.

SB-27 Usable Apertures and Flash Range in TTL Mode (24mm)

ISO 800	400	200	100	50	25	Range in Ft	Range in M
f/2	f/1.4	—	—	—	—	12–60	3.8–20
f/2.8	f/2	f/1.4	—	—	—	8.7–60	2.7–20
f/4	f/2.8	f/2	f/1.4	—	—	6.2–60	1.9–20
f/5.6	f/4	f/2.8	f/2	f/1.4	—	4.4–49	1.4–15
f/8	f/5.6	f/4	f/2.8	f/2	f/1.4	3.1–34	1.0–10
f/11	f/8	f/5.6	f/4	f/2.8	f/2	2.2–24	0.7–7.5
f/16	f/11	f/8	f/5.6	f/4	f/2.8	2.0–17	0.6–5.3
f/22	f/16	f/11	f/8	f/5.6	f/4	2.0–12	0.6–3.7
f/32	f/22	f/16	f/11	f/8	f/5.6	2.0–8.6	0.6–2.6
—	f/32	f/22	f/16	f/11	f/8	2.0–6.1	0.6–1.8

SB-27 Usable Apertures and Flash Range in TTL Mode (28mm)

ISO 800	400	200	100	50	25	Range in Ft	Range in M
f/2	f/1.4	—	—	—	—	13–60	4.0–20
f/2.8	f/2	f/1.4	—	—	—	9.3–60	2.9–20
f/4	f/2.8	f/2	f/1.4	—	—	6.6–60	2.0–20
f/5.6	f/4	f/2.8	f/2	f/1.4	—	4.7–52	1.5–16
f/8	f/5.6	f/4	f/2.8	f/2	f/1.4	3.3–37	1.0–11
f/11	f/8	f/5.6	f/4	f/2.8	f/2	2.4–26	0.7–8
f/16	f/11	f/8	f/5.6	f/4	f/2.8	2.0–18	0.6–5.6
f/22	f/16	f/11	f/8	f/5.6	f/4	2.0–13	0.6–4
f/32	f/22	f/16	f/11	f/8	f/5.6	2.0–9.2	0.6–2.8
—	f/32	f/22	f/16	f/11	f/8	2.0–6.5	0.6–2.0

SB-27 Usable Apertures and Flash Range in TTL Mode (35mm)

ISO 800	400	200	100	50	25	Range in Ft	Range in M
f/2	f/1.4	—	—	—	—	15–60	4.5 -20
f/2.8	f/2	f/1.4	—	—	—	11–60	3.2–20
f/4	f/2.8	f/2	f/1.4	—	—	7.4–60	2.3–20
f/5.6	f/4	f/2.8	f/2	f/1.4	—	5.2–60	1.6–18
f/8	f/5.6	f/4	f/2.8	f/2	f/1.4	3.7–41	1.1–13
f/11	f/8	f/5.6	f/4	f/2.8	f/2	2.6–29	0.8–9
f/16	f/11	f/8	f/5.6	f/4	f/2.8	2.0–20	0.6–6.3
f/22	f/16	f/11	f/8	f/5.6	f/4	2.0–14	0.6–4.5
f/32	f/22	f/16	f/11	f/8	f/5.6	2.0–10	0.6–3.2
—	f/32	f/22	f/16	f/11	f/8	2.0–7.3	0.6–2.3

SB-27 Usable Apertures and Flash Range in TTL Mode (50mm)

ISO 800	400	200	100	50	25	Range in Ft	Range in M
f/2	f/1.4	—	—	—	—	17–60	5.2–20
f/2.8	f/2	f/1.4	—	—	—	12–60	3.7–20
f/4	f/2.8	f/2	f/1.4	—	—	8.6–60	2.6–20
f/5.6	f/4	f/2.8	f/2	f/1.4	—	6.1–60	1.9–20
f/8	f/5.6	f/4	f/2.8	f/2	f/1.4	4.3–48	1.4–14
f/11	f/8	f/5.6	f/4	f/2.8	f/2	3.0–34	1.0–10
f/16	f/11	f/8	f/5.6	f/4	f/2.8	2.2–24	0.7–7.4
f/22	f/16	f/11	f/8	f/5.6	f/4	2.0–17	0.6–5.2
f/32	f/22	f/16	f/11	f/8	f/5.6	2.0–12	0.6–3.7
—	f/32	f/22	f/16	f/11	f/8	2.0–8.6	0.6–2.6

SB-27 Usable Apertures and Flash Range in TTL Mode (70mm)

ISO 800	400	200	100	50	25	Range in Ft	Range in M
f/2	f/1.4	—	—	—	—	20–60	6.0–20
f/2.8	f/2	f/1.4	—	—	—	14–60	4.3–20
f/4	f/2.8	f/2	f/1.4	—	—	9.8–60	3.0–20
f/5.6	f/4	f/2.8	f/2	f/1.4	—	7.0–60	2.2–20
f/8	f/5.6	f/4	f/2.8	f/2	f/1.4	4.9–55	1.5–16
f/11	f/8	f/5.6	f/4	f/2.8	f/2	3.5–39	1.1–12
f/16	f/11	f/8	f/5.6	f/4	f/2.8	2.5–27	0.8–8.4
f/22	f/16	f/11	f/8	f/5.6	f/4	2.0–19	0.6–6.0
f/32	f/22	f/16	f/11	f/8	f/5.6	2.0–13	0.6–4.2
—	f/32	f/22	f/16	f/11	f/8	2.0–9.8	0.6–3.0

Setting Programmed TTL Flash Exposure (N2020/F-501, N4004s/ F-401s, N2000/F-301)

1. Set the power switch/flash mode selector on the back of the SB-27 to AUTO.

 Note: Despite being set to AUTO, the LCD display should show **TTL**, **TTL⚡**, or **TTL⚙**.

2. Set the camera to program auto (on the N4004s/F-401s: shutter speed dial at A, aperture dial at S; on the other cameras: shutter speed dial at PDUAL, P, or PHIGH and the lens set at its smallest aperture).

 Note: The N4004s/F-401s only performs programmed TTL flash. But the ⚡ indicator does not appear on the SB-27's LCD.

Note: Setting exposure modes other than program (P) results in standard TTL flash being used (exception: N4004/F-401 will also perform programmed TTL flash when set to shutter-priority [S] exposure mode).

3. Set autofocus cameras to single servo (S) autofocus mode.

4. Focus on the subject by pressing lightly on the shutter release. Confirm that the subject is within flash range by looking at the shooting range scale on the SB-27's LCD. After you've confirmed the distance, you're ready to shoot.

 You can set the aperture on the flash by using the **F** button on the SB-27. N4004s/F-401s users should set the aperture according to the ISO value they're using (see table below).

SB-27 Usable Apertures and Flash Range in Programmed TTL Mode

Zoom	ISO 400	200	100	50	25	Range in Ft	Range in M
24mm	f/11	f/8	f/5.6	f/4	f/2.8	2.0–17	0.6–5.3
28mm	f/11	f/8	f/5.6	f/4	f/2.8	2.0–18	0.6–5.6
35mm	f/11	f/8	f/5.6	f/4	f/2.8	2.0–20	0.6–6.3
50mm	f/11	f/8	f/5.6	f/4	f/2.8	2.2–24	0.7–7.4
70mm	f/11	f/8	f/5.6	f/4	f/2.8	2.5–27	0.8–8.4
85mm	f/11	f/8	f/5.6	f/4	f/2.8	2.6–29	0.8–8.8

Note: N4004s/F-401s and N4004/F-401 users should set an aperture of f/5.6 to f/16 and consult flash unit for usable range.

Setting Automatic Flash Exposure (All Nikon Bodies)

1. Hold down the zoom (green ◦) button on the back of the SB-27 while moving the power switch/flash mode selector from OFF to AUTO.

2. Set the ISO film speed on the SB-27, if necessary.

 In automatic (A) flash mode, all exposure calculations are performed by the SB-27. If the camera doesn't automatically communicate the ISO value to the flash, you must set the ISO value manually, or incorrect exposure may result.

3. Set the camera to aperture-priority (A) or manual (M) exposure mode.

4. Set autofocus cameras to single servo (S) autofocus mode (A on the N4004s/F-401s).

5. Focus on the subject by pressing lightly on the shutter release. Note the distance.

6. Adjust your camera to the desired aperture and/or shutter speed, as usual. Set the corresponding aperture on the flash by using the F button on the SB-27. The aperture set on both the camera and flash should match.

Confirm that the subject is within flash range by looking at the shooting range scale on the SB-27's LCD and comparing it to the distance you noted in Step 5. Shooting ranges for automatic (A) flash mode are shown in the following tables (or look at the shooting range scale on the SB-27).

SB-27 Usable Apertures and Flash Range in A Mode (24mm)

ISO 800	400	200	100	50	25	Range in Ft	Range in M
f/5.6	f/4	f/2.8	f/2	f/1.4	—	4.4–49	1.4–15
f/8	f/5.6	f/4	f/2.8	f/2	f/1.4	3.1–34	1.0–10
f/11	f/8	f/5.6	f/4	f/2.8	f/2	2.2–24	0.7–7.5
f/16	f/11	f/8	f/5.6	f/4	f/2.8	2.0–17	0.6–5.3
f/22	f/16	f/11	f/8	f/5.6	f/4	2.0–12	0.6–3.7
f/32	f/22	f/16	f/11	f/8	f/5.6	2.0–8.6	0.6–2.6

SB-27 Usable Apertures and Flash Range in A Mode (28mm)

ISO 800	400	200	100	50	25	Range in Ft	Range in M
f/5.6	f/4	f/2.8	f/2	f/1.4	—	4.7–52	1.5–16
f/8	f/5.6	f/4	f/2.8	f/2	f/1.4	3.3–37	1.0–11
f/11	f/8	f/5.6	f/4	f/2.8	f/2	2.4–26	0.7–8
f/16	f/11	f/8	f/5.6	f/4	f/2.8	2.0–18	0.6–56.
f/22	f/16	f/11	f/8	f/5.6	f/4	2.0–13	0.6–4
f/32	f/22	f/16	f/11	f/8	f/5.6	2.0–9.2	0.6–2.8

SB-27 Usable Apertures and Flash Range in A Mode (35mm)

ISO 800	400	200	100	50	25	Range in Ft	Range in M
f/5.6	f/4	f/2.8	f/2	f/1.4	—	5.2–60	1.6–18
f/8	f/5.6	f/4	f/2.8	f/2	f/1.4	3.7–41	1.1–13
f/11	f/8	f/5.6	f/4	f/2.8	f/2	2.6–29	0.8–9
f/16	f/11	f/8	f/5.6	f/4	f/2.8	2.0–20	0.6–6.3
f/22	f/16	f/11	f/8	f/5.6	f/4	2.0–14	0.6–4.5
f/32	f/22	f/16	f/11	f/8	f/5.6	2.0–10	0.6–3.2

SB-27 Usable Apertures and Flash Range in A Mode (50mm)

ISO 800	400	200	100	50	25	Range in Ft	Range in M
f/5.6	f/4	f/2.8	f/2	f/1.4	—	6.1–60	1.9–20
f/8	f/5.6	f/4	f/2.8	f/2	f/1.4	4.3–48	1.4–14
f/11	f/8	f/5.6	f/4	f/2.8	f/2	3.0–34	1.0–10
f/16	f/11	f/8	f/5.6	f/4	f/2.8	2.2–24	0.7–7.4
f/22	f/16	f/11	f/8	f/5.6	f/4	2.0–17	0.6–5.2
f/32	f/22	f/16	f/11	f/8	f/5.6	2.0–12	0.6–3.7

SB-27 Usable Apertures and Flash Range in A Mode (70mm)

ISO 800	400	200	100	50	25	Range in Ft	Range in M
f/5.6	f/4	f/2.8	f/2	f/1.4	—	7.0–60	2.2–20
f/8	f/5.6	f/4	f/2.8	f/2	f/1.4	4.9–55	1.5–16
f/11	f/8	f/5.6	f/4	f/2.8	f/2	3.5–39	1.1–12
f/16	f/11	f/8	f/5.6	f/4	f/2.8	2.5–27	0.8–8.4
f/22	f/16	f/11	f/8	f/5.6	f/4	2.0–19	0.6–6.0
f/32	f/22	f/16	f/11	f/8	f/5.6	2.0–13	0.6–4.2

Setting Manual Flash Exposure (All Nikon Bodies)

1. Set the power switch/flash mode selector on the back of the SB-27 to M.

2. Set the camera to aperture-priority (A) or manual (M) exposure mode and set the aperture and shutter speed, as usual. Make sure that the shutter speed selected is not above the camera's flash sync speed (most Nikon bodies force this).

3. Set autofocus cameras to single servo (S) autofocus mode (A on the N4004s/F-401s).

4. Focus on the subject by pressing lightly on the shutter release. Note the distance.

5. On newer cameras (F4 and N8008s/F-801s or later) equipped with lenses that have CPUs (all autofocus and AI-P lenses), simply changing the aperture on the camera will cause the SB-27 to match it. You should see the aperture change and the distance in the shooting range scale change on the SB-27, as well. You have two choices (you can also use a combination of both):

1. Change the aperture (on the camera) until the distance noted in Step 4 is shown in the SB-27's shooting range scale.

2. Press **M** on the SB-27 to change the flash unit's power level until the distance noted in Step 4 is shown in the SB-27's shooting range scale.

On older cameras, or with lenses that don't have CPUs (AI and AI-S), the aperture on the camera isn't linked with the SB-27, so you should adjust the aperture and flash power settings on the SB-27 until the shooting range scale indicates the distance you noted in Step 4 and then set the aperture on the camera to match that shown on the SB-27.

Note: The SB-27 is capable of keeping up with a motor-driven camera (up to 6 fps) at powers of 1/8 or 1/16 as follows:

1/8	**4 consecutive frames**
1/16	**8 consecutive frames**

However, let the flash cool at least 10 minutes after firing 40 frames.

SB-27 Specifications (Guide Numbers in Feet)

Output Level/ Coverage	24mm	28mm	35mm	50mm	70mm	Duration (sec)
Full Power	82	89	98	112	112*	1/1,000
1/2 Power	58	62	69	79	79*	1/1,100
1/4 Power	41	44	49	56	56*	1/2,500
1/8 Power	29	31	34	39	39*	1/4,200
1/16 Power	20	22	24	28	28*	1/6,700
Horizontal	78°	70°	60°	46°	36°*	
Vertical	60°	53°	46°	36°	46°*	

** Flash head is vertical.*

SB-27 Specifications (Guide Numbers in Meters)

Output Level	24mm	28mm	35mm	50mm	70mm
Full Power	25	27	30	34	34*
1/2 Power	17.7	19	21.2	24	24*
1/4 Power	12.5	13.5	15	17	17*
1/8 Power	8.8	9.5	10.5	12	12*
1/16 Power	6.2	6.7	7.4	8.5	8.5*

** Flash head is vertical.*

Note: GNs listed are for flash head settings, not lenses! In other words, if you use a 50mm lens but the flash head is set for 35mm, you get a GN of 98 in feet (30 in meters), not 112 (34).

Note: Nikon has not been consistent in the way they round numbers when calculating GNs for meters. I've used the numbers in the original manuals, complete with Nikon's rounding error.

Setting the Zoom Head Manually

1. Press the zoom button to change the zoom setting. Each button press selects the next higher logical setting (and it will eventually loop back to the lowest setting). The LCD shows a small ₘ when the setting doesn't correspond to the lens being used (when using autofocus or AI-P lenses on newer bodies).

 Note: The position of the flash head influences the zoom settings you may make. In a vertical position, only 35mm, 50mm, and 70mm are available. In a horizontal position, 24mm, 28mm, 35mm, and 50mm are available.

2. To cancel a manual zoom setting, press the zoom button until the ₘ no longer appears on the LCD (i.e., until the setting matches the lens being used).

 Note: To cancel automatic zooming, hold the **ZOOM** and **M** buttons simultaneously for about 2 seconds until the M above zoom blinks. To return to automatic zoom settings, hold the **ZOOM** and **M** buttons again until the M above the zoom stops blinking.

Setting Flash Exposure Compensation

Note: If using an N6006/F-601 or N6000/F-601m, you must set flash exposure compensation on the camera, not on the SB-27.

1. With the flash set to a TTL mode, simultaneously press the **F** and **M** buttons until the ☉·☉ in the lower right portion of the LCD begins to blink (just below 🔁).

2. Use the **▼** and **▲** buttons to adjust the amount of compensation. The SB-27 allows a maximum of +1 stop and –3 stops of flash compensation, which is indicated in 1/3-stop increments by the flash compensation value.

3. Again simultaneously press the **F** and **M** buttons to lock in the compensation (or wait a few seconds and it will be done automatically). The compensation value should stop blinking. The compensation amount should still appear in the LCD (unless you've set 0.0, in which case the compensation section of the LCD is blank).

4. To cancel exposure compensation, repeat Steps 1 through 3 and set a value of 0.0.

Note: Flash compensation does not change the background exposure calculated by the camera.

Tip: It's probably best to avoid flash compensation in any of the balanced fill-flash TTL modes. You don't know what level of compensation the camera is already making, so any changes you make are in addition to this unknown, camera-calculated compensation. For full control switch to automatic or manual flash modes, where any compensation you dial in will be from a known flash level.

Setting Red-Eye Reduction (N90/F90 and Later Nikon Bodies)

1. Set red-eye reduction on the camera body (see camera instructions). On Nikon's most recent bodies, this is done by holding the **⚡** button on the camera and turning the command dial until ⊛ appears (⊛⚡ appears on the SB-27's LCD).

Note: The F5 doesn't support the red-eye reduction function.

Note: Red-eye reduction works in most flash modes, but not in the rear-curtain sync mode.

SB-27 Notes

- TTL operation on some cameras (e.g., FA, FE2, FG) has a more limited ISO range (25–400) than later bodies (ISO 25–1,000).

- For autofocus bodies, the camera's focus mode selector should be set to single servo (S) autofocus (N50/F50 should be set to AF, N5005/F-401x, N4004s/F-401s, and N4004/F-401 should be set to A). The flash will not fire unless the subject is in focus. The autofocus assist illuminator will be used automatically if the ambient light is low. Autofocus assist works only at distances from 3.3 feet (1 m) up to 16.4 feet (5 m), and with lenses up to 105mm.

- If the **F** indicator on the SB-27's LCD panel is blinking, that means that the flash needs you to set the aperture. This happens in several situations: (1) in automatic (A) flash mode; (2) when using lenses without a CPU (AI or AI-S lenses); and (3) when using earlier Nikon bodies (generally those prior to the F4 and N8008/F-801). If the **F** is blinking, use the ▼ and ▲ buttons to set the correct aperture on the flash (i.e., the aperture that matches what is set on the camera).

- The SB-27 automatically goes into standby power mode about a minute after the camera's meter turns OFF if the SB-27 is in a non-"forced" mode (if it is in a "forced" mode, see third bullet from the end of this list). A light press on the shutter release generally turns most Nikon bodies' light meters back ON, and the SB-27 will turn ON at the same time. A few older bodies do not control the flash in this manner. On those cameras, when the SB-27 is turned ON, it automatically turns itself OFF after 80 seconds, regardless of whether the camera meter is active or not. To restore power to the SB-27, turn the SB-27 OFF and back ON.

- The maximum aperture in automatic (A) flash mode may be limited on some cameras (example: on N6006/F-601 at ISO 100 the maximum aperture that will be set is f/5.6.

- Rear-sync mode must be selected on the camera. Rear sync is not performed if using one of the vari-program modes (N90/F90, N70/F70) or when red-eye reduction is being used.

- Viewfinder ready light warnings (blinking light) occur in the following conditions:

 When the shutter release on the camera is pressed halfway and the SB-27 is not mounted correctly in the hot shoe.

 When you attempt to use the SB-27 in TTL mode on cameras set to a mechanical shutter speed (M250, M90, B).

 When you attempt to use the SB-27 in TTL mode with an unavailable film speed (e.g., ISO 800 on an FA, FE2, FG, or N4004s/F-401s).

 When the shutter speed is set faster than the allowable flash sync speed of the camera.

- The SB-27's ready light blinks when you've taken a flash picture with the SB-27 in TTL or A mode and the flash fired at full power (indicating it might have produced insufficient light for a flash exposure).

- After the flash fires, a ◢ symbol may appear in the SB-27's LCD along with a value. This indicates potential underexposure. This indicator appears for only 3 seconds after the shot.

- Changing the ISO setting on the SB-27 does not change the way the flash fires, except in automatic (A) flash mode. In other modes, changing the ISO value changes only the apertures displayed in the shooting range table. Accidentally moving the ISO setting after correctly making all flash and camera adjustments won't affect the resulting exposure.

- If TTL or A is blinking on the SB-27's LCD, this indicates that the flash is in "forced" mode. This is typically used when the SB-27 is used as a slave flash, as in forced mode the unit does not go into standby. Forced mode requires the switch in the battery compartment to be set to the camera silhouette icon. To cancel the forced modes, hold down the zoom button (green ○) while turning the SB-27 OFF and back ON again.

 Note: When the SB-27 is used as a slave flash, you must use the forced TTL function (i.e., set the battery compartment switch to ▅).

- It is possible to get the SB-27 into a situation where it doesn't recognize the camera but otherwise seems to be ON (sometimes due to changing standby modes while the flash is still connected to the camera). Press the test fire button to fire the flash. This usually resets the flash and allows it to recognize the camera again.

- A ◿ icon appears on the SB-27's LCD if the bounce adapter is pulled out (and the lens focal length and distance indicators disappear). Note that you have to use the flash upside down to use the bounce adapter (i.e., flip the flash over from its regular orientation so the logo is upside down!). If you somehow break the bounce adapter, you'll need to hold the ZOOM and F buttons simultaneously for 4 seconds until the zoom head position indicator reappears.

SB-28 and SB-28DX

The SB-28 is a modest update of the top-of-the-line Speedlight model SB-26. The SB-28 is somewhat lighter and smaller than the SB-26 and has slightly better recycling and battery characteristics. However, it has no remote wireless slave capability. It was introduced in 1997. The SB-28DX, introduced in 1999, allows TTL flash with the digital D1 camera body (this is the only feature change).

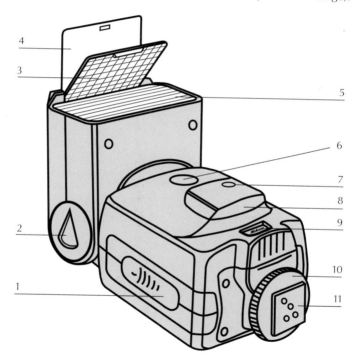

1	Battery compartment cover	6	Redeye reduction lamp
2	Tilt and rotate angle release/lock lever	7	Light sensor
		8	AF assist illuminator
3	Wide-angle adapter (pulls out, flips down)	9	External power socket (under logo)
4	Bounce diffuser card (pulls out)	10	Locking ring
5	Flashtube	11	Flash mounting foot (ISO)

11 TTL multiple flash socket
12 Sync socket
13 Rubber socket cover
14 Rotation scale
15 Tilt angle scale
16 LCD information display
17 Adjustment (+ -) button
18 On/Off button
19 Selection (SEL) button
20 LCD illuminator button
21 Mode button
22 Ready light/test fire button
23 Zoom button

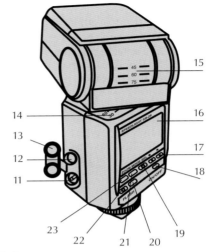

Specifications

GN: 118 (ft), 36 (m)
Weight: 11.8 oz. (335 g) (w/o batteries)
Size: 5" (127 mm) tall x 2.7" (68 mm) wide x 3.6"
 (91 mm) deep
Power: 4 AA batteries
Recycle Time: 6.5 seconds minimum (full discharge)
No. of Flashes: ~150 at full manual
Flash Duration: 1/1,000 second
Coverage: (102° horizontal, 90° vertical) 18mm lens; also
 supports 20mm, 24mm, 28mm, 35mm, 50mm,
 70mm, and 85mm coverage
Case: SS-28 for main unit
Key Features: TTL flash control on most TTL-capable Nikon
 bodies, monitor pre-flash on N90s/F90X or later
 bodies; full power TTL, seven power level
 manual and automatic (six apertures) settings.
 LCD panel shows settings. Rear-curtain sync.
 High-speed sync, repeating flash, red-eye
 reduction. The SB-28 can synchronize with up to
 four additional flash units. Head tilts from –7°
 below horizontal up to 90° above horizontal, and
 rotates –270° to +180° clockwise. Built-in diffuser
 card. Autofocus assist illuminator.

Note: The SB-28 features a locking pin, which is controlled by the knurled knob on the hot shoe mechanism. The knob should be turned fully counterclockwise (to the right as you face the back of the SB-28) to retract the pin before putting the flash onto the camera. Once the SB-28 is on the camera, turn the knob clockwise (to the left as you face the back of the SB-28) to lock the flash to the camera (all bodies starting with the N90/F90 have the proper slot for the pin. Likewise, be sure to retract the locking pin by turning the knob fully counterclockwise (to the right as you face the back of the SB-28) before attempting to remove the flash from the camera. Failure to do so could damage the flash or camera.

Setting Automatic TTL Flash Exposure (TTL-Capable Nikon Bodies)

1. Press the power (ON/OFF) button on the SB-28 to turn it ON.

2. Set the ISO film speed on the SB-28, if necessary. The ISO value blinks when you first turn the SB-28 ON if the ISO value needs to be set manually. (If it stops blinking, you can turn the flash OFF and then back ON to set the ISO.)

 Note: You do not have to set the ISO value on the SB-28 as in TTL flash mode all exposure calculations are done by the camera. However, the shooting range scale may not show the proper results if you don't.

3. Press the mode button until the ▥ (and ▦ or ▤) symbol(s) appears on the LCD.

4. Select the type of TTL to be performed. Basically, with most modern Nikon bodies you have only one choice: whether or not to cancel the balanced fill-flash mode (you do so by pressing the mode button until only the ▥ symbol appears; if ▥▦ or ▥▤ appear, the camera is in a balanced fill-flash mode). Otherwise, the SB-28 sets the TTL mode based upon the camera body, lens type, and metering system as follows:

 N90/F90 and later bodies (any body that supports the 3D flash capability, see "Camera Capabilities," pages 326–327): 3D balanced fill-flash (TTL) is performed in all metering modes if a D-type lens is mounted on the camera. Multi-sensor balanced fill-flash (TTL) is performed for all other autofocus and AI-P lenses. Center-weighted fill-flash (TTL) or spot fill-flash (TTL) is performed based upon metering selection for all other lenses.

With other TTL-capable bodies, matrix balanced fill-flash (TTL), center-weighted fill-flash (TTL), or spot fill-flash (TTL) is usually performed (matrix is available only with an autofocus or AI-P lens), depending upon the metering mode. In some cases (F4 with AI or AI-S lens, for example), standard TTL is performed instead.

Note: When the camera body is set for spot metering, standard TTL is set automatically.

Note: The N4004s/F-401s allows only programmed TTL flash and the 🔳 indicator does not appear, even though the camera and flash will perform TTL. See "Setting Programmed TTL Flash Exposure," page 305.

5. Set autofocus cameras to single servo (S) autofocus mode.

6. Set the camera's exposure mode, if you haven't already. In aperture-priority (A), shutter-priority (S), and manual (M) exposure modes, make any necessary aperture or shutter speed selections.

 With AI, AI-S, and AF teleconverters, some cameras will switch automatically to aperture-priority (A) exposure mode (program and shutter-priority modes are not available). Other cameras need to be manually switched to aperture-priority (A) mode with these lenses.

 In program modes you can usually override the camera's selection of aperture and shutter speed combinations by turning the camera's control dial (when the shutter release is partially pressed).

 The aperture the camera (or you) selected also appears on the SB-28's LCD panel when you partially press the shutter release.

Note: The camera and SB-28 may warn you of several possible errors when you partially press the shutter release to verify settings:

• In program modes (P, PD, PH), and on the most recent bodies (F5, F100, N80/F80), the lens must be set on its minimum aperture, or else the error message ＦＥＥ appears in the viewfinder.

• Any time that Ｈ is visible in the viewfinder indicates that overexposure is likely. For many of the later bodies, starting with the N8008/F-801, the placement of the

⊁ symbol varies with exposure mode: ⊁ and the smallest aperture appear in the camera's viewfinder if overexposure is likely in the program (P) modes. ⊁ appears in place of the aperture for overexposure warnings in shutter-priority (S) mode. ⊁ appears in place of the shutter speed in aperture-priority (A) mode.

• The shutter speed will be automatically reset to 1/250 second if you selected a faster shutter speed in shutter-priority (S) or manual (M) exposure mode.

• In manual (M) exposure mode, under- and overexposure are indicated solely by the analog exposure display. If the exposure bar goes to either side of the ⅰ point, the ambient-only lighting exposure will not be correct.

7. Focus on the subject by pressing lightly on the shutter release. Confirm that the subject is within flash range by looking at the shooting range scale on the SB-28's LCD. After you've confirmed the distance, you're ready to shoot.

SB-28 Usable Apertures and Flash Range in TTL Mode

It is surprising that Nikon didn't publish this information in its SB-28 manual. However, you can use the tables for the SB-26 (see pages 265–268), since the units are nearly identical.

Setting Programmed TTL Flash Exposure (N2020/F-501, N4004s/F-401s, N2000/F-301)

1. Press the power (ON/OFF) button on the SB-28 to turn it ON.

2. Set the ISO film speed on the SB-28, if necessary. The ISO value blinks when you first turn the SB-28 ON if the ISO value needs to be set manually. (If it stops blinking, you can turn the flash unit OFF and then back ON to set ISO.)

 Note: You do not have to set the ISO value on the SB-28 as in TTL flash mode all exposure calculations are done by the camera. However, the shooting range scale may not show the proper results if you don't.

3. Press the MODE button until TTL appears on the LCD.

4. Set the camera to program auto (on the N4004s/F-401s: shutter speed dial at A, aperture dial at S; on the other cameras: shutter speed dial at P, PD, or PH and the lens set at its smallest aperture).

Note: The N4004s/F-401s performs only programmed TTL flash. But the 🔲 indicator does not appear on the SB-28's LCD.

Note: Setting exposure modes other than program (P) results in standard TTL flash being used (exception: N4004/F-401 will also perform programmed TTL flash when set to shutter-priority [S] exposure mode).

5. Set autofocus cameras to single servo (S) autofocus mode.

6. Focus on the subject by pressing lightly on the shutter release. Confirm that the subject is within flash range by looking at the shooting range scale on the SB-28's LCD. After you've confirmed the distance, you're ready to shoot.

You can set the aperture on the SB-28 by using the 🔽 and 🔼 buttons. N2000/F-301 and N2020/F-501 users should set the aperture according to the ISO value they're using (see table below).

SB-28 Recommended Apertures in Programmed TTL Mode (N2000/F-301, N2020/F-501)

ISO 400	200	100	50	25
f/11	f/8	f/5.6	f/4	f/2.8

SB-28 Recommended Apertures in Programmed TTL Mode (N4004/F-401, N4004s/F-401s)

Use f/5.6 to f/11 at ISO 100.

Setting Automatic Flash Exposure (All Nikon Bodies)

1. Press the power (ON/OFF) button on the SB-28 to turn the flash unit ON.

2. In automatic (A) flash mode all the exposure calculations are performed by the SB-28. If the camera doesn't automatically communicate the ISO value to the flash, you must manually set the ISO value on the flash, or incorrect exposure may result.

The ISO value blinks when you first turn the SB-28 ON if the ISO value needs to be set manually. (If it stops blinking, you can turn the flash OFF and then back ON to set ISO.)

3. Press the mode button until A appears on the LCD.

4. Set the camera to aperture-priority (A) or manual (M) exposure mode.

5. Set autofocus cameras to single servo (S) autofocus mode (A on the N4004s/F-401s).

6. Focus on the subject by pressing lightly on the shutter release. Note the distance.

7. Adjust your camera to the desired aperture and/or shutter speed, as usual. Set the corresponding aperture on the flash by using the ▼ and ▲ buttons on the SB-28. The aperture being set flashes (wait a few seconds for it to lock in). The aperture on both the camera and flash should match.

 Confirm that the subject is within flash range by looking at the shooting range scale on the SB-28's LCD and comparing it to the distance you noted in Step 6. Or, shooting ranges for automatic (A) flash mode are shown in the shooting range scale on the SB-28.

SB-28 Usable Apertures and Flash Range in A Mode

Nikon did not publish these tables for the SB-28, but you can use the tables for the SB-26, see pages 271–273.

Setting Manual Flash Exposure (All Nikon Bodies)

1. Press the power (ON/OFF) button on the SB-28 to turn the flash unit ON.

2. Set the ISO film speed on the SB-28, if necessary. The ISO value blinks when you first turn the SB-28 ON if the ISO value needs to be set manually. (If it stops blinking, you can turn the flash OFF and then back ON to set the ISO.)

 Note: You do not have to set the ISO value on the SB-28 as in manual (M) flash mode the flash always fires at a fixed power. However, the shooting range scale may not show the proper results if you don't.

3. Press the **MODE** button until **M** appears on the LCD.

 Note: If an **FP** also appears immediately beneath the **M**, you need to cancel out of the high-speed mode. Do so by pressing the ▬ button until the **FP** disappears and the power level you want set appears (you can also press the ➕ button, but in most cases you'll get to the power you want faster by pressing ▬).

4. Set the camera to aperture-priority (A) or manual (M) exposure mode and set your aperture and shutter speed, as usual. Make sure that the shutter speed selected is not faster than the camera's flash sync speed (most Nikon bodies force this, except in manual [M] exposure mode).

5. Set autofocus cameras to single servo (S) autofocus mode (A on the N4004s/F-401s).

6. Focus on the subject by pressing lightly on the shutter release. Note the distance.

7. *On newer cameras* (F4 and N8008s/F-801s or later) equipped with lenses that have CPUs (all autofocus and AI-P lenses), simply changing the aperture on the camera causes the SB-28 to match it. You should see the aperture change on the SB-28 and the distance in the shooting range scale change, as well. You have two choices (you can also use a combination of both):

(1) Change the aperture on the camera until the distance noted in Step 6 is shown in the SB-28's shooting range scale.

(2) Press the **+** or **–** buttons on the SB-28 to change the flash unit's power level until the distance noted in Step 6 is shown in the SB-28's shooting range scale.

On older cameras, or with lenses that don't have CPUs (AI and AI-S), the aperture on the camera isn't linked with the SB-28, so you should adjust aperture and flash power settings on the SB-28 until the shooting range scale indicates the distance you noted in Step 6, and then set the aperture on the camera to match that shown on the SB-28.

Note: The power setting of the SB-28 is controlled in 1/3-stop increments between 1/1 (full) and 1/64 power. You control the setting by pressing the **SEL** button until the numbers under the ⚡ indicator begin flashing, then using the **▼** and **▲** buttons to choose a value (0.3 is 1/3 stop, 0.7 is 2/3 stop). Press **SEL** a second time to lock in the chosen value. (or wait a few seconds and the SB-28 does it automatically).

Note: After you reach 1/64 power, the next increment is labeled FP, which is the FP high-speed flash mode (see "Setting FP High-Speed Flash," on page 312). Don't set the power rating to this mode for normal flash use.

Note: The SB-28 is capable of keeping up with a motor-driven camera (up to 6 fps) at powers of M1/8, M1/16, M1/32, or M1/64 as follows:

M1/8	**4 consecutive frames**
M1/16	**8 consecutive frames**
M1/32	**16 consecutive frames**
M1/64	**30 consecutive frames**

However, let the flash cool at least 10 minutes after firing 40 consecutive flash bursts (normally this is 15 flash bursts in higher power, TTL, and A modes).

SB-28 Specifications (Guide Numbers in Feet)

Output Level/Coverage	18mm	20mm	24mm	28mm	35mm	50mm	70mm	85mm
Full Power	59	66	98	105	118	138	157	164
1/2 Power	42	46	69	72	82	98	112	118
1/4 Power	30	33	49	52	59	69	79	82
1/8 Power	21	23	33	36	43	49	56	59
1/16 Power	15	16	25	26	30	33	39	43
1/32 Power	10	11	17	19	21	25	28	30
1/64 Power	8	8	13	13	15	17	20	21
Horizontal*	102°	98°	78°	70°	60°	46°	36°	31°
Vertical*	90°	85°	60°	53°	45°	34°	26°	23°

** Nikon manual has these reversed.*

SB-28 Specifications (Guide Numbers in Meters)

Output Level	18mm	20mm	24mm	28mm	35mm	50mm	70mm	85mm
Full Power	18	20	30	33	36	42	48	50
1/2 Power	12.7	14	21	23	26	30	34	36
1/4 Power	9	10	15	16	18	21	24	25
1/8 Power	6.4	7	10	11	13	15	17	18
1/16 Power	4.5	5	7.5	8	9	10	12	13
1/32 Power	3.2	3.5	5.3	5.7	6.4	7.5	8.5	9
1/64 Power	2.3	2.5	3.8	4	4.5	5.3	6	6.3

Note: GNs listed are for flash head settings, not lenses! In other words, if you use a 50mm lens but the flash head is set for 35mm, you get a GN of 118 in feet (36 m), not 138 (42).

Note: Nikon has not been consistent in the way it rounds numbers when calculating GNs for meters. I've used the numbers in the original manuals, complete with Nikon's rounding error.

Output	Duration (sec)
Full Power	1/830
1/2 Power	1/830
1/4 Power	1/1,250
1/8 Power	1/2,500
1/16 Power	1/4,250
1/32 Power	1/6,450
1/64 Power	1/8,700

Setting Repeating Flash (All Nikon Bodies)

1. Press the power (ON/OFF) button on the SB-28 to turn the flash unit ON.

2. Set the ISO film speed on the SB-28, if necessary. The ISO value blinks when you first turn the SB-28 ON if the ISO value needs to be set manually. (If it stops blinking, you can turn the flash OFF and then back ON to set the ISO.)

 Note: You do not have to set the ISO value on the SB-28 as the flash always fires at a fixed power in manual (M) flash mode. However, the shooting range scale may not show the proper results if you don't.

3. Press the ᴍᴏᴅᴇ button until Ⅿ🔳 appears on the LCD.

4. Press the ➕ and ➖ buttons on the SB-28 to choose the flash power setting (only settings between 1/8 or 1/64 are allowed). Note the distance displayed on the shooting range scale. (**Note:** Changing the zoom head setting also changes the shooting distance.) This will be the flash-to-subject distance you must use (i.e., if the subject is farther away than this distance, you're going to have to move closer). You'll get another chance to modify the distance slightly in Step 9.

 Note: Don't proceed with the remaining steps until you've completed this one! In repeating flash (RF) mode, like manual (M) flash mode, the SB-28 fires at a fixed output level.

5. You must set both the number of flash bursts and the frequency at which they occur. Based upon the power level you set in

Step 4, the SB-28 displays the maximum number of flash bursts that can be produced. You must set two items:

- The frequency of the flash bursts is set by pressing the **SEL** button until the number next to the label **Hz**; begins blinking, then pressing the **+** and **−** buttons until the frequency you want is shown on the LCD.

- The number of flash bursts is set by again pressing the **SEL** button (the number of flash bursts begins blinking), then pressing the **+** and **−** buttons until the number of flash bursts you want is shown (to the left of the frequency number). The maximum number of flash bursts you can set is determined by the power level you set in Step 4, as follows:

Frequency	*1/8 Power*	*1/16 Power*	*1/32 Power*	*1/64 Power*
1–2 Hz	14	30	60	90
3 Hz	12	30	60	90
4 Hz	10	20	50	80
5 Hz	8	20	40	70
6 Hz	6	20	32	56
7 Hz	6	20	28	44
8 Hz	5	10	24	36
9 Hz	5	10	22	32
10 Hz	4	8	20	28
20–50 Hz	4	8	12	24

Note: To determine your settings, divide the number of flash bursts by the frequency (Hertz is "cycles per second"); the result should be less than the shutter speed. For example:

Number of flash bursts = 4
Frequency of flash bursts = 8 Hertz
Shutter speed = 4/8, or 1/2 second

In general, round to the next longer shutter speed, if the value falls between speeds.

6. Press the **SEL** button on the SB-28 one last time to complete your settings (the blinking should stop), or wait for the SB-28 to do so automatically after a few seconds.

7. Set the camera to manual (M) exposure mode and set your aperture and shutter speed for ambient light levels, as usual.

Note: Since you're using repeating flash to put multiple images on a single shot, make sure that you've set a slow enough shutter speed, set Bulb, or have the camera set to create multiple exposures on a frame.

Note: Nikon's documentation says the exposure "is the correct exposure for the first flash in the sequence." Actually, it's the correct exposure for each flash in the sequence, but if the subject doesn't move between exposures, the overlap may result in overexposure. If you're in doubt, bracket (though in this case, you'd bracket the number of exposures or frequency).

Also, place the subject against a dark background or underexpose the background. Failure to do so may result in one of two problems: (1) the background receives light from the multiple flash bursts and becomes overexposed; or (2) the subject appears to fade into the background (especially true if you're off by a bit in your distance). If in doubt, bracket your exposures for the background!

8. When an AI or AI-S lens is mounted on the camera, you need to set the aperture on the SB-28 to match the one you set on the camera in Step 7 (autofocus or AI-P lenses do this automatically on newer bodies).

9. If the distance being shown on the SB-28's shooting range table doesn't match your flash-to-subject distance, press the ➕ and ➖ buttons on the SB-28 until they do. Note that this changes the power at which the flash fires, which interacts with your other settings. Moreover, you may find that your settings won't get you the flash-to-subject distance you desire. You may find that you have to go back to Step 4 and iterate until all the settings match up well.

Setting FP High-Speed Flash (N90/F90 or Later Nikon Bodies)

Note: The 18mm and 20mm zoom settings cannot be used in FP high-speed flash mode.

1. Press the power (ON/OFF) button on the SB-28 to turn the flash unit ON.

2. Press the **MODE** button until M appears on the LCD. Press the ➕ and ➖ buttons until **FP** appears underneath it (this may take quite a few presses if you use the ➖ button and started at full power, the normal condition; since the powers "wrap around,"

it's quicker to press the 🔲 button if you started at full power).

3. Set the camera to the following modes:

 Exposure: Manual (M)

 Autofocus: Single servo (S) or manual (M)

 Advance: Single frame (S)

4. Set your shutter speed to a value between 1/250 and 1/4,000 second and your aperture as you normally would.

5. Focus on the subject by pressing lightly on the shutter release. Note the distance.

6. If you're using a lens that has a CPU (i.e., all autofocus and AI-P lenses), the SB-28 will automatically match the aperture set on the camera. You should see the aperture and the distance in the shooting range scale change on the SB-28 as well.

 If the distance on the shooting range scale matches the flash-to-subject distance, you're ready to shoot. Otherwise, you'll have to change the aperture, the zoom position of the flash, or your actual distance from the subject.

 Note: Nikon suggests underexposing slightly in very bright scenes (the flash will be added to the scene's lighting, possibly resulting in overexposure).

SB-28 Guide Numbers for FP High-Speed Flash (Feet)

Shutter Speed (sec)	24mm	28mm	35mm	50mm	70mm	85mm
1/250	46	50	56	65	74	77
1/500	33	36	39	46	52	56
1/1,000	23	25	28	33	36	39
1/2,000	16	17	20	23	26	28
1/4,000	11	12	14	16	18	20

SB-28 Guide Numbers for FP High-Speed Flash (Meters)

Shutter Speed (sec)	24mm	28mm	35mm	50mm	70mm	85mm
1/250	14	15	17	20	23	24
1/500	10	11	12	14	16	17
1/1,000	7	7.5	8.5	10	11	12
1/2,000	5	5.3	6	7	8	8.5
1/4,000	3.5	3.7	4.2	5	5.7	6

Setting the Zoom Head Manually

1. Press the ▨▨ button to change the zoom setting. Each button press selects the next higher logical setting (and you'll eventually loop back to the lowest setting). The 🖪 symbol appears on the LCD when the setting doesn't correspond to the lens being used.

 Note: To cancel an automatic zoom head setting and lock a manual setting, press the ▨▨ and ➕ buttons simultaneously until the M above ᴢᴏᴏᴹ on the LCD panel begins blinking. Then use the ▨▨ button, as usual, to set a focal length. As long as the M is blinking, the focal length is locked on the SB-28 (i.e., it doesn't respond to changes in lens focal length). To cancel the lock, again press the ▨▨ and ➕ buttons simultaneously (until the blinking stops).

2. To cancel a manual zoom setting, press the ▨▨ button repeatedly until the 🖪 no longer appears on the LCD (i.e., until the setting matches the lens being used).

 Note: Remember that the guide number of the flash unit changes with the zoom setting (see tables on page 309).

 Note: If you pull out the built-in wide-angle adapter and move it into position in front of the flashtube, the SB-28 is set to the 18mm or 20mm focal length and the automatic zoom head function cannot be set to another setting.

Setting the Distance Scale to Feet or Meters

1. Move the switch inside the battery compartment to ft (feet) or m (meters).

Setting Flash Exposure Compensation

Note: If using an N6006/F-601 or N6000/F-601m, you must set flash exposure compensation on the camera, not the SB-28.

1. With the flash in a TTL mode, press the ▨▨ button until the 🗲▨ indicator appears along with a blinking ⊙.⊙ in the upper right portion of the LCD.

2. Use the ➕ and ➖ buttons to adjust the amount of compensation. The SB-28 allows a maximum of +1 stop and –3 stops of flash compensation, which is indicated in 1/3-stop increments on the flash compensation indicator.

3. Press the ⬛ button again to lock in the compensation value. The compensation indicator should stop blinking. The compensation amount should still appear in the LCD (unless you've set 0.0, in which case the compensation section of the LCD is blank).

4. To cancel exposure compensation, repeat Steps 1 through 3 and set a value of 0.0.

Note: Flash compensation does not change the background exposure calculated by the camera.

Warning: It's probably best to avoid flash compensation in any of the balanced fill-flash TTL modes. You don't know what level of compensation the camera is already making, so any changes you make are in addition to this unknown, camera-calculated compensation. If you need absolute control, switch to the automatic or manual flash modes, where any compensation you dial in will be from a known flash level.

Setting Red-Eye Reduction (N90/F90 and Later Nikon Bodies)

1. Set red-eye reduction on the camera body (see camera instructions). On Nikon's most recent bodies, this is done by holding the ⬛ button on the camera and turning the command dial until ⊛ appears on the SB-28's LCD).

Note: The F5 doesn't support the red-eye reduction function.

Note: Red-eye reduction works in most flash modes, but not in the rear-curtain sync or repeating flash modes.

SB-28 Notes

• TTL operation on some cameras (e.g., FA, FE2, FG) has a more limited ISO range (25–400) than later bodies (ISO 25–1,000).

• For autofocus bodies, the camera's focus mode selector should be set to single servo (S) autofocus (N50/F50 should be set to AF, N5005/F-401x, N4004s/F-401s, and N4004/F-401 should be set to A). The flash will not fire unless the subject is in focus. The autofocus assist illuminator will be used automatically if the ambient light is low. Autofocus assist works only at distances from 3.3 feet (1 m) up to 26 feet (8 m), and with lenses up to 105mm. (The manual incorrectly states 16.4 feet.)

Note: The autofocus assist illuminator will not function on an F5, F100, or N80/F80 unless the central autofocus sensor is selected.

Note: You can turn off the autofocus assist illuminator by pressing down the mode button and the – button simulta- neously. No AF-ILL will appear in the SB-28's LCD.

- If the **F** indicator on the SB-28's LCD panel is blinking, that means that the flash needs you to set the aperture. This happens in several situations: (1) in automatic (A) flash mode; (2) when using lenses without a CPU (AI or AI-S lenses); and (3) when using earlier Nikon bodies (generally those prior to the F4 and N8008/F-801). If the **F** is blinking, use the ➕ and ➖ buttons to set the correct aperture on the flash (i.e., the aperture that matches what is set on the camera).

- The SB-28 has an automatic standby power system. With most Nikon bodies, the SB-28 automatically turns OFF 80 seconds after the camera's meter turns OFF (STBY is displayed in the SB-28's LCD). A light press on the shutter release generally turns most Nikon bodies' light meters back ON, and the SB-28 will turn ON at the same time. A few older bodies do not control the flash in this manner. On those cameras, when the SB-28 is in STBY, it automatically turns itself OFF after 80 seconds, regard- less of whether the camera's meter is active or not. To restore power to the SB-28, press the power button.

Note: The SB-28 has a special "no standby" mode that can be set. With the flash OFF, hold down the mode button and press the ON/OFF button. This function is cancelled the same way it is set (with the flash OFF, hold down the mode button and press the ON/OFF button).

- After the flash fires, a – symbol may appear in the SB-28's LCD along with a value. This indicates potential underexposure. This indicator appears for only 3 seconds after the shot. Use the LCD illumination button (☼) to recall the last indication.

- The maximum aperture in automatic (A) flash mode may be limited on some cameras (e.g., on N6006/F-601 at ISO 100 the maximum aperture that can be set is f/5.6).

- Rear-sync mode must be selected on the camera. Rear sync is not performed if using one of the vari-program modes (N90/F90, N70/F70) or when red-eye reduction is being used.

- The shooting range scale does not appear on the LCD panel if the flash head is tilted or rotated (exception: the scale blinks if the flash is set at –7° below horizontal).

- While the SB-28 has "click stops" for commonly used flash head positions (45, 60, 75, and 90° for tilt, every 30° for rotation), you aren't restricted to those positions. Setting an intermediate position is allowed (though it can be easily dislodged).

- Viewfinder ready light warnings (blinking light) occur in the following conditions:

 When you attempt to use the SB-28 in TTL mode on cameras set to a mechanical shutter speed (M250, M90, B).

 When you attempt to use the SB-28 in TTL mode with an unavailable film speed (e.g., ISO 800 on an FA, FE2, FG, or N4004s/F-401s).

 When the shutter speed is set faster than the allowable flash sync speed of the camera.

 On an N4004s/F-401s: When the SB-28 and the camera's built-in flash are both OFF, but the camera's meter recommends flash use.

 When you press the shutter release halfway and the SB-28 is not correctly mounted on the hot shoe.

 After the flash fires at full power, indicating possible under-exposure.

- Changing the ISO setting on the SB-28 does not change the way the flash fires, except in automatic (A) flash mode. In other modes, changing the ISO value changes only the apertures displayed in the shooting range table. Accidentally moving the ISO setting after correctly making all flash and camera adjustments won't affect the resulting exposure.

SB-29

An updated and simplified version of Nikon's macro Speedlight, the SB-29 was introduced in 1999.

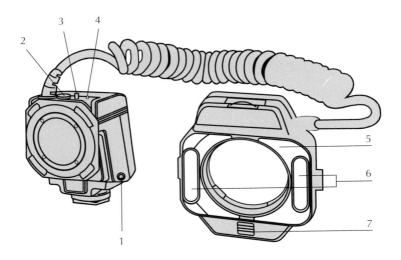

1 Sync socket
2 TTL multiple flash socket
3 Modeling light button
4 AF assist illuminator button
5 Light reducer panels
6 Flashtubes
7 AF assist illuminator

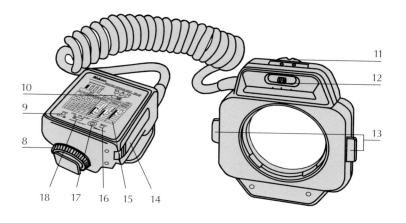

8 Locking ring
9 Overexposure indicator light
10 Flash mode selector switch
11 Light reduction dial
12 Flashtube selector switch
13 Adapter ring mounting
 buttons (levers)

14 Battery compartment cover
15 Distance scale
16 Ready light
17 Test fire button
18 On/Off/standby switch

Specifications

GN:	36 (ft), 11 (m)
Weight:	14.5 oz (410 g) (w/o batteries)
Size:	5.2" (133 mm) tall x 4.7" (119 mm) wide x 1.1" (28.5 mm) deep (main unit); 4.2" (106.5 mm) tall x 3.5" (88.5 mm) deep x 2.7" (69 mm) wide (controller)
Power:	4 AA batteries
Recycle Time:	3 seconds minimum (full discharge)
No. of Flashes:	~300 at full manual
Flash Duration:	1/1,400 second

Coverage: 20mm lens at distance of 3.3 feet (1 m) with
 flashtubes on sides, 24mm lens with flashtubes
 set to top and bottom.
Case: SS-29 (supplied)
Key Features: TTL flash control on most TTL-capable Nikon
 bodies; full or 1/4 power settings. Left, right, or
 both flashtubes can be fired. Balance of tubes can
 be set to 1:4, either direction. The SB-29 can
 synchronize with additional off-camera flash
 units, but the SB-29 must be the master flash.
 Modeling light. Comes with 52mm, 62mm, and
 72mm mounting rings. Sync terminal for multiple
 flash use.

Setting TTL Flash Exposure (TTL-Capable Nikon Bodies)

1. On the SB-29's camera-mounted controller, set the light output
 selector to ▥.

2. On the SB-29's main unit, which you've previously attached to
 the lens using one of the mounting rings, set the flash module
 selector to 〔 , 〔〕 , or 〕 to indicate which flashtubes you want
 to fire. (If you wish to set the two tubes to fire at a 1:4 ratio,
 select BOTH, then rotate the knurled light reducer ring on the
 top of the main unit towards the tube you want to produce the
 lesser amount of light. Green indicates the main light comes
 from the subject's left, red indicates the main light comes from
 the subject's right.)

3. Select the camera's exposure and metering modes and set the
 exposure. Note the aperture selected and make sure that the
 shutter speed is within the sync range of the camera (see
 "Camera Capabilities," pages 326–327).

 Note: While you can use program (P) and shutter-priority (S)
 exposure modes, it becomes very difficult to determine
 whether the subject is within TTL range. Nikon wisely recom-
 mends that you use only aperture-priority (A) or manual (M)
 exposure modes.

Note: The type of TTL performed is determined solely on the type of camera and lens used. For example, if you use a D-type lens on an F100, you'll get matrix balanced fill-flash, but if you use a non-D autofocus lens, you'll get multi-sensor balanced fill-flash instead.

4. You should verify that the aperture set in Step 3 is usable. Do this by first determining the magnification level (1:1, 1:3, 1:5, or 1:10), then using the table on the back of the camera-mounted controller. Find the column for the film speed you're using, then go down that column until you find the aperture set in Step 3.

Next, draw a horizontal line across to the appropriate ranges for the lens you're using. If that imaginary line intersects the magnification level bar, you can perform TTL. For example, if you are shooting ISO 100 film, your aperture is f/8, and you've got a 60mm macro lens all the way out to a 1:1 ratio, you'd find that you've gone beyond the TTL capabilities of the flash (e.g., the white 1:1 bar shows that only apertures of f/11 to f/45 should be used).

Note: Most serious SB-29 users reverse Steps 3 and 4. After setting up their shot, they calculate the magnification ratio, then consult the back of the flash unit to find an appropriate aperture. For example, if I'm using the 105mm Micro Nikkor at about a 1:2 ratio, I'll look at where the 1:1 and 1:3 bars overlap and discover that I can probably use any aperture between f/11 and f/45. Thus, I'll set an exposure on the camera that uses one of those apertures.

Tip: When using a lens in the reversed position or at magnifications greater than 1:1, use the following formula to determine a maximum aperture:

Aperture = Coefficient / Flash-to-Subject Distance

Where the **Coefficient** is:

	Feet	*Meters*
ISO 25–100	6.6	2
ISO 125–400	13	4
ISO 500+	18	5.6

Set an aperture physically smaller than the one you just calculated. After the shot has been made, watch carefully for underexposure or overexposure warnings from the SB-29, and adjust your selected aperture up or down, if necessary.

Tip: How do you determine magnification ratio? Carry a ruler measured in millimeters with you. Place the ruler across the subject (at the focus point) and read how many millimeters there are across the width of the frame. If you're using an F4 or F5 divide 36 by the number you obtained. Example: You see that there are 72mm across the frame. Your ratio is 1:2 (36 / 72 = 1/2). If you're using an F100 divide 34.5 by the number you obtained. For most other cameras, divide 32 by the number you obtained. (The reason for the camera differences has to do with how much of the full frame the viewfinder shows.)

5. Turn the camera-mounted controller to ON or STBY, if it isn't already. When the ready light glows, you can take the picture.

Setting Manual Flash Exposure (All Nikon Bodies)

1. On the SB-29's camera-mounted controller, set the light output selector to M or M1/4 (indicates full and quarter power, respectively).

2. On the SB-29 main unit, set the flash module selector to [, [] , or] to indicate which flashtubes you want to fire.

3. Set the camera to aperture-priority (A) or manual (M) exposure mode and to any metering method.

4. Determine which aperture to use:

 If magnification is lower than 1:10, use the formula:
 Aperture = GN / Flash-to-Subject Distance
 to calculate the aperture. See "Guide Numbers," page 21.

 If magnification is 1:1 to 1:10, use the table on the back of the SB-29's camera-mounted controller. Use the bottom of the appropriate magnification ratio bar to determine aperture for full power. For example, with a 105mm Micro Nikkor and ISO 100 film and a 1:1 ratio, that would be f/64. Use the small point (circle) within the appropriate magnification ratio bar for 1/4 power. For example, for the settings given above, that would be f/45.

If the magnification ratio is greater than 1:1, see the Tip on page 321 to determine the aperture (set the maximum aperture).

5. On the camera, set the aperture you determined in Step 4, then make sure that the shutter speed is in the sync range (see "Camera Capabilities," pages 326–327).

6. Turn the camera-mounted controller to ON or STBY, if it isn't already. When the ready light glows, you can take the picture.

Guide Numbers in Manual Mode

Both flash modules: Full power 36 in feet (11 m), 1/4 power 18 in feet (5.5)

One flash module: Full power: 39 in feet (12 m), 1/4 power 20 in feet (6)

SB-29 Flash Durations (Seconds)

Output	Both Flashtubes	One Flashtube
Full	1/1,400	1/1,250
1/4	1/5,500	1/3,300

Using the Modeling Light

1. On the SB-29's camera-mounted controller, press the button on top labeled MODELING. The modeling light stays on for approximately 3 seconds under optimum conditions.

 Note: This doesn't work unless the ready light is ON.

 Tip: The modeling light is very similar to the repeating flash modes of the SB-26 and SB-28. The light fires at 40 Hz according to the manual. It might be possible to perform macro repeating flash by doing some experiments to calculate a repeating flash guide number.

Using the Focus Illuminator

1. On the SB-29's camera-mounted controller, press the button labeled ☼ (on top, next to the modeling light button). You can press the button again to turn the light OFF.

Note: The small focus help lamp stay on for approximately
1 minute after you press the button or when you press the
shutter release, whichever occurs first.

Note: When shooting at close distances (less than 6" [150mm]),
turn the focus illuminator light OFF before taking a picture,
otherwise the light may affect exposure.

SB-29 Notes

• Note that the SB-29 main unit rotates on lenses that turn the filter
 ring during focusing. Among other problems, this may cause the
 flashtubes to be aligned at an angle you don't want. To cope
 with this, screw the adapter ring into the lens, but don't mount
 the SB-29 until you've focused. Be careful not to change the
 focusing point as you mount the SB-29 onto the adapter ring.

• Nikon recommends using only the following lenses:

 AF Micro Nikkor 60mm f/2.8D

 AF Micro Nikkor 105mm f/2.8D

 AF Micro Nikkor 200mm f/4D

 AF Micro Nikkor 70-180mm f/4.5-5.6D (manual focus only)

 PC Micro Nikkor 85mm f/2.8D (but without shift or tilt)

 Nikon does not recommend that the SB-29 be mounted on
 autofocus lenses other than the Micro Nikkors, though it can be
 done. It is curious that none of Nikon's recommended lenses use
 a 72mm adapter, so why does Nikon provide one?

• The 60mm f/2.8 Micro Nikkor AF requires a UR-3 Adapter Ring
 to attach the SB-29 main body to the lens, otherwise the weight
 of the Speedlight impairs the lens's autofocus abilities and could
 damage it. Attach the UR-3 to the lens first, set the lens at infinity
 focus, then attach the SB-29 main body to the UR-3. Nikon's
 manual warns of damage to the (autofocus) camera when using
 autofocus Micro Nikkors with the SB-29 attached via the
 supplied 52mm, 62mm, or 72mm adapter rings and recom-
 mends manual focus.

Note: The 62mm filter ring supplied with the SB-29 can be used
like the UR-3 on the 105mm f/2.8 Micro Nikkor AF lens (i.e., it
can be used to slip over the lens body to provide better support
instead of being screwed into the filter ring threads).

- Only lenses with a focal length of 50mm or longer should be used with the SB-29, as vignetting occurs with shorter lenses (it may also occur with some zooms set at 50mm). Two autofocus zooms, the 28-70mm f/3.5-4.5D and 28-85mm f/3.5-4.5 can be used at 35mm (indeed, perhaps even wider).

- The SB-29 cannot be used for TTL flash photography on the N4004s/F-401s or N4004/F-401.

- In TTL mode, the SB-29's camera-mounted controller unit may display an overexposure lamp for about 4 seconds after the shot. Most photographers are used to seeing the ready lamp (and camera viewfinder flash indicator) blink when a Speedlight fires at full power (indicating potential underexposure), but few are used to looking for overexposure warnings. Make sure to always check the controller for any warnings immediately after taking a shot with the SB-29.

- You may see a ready light warning (blinking light) under the following conditions:

 When you attempt to use the SB-29 in TTL mode on cameras that are not TTL-capable (see "Non-TTL-Capable Bodies," page 326).

 When you attempt to use the SB-29 in TTL mode with an unavailable film speed (e.g., ISO 800 on an F3, FA, FE2, or FG).

 When the shutter speed is set faster than the allowable flash sync speed of the camera (on FE and FM2, for example).

 When you've taken a flash picture with the SB-29 in TTL mode and the flash fired at full power (indicating it might have produced insufficient light for a flash exposure).

 When certain cameras are set to a mechanical shutter speed (e.g., M250, M90, or B on bodies such as the FA, FE2, or FG).

Camera-Specific Flash Use

Nikon Cameras and Speedlight Compatibility

TTL Capability

Recent Nikon camera bodies have one or more TTL sensors, which are required for a TTL-capable Speedlight to perform in TTL mode. If the body isn't TTL-capable, the connected Speedlight must be used in automatic (A) or manual (M) flash mode.

TTL-Capable Bodies

F5	F4 (all)	F3 (all)*
F100	N80/F80	N90s/F90X
N90/F90	N70/F70	N8008/F-801
N8008s/F-801s	N6006/F-601	N6000/F-601m
N50/F50	N60/F60	N65/F65
N5005/F-401x	N2020/F-501	N4004s/F-401s
N4004/F-401	N2000/F-301	FA
FE2	FG	Nikonos V
Pronea 6i/600	D1	D1X
D1H		

May require AS-17 or other flash adapter.

Non-TTL-Capable Bodies

FM2	FM10	FE10
F (all)	F2 (all)	FM2n
EM	EL2	FG20
FE	Nikkormat FS	Nikkormat FT
Nikkormat FT2	Nikkormat FT3	Nikkormat EL
Nikkormat FTn	Nikkorex F	

Camera Capabilities

Other flash capabilities vary considerably with both the camera body and Speedlight model used. For recent and professional Nikon bodies, the following table provides a basic guide.

Camera	Built-in Flash	X-Sync Speed	TTL Sensors	Features								
				AZ	RS	FC	3D	RE	HS	FB	PT	AF
FM	—	1/125	—	—	—	—	—	—	—	—	—	—
FM2	—	1/200	—	—	—	—	—	—	—	—	—	—
FM2n	—	1/250	—	—	—	—	—	—	—	—	—	—
FM2T	—	1/250	—	—	—	—	—	—	—	—	—	—
FG	—	1/90	1	—	—	—	—	—	—	—	—	—
FG-20	—	1/90	—	—	—	—	—	—	—	—	—	—
FE	—	1/125	—	—	—	—	—	—	—	—	—	—
FE2	—	1/250	—	—	—	—	—	—	—	—	—	—
FA	—	1/250	1	—	—	—	—	—	—	—	—	—
FM-10	—	1/125	—	—	—	—	—	—	—	—	—	—
FE-10	—	1/90*	—	—	—	—	—	—	—	—	—	—
EM	—	1/90	—	—	—	—	—	—	—	—	—	—
EL2	—	1/125	—	—	—	—	—	—	—	—	—	—
F	—	1/60	—	—	—	—	—	—	—	—	—	—
F2	—	1/80	—	—	—	—	—	—	—	—	—	—
F3	—	1/80	1	—	—	—	—	—	—	—	—	—
F4	—	1/250	1	—	—	—	—	—	—	—	—	Y
F5	—	1/300**	5	Y	Y	Y	Y	—	Y	Y	—	Y
D1, D1X, D1H	—	1/500	5	Y	Y	Y	Y	—	Y	Y	—	Y
N50/F50	GN 43' (13 m)	1/125	1	—	—	—	—	—	—	—	—	Y
N60/F60	GN 49' (15 m)	1/125	1	—	—	—	—	—	—	—	—	Y
N65/F65	GN 40' (12 m)	1/90	1	—	—	—	Y	—	—	—	—	Y
N70/F70	GN 46' (14 m)	1/125	5	Y	Y	Y	Y	—	—	—	—	Y
N80/F80	GN 39' (12 m)	1/125	5	Y	Y	Y	Y	Y	Y	Y	—	Y
N90/F90	—	1/250	5	Y	Y	Y	Y	Y	Y	Y	—	Y
N90s/F90X	—	1/250	5	Y	Y	Y	Y	Y	Y	Y	—	Y
F100	—	1/250	5	Y	Y	Y	Y	Y	Y	Y	—	Y
N2000/F-301	—	1/125	1	—	—	—	—	—	—	—	Y	—
N4004/F-401	—	1/100	1	—	—	—	—	—	—	—	Y	Y
N4004s/F-401s	—	1/100	1	—	—	—	—	—	—	—	Y	Y
N5005/F-401x	GN 39' (12 m)	1/125	1	Y	—	—	—	—	—	—	—	Y
N2020/F-501	—	1/125	1	—	—	—	—	—	—	—	Y	Y
N6006/F-601	GN 43' (13 m)	1/125	1	—	Y	Y	—	—	—	—	—	Y
N6000/F-601m	—	1/125	1	—	Y	Y	—	—	—	—	—	—
N8008/F-801	—	1/250	1	Y	Y	Y	—	—	—	—	—	Y
N8008s/F-801s	—	1/250	1	Y	Y	Y	—	—	—	—	—	Y
Nikkormats***	—	1/125	—	—	—	—	—	—	—	—	—	—
Nikkorex	—	1/125	—	—	—	—	—	—	—	—	—	—

* On auto only, 1/60 second on manual.

** With custom setting on camera, at reduced GN.

*** All Nikkormat models.

3D = 3D multi-sensor balanced fill-flash

AF = Autofocus assist

AZ = Autozoom of flash head to match lens focal length

FB = Flash exposure bracketing (may require optional databack)

FC = Flash exposure compensation (may require optional databack)

HS = High-speed sync mode of SB-26 and SB-28

PT = Programmed TTL

RE = Red-eye reduction

RS = Rear (second-curtain) sync

X-Sync = Fastest shutter speed at which camera can synchronize flash

Y = Yes

Note: Some features are available only with a dedicated camera databack (e.g., flash bracketing on the N90/F90 and N90s/F90X). Other features, like 3D, require that D-type lenses be used.

Note: Some features can be controlled by certain Speedlight models, even if the camera doesn't support it (e.g., flash exposure compensation can be set on the SB-26, SB-27, and SB-28).

Camera Groups

Nikon manuals often refer to cameras as belonging to a "group." Cameras in the same group generally have the same flash capabilities, and the flash is set the same for each. The primary differences have to do with the TTL modes that are available in each group. Most professional photographers tend to keep all their bodies within one group.

Here is the full lineup of available TTL modes and the key differences between the groups:

Group I: N90/F90, N90s/F90X, N70/F70, N80/F80, F100, F5, D1*, D1X*, D1H*

3D multi-sensor balanced fill-flash (with D-type lens)

Multi-sensor balanced fill-flash

Center-weighted/Spot fill-flash

Standard TTL flash

TTL ISO film speed range: 25 to 1,000, set automatically on flash

Plus, FP high-speed supported on SB-26, SB-28

Require SB-28DX

Group II: F4, N8008/F-801, N8008s/F-801s, Pronea 6i/600i, N65/F65

Matrix balanced fill-flash

Center-weighted/Spot fill-flash

Standard TTL flash

TTL ISO film speed range: 25 to 1,000, set automatically on flash

Group III: N6006/F-601, N6000/F-601m

Matrix balanced fill-flash
Center-weighted/Spot fill-flash
Standard TTL flash
TTL ISO film speed range: 25 to 1,000, set manually on flash
Plus, some key flash functions are controlled only on camera.

Group IV: N50/F50, N60/F60, N5005/F-401x

Matrix balanced fill-flash
Center-weighted fill-flash
TTL ISO film speed range: 25 to 1,000, set manually on flash

Group V: N2020/F-501, N4004s/F-401s, N4004/F-401, N2000/F-301

Programmed TTL auto flash
Standard TTL flash
TTL ISO film speed range: 25 to 1,000, except for N4004s/
F-401s and N4004/F-401, which allow 25 to 400, set manually
on flash
SB-11, SB-14, SB-140, and SB-21A/B Speedlights cannot be used as
master or slave units in multiple flash use with the N4004s/F-401s
or N4004/F-401.

Group VI: FA, FE2, FG, Nikonos V

Standard TTL flash
TTL ISO film speed range: 25 to 400, set manually on flash

Group VII: F3, FM2, and All Other Manual Bodies

Not TTL-capable (F3 is with appropriate adapter, though)

Note that all camera groups support automatic and manual flash
modes, and all can be used with the SB-26 and SB-28 repeating
flash modes.

FM2, FM2n, FM2T

The FM2 series does not have built-in TTL sensors for flash, nor does it support any of the advanced flash features available with current Speedlights, so a Speedlight with automatic (A) flash or manual (M) mode should be used.

Special FM2 Note

- Early FM2s had a top sync speed of 1/200 second. Later models, including all FM2n and FM2T models, support 1/250 second sync.

Flash Features Available Using FM2 with Speedlights

Model	TTL	A	M	AF	Rear	Slow	RF	RE	HS
SB-29	No	No	Yes	No	No	No	No	No	No
SB-28	No	Yes	Yes	No	No	No	Yes	No	No
SB-27	No	Yes	Yes	No	No	No	No	No	No
SB-26	No	Yes	Yes	No	No	No	Yes	No	No
SB-25	No	Yes	Yes	No	No	No	Yes	No	No
SB-24	**No**	**Yes**	**Yes**	**No**	**No**	**No**	**Yes**	**No**	**No**
SB-23	No	No	Yes	No	No	No	No	No	No
SB-22s	**No**	**Yes**	**Yes**	**No**	**No**	**No**	**No**	**No**	**No**
SB-22	**No**	**Yes**	**Yes**	**No**	**No**	**No**	**No**	**No**	**No**
SB-21B	**No**	**Yes**	**Yes**	**No**	**No**	**No**	**No**	**No**	**No**
SB-20	**No**	**Yes**	**Yes**	**No**	**No**	**No**	**No**	**No**	**No**
SB-16B	**No**	**Yes**	**Yes**	**No**	**No**	**No**	**No**	**No**	**No**
SB-15	No	Yes	Yes	No	No	No	No	No	No
SB-14	No	Yes	Yes	No	No	No	No	No	No
SB-140	No	Yes	Yes	No	No	No	No	No	No
SB-11	No	Yes	Yes	No	No	No	No	No	No

A = Automatic flash mode

AF = Autofocus assist

HS = High-speed sync mode

M = Manual flash mode

RE = Red-eye reduction

RF = Repeating flash

Rear = Rear (second-curtain) sync

Slow = Slow sync (Since the FM2 is a manual camera, any shutter speed slower than the fastest sync speed can be used, with the exception of B.)

TTL = Through-the-lens metering

Note: Preferred Speedlights are highlighted in bold in the table. Speedlights not listed are *not* recommended for use on the FM2.

N60/F60

The N60/F60 comes with a built-in Speedlight that has a guide number of 49 in feet (15 m). While not particularly bright, this built-in flash unit has a few of the current state-of-the-art flash functions (see table on page 333). The built-in Speedlight covers lenses as wide as 28mm (though lens hoods may impede full light coverage).

With the built-in Speedlight, or an SB-24, SB-25, SB-26, SB-27, or SB-28, the N60/F60 provides the following flash capabilities:

• _With D-type lenses, non-D autofocus and AI-P lenses_—Matrix balanced fill-flash is used, regardless of the metering method.

• _With AI or AI-S lenses_—Only manual (M) metering is allowed with non-CPU lenses, and center-weighted fill-flash is used.

TTL and ⚙ appear on the Speedlight's LCD to indicate matrix balanced fill-flash mode (the camera's LCD does not have the ability to show which, if any, TTL mode is set). **TTL** and 🔲 appear on the Speedlight's LCD to indicate center-weighted fill-flash.

Note: If the camera is in any exposure mode other than program (P), you can override the selection of balanced fill-flash by pressing the mode button on the Speedlight.

With an SB-11, SB-14, SB-140, SB-15, SB-16B, SB-20, SB-21B, SB-22, SB-23, the N60/F60 provides the following capabilities:

• _With all autofocus and AI-P lenses_—Matrix balanced fill-flash is used, regardless of the metering method chosen. However, if manual (M) exposure mode is set on the camera, standard TTL flash is performed.

• _With AI or AI-S lenses_—Center-weighted fill-flash is used.

The N60/F60 limits shutter speed choices with flash depending upon the exposure mode:

• _Program (P):_ Automatically set between 1/60 and 1/125 second unless slow or rear sync is also set.

• _Shutter-Priority (S):_ Manually set by user between 30 seconds and 1/125 second.

• _Aperture-Priority (A):_ Automatically set between 1/60 and 1/125 second unless slow or rear sync is also set.

• _Manual (M):_ Manually set by user between 30 seconds and 1/125 second.

N60/F60 Usable Apertures and Flash Range (Built-in Flash)

ISO 400	200	100	Range in Ft	Range in M
f/2.8	f/2	f/1.4	6.6–35	2–10.6
f/4	f/2.8	f/2	4.6–25	1.4–7.5
f/5.6	f/4	f/2.8	3.3–17	1.0–5.3
f/8	f/5.6	f/4	2.3–13	0.7–3.8
f/11	f/8	f/5.6	2.0–8.9	0.6–2.7
f/16	f/11	f/8	2.0–6.2	0.6–1.9
f/22	f/16	f/11	2.0–4.3	0.6–1.3
f/32	f/22	f/16	2.0–3.0	0.6–0.9

Special N60/F60 Notes

- The shutter speed blinks in the LCD (but not the viewfinder) if the user sets a shutter speed faster than 1/125 second and mounts a Speedlight on the camera.

- Flash sync mode is set on the camera by holding down the 🔲 button on the camera and turning the command dial. Choices are: ⌷, ⌷, or ☯.

- The ⚡ symbol blinks in the viewfinder if the camera thinks that the built-in flash should be used. The ⚡ symbol is red when the flash is ready to fire.

- If the ⚡ symbol and Ɛ⌐⌐ blink, the flash mode must be set to TTL (required for shutter-priority (S) and program [P] exposure modes).

- The built-in Speedlight fires for every picture taken when it is in the "popped up" (ready) position. The camera won't take a picture unless the flash has recycled and is ready to fire.

- With the SB-24, SB-25, and SB-26, the flash mode set on the Speedlight overrides the mode set on the N60/F60.

- For red-eye reduction, the AF assist illuminator on the N60/F60 is used instead of the one on the Speedlight, if any.

- Lenses without CPUs (AI or AI-S) require that the camera be put in manual (M) exposure mode and the aperture be set on the lens.

- Only TTL flash mode can be used if the camera's exposure mode is set to program (P). If the Speedlight is set to a non-TTL mode when the N60/F60 is in program (P) mode, the shutter locks and FƐƐ and P blink in the top LCD panel.

- TTL may be performed at ISO 25 to 1,600.
- Viewfinder shows ± when flash compensation is set on the Speedlight.

Flash Features Available Using N60/F60 with Speedlights

Model	TTL	A	M	AF	Rear	Slow	RF	RE	HS
Built-in	**Yes***	**No**	**No**	**Yes**	**Yes**	**Yes**	**No**	**Yes**	**No**
SB-29	Yes	No	Yes	Yes	Yes	Yes	No	No	No
SB-28	**Yes***	**Yes**	**Yes**	**Yes**	**Yes**	**Yes**	**Yes**	**Yes**	**No**
SB-27	**Yes***	**Yes**	**Yes**	**Yes**	**Yes**	**Yes**	**No**	**Yes**	**No**
SB-26	Yes*	Yes	Yes	Yes	Yes	Yes	Yes	Yes	No
SB-25	Yes*	Yes	Yes	Yes	Yes	Yes	Yes	No	No
SB-24	Yes*	Yes	Yes	Yes	Yes	Yes	Yes	No	No
SB-23	Yes*	No	Yes	Yes	Yes	Yes	No	No	No
SB-22s	Yes*	Yes	Yes	Yes	Yes	Yes	No	No	No
SB-22	Yes*	Yes	Yes	Yes	Yes	Yes	No	No	No
SB-21B	Yes*	Yes	Yes	No	Yes	Yes	No	No	No
SB-20	Yes*	Yes	Yes	Yes	Yes	Yes	No	No	No
SB-16B	Yes*	Yes	Yes	No	Yes	Yes	No	No	No
SB-15	Yes*	Yes	Yes	No	Yes	Yes	No	No	No
SB-14	Yes**	Yes	Yes	No	Yes	Yes	No	No	No
SB-140	Yes**	Yes	Yes	No	Yes	Yes	No	No	No
SB-11	Yes**	Yes	Yes	No	Yes	Yes	No	No	No

** Balanced fill-flash possible.*

*** Only when connected using an SC-23 Cord.*

A = Automatic flash mode

AF = Autofocus assist

HS = High-speed sync mode

M = Manual flash mode

RE = Red-eye reduction

RF = Repeating flash

Rear = Rear (second-curtain) sync

Slow = Slow sync

TTL = Through-the-lens metering

Note: Preferred Speedlights are highlighted in bold in the table. Speedlights not listed are *not* recommended for use on the N60/F60.

N65/F65

The N65/F65 comes with a built-in Speedlight, which has a guide number of 40 in feet (12 m). While not particularly bright, this built-in flash unit is capable of many of the current state-of-the-art flash functions (see table on page 336). The built-in Speedlight covers lenses as wide as 28mm (though lens hoods may impede full light coverage).

With the built-in Speedlight or an SB-11, SB-14, SB-140, SB-15, SB-16B, SB-20, SB-21B, SB-22, SB-23, SB-24, SB-25, SB-26, SB-27, or SB-28, the N65/F65 provides the following flash capabilities:

- *With D-type lenses, non-D autofocus and AI-P lenses*—Matrix balanced fill-flash is used if the metering mode is matrix; standard TTL is used when center-weighted metering is used (i.e., in manual [M] exposure mode).

- *With AI or AI-S lenses*—Metering is inactive with these lenses, and external flashes must be used in automatic or manual flash mode.

▥ and ▣ appear on the Speedlight's LCD to indicate matrix balanced fill-flash mode (the camera's LCD does not have the ability to show which, if any, TTL mode is set). ▥ appears on the Speedlight's LCD to indicate standard TTL flash.

Note: If the camera is in any exposure mode other than program (P), you can override the selection of balanced fill-flash by pressing the mode button on the Speedlight. This puts the N65/F65 in standard TTL mode.

The N65/F65 limits shutter speed choices with flash depending upon the exposure mode:

- *Program (P):* Automatically set between 1/60 and 1/90 second unless slow or rear sync is also set.

- *Shutter-Priority (S):* Manually set by user between 30 seconds and 1/90 second.

- *Aperture-Priority (A):* Automatically set between 1/60 and 1/90 second unless slow or rear sync is also set.

- *Manual (M):* Manually set by user between 30 seconds and 1/90 second.

N65/F65 Usable Apertures and Flash Range (Built-in Flash)

ISO 400	200	100	Range in Ft	Range in M
f/2.8	f/2	f/1.4	6.6 - 28	2–8.5
f/4	f/2.8	f/2	4.6–20	1.4–6
f/5.6	f/4	f/2.8	3.3–14	1.0–4.2
f/8	f/5.6	f/4	2.3–10	0.7–3
f/11	f/8	f/5.6	2.0–6.9	0.6–2.1
f/16	f/11	f/8	2.0–4.9	0.6–1.5
f/22	f/16	f/11	2.0–3.6	0.6–1.1
f/32	f/22	f/16	2.0–2.6	0.6–0.8

Special N65/F65 Notes

• The shutter speed blinks in the LCD (but not the viewfinder) if the user sets a shutter speed faster than 1/90 second and mounts a Speedlight on the camera.

• Flash sync mode is set on the camera by holding down the 🔲 button on the camera and turning the command dial. Choices are: auto, ⬚, ⬚, ⊚ . Depending upon the exposure mode, some of these choices may be combined (Hint: aperture-priority exposure mode allows the most flexibility).

• The ⚡ symbol blinks in the viewfinder if the camera thinks that the built-in flash should be used. The ⚡ symbol glows steadily green when the flash is ready to fire.

• The built-in Speedlight fires for every picture taken when it is in the "popped up" (ready) position. The camera won't take a picture unless the flash has recycled and is ready to fire.

• With the SB-24, SB-25, and SB-26, the sync mode set on the Speedlight overrides the mode set on the N65/F65.

• For red-eye reduction, the AF assist illuminator on the N65/F65 is used instead of the one on an SB-26, SB-27, or SB-28.

• The autofocus assist light on the SB-24 or later flash is used only if the focus mode is set to autofocus, an autofocus lens is attached, and the central focus area is being used. With earlier Speedlights, the camera's autofocus assist light is used.

• TTL may be performed at ISO 25 to 800.

• Viewfinder shows ± when flash compensation is set on the Speedlight.

• ꟻ∃∃ and ⚡ blink in the viewfinder and the shutter is locked when you attempt to use flash with the external Speedlight not set to TTL auto flash and the camera is in an automatic program mode (including the Vari-programs).

Flash Features Available Using F65/N65 with Speedlights

Model	TTL	A	M	AF	Slow	Rear	RF	RE	HS
Built-in	**Yes***	**No**	**No**	**Yes**	**Yes**	**Yes**	**No**	**Yes**	**No**
SB-29	Yes*	No	Yes	Yes	Yes	Yes	No	No	No
SB-28	**Yes***	**Yes**	**Yes**	**Yes**	**Yes**	**Yes**	**Yes**	**Yes**	**No**
SB-27	**Yes***	**Yes**	**Yes**	**Yes**	**Yes**	**Yes**	**No**	**Yes**	**No**
SB-26	Yes*	Yes	Yes	Yes	Yes	Yes	Yes	Yes	No
SB-25	Yes*	Yes	Yes	Yes	Yes	Yes	Yes	No	No
SB-24	Yes*	Yes	Yes	Yes	Yes	Yes	Yes	No	No
SB-23	Yes*	No	Yes	Yes	Yes	Yes	No	No	No
SB-22s	Yes*	Yes	Yes	Yes	Yes	Yes	No	No	No
SB-22	Yes*	Yes	Yes	Yes	Yes	Yes	No	No	No
SB-21B	Yes*	Yes	Yes	No	Yes	Yes	No	No	No
SB-20	Yes*	Yes	Yes	Yes	Yes	Yes	No	No	No
SB-16B	Yes*	Yes	Yes	No	Yes	Yes	No	No	No
SB-15	Yes*	Yes	Yes	No	Yes	Yes	No	No	No
SB-14	Yes**	Yes	Yes	No	Yes	Yes	No	No	No
SB-140	Yes**	Yes	Yes	No	Yes	Yes	No	No	No
SB-11	Yes**	Yes	Yes	No	Yes	Yes	No	No	No

** Balanced fill-flash possible.*

*** Only when connected using an SC-23 Cord.*

A = Automatic flash mode

AF = Autofocus assist

HS = High-speed sync mode

M = Manual flash mode

RE = Red-eye reduction

RF = Repeating flash

Rear = Rear (second-curtain) sync

Slow = Slow sync

TTL = Through-the-lens metering

Note: Preferred Speedlights are highlighted in bold in the table. Speedlights not listed are *not* recommended for use on the N65/F65.

N70/F70

The N70/F70 comes with a built-in Speedlight, which has a guide number of 46 in feet (14 m). While not particularly bright, this built-in flash unit is capable of almost all the current state-of-the-art flash functions (see table on page 340). The built-in Speedlight covers lenses as wide as 28mm (though lens hoods may impede full light coverage).

With the built-in Speedlight, or an SB-25, SB-26, SB-27, or SB-28, the N70/F70 provides the following flash capabilities:

- *With D-type lenses*—3D multi-sensor balanced fill-flash is used, regardless of the metering method chosen.

- *With non-D autofocus and AI-P lenses*—Multi-sensor balanced fill-flash is used, regardless of the metering method chosen.

- *With AI or AI-S lenses*—Center-weighted fill-flash is used if the metering is set to matrix or center-weighted, while spot fill-flash is used if the metering is set to spot. Note that if the camera was originally set to program (P) or shutter-priority (S) exposure modes, it automatically switches to aperture-priority (A) exposure mode when you use a Speedlight with this type of lens.

▨ and ▧ appear on the Speedlight's LCD to indicate either multi-sensor balanced fill-flash mode (the camera's LCD does not have the ability to show which, if any, TTL mode is set). ▨ and ▧ appear on the Speedlight's LCD to indicate center-weighted or spot fill-flash.

Note: If the camera is in any exposure mode other than program (P), you can override the selection of balanced fill-flash by pressing the ▨▨▨ button on the Speedlight.

With an SB-24, the N70/F70 provides the following flash capabilities:

- *With all autofocus and AI-P lenses*—Multi-sensor balanced fill-flash is used, regardless of the metering method chosen.

- *With AI or AI-S lenses*—Center-weighted fill-flash is used if the metering is set to matrix or center-weighted, while spot fill-flash is used if the metering is set to spot. Note that if the camera was originally set to program (P) or shutter-priority (S) exposure modes, it automatically switches to aperture-priority (A) exposure mode when you use a Speedlight with this type of lens.

The Nikon Flash Guide

TTL and **⊡** appear on the Speedlight's LCD to indicate all fill-flash modes with an SB-24 mounted on the N70/F70.

With an SB-11, SB-14, SB-140, SB-15, SB-16B, SB-20, SB-21B, SB-22, or SB-23, the N70/F70 provides the following capabilities:

- *With all autofocus and AI-P lenses*—Multi-sensor balanced fill-flash is used, regardless of the metering method chosen. However, if manual (M) exposure mode is set on the camera, standard TTL flash is performed.

- *With AI or AI-S lenses*—Center-weighted fill-flash is used if the metering is set to matrix or center-weighted, while spot fill-flash is used if the metering is set to spot. Note that if the camera was originally set to program (P) or shutter-priority (S) exposure modes, it automatically switches to aperture-priority (A) exposure mode when you use a Speedlight with this type of lens. However, if manual (M) exposure mode is set on the camera, the Speedlight is always set to standard TTL flash.

The N70/F70 limits shutter speed choices with flash depending upon the exposure mode:

- *Program (P):* Automatically set between 1/60 and 1/250 second unless slow or rear sync is also set.

- *Shutter-Priority (S):* Manually set by user between 30 seconds and 1/250 second.

- *Aperture-Priority (A):* Automatically set by the camera between 1/60 and 1/250 second unless slow or rear sync is also set.

- *Manual (M):* Manually set by user between 30 seconds and 1/250 second.

N70/F70 Usable Apertures and Flash Range (Built-in Flash)

ISO 400	200	100	Range in Ft	Range in M
f/2.8	f/2	f/1.4	6.6–32.5	2–10
f/4	f/2.8	f/2	4.6–23	1.4–7
f/5.6	f/4	f/2.8	3.3–16.4	1.0–5.0
f/8	f/5.6	f/4	2.3–11.5	0.7–3.5
f/11	f/8	f/5.6	2.0–8.2	0.6–2.5
f/16	f/11	f/8	2.0–5.9	0.6–1.8
f/22	f/16	f/11	2.0–4.3	0.6–1.3
f/32	f/22	f/16	2.0–3.0	0.6–0.9

Special N70/F70 Notes

* The shutter speed blinks in the camera's LCD (but not the viewfinder) if the user sets a shutter speed faster than 1/250 second and mounts a Speedlight on the camera.

* Flash sync mode is set on the camera by holding down the function button on the camera and turning the command dial until the flash segment of the camera's LCD is selected (small arrow at inside of arc). Then, hold the camera's SET button and rotate the command dial until the mode you want is selected. Choices are: [SLOW], [REAR], or ⊚.

* A green ⚡ symbol is displayed in the viewfinder if the camera thinks that the built-in flash should be used. The ⚡ symbol is red when the flash is ready to fire. (Yes, this is the opposite of what logical interface design would suggest.)

* The built-in Speedlight fires for every picture taken when it is in the "popped up" (ready) position. The camera won't take a picture unless the flash has recycled and is ready to fire.

* With the SB-24, SB-25, and SB-26, the flash mode set on the Speedlight overrides the mode set on the N70/F70.

* Only TTL auto flash mode can be used if the camera's exposure mode is set to program (P). If the Speedlight is set to something other than TTL when the N70/F70 is in P mode, the shutter locks and ⸝ᙓᙓ and ᴘ blink in the top LCD panel.

* TTL may be performed at ISO 25 to 1,600.

* Viewfinder shows ± when flash compensation is set on the Speedlight.

Flash Features Available Using N70/F70 with Speedlights

Model	TTL	A	M	AF	Slow	Rear	RF	RE	HS
Built-in	**Yes***	**No**	**No****	**Yes**	**Yes**	**Yes**	**No**	**Yes**	**No**
SB-29	Yes*	No	Yes	Yes	Yes	Yes	No	No	No
SB-28	**Yes***	**Yes**	**Yes**	**Yes**	**Yes**	**Yes**	**Yes**	**Yes**	**Yes**
SB-27	**Yes***	**Yes**	**Yes**	**Yes**	**Yes**	**Yes**	**No**	**Yes**	**Yes**
SB-26	Yes*	Yes	Yes	Yes	Yes	Yes	Yes	Yes	Yes
SB-25	Yes*	Yes	Yes	Yes	Yes	Yes	Yes	No	Yes
SB-24	Yes*	Yes	Yes	Yes	Yes	Yes	Yes	No	No
SB-23	Yes*	No	Yes	Yes	Yes	Yes	No	No	No
SB-22s	Yes*	Yes	Yes	Yes	Yes	Yes	No	No	No
SB-22	Yes*	Yes	Yes	Yes	Yes	Yes	No	No	No
SB-21B	Yes*	Yes	Yes	No	Yes	Yes	No	No	No
SB-20	Yes*	Yes	Yes	Yes	Yes	Yes	No	No	No
SB-16B	Yes*	Yes	Yes	No	Yes	Yes	No	No	No
SB-15	Yes*	Yes	Yes	No	Yes	Yes	No	No	No
SB-14	Yes***	Yes	Yes	No	Yes	Yes	No	No	No
SB-140	Yes***	Yes	Yes	No	Yes	Yes	No	No	No
SB-11	Yes***	Yes	Yes	No	Yes	Yes	No	No	No

** Balanced fill-flash possible.*

*** Flash exposure compensation can be set.*

**** Only when connected using an SC-23 Cord.*

A = Automatic flash mode

AF = Autofocus assist

HS = High-speed sync mode

M = Manual flash mode

RE = Red-eye reduction

RF = Repeating flash

Rear = Rear (second-curtain) sync

Slow = Slow sync

TTL = Through-the-lens metering

Note: Preferred Speedlights are highlighted in bold in the table. Speedlights not listed are *not* recommended for use on the N70/F70.

N80/F80

The N80/F80 comes with a built-in Speedlight, which has a guide number of 40 in feet (12 m). While not particularly bright, this built-in flash unit is capable of virtually all the current state-of-the-art flash abilities (see table on page 344). The built-in Speedlight covers lenses as wide as 28mm (though lens hoods may impede full light coverage).

With the built-in Speedlight, or a SB-25, SB-26, SB-27, or SB-28, the N80/F80 provides the following flash capabilities:

• *With D-type lenses*—3D multi-sensor balanced fill-flash is used, regardless of the metering method chosen.

• *With non-D autofocus and AI-P lenses*—Multi-sensor balanced fill-flash is used, regardless of the metering method chosen.

• *With AI or AI-S lenses*—Center-weighted fill-flash is used if the metering is set to matrix or center-weighted, while spot fill-flash is used if the metering is set to spot. Note that if the camera was originally set to program (P) or shutter-priority (S) exposure modes, it automatically switches to aperture-priority (A) exposure mode when you use a Speedlight with this type of lens.

▥ and ◔ appear on the Speedlight's LCD to indicate either multi-sensor balanced fill-flash mode (the camera's LCD does not have the ability to show which, if any, TTL mode is set). ▥ and ▣ appear on the Speedlight's LCD to indicate center-weighted or spot fill-flash.

Note: If the camera is in any exposure mode other than program (P), you can override the selection of balanced fill-flash by pressing the ▭MODE button on the Speedlight.

With a SB-24, the N80/F80 provides the following flash capabilities:

• *With all autofocus and AI-P lenses*—Multi-sensor balanced fill-flash is used, regardless of the metering method chosen.

• *With AI or AI-S lenses*—Center-weighted fill-flash is used if the metering is set to matrix or center-weighted, while spot fill-flash is used if the metering is set to spot. Note that if the camera was originally set to program (P) or shutter-priority (S) exposure modes, it automatically switches to aperture-priority (A) exposure mode when you use a Speedlight with this type of lens.

▥ and ▣ appear on the Speedllight's LCD to indicate all fill-flash modes with an SB-24 mounted on the N80/F80.

With an SB-11, SB-14, SB-140, SB-15, SB-16B, SB-20, SB-21B, SB-22, SB-23, the N80/F80 provides the following capabilities:

- *With all autofocus and AI-P lenses*—Multi-sensor balanced fill-flash is used, regardless of the metering method chosen. However, if manual (M) exposure mode is set on the camera, standard TTL flash is performed.

- *With AI or AI-S lenses*—Center-weighted fill-flash is used if the metering is set to matrix or center-weighted, while spot fill-flash is used if the metering is set to spot. Note that if the camera was originally set to program (P) or shutter-priority (S) exposure modes, it automatically switches to aperture-priority (A) expo-sure mode when you use a Speedlight with this type of lens. However, if manual (M) exposure mode is set on the camera, the Speedlight is always set to standard TTL flash.

The N80/F80 limits shutter speed choices with flash depending upon the exposure mode:

- *Program (P):* Automatically set between 1/60 and 1/125 second unless slow or rear sync is also set.

- *Shutter-Priority (S):* Manually set by user between 30 seconds and 1/125 second.

- *Aperture-Priority (A):* Automatically set by the camera between 1/60 and 1/125 second unless slow or rear sync is also set.

- *Manual (M):* Manually set by user between 30 seconds and 1/125 second; also allows Bulb.

F80/N80 Usable Apertures and Flash Range (Built-in Flash)

ISO 400	200	100	50	25	Range in Ft	Range in M
f/2.8	f/2	f/1.4	—	—	6.6–28	2–8.5
f/4	f/2.8	f/2	f/1.4	—	4.6–20	1.4–6
f/5.6	f/4	f/2.8	f/2	f/1.4	3.3–14	1.0–4.2
f/8	f/5.6	f/4	f/2.8	f/2	2.3–10	0.7–3
f/11	f/8	f/5.6	f/4	f/2.8	2.0–6.9	0.6–2.1
f/16	f/11	f/8	f/5.6	f/4	2.0–4.9	0.6–1.5
f/22	f/16	f/11	f/8	f/5.6	2.0–3.6	0.6–1.1
f/32	f/22	f/16	f/11	f/8	2.0–2.6	0.6–0.8

Special N80/F80 Notes

- The shutter speed blinks in the camera's LCD (but not the viewfinder) if the user sets a shutter speed faster than 1/125 second and mounts a Speedlight on the camera.

- Flash sync mode is set on the camera by holding down the flash button on the camera and turning the command dial until the flash "segment" of the camera's LCD is selected (small arrow at inside of arc). Then, hold the camera's Set button and rotate the command dial until the mode you want is selected. Choices are: ⌞ᴸᴼᵂ⌟, ⌞ᴿᴱᴬᴿ⌟, ⊛, and ⌞ᴿᴱᴬᴿ⌟+⊛.

- The built-in Speedlight fires for every picture taken when it is in the "popped up" (ready) position. The camera won't take a picture unless the flash has recycled and is ready to fire.

- Setting manual (M) exposure or spot metering automatically sets standard TTL flash for the built-in Speedlight, SB-23, SB-22, SB-22s, SB-21, SB-16, SB-15, SB-14, SB-140, or SB-11.

- With the SB-26, SB-25, and SB-24, flash sync modes set on the Speedlight override the camera's setting.

- Autofocus illumination does not occur when an SK-6 and SB-24 are attached.

- Only TTL flash modes can be used if the camera's exposure mode is set to program (P). If the Speedlight is set to something other than TTL when the N80/F80 is in P mode, the shutter locks and ℉ℇℇ and P blink in the top LCD panel.

- TTL may be performed at ISO 25 to 800.

- Viewfinder shows ± when flash compensation is set on the Speedlight.

Flash Features Available Using N80/F80 with Speedlights

Model	TTL	A	M	AF	Slow	Rear	RF	RE	HS
Built-in	Yes*	No	No**	Yes	Yes	Yes	No	Yes	No
SB-29	Yes*	No	Yes	Yes	Yes	Yes	No	No	No
SB-28	Yes*	Yes	Yes	Yes	Yes	Yes	Yes	Yes	Yes
SB-27	Yes*	Yes	Yes	Yes	Yes	Yes	No	Yes	Yes
SB-26	Yes*	Yes	Yes	Yes	Yes	Yes	Yes	Yes	Yes
SB-25	Yes*	Yes	Yes	Yes	Yes	Yes	Yes	No	Yes
SB-24	Yes*	Yes	Yes	Yes	Yes	Yes	Yes	No	No
SB-23	Yes*	No	Yes	Yes	Yes	Yes	No	No	No
SB-22s	Yes*	Yes	Yes	Yes	Yes	Yes	No	No	No
SB-22	Yes*	Yes	Yes	Yes	Yes	Yes	No	No	No
SB-21B	Yes*	Yes	Yes	No	Yes	Yes	No	No	No
SB-20	Yes*	Yes	Yes	Yes	Yes	Yes	No	No	No
SB-16B	Yes*	Yes	Yes	No	Yes	Yes	No	No	No
SB-15	Yes*	Yes	Yes	No	Yes	Yes	No	No	No
SB-14	Yes***	Yes	Yes	No	Yes	Yes	No	No	No
SB-140	Yes***	Yes	Yes	No	Yes	Yes	No	No	No
SB-11	Yes***	Yes	Yes	No	Yes	Yes	No	No	No

** Balanced fill-flash possible.*

*** Flash exposure compensation can be set.*

*** *Only when connected using an SC-23.*

A = Automatic flash mode

AF = Autofocus assist

HS = High-speed sync mode

M = Manual flash mode

RE = Red-eye reduction

RF = Repeating flash

Rear = Rear (second-curtain) sync

Slow = Slow sync

TTL = Through-the-lens metering

Note: Preferred Speedlights are highlighted in bold in the table. Speedlights not listed are *not* recommended for use on the N80/F80.

N90/F90 and N90s/F90X

At the time of its introduction, Nikon recommended using a SB-25 Speedlight with the N90/F90. No changes were made to the camera that affect flash between the N90/F90 and the N90s/F90X. However, to fully utilize the capabilities of both the camera and the flash, an SB-25, SB-26, SB-27, or SB-28 should be used. Nevertheless, for basic flash, any of the TTL-capable Speedlights should work just fine.

With an SB-25, SB-26, SB-27, or SB-28, the N90/F90 and N90s/F90X provide the following flash capabilities:

- _With D-type lenses_—3D multi-sensor balanced fill-flash is used, regardless of the metering method chosen.

- _With non-D autofocus and AI-P lenses_—Multi-sensor balanced fill-flash is used, regardless of the metering method chosen.

- _With AI or AI-S lenses_—Center-weighted fill-flash is used if the metering is set to matrix or center-weighted, while spot fill-flash is used if the metering is set to spot. Note that if the camera was originally set to program (P) or shutter-priority (S) exposure modes, it automatically switches to aperture-priority (A) exposure mode when you use a Speedlight with this type of lens.

🎴 and 🔆 appear on the Speedlight's LCD to indicate either multi-sensor balanced fill-flash mode. 🎴 and 📷 appear on the Speedlight's LCD to indicate center-weighted or spot fill-flash.

Note: If the camera is in any exposure mode other than program (P), you can override the selection of balanced fill-flash by pressing the 𝗠𝗢𝗗𝗘 button on the Speedlight.

With an SB-24, the N90/F90 and N90s/F90X provide the following flash capabilities:

- _With all autofocus and AI-P lenses_—Multi-sensor balanced fill-flash is used, regardless of the metering method chosen.

- _With AI or AI-S lenses_—Center-weighted fill-flash is used if the metering is set to matrix or center-weighted, while spot fill-flash is used if the metering is set to spot. Note that if the camera was originally set to program (P) or shutter-priority (S) exposure modes, it automatically switches to aperture-priority (A) exposure mode when you use a Speedlight with this type of lens.

🎴 and 📷 appear on the Speedlight's LCD to indicate all fill-flash modes.

With an SB-11, SB-14, SB-140, SB-15, SB-16B, SB-20, SB-21B, SB-22, or SB-23, the N90/F90 and N90s/F90X provide the following capabilities:

- *With all autofocus and AI-P lenses*—Multi-sensor balanced fill-flash is used, regardless of the metering method chosen. However, if manual (M) exposure mode is set on the camera, standard TTL flash is performed.

- *With AI or AI-S lenses*—Center-weighted fill-flash is used if the metering is set to matrix or center-weighted, while spot fill-flash is used if the metering is set to spot. Note that if the camera was originally set to program (P) or shutter-priority (S) exposure modes, it automatically switches to aperture-priority (A) exposure mode when you use a Speedlight with this type of lens. However, if manual (M) exposure mode is set on the camera, the Speedlight is always set to standard TTL flash.

The N90/F90 and N90s/F90X limit shutter speed choices with flash depending upon the exposure mode:

- *Program (P):* Automatically set by the camera between 1/60 and 1/250 second unless slow or rear sync is also set.

- *Shutter-Priority (S):* Manually set by user between 30 seconds and 1/250 second.

- *Aperture-Priority (A):* Automatically set by the camera between 1/60 and 1/250 second unless slow or rear sync is also set.

- *Manual (M):* Manually set by user between 30 seconds and 1/250 second.

Special N90/F90 and N90s/F90X Notes

- The shutter speed blinks in the camera's LCD (but not the viewfinder) if the user sets a shutter speed faster than 1/250 second and mounts a Speedlight on the camera.

- The flash sync mode is set on the camera by pressing the 🔳 button and rotating the rear command dial. Choices are: ⌊REAR⌋, ⌊SLOW⌋, or ⊚.

- With the SB-24, SB-25, and SB-26, the flash mode set on the Speedlight overrides the mode set on the N90/F90 and N90s/F90X.

- Only TTL flash mode can be used if the camera's exposure mode is set to program (P). If the Speedlight is set to something other than TTL when the N90/F90 or N90s/F90X is in program (P)

mode, the shutter locks and ⸆Ɛᴇ and **P** blink in the top LCD panel.

- TTL may be performed at ISO 25 to 1,000.
- The viewfinder shows ± when flash compensation is set on the Speedlight.

Flash Features Available Using N90s/F90X with Speedlights

Model	TTL	A	M	AF	Slow	Rear	RF	RE	HS
SB-29	**Yes***	**No**	**Yes**	**Yes**	**Yes**	**Yes**	**No**	**No**	**No**
SB-28	**Yes***	**Yes**	**Yes**	**Yes**	**Yes**	**Yes**	**Yes**	**Yes**	**Yes**
SB-27	**Yes***	**Yes**	**Yes**	**Yes**	**Yes**	**Yes**	**No**	**Yes**	**Yes**
SB-26	Yes*	Yes	Yes	Yes	Yes	Yes	Yes	Yes	Yes
SB-25	Yes*	Yes	Yes	Yes	Yes	Yes	Yes	No	Yes
SB-24	Yes*	Yes	Yes	Yes	Yes	Yes	Yes	No	No
SB-23	Yes*	No	Yes	Yes	Yes	Yes	No	No	No
SB-22s	Yes*	Yes	Yes	Yes	Yes	Yes	No	No	No
SB-22	Yes*	Yes	Yes	Yes	Yes	Yes	No	No	No
SB-21B	Yes*	Yes	Yes	No	Yes	Yes	No	No	No
SB-20	Yes*	Yes	Yes	Yes	Yes	Yes	No	No	No
SB-16B	Yes*	Yes	Yes	No	Yes	Yes	No	No	No
SB-15	Yes*	Yes	Yes	No	Yes	Yes	No	No	No
SB-14	Yes**	Yes	Yes	No	Yes	Yes	No	No	No
SB-140	Yes**	Yes	Yes	No	Yes	Yes	No	No	No
SB-11	Yes**	Yes	Yes	No	Yes	Yes	No	No	No

** Balanced fill-flash possible.*

*** Only when connected using an SC-23 Cord.*

A = Automatic flash mode

AF = Autofocus assist

HS = High-speed sync mode

M = Manual flash mode

RE = Red-eye reduction

RF = Repeating flash

Rear = Rear (second-curtain) sync

Slow = Slow sync

TTL = Through-the-lens metering

Note: Preferred Speedlights are highlighted in bold in the table. Speedlights not listed are *not* recommended for use on the N90/F90 or N90s/F90X.

F100

At the time of the F100's introduction, Nikon recommended using it with either an SB-27 or SB-28 Speedlight. To fully utilize the capabilities of both the camera and the flash, an SB-26 or SB-28 should be used with an F100. Nevertheless, for basic flash, any of the TTL-capable Speedlights should work just fine.

With an SB-25, SB-26, SB-27, or SB-28, the F100 provides the following flash capabilities:

• *With D-type lenses*—3D multi-sensor balanced fill-flash is used, regardless of the metering method chosen.

• *With non-D autofocus and AI-P lenses*—Multi-sensor balanced fill-flash is used, regardless of the metering method chosen.

• *With AI or AI-S lenses*—Center-weighted fill-flash is used if the metering is set to matrix or center-weighted, while spot fill-flash is used if the metering is set to spot. Note that if the camera was originally set to program (P) or shutter-priority (S) exposure modes, it automatically switches to aperture-priority (A) exposure mode when you use a Speedlight with this type of lens.

🔲 and 🔳 appear on the Speedlight's LCD to indicate either multi-sensor balanced fill-flash mode. 🔲 and 🔳 appear on the Speedlight's LCD to indicate center-weighted or spot fill-flash.

Note: If the camera is in any exposure mode other than program (P), you can override the selection of balanced fill-flash by pressing the 🔲 button on the Speedlight.

With an SB-24, the F100 provides the following flash capabilities:

• *With all autofocus and AI-P lenses*—Multi-sensor balanced fill-flash is used, regardless of the metering method chosen.

• *With AI or AI-S lenses*—Center-weighted fill-flash is used if the metering is set to matrix or center-weighted, while spot fill-flash is used if the metering is set to spot. Note that if the camera was originally set to program (P) or shutter-priority (S) exposure modes, it automatically switches to aperture-priority (A) exposure mode when you use a Speedlight with this type of lens.

🔲 and 🔳 appear on the Speedlight's LCD to indicate all fill-flash modes.

With an SB-11, SB-14, SB-140, SB-15, SB-16B, SB-20, SB-21B, SB-22, or SB-23, the F100 provides the following capabilities:

- *With all autofocus and AI-P lenses*—Multi-sensor balanced fill-flash is used, regardless of the metering method chosen. However, if manual (M) exposure mode is set on the camera, standard TTL flash is performed.

- *With AI or AI-S lenses*—Center-weighted fill-flash is used if the metering is set to matrix or center-weighted, while spot fill-flash is used if the metering is set to spot. Note that if the camera was originally set to program (P) or shutter-priority (S) exposure modes, it automatically switches to aperture-priority (A) exposure mode when you use a Speedlight with this type of lens. However, if manual (M) exposure mode is set on the camera, the Speedlight is always set to standard TTL flash.

The F100 limits shutter speed choices with flash depending upon the exposure mode:

- *Program (P):* Automatically set between 1/60 and 1/250 second unless slow or rear sync is also set.

- *Shutter-Priority (S):* Manually set by user between 30 seconds and 1/250 second.

- *Aperture-Priority (A):* Automatically set between 1/60 and 1/250 second unless slow or rear sync is also set.

- *Manual (M):* Manually set by user between 30 seconds and 1/250 second.

Special F100 Notes

- The shutter speed blinks in the LCD (but not the viewfinder) if the user sets a shutter speed faster than 1/250 second and mounts a Speedlight on the camera.

- Flash sync mode is set on the camera by pressing the 🔲 button and rotating the rear command dial. Choices are: (ˢᴸᴼʷ), (ᴿᴱᴬᴿ), (ˢᴸᴼʷᴿᴱᴬᴿ), or ⊙.

- The autofocus assist illuminator on a Speedlight is not functional unless the F100's center AF sensor is selected.

- With the SB-24, SB-25, and SB-26, the flash mode set on the Speedlight overrides the mode set on the F100.

- Only TTL flash mode can be used if the camera's exposure mode is set to program (P). If the Speedlight is set to something other than TTL when the F100 is in program (P) mode, the shutter locks and ⊦ЄЄ and P blink in the top LCD panel.

- TTL may be performed at ISO 25 to 1,000.
- The viewfinder shows ± when flash compensation is set on the Speedlight.

Flash Features Available using F100 with Speedlights

Model	TTL	A	M	AF	Slow	Rear	RF	RE	HS
SB-29	**Yes***	**No**	**Yes**	**Yes**	**Yes**	**Yes**	**No**	**No**	**No**
SB-28	**Yes***	**Yes**	**Yes**	**Yes**	**Yes**	**Yes**	**Yes**	**Yes**	**Yes**
SB-27	**Yes***	**Yes**	**Yes**	**Yes**	**Yes**	**Yes**	**No**	**Yes**	**Yes**
SB-26	Yes*	Yes	Yes	Yes	Yes	Yes	Yes	Yes	Yes
SB-25	Yes*	Yes	Yes	Yes	Yes	Yes	Yes	No	Yes
SB-24	Yes*	Yes	Yes	Yes	Yes	Yes	Yes	No	No
SB-23	Yes*	No	Yes	Yes	Yes	Yes	No	No	No
SB-22s	Yes*	Yes	Yes	Yes	Yes	Yes	No	No	No
SB-22	Yes*	Yes	Yes	Yes	Yes	Yes	No	No	No
SB-21B	Yes*	Yes	Yes	No	Yes	Yes	No	No	No
SB-20	Yes*	Yes	Yes	Yes	Yes	Yes	No	No	No
SB-16B	Yes*	Yes	Yes	No	Yes	Yes	No	No	No
SB-15	Yes*	Yes	Yes	No	Yes	Yes	No	No	No
SB-14	Yes**	Yes	Yes	No	Yes	Yes	No	No	No
SB-140	Yes**	Yes	Yes	No	Yes	Yes	No	No	No
SB-11	Yes**	Yes	Yes	No	Yes	Yes	No	No	No

** Balanced fill-flash possible.*

*** Only when connected using an SC-23 Cord.*

A = Automatic flash mode

AF = Autofocus assist

HS = High-speed sync mode

M = Manual flash mode

RE = Red-eye reduction

RF = Repeating flash

Rear = Rear (second-curtain) sync

Slow = Slow sync

TTL = Through-the-lens metering

Note: Preferred Speedlights are highlighted in bold in the table. Speedlights not listed are *not* recommended for use on the F100.

F3

At the time of the F3's introduction, Nikon also introduced the SB-12 Speedlight, which works only with the F3. Unlike other currently available bodies, the F3 uses the old-style rewind mount for flash units. This means that you must use a flash unit made specifically for the F3 (e.g., the SB-12, SB-16A, or SB-21A), or you need to use the AS-4 Flash Adapter (or an AS-7 or AS-17) to mount a hot-shoe compatible Speedlight. (*Exceptions:* The uncommon F3P, sold primarily in Japan to photojournalists, which has a non-TTL hot shoe; the very rare F3H; and the F3 Limited, sold only in Japan. These are the only three F3 bodies that have the necessary contacts in the removable viewfinder mechanism to support the DE-5 Finder, which includes a hot shoe.)

While the F3 has TTL capability, it does not support any of the more sophisticated fill-flash or balanced modes; it performs standard TTL flash only. However, note that the F3 is TTL-capable only with F3-dedicated flash units or when used with the AS-17 Cable, as the F3 doesn't have a built-in computer to calculate TTL. The F3's TTL is performed using a single SPD sensor (the same sensor used for ambient light metering).

Note: The DE-5 viewfinder's hot shoe does not support TTL. On F3s using this finder, you are limited to automatic or manual flash modes.

Special F3 Note

• If you select a shutter speed faster than 1/80 second and mount a Speedlight on the F3's rewind flash mount, the camera resets the shutter speed to 1/80 second, the maximum sync speed.

Flash Features Available Using F3 with Speedlights

Model	TTL*	A**	M	AF	Slow	Rear	RF	RE	HS
SB-29	Yes	No	Yes	No	No	No	No	No	No
SB-28	Yes	Yes	Yes	No	No	No	Yes	No	No
SB-27	Yes	Yes	Yes	No	No	No	Yes	No	No
SB-26	Yes	Yes	Yes	No	No	No	Yes	No	No
SB-25	Yes	Yes	Yes	No	No	No	Yes	No	No
SB-24	Yes	Yes	Yes	No	No	No	No	No	No
SB-23	Yes	No	Yes	No	No	No	No	No	No
SB-22s	Yes	Yes	Yes	No	No	No	No	No	No
SB-22	Yes	Yes	Yes	No	No	No	No	No	No
SB-21A	**No**	**Yes**	**Yes**	**No**	**No**	**No**	**No**	**No**	**No**
SB-20	Yes	Yes	Yes	No	No	No	No	No	No
SB-17	Yes	Yes	Yes	No	No	No	No	No	No
SB-16A	**Yes**	**Yes**	**Yes**	**No**	**No**	**No**	**No**	**No**	**No**
SB-15	Yes	Yes	Yes	No	No	No	No	No	No
SB-14	**Yes***	**Yes**	**Yes**	**No**	**No**	**No**	**No**	**No**	**No**
SB-12	**Yes**	**Yes**	**Yes**	**No**	**No**	**No**	**No**	**No**	**No**
SB-11	Yes***	Yes	Yes	No	No	No	No	No	No

** If Yes, typically requires AS-17 Flash Shoe.*

*** If Yes, requires AS-17, AS-4, or PC cable.*

**** Only when connected using an SC-12 Cord.*

A = Automatic flash mode

AF = Autofocus assist

HS = High-speed sync mode

M = Manual flash mode

RE = Red-eye reduction

RF = Repeating flash

Rear = Rear (second-curtain) sync

Slow = Slow sync

TTL = Through-the-lens metering

Note: Preferred Speedlights are highlighted in bold in the table. Speedlights not listed are *not* recommended for use on the F3.

F4

At the time of the F4's introduction, Nikon recommended using it with the SB-24 Speedlight. To fully utilize the capabilities of both the camera and the flash, an SB-24, SB-25, or SB-26 should be used on an F4 (note that the SB-27 and SB-28 are less capable on the F4, as they require many settings to be performed on the camera, for which the F4 has no controls). Nevertheless, for basic flash, any of the TTL-capable Speedlights should work just fine.

With an SB-25, SB-26, SB-27, or SB-28, the F4 provides the following flash capabilities:

• Matrix balanced fill-flash or matrix TTL flash is used with the meter set to matrix and an autofocus or AI-P lens is used.

• Center-weighted fill-flash or center-weighted TTL flash is used with the meter set to center-weighted. This is also what is set when you use an AI or AI-S lens in matrix metering mode (aperture-priority [A] or manual [M] exposure mode must be used).

• Standard TTL flash is used with the meter set to spot, regardless of lens type.

▥ and ◘ appear on the Speedlight's LCD to indicate either matrix mode. ▥ and ▣ appear on the Speedlight's LCD to indicate either of the other fill-flash modes. ▥ appears on the Speedlight's LCD to indicate standard TTL flash.

With an SB-24, the F4 provides the following flash capabilities:

• *With all autofocus and AI-P lenses*—Matrix balanced fill-flash is used, regardless of the exposure mode chosen.

• *With AI or AI-S lenses*—Center-weighted fill-flash is used if the metering is set to matrix or center-weighted, while standard TTL flash is used if the metering is set to spot. Note that if the camera was originally set to program (P) or shutter-priority (S) exposure modes, it automatically switches to aperture-priority (A) exposure mode when you use a Speedlight with this type of lens.

▥ and ▣ appear on the Speedlight's LCD to indicate all fill-flash modes.

With an SB-11, SB-14, SB-15, SB-16B, SB-20, SB-22, or SB-23, the F4 provides the following capabilities:

• *With all autofocus and AI-P lenses*—Matrix balanced fill-flash is used for all exposure modes except manual (M), where matrix TTL flash is used instead.

- *With AI or AI-S lenses*—Center-weighted fill-flash is used if the metering is set to matrix or center-weighted, while spot fill-flash is used if the metering is set to spot. Center-weighted TTL flash is used if the exposure mode is set to manual (M).

Special F4 Notes

- The shutter speed can be set no faster than 1/250 second with a Speedlight on the camera.
- In shutter-priority and manual modes and using rear sync, F4 users are limited to shutter speeds of between 4 seconds and 1/250 second.

Flash Features Available Using F4 with Speedlights

Model	TTL	A	M	AF	Slow	Rear	RF	RE	HS
SB-29	Yes*	No	Yes	Yes	No	No	No	No	No
SB-28	Yes*	Yes	Yes	Yes	No	No	Yes	No	No
SB-27	**Yes***	**Yes**	**Yes**	**Yes**	**No**	**No**	**No**	**No**	**No**
SB-26	**Yes***	**Yes**	**Yes**	**Yes**	**Yes**	**Yes**	**Yes**	**No**	**No**
SB-25	**Yes***	**Yes**	**Yes**	**Yes**	**Yes**	**Yes**	**Yes**	**No**	**No**
SB-24	**Yes***	**Yes**	**Yes**	**Yes**	**Yes**	**Yes**	**Yes**	**No**	**No**
SB-23	Yes*	No	Yes	Yes	No	No	No	No	No
SB-22s	Yes*	Yes	Yes	Yes	No	No	No	No	No
SB-22	Yes*	Yes	Yes	Yes	No	No	No	No	No
SB-21B	Yes*	Yes	Yes	No	No	No	No	No	No
SB-21A	No	Yes	Yes	No	No	No	No	No	No
SB-20	Yes*	Yes	Yes	Yes	No	No	No	No	No
SB-16B	Yes*	Yes	Yes	No	No	No	No	No	No
SB-16A	No	Yes	Yes	No	No	No	No	No	No
SB-15	Yes*	Yes	Yes	No	No	No	No	No	No
SB-14	Yes**	Yes	Yes	No	No	No	No	No	No
SB-11	Yes**	Yes	Yes	No	No	No	No	No	No

** Balanced fill-flash possible.*

*** Only when connected using an SC-23 Cord.*

A = Automatic flash mode

AF = Autofocus assist

HS = High-speed sync mode

M = Manual flash mode

RE = Red-eye reduction

RF = Repeating flash

Rear = Rear (second-curtain) sync

Slow = Slow sync

TTL = Through-the-lens metering

Note: Preferred Speedlights are highlighted in bold in the table. Speedlights not listed are *not* recommended for use on the F4.

F5

At the time of the F5's introduction, Nikon recommended using it with either an SB-26 or SB-27 Speedlight. However, to fully utilize the capabilities of both the camera and the flash, an SB-26 or SB-28 should be used on an F5. Nevertheless, for basic flash, any of the TTL-capable Speedlights should work just fine.

With an SB-25, SB-26, SB-27, or SB-28, the F5 provides the following flash capabilities:

- *With D-type lenses*—3D multi-sensor balanced fill-flash is used, regardless of the metering method chosen.

- *With non-D autofocus and AI-P lenses*—Multi-sensor balanced fill-flash is used, regardless of the metering method chosen.

- *With AI or AI-S lenses*—Center-weighted fill-flash is used if the metering is set to matrix or center-weighted, while spot fill-flash is used if the metering is set to spot. Note that if the camera was originally set to program (P) or shutter-priority (S) exposure modes, it automatically switches to aperture-priority (A) exposure mode when you use a Speedlight with this type of lens.

▥ and ◉ appear on the Speedlight's LCD to indicate either multi-sensor balanced fill-flash mode. ▥ and ▣ appear on the Speedlight's LCD to indicate center-weighted or spot fill-flash.

Note: If the camera is in any exposure mode other than program (P), you can override the selection of balanced fill-flash by pressing the mode button on the Speedlight.

With an SB-24, the F5 provides the following flash capabilities:

- *With all autofocus and AI-P lenses*—Multi-sensor balanced fill-flash is used, regardless of the metering method chosen.

- *With AI or AI-S lenses*—Center-weighted fill-flash is used if the metering is set to matrix or center-weighted, while spot fill-flash is used if the metering is set to spot. Note that if the camera was originally set to program (P) or shutter-priority (S) exposure modes, it automatically switches to aperture-priority (A) exposure mode when you use a Speedlight with this type of lens.

▥ and ▣ appear on the Speedlight's LCD to indicate all other (non-multisensor) fill-flash modes.

With an SB-11, SB-14, SB-15, SB-16B, SB-20, SB-22, or SB-23, the F5 provides the following capabilities:

- *With all autofocus and AI-P lenses*—Multi-sensor balanced fill-flash is used, regardless of the metering method chosen. However, if manual (M) exposure mode is set on the camera, standard TTL flash is performed.

- *With AI or AI-S lenses*—Center-weighted fill-flash is used if the metering is set to matrix or center-weighted, while spot fill-flash is used if the metering is set to spot. Note that if the camera was originally set to program (P) or shutter-priority (S) exposure modes, it automatically switches to aperture-priority (A) exposure mode when you use a Speedlight with this type of lens. However, if manual (M) exposure mode is set on the camera, the Speedlight is always set to standard TTL flash.

The F5 limits shutter speed choices with flash depending upon the exposure mode:

- *Program (P):* Automatically set between 1/60 and 1/250 second (or 1/300 if custom setting 20 is set) unless slow or rear sync is also set.

- *Shutter-Priority (S):* Manually set by user between 30 seconds and 1/250 second (or 1/300 second if custom setting 20 is set).

- *Aperture-Priority (A):* Automatically set by the camera to between 1/60 and 1/250 second (or 1/300 second if custom setting 20 is set) unless slow or rear sync is also set.

- *Manual (M):* Manually set by user between 30 seconds and 1/250 second (or 1/300 second if custom setting 20 is set).

Special F5 Notes

- The shutter speed blinks in the LCD (but not the viewfinder) if the user sets a shutter speed faster than 1/250 second and mounts a Speedlight on the camera.

- With an SB-20, SB-22, SB-22s, SB-23, SB-24, SB-25, SB-26, SB-27, or SB-28, you can use custom setting 20 to set the maximum flash shutter speed on the F5 to 1/300 second. This has the further impact of reducing the GN of the flash to a maximum of 45 in feet (14 m), so it is generally not the correct choice.

- You can also use custom setting 20 to set a lower maximum flash sync speed than 1/250 second. You may select maximum sync speeds of 1/60, 1/80, 1/100, 1/125, 1/160, 1/200, and 1/250 second without any impact on flash strength.

- Flash sync mode is set on the camera by pressing the ⚡ button and rotating the rear command dial. Choices are: 〔SLOW〕, or 〔REAR〕.

- The autofocus assist illuminator on a Speedlight is not functional unless the F5's center AF sensor is selected.

Flash Features Available Using F5 with Speedlights

Model	TTL	A	M	AF	Slow	Rear	RF	1/300	HS
SB-29	**Yes***	**No**	**Yes**	**Yes**	**Yes**	**Yes**	**No**	**Yes**	**No**
SB-28	**Yes***	**Yes**	**Yes**	**Yes**	**Yes**	**Yes**	**Yes**	**Yes**	**Yes**
SB-27	**Yes***	**Yes**	**Yes**	**Yes**	**Yes**	**Yes**	**No**	**Yes**	**Yes**
SB-26	Yes*	Yes	Yes	Yes	Yes	Yes	Yes	Yes	Yes
SB-25	Yes*	Yes	Yes	Yes	Yes	Yes	Yes	Yes	Yes
SB-24	Yes*	Yes	Yes	Yes	Yes	Yes	Yes	Yes	No
SB-23	Yes*	No	Yes	Yes	Yes	Yes	No	Yes	No
SB-22s	Yes*	Yes	Yes	Yes	Yes	Yes	No	Yes	No
SB-22	Yes*	Yes	Yes	Yes	Yes	Yes	No	Yes	No
SB-21B	Yes*	Yes	Yes	No	Yes	Yes	No	No	No
SB-21A	No	Yes	Yes	No	Yes	Yes	No	No	No
SB-20	Yes*	Yes	Yes	Yes	Yes	Yes	No	Yes	No
SB-16B	Yes*	Yes	Yes	No	Yes	Yes	No	No	No
SB-16A	No	Yes	Yes	No	Yes	Yes	No	No	No
SB-15	Yes*	Yes	Yes	No	Yes	Yes	No	No	No
SB-14	Yes**	Yes	Yes	No	Yes	Yes	No	No	No
SB-11	Yes**	Yes	Yes	No	Yes	Yes	No	No	No

* *Balanced fill-flash possible.*
** *Only when connected using an SC-23 Cord.*

A = Automatic flash mode
AF = Autofocus assist
HS = High-speed sync mode
M = Manual flash mode
RE = Red-eye reduction
RF = Repeating flash
Rear = Rear (second-curtain) sync
Slow = Slow sync
TTL = Through-the-lens metering

Note: Preferred Speedlights are highlighted in bold in the table. Speedlights not listed are *not* recommended for use on the F5.

Understanding Viewfinder Information

One of the most common questions asked about Speedlight flash use is "Why does my viewfinder say the shot will be underexposed?" Another variant: "Why does the viewfinder say exposure compensation is being used when I haven't set any on the camera?" Or this: "Why doesn't the camera warn me that my shot will be overexposed before I fire the flash?"

These questions all derive from a common basic problem: flash exposure is highly variable and the camera doesn't necessarily have all the information it needs to "know" the outcome of a shot. Let's review the questions one by one:

• *Why does the camera say the shot will be underexposed?*

Unfortunately, the camera doesn't know much about the flash that's attached other than that it is ON. The camera doesn't know, for example, how much power the flash has. The underexposure warning in the viewfinder is useful, however. The camera is telling you that the background will be underexposed, even if the flash lights the primary subject correctly. If you wish the background exposure to be correct, switch to slow sync mode and set a proper exposure for the scene.

• *Why does the viewfinder show that exposure compensation is being used?*

If you didn't set exposure compensation on the camera body, then you've set flash exposure compensation on the Speedlight (a few bodies and optional databacks can set flash exposure compensation, as well). You're being given a warning that the flash may not provide the correct primary exposure for the scene.

• *Why doesn't the camera warn me ahead of time that the shot will be overexposed?*

This situation typically happens when you've set a proper exposure in a bright setting (say f/2.8 at 1/500 second) then turn the flash unit ON. This is especially true if you're shooting in aperture-priority mode—on some bodies, the camera simply lowers the shutter speed to one that can be used with flash when you turn the Speedlight ON, giving you no warning that you might be overexposing.

Most Nikon bodies automatically switch the shutter speed to between 1/60 second and the top sync speed (1/125 or 1/250 second) when the flash is ON. If the camera settings are left as-is, your shot can be overexposed. If you're going to use a flash, make your exposure setting using a shutter speed that is supported by flash sync. Most newer Nikon bodies warn you of background overexposure with the message "⚡ " in the viewfinder and on the LCD.

Finally, be aware that the flash adds light to the scene. Thus, if your camera is set for proper exposure prior to connecting the flash, adding flash may lead to overexposure of the subject. In general, if the subject is well exposed without the flash, you should use only fill-flash modes or you'll risk overexposing the subject. Again, there's no way the camera can know to warn you of this, because it doesn't know the power of the flash being used.

Nikon Speedlight Accessories

Couplers

AS-1: Coupler used to adapt a regular ISO hot-shoe-compatible foot on the flash to the unique rewind-based mounts of the original Nikon F and F2 series bodies.

AS-2: Coupler used to adapt Nikon's unique rewind-based mounts to a regular camera body ISO hot shoe.

AS-3: Coupler used to adapt an F3 rewind-based mount to that used for the Nikon F and F2-type flash units.

AS-4: Coupler used to adapt an F3 rewind-based mount to a regular camera body ISO hot shoe.

AS-5: Coupler used to adapt an SB-17 to be mounted on the F2 series hot shoe.

AS-6: Coupler used to adapt an SB-17 to mount on a standard ISO hot shoe of Nikon bodies such as the FE2, FE, FM2, FG, and EM.

AS-7: Coupler used to adapt an F3 rewind-based mount to a regular camera body hot shoe. Allows rewinding and changing of film without removing the flash.

AS-8: Integral coupler supplied with the SB-16A for use on F3 series cameras.

AS-9: Integral coupler supplied with the SB-16B for use with Nikon bodies that have hot shoes.

AS-10: Coupler used with SC-18 or SC-19 sync cords to connect three or more slave flash units to a master flash.

AS-11: Coupler/mount that allows you to mount a slave flash unit on a 1/4"-20 threaded tripod.

AS-15: Sync terminal adapter used to connect SC-11 or SC-15 cables to cameras that don't have a sync terminal.

AS-17: TTL flash coupler used to adapt a flash unit with a standard hot foot to an F3.

Nikkormat Accessory Shoe:
Designed to add a flash mount to the Nikkormat FTn. Note that this is not a hot shoe; you still need a cable to connect and synchronize the camera and flash.

The Nikon Flash Guide

Cables

SC-4: Provides a ready light for FTn Photomic viewfinder when used with an SB-5.

SC-5: A 6-inch (15 cm) sync cord that has a standard PC (X) terminal plug at one end and a Nikon Speedlight-specific three-prong plug at the other. Designed for the SB-5, SB-7E/8E, and SB-10.

SC-6: Coiled, 3.2 foot (1 m) sync cord that has a standard PC (X) terminal plug at one end and a Nikon Speedlight-specific three-prong plug at the other. Designed for the SB-7E/8E and SB-10.

SC-7: Sync cord that has a standard PC (X) terminal plug at one end and a Nikon Speedlight-specific three-prong plug at the other. Designed for the SB-7E/8E and SB-10.

SC-8: A 10-inch (25 cm) sync cord that has a standard PC (X) terminal plug at one end and a Nikon Speedlight-specific two-prong plug at the other. Designed for the SB-4.

SC-9: Enables automatic flash operation with the SB-5 or SB-6 off the camera. Permits mounting the SU-1 on the camera's flash shoe.

SC-10: Sync cord designed to provide hot shoe contact for cameras with inactive hot shoes. One end has a standard PC (X) terminal plug and the other is a hot-shoe that plugs into a non-hot shoe. Designed for the SB-11.

SC-11: A 10-inch (25 cm) sync cord with a standard PC (X) terminal plugs at both ends.

SC-12: A 3.2-foot (1 m) sensor cord that allows an SB-11 or SB-14 to be used with F3 for automatic TTL flash exposure. When an SC-12 connects an SB-11 with an F3, the F3 is automatically switched to a shutter speed of 1/80 second (if camera is set to A or a faster shutter speed). Also, the F3's ready light is operative when this cable is used.

SC-13: A 3.2-foot (1 m) sensor cord that allows mounting the SB-11 or SB-14's sensor unit (SU-2) to plug into the hot shoe (originally intended for FE, FM, and EM). This provides camera position control for an off-camera flash unit (i.e., automatic flash control is done at the camera position, not at the flash position).

SC-14: A 3.2-foot (1 m) sync cord that allows the SB-17 to be used off camera in TTL mode with the F3.

SC-15: A coiled, 3.2-foot (1 m) sync cord with standard PC (X) terminal plugs at both ends.

SC-17: A coiled, 5-foot (1.5 m) sync cord designed to plug into a camera body hot shoe at one end, providing remote hot shoe capability. Retains shutter speed switchover, ready light, and other flash features in the viewfinder.

SC-18: A 5-foot (1.5 m) sync cord designed to connect a slave flash unit to a master.

SC-19: A 10-foot (3 m) sync cord designed to connect a slave flash unit to a master.

SC-23: A 3.2-foot (1 m) sensor cord that allows SB-11 and SB-14 to be used with hot-shoe-equipped cameras for TTL flash exposure.

SC-24: A 5-foot (1.5 m) sync cord designed for using a Speedlight on an F4 or an F5 equipped with the alternate finders (DW-31 or DW-30).

SE-2: A 10-foot (3 m) extension sync cord.

Other Accessories

BR-2A: Adapter ring to mount a reversed lens with 52mm threads; used in conjunction with a BR-6 and either the SB-21 or SB-29.

BR-5: Adapter ring to mount a reversed lens with 52mm threads; used in conjunction with a BR-6 and either the SB-21 or SB-29.

BR-6: Adapter necessary to mount the SB-21 or SB-29 on a lens mounted in the reverse position. To retain automatic aperture control, use the AR-10 Double Release or AR-7/ AR-4 Double Cable Releases.

SF-1: An eyepiece pilot lamp that provides a viewfinder ready light for bodies that don't already have one. Designed for the SB-7E/8E.

SK-3: Adjustable bracket for the SB-5 (supplied with flash).

SK-5: Adjustable bracket for the SB-14 (supplied with flash). Note that the position of the camera attachment screw is

adjustable to several positions (the Nikon FE and FM connect in a slightly different place than the F3, EM, or F2, for example). If you're using the bracket with a camera that has the MD-4 Motor Drive, you must detach the camera attachment screw and move it to the other short slot. This is done by moving the screw to the threaded end of a slot and unscrewing it.

Wide-Angle Adapters

SW-2: Wide-angle adapter for the SB-7E/8E and SB-10, which provides coverage for a 28mm lens. Reduces the GN by from 80 in feet (25 m) to 58 (18 m).

SW-3: Wide-angle adapter for the SB-11, which provides coverage for a 28mm lens. Reduces GN from 118 in feet (36 m) to 80 (25 m).

SW-4: Wide-angle adapter for the SB-12, which provides coverage for a 28mm lens. Reduces GN from 80 in feet (25 m) to 58 (18 m) (e.g., maximum focus distance reduces from 20.3 feet [6.2 m] to 14.4 feet [4.4 m] at f/4 and ISO 100).

SW-5: Wide-angle adapter for the SB-14, which provides coverage for a 24mm lens. Reduces GN from 106 in feet (32 m) to 73 (22 m).

SW-6: Wide-angle adapter for the SB-15 and SB-17, which provides coverage for a 28mm lens. Reduces GN from 80 in feet (25 m) to 58 (18 m).

SW-7: Wide-angle adapter for the SB-16A and SB-16B, which provides coverage for a 24mm lens.

SW-8: Condenser adapter for the SB-21, which provides coverage for extreme close-up work (1.3 inches, [4 cm]).

Battery Holders/External Power

LA-2: An AC power source for the SB-21. This unit can be configured to 100, 117, 220, and 240 volts at 50 or 60 hertz, allowing it to be used worldwide.

LD-2: A remote battery power source for the SB-21. Because it uses 8 AA batteries instead of the SB-21's 4,

recycling times are cut in half and flash power is about 1/2-stop higher.

MS-2: Battery holder with same cover and release as the SB-10, allows rapid changing of batteries by swapping it for holder in the flash unit.

MS-6: Battery holder with same cover and release as the SB-15, allows rapid changing of batteries by swapping it for holder in the flash unit.

SA-1: Charger and AC power unit for the SB-1.

SA-2: AC power unit for the SB-2 and SB-3.

SA-3: AC power unit supplied with the SB-6.

SD-2: External battery pack that uses 6 D-type cells, designed for the SB-1.

SD-3: External battery pack uses a 510-volt battery to power the flash and 4 AA batteries to operate the built-in voltage stabilizer. Designed for the SB-1.

SD-4: External, heavy-duty 240-volt battery pack for the SB-5. Accepts two 0160-type or one 0160W-type battery.

SD-5: External power unit for the SB-6, includes SN-3 NiCd battery.

SD-6: External battery pack uses one 315-volt and 6 AA batteries. The high-voltage battery allows very fast recycling, enough to use with a motor-driven camera. (Works with the SB-11 and SB-14)

SD-7: External battery pack uses 6 C cells. (Works with the SB-11, SB-14, SB-140, SB-20, SB-22, SB-24, SB-25, SB-26, SB-27, SB-28, and SB-28DX.)

SD-8: External battery pack uses 6 AA cells. (Works with SB-11, SB-14, SB-22, SB-24, SB-25, SB-26, SB-27, SB-28).

SD-8A: Same as SD-8, only with UL approval.

SH-1: Charger for the SB-1's SN-1 battery.

SH-2: Charger for the SB-5's SN-2 battery.

SK-6: External power pack and handgrip uses 4 AA cells, can be used in conjunction with the SD-8 or SD-8A.

SN-1: Rechargeable NiCd battery pack for the SB-1.

SN-2: Rechargeable NiCd battery pack for the SB-5.

Questions & Answers

What does each contact on the hot shoe do?

Looking down at the camera's hot shoe, you'll see either two or four silver dots (contacts), depending upon the camera model. Contact 2 is in the center and is larger than the others.

● (1)

● (2)

● (3) ● (4)

Contact 1—Monitor contact (flash to camera)
Contact 2—Flash trigger signal (camera to flash)
Contact 3—Ready-light signal (flash to camera)
Contact 4—TTL flash auto-stop (quench) signal (camera to flash)

Older cameras, such as the FE and FM2, have only contacts 2 and 3. Newer cameras, such as the N90s/F90x and F5, have all four contacts plus a small hole just above and to the left of contact 1. The hole is used to keep the flash unit locked in place (when you use the Speedlight's knurled wheel to lock the flash against the camera).

Nikon's internal documentation (as in their repair manuals for Speedlights) uses different nomenclature:

Contact 1—SP (camera distinction signal, unfit camera warning signal, battery actuating signal)

Contact 2—X (trigger signal)

Contact 3—CRY (charge signal, warning signal, autofocus illuminator signal)

Contact 4—CSTP (stop signal, over the usable film speed range signal)

Each of the contacts uses a specific voltage or current to indicate the various signals. For example, on contact 1 (monitor contact, or SP in Nikon literature):

Voltage	Meaning
< 0.6V	TTL mode
1.0 – 1.3V	A or M mode
~3V	Flash is OFF

To use a third-party flash on a Nikon camera body, you must know if it complies with the limitations of voltages and currents Nikon uses to communicate. Many third-party flash units deliver signals that are too strong for the Nikon bodies to handle and may damage your camera. Nikon specifies that no contact should have more than 250 volts present.

Why do my exposures come out too dark or too light when I use the flash in manual (M) mode?

Most early Nikon Speedlights fire only at full power when set to Manual (M) flash mode. This means that you need to pay very careful attention to what the Speedlight tells you about the flash-to-subject distance and aperture. In fact, you must set exactly the aperture indicated on the flash dial, even though that often isn't one of the click stops on your lens. Even if you have a newer Speedlight that supports 1/2, 1/4, and other powers, you still need to exactly match the aperture and distance to get "perfect" exposures.

For example, let's say you're using ISO 100 film and an SB-11, and your subject is 4 meters (4.3 yards) away. Looking at the Speedlight's dial tells you that the aperture should be about halfway between f/8 and f/11. If you set f/8 your subject will be overexposed by 1/2 stop at 4 meters (4.3 yards), if you set f/11 it will be underexposed by 1/2 stop. Even though there's no click setting on many Nikon lenses at that intermediate stop (f/9.5, in case you're wondering), you should set your lens there anyway. Most users don't realize that lenses can actually be set (albeit crudely using the aperture ring) between f/stops. With slide film, that 1/2 stop may be the difference between a usable and an unusable image.

Other factors come into play as well. If you're shooting outdoors (or even indoors in a very large room), most Speedlights set to manual flash mode progressively underexpose as distance increases. If you want to find out by how much, take your camera

and flash outside on a dark night and fire off a series of pictures on slide film at each aperture and distance combination on manual. It helps if you have a gray scale (preferably using the zone system) in the picture so you can directly compare gray patch densities to approximate the drop-off.

Does flash compensation work only in fill-flash mode?

No. If you set exposure compensation on the flash, it will be used no matter what flash mode you set. Remember, in all balanced fill-flash modes, you don't know what flash exposure compensation the camera sets, so what you set may cancel out what the camera sets, or it may double it. Don't set any flash exposure compensation in balanced fill-flash modes unless you're comfortable with how the camera calculates flash exposure!

To achieve a shallow depth of field, I use aperture-priority (A) exposure mode and select f/2.8 on my 80-200mm lens, which usually gives me a shutter speed of 1/60 second. I use matrix balanced fill-flash. Sometimes my pictures come out fine, but sometimes I have visible camera shake. Why?

The key word here is "balanced," and the vital clue is the 1/60 second shutter speed, which is the slowest shutter speed most Nikon bodies set unless you select rear or slow sync.

I suspect that in the case where the pictures are blurred due to camera shake, the ambient light exposure was correct at f/2.8 and 1/60 second. Thus, in this case flash provides only fill, and your camera shake is visible in the base exposure.

When your pictures were not blurred, I'd be willing to bet that the ambient light exposure was two or more stops underexposed at f/2.8 and 1/60 second. In that case, the flash provides the main exposure, and because the flash duration is so short (typically 1/1,000 second or shorter), you don't see any camera shake.

Why do my shots in slow sync appear to have different flash amounts than ones shot in the same situation with rear sync?

Nikon camera bodies do not ask the flash to perform a pre-flash when set in rear sync mode. Since pre-flash results are used to make exposure decisions, it's quite possible for the flash to fire at different levels in rear sync from slow sync, all other factors remaining the same.

Can I leave batteries in the flash unit?

If you'll be using the flash unit within a few weeks, don't worry about taking out the batteries. However for long periods of time, it's best to remove batteries from the flash. A leaky battery can corrode and result in your having to have the battery contacts replaced. Note that when flash units are stored for long periods, they may not fire at full capacity right away (see "Troubleshooting," page 372). One way to combat this is to test fire the flash once a month (removing the batteries in between).

Are all alkaline batteries the same for flash use?

One consumer magazine has performed a number of tests over the years in which they invariably report that the lifespan of most batteries is pretty much the same, and you should therefore buy the least expensive ones. These tests are done with flashlights, low-current toys (you know, that annoying yipping dog your four-year old seems to turn on just when you most cherish silence!), and digital cameras. The magazine's 1999 report said nearly the same thing as previous ones: for alkalines, buy the least expensive batteries because most are virtually identical in quality.

Most professional photographers would seriously dispute these results, especially as it applies to a high-current device like a Speedlight. Heavy flash use is a stress test for batteries, as every time it recycles it generates huge current demands (compared to that yipping dog and even most digital cameras). Likewise, the internal resistance of the battery has some effect on the battery's ability to meet the load from the flash—all other things being equal, batteries with lower internal resistance recycle a flash faster than ones with higher resistance. In fairness to the magazine, their conclusions are perfectly appropriate to casual consumers of batteries: when battery

life is considered solely on cost, less-expensive batteries generally produce more bang for your buck.

Popular Photography has also published a number of battery tests over the years. The September 2000 issue showed that a newly reformulated Kodak Photolife alkaline battery had consistently lower recycle times than an Energizer alkaline battery (at recycle #180, the difference was more than 5 seconds). Obviously, that's a tangible difference to most of us. Moreover, that agrees with my experience in the field. If you were serious enough about flash use to purchase this book, you'll find that even modest gains in recycle times will affect how you work with your Speedlight.

Unfortunately, there's no place you can go to get unbiased test results that are current for every battery on the market, and many batteries with different brand names are exactly the same (manufactured at the same plant using the same materials, but for different companies). If you do a lot of flash photography, it does pay to try different batteries and keep careful notes about how long they last and what their recycle time is after use. Most often in flash photography the cost analysis isn't the deciding factor (if battery A costs $1 and gets 50 flashes while battery B costs $2 and gets 75 flashes, cost analysis would dictate that you should buy battery A). Photographers generally prefer faster flash recycling over longevity, which is more difficult (and possibly irrelevant) to compare using costs. Since I often shoot with fill-flash, I simply measure a single recycle time after shooting three 36-exposure rolls, which is a little more than midway through the expected life of most AA batteries. Between that and noting how many rolls I can shoot before replacing the batteries, I have two simple statistics to use in my decision making. These crude measurements were enough to convince me that the generic batteries I bought at the local discount store simply weren't up to the standards of a more expensive brand name. But all this should really be moot—switch to high capacity rechargeables and stop polluting the earth with bushels of disposed of alkalines!

Can I use lithium batteries in my Speedlights?

Nikon has only recently acknowledged that lithium batteries work with a few of the current flash units (they're specifically mentioned in the SB-28 manual, for example). However, anecdotal evidence seems to indicate that they can be used with virtually any Speedlight that uses AA batteries.

Why does my camera set itself to 1/60 second at f/4 when I'm in program (P) mode? Why doesn't it set the camera's flash sync of 1/250 (or 1/125) second?

You're probably indoors in dim light. The camera is trying to match the ambient light, so it selects a sync speed slower than the maximum. However, it won't go slower than 1/60 second unless you set the camera or flash to rear sync or slow sync. If you'd like to select a faster sync speed, you'll have to take the camera out of program mode.

I'm in the situation described in the last question, and I decide to set the camera to manual (M) exposure mode. With the camera set to 1/60 second at f/4, the bar graph in the camera now shows that I'm 2 stops underexposed. How can the exposure be OK in program (P) mode, but wrong in manual mode?

The exposure wasn't correct in program mode, it was merely "the best" the camera could do given its settings. In program mode, the camera is trying to match the flash to the ambient light. But if the camera body can't do this (i.e., the ambient light is so low it requires a shutter speed slower than the 1/60 second minimum), it does not alert you; instead, the camera just sets the minimum shutter speed. When you selected manual mode on the camera, you were in full control of the camera and could see the underexposure. That's one reason why I often just shoot in manual (M) exposure mode when I've got a flash unit mounted. Between manual mode and slow sync, you should be able to obtain correct flash exposures for virtually any low-light condition.

With my camera set on program (P) exposure mode, why can't I "shift" my program settings to an aperture faster than f/4 (at ISO 100)?

The program (P) exposure mode maintains a minimum aperture based upon the film's ISO film speed. This is done to avoid possible overexposure at very close ranges. To overcome this limitation, you'll have to take the camera out of program mode (are you getting an idea why professionals avoid program mode, when possible?).

Troubleshooting

Speedlights are quite reliable. Most common problems are attributable to physical damage or poor connections. Power supply failures are also common.

Warning: *Do not disassemble your Speedlight. Speedlight capacitors store large amounts of energy (520 volts). While the amperage is low, disassembling a Speedlight will put your health in jeopardy. I've had a smaller flash capacitor discharge on an accidental touch, and believe me, the resulting shock is not something you'll want to repeat. If you have no electronic experience and do not know how to discharge and disable a capacitor, you have no business opening up your Speedlight.*

Symptom: Unit doesn't function correctly after long storage (most typical: long cycle times, low output).

Likely causes: The capacitor needs "reforming" due to lack of use.

What you can do: Put in fresh batteries, turn the flash unit on and leave it on for 15 minutes. Fire the flash to discharge it. Fire the flash 10 to 20 more times immediately after the unit shows full charge. You're essentially helping the capacitor to relearn how to store a charge and release it (some components tend to get a "memory," and when flash units are left unused for long periods, the memory may be of a discharged state).

Symptom: Flash unit is totally dead.

Likely causes: Dead batteries; defective charging circuit; worn power switch (not making connection).

What you can do: Replace batteries; visually inspect battery contacts and clean if necessary.

Symptom: Very long recycle times.

Likely causes: Weak batteries; intermittent internal connections.

What you can do: Replace batteries; visually inspect battery contacts and clean if necessary.

***Symptom:* Reduced output and very short recycle times.**

Likely causes: Leak in capacitor; damaged capacitor; short circuit across capacitor.

What you can do: Have flash unit repaired; capacitor may need to be replaced.

***Symptom:* Flash cycles, ready light comes on, unit makes noise when triggered, but no flash is seen.**

Likely causes: The xenon tube is damaged, keeping the ionized particles from igniting.

What you can do: Have flash unit repaired; xenon tube likely needs to be replaced.

***Symptom:* SB-28 fires spontaneously (typically on N90s/F90x).**

Likely causes: This is a commonly reported problem with early SB-28s.

What you can do: Many people report that putting in fresh batteries and/or re-seating the flash in the hot shoe solves the problem. This would seem to indicate that the voltages used to communicate between the flash and camera are very close to their tolerance levels.

***Symptom:* The LCD is black.**

Likely causes: This is common when the flash is used in very hot climates. Nikon cites threshold temperatures of 140° F (60° C), but it can happen at lower air temperatures as well.

What you can do: Take the flash out of the sun and cool it off. Once temperatures return to normal, so should the LCD display.

***Symptom:* The LCD operates slowly or not at all.**

Likely causes: This is common when the flash is used in very cold climates. Nikon cites threshold temperatures of 41° F (5° C).

What you can do: Put the flash unit somewhere where it will warm up. Once temperatures return to normal, so should the LCD.

Calculations

Guide Number

Guide Number = Aperture x Distance
Aperture = Guide Number / Distance
Distance = Guide Number / Aperture

Thus, if you know your **Guide Number** and **Aperture**, you can easily solve for **Distance**.

Example:

GN = 116 (in feet)
Aperture = f/4
The **Distance** (maximum) the flash can reach is 29 feet (116/4).

Note: Guide numbers are different for feet and meters. When you look up the guide number for your flash, make sure you know whether it's expressed in feet or meters. You can't mix and match a guide number expressed in meters and a distance expressed in feet, for example.

Note: Guide numbers are based upon an average-sized room with 8-foot (2.4 m) ceilings and light-colored walls. Under other conditions (especially outside) compensation may be required (see "Guide Numbers," page 21).

Guide Numbers for ISO Film Speed Values Other Than 100

All examples in this book have been calculated for ISO 100 film. To calculate the guide number for another ISO film speed value, simply multiple the ISO 100 guide number by the following multipliers:

ISO	Multiplier
25	0.5
50	0.71
64	0.8
80	0.9
100	1.0
125	1.1
160	1.3
200	1.4
250	1.6
320	1.8
400	2.0
500	2.3
640	2.5
800	2.8
1,000	3.2
1,250	3.6
1,600	4.0

For example, if you have a flash with a GN of 98 in feet (at ISO 100) but you're using Kodachrome 64 (ISO 64), you'd multiply 98 by 0.8 to calculate an effective guide number of 78 (if the GN is expressed in meters, use the same technique; the multiplier is the same).

About the Author

Thom Hogan's resume reads like a random walk, albeit an interesting one. Author of a dozen books that have sold over a million copies combined, Thom has also been at the forefront of a number of high-tech startups, including companies that created the first mass-produced portable computer (Osborne), the first complete pen-based operating system designed entirely from scratch (GO), and the first consumer digital camera (QuickCam). A frequent traveler, Thom spends much of his travel time photographing the wilds, most recently in a stint as executive editor of *BACKPACKER* magazine.

Other photography books by Thom Hogan:
The Nikon Field Guide, Second Edition (Silver Pixel Press)
ISBN 1-883403-58-8
The Nikon Coolpix Guide (forthcoming from Silver Pixel Press)
ISBN 1-883403-97-9
Photography 101 (forthcoming, visit www.bythom.com for info)

The author takes a licking in Alaska.